KED ONE OF CANAD
10 BEST PLACES TO LIV

WELCOME
TO
GANDER

DISCARD
CADL

GANDER LIONS CLUB
1ST & 3RD WED. 6:30

ELKS

B.P.O.E. O.O.R.P.
CANADA
ROYAL PURPLE

GANDER #6860
AIRWAYS #8777

GANDER
SHRINERS CLUB
256-3689

We are a Crime Stoppers Community

1-800-222-TIPS
(8477)

TOWN OF GA

Stoppers
Newfoundland & Labrador

COME FROM AWAY

WELCOME TO THE ROCK

BOOK, MUSIC, AND LYRICS BY IRENE SANKOFF AND DAVID HEIN
TEXT BY LAURENCE MASLON

FOREWORD BY PRIME MINISTER JUSTIN TRUDEAU

hachette BOOKS

NEW YORK BOSTON

Hachette Books
Hachette Book Group
1290 Avenue of the Americas
New York, NY 10104
HachetteBooks.com
Twitter.com/HachetteBooks
Instagram.com/HachetteBooks

First Edition: September 2019

Hachette Books is an imprint of Perseus Books, LLC, a subsidiary of Hachette Book Group, Inc.
The Hachette Books name and logo are trademarks of Hachette Book Group, Inc.

The publisher is not responsible for websites (or their content) that are not owned by the publisher.

Production by Stonesong
Print book interior design by Stan Madaloni, studio2pt0, llc

LCCN: 2019937851
ISBNs: 978-0-316-42222-2 (paper over board), 978-0-306-84677-9 (ebook),
978-0-306-84678-6 (ebook), 978-0-316-42221-5 (ebook)

Printed in the United States of America

WORZALLA
10 9 8 7 6 5 4 3 2 1

CONTENTS

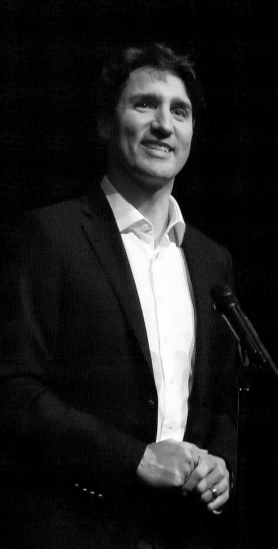

FOREWORD

Since 2013, *Come From Away* has told the story of strangers turning into friends—and shone a light on the thousands of people who, in the wake of one of the darkest days we've experienced, showed us humanity at its best.

From Beverley Bass to Oz and Claude, Beulah and Hannah to Diane and Nick, the characters in *Come From Away* give voice to the experience of thousands of people—in Newfoundland, across North America, and around the world—who grappled with the aftermath of September 11. We see their fear and uncertainty, their pain and grief— but also their courage, their resilience, and their unfailing humanity. In the connections between the "plane people" and the thousands of residents who welcomed them, everyday kindness becomes an extraordinary act.

In a matter of hours, thirty-eight planes of stranded passengers temporarily doubled Gander's population. Together with the communities of Glenwood, Lewisporte, Appleton, Gambo, and Norris Arm, residents welcomed "come-from-aways" into their homes—sharing connections and forging friendships along the way. Beyond the practical challenge of providing shelter, bedding, and food for seven thousand people, they worked to give comfort and support in a time of profound loss. Through it, residents and newcomers built relationships and became friends across languages and cultures. They stood together at a time when fear threatened to divide. But that's no surprise to anyone

familiar with the generosity that marks communities throughout Newfoundland and Labrador. As the show's very first number tells us, "If you're hoping for a harbour, then you'll find an open door."

Come From Away is a Canadian musical, written by Canadians, about Canadians. It brought Canadian creativity to Broadway, and showcased the Canadian spirit of compassion, resourcefulness, and generosity. It's a unique story, rooted in a singular tragedy—but it's emblematic of what it means to be a neighbour and a friend. When a grieving United States shut down its airspace for the first time in history, *Come From Away*'s communities—like so many others—did what neighbours do: pitched in, stepped up, and opened their arms.

When I saw *Come From Away* in New York, I got to see firsthand its remarkable impact—bringing us together across borders to witness the courage and kindness that made so many people heroes. As this play touches audiences in North America and beyond, it will continue to remind us to keep faith—even, and perhaps especially, when that seems most impossible. *Come From Away* showed us how, in one of our darkest times, thousands found solace and hope by looking at it. Together, right along with the cast of characters, we "honour what was lost—but we also commemorate what we found."

—Prime Minister Justin Trudeau
Fall 2018

I N T R O D U C T I O N

When we first traveled out to Gander, Newfoundland, on the tenth anniversary of September 11 to research our second musical (then tentatively and unimaginatively called "Gander") we never expected to hear so many incredible stories or to be welcomed so warmly into the community there, just as they had a decade earlier welcomed the stranded Come From Aways (a much better title, referring to anyone not from Newfoundland, but also, when displayed on a sign, a welcome message). The Newfoundlanders told us that the kindness they'd shown is "just what people do." And it should be.

We're often asked which stories we couldn't fit in to *Come From Away*–and for the most part, we tried to fit them all in.

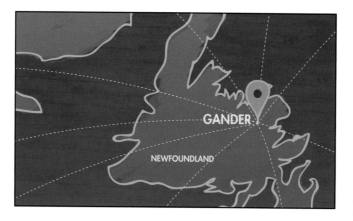

But one story we've never told is how Matt Kane predicted the future.

Our first interview for the show was over the phone with Matt's daughter, Crystal. When she heard we were traveling to Newfoundland, she put us in touch with her parents, Matt and Brenda, who live in Gambo, one of the many Newfoundland towns that housed and helped stranded passengers. And even though we were complete strangers, they put us up for several weeks–wouldn't let us spend money on a hotel–and gave us the keys to their house while they left for their tiny cabin ("to get away from it all").

And one night, in that cabin, they made us dinner by candlelight, and Matt predicted the future, which he apparently often did and (according to everyone) with much success.

"This project you're working on? It's going to be big."

At that point, we were just hoping that Canadian high schools would be forced to do this show because of the large number of parts and the Canada content, so we were somewhat skeptical.

So was everyone else. Reg Wright, president of the Gander airport, after an extensive three-hour tour, asked us, "Now what are you doing? A musical about . . . people making sandwiches? Good luck with that."

But it wasn't just luck that got us here. Like Gander, we had a remarkable community supporting us, starting with Michael Rubinoff, who introduced us to the story (after five other skeptical writing teams passed on it), the students and staff at Sheridan College and Goodspeed Musicals who helped us develop it, and the incredible National Alliance of Music Theatre team who showcased it. Our producers,

Junkyard Dog Productions, assembled the best team you could dream of, led by our brilliant director, Christopher Ashley, our music supervisor, Ian Eisendrath, and choreographer, Kelly Devine. From our amazing cast and band to our designers, advisors, producers, music and marketing teams, backstage crews, theatre staff, ushers, and front of house crews, we have been blessed to work with such a talented and wonderful family, all telling this story as one.

That family helped us develop a show that has earned Best Musical accolades across North America, breaking box office records and playing some of the finest theatres in North America–definitely including the Gander Community Centre hockey rink ("the world's largest walk-in refrigerator"). And eight years after we first traveled to Newfoundland, we are now the longest running Canadian musical

on Broadway–with five unique and exciting companies sharing Newfoundland kindness with the world on Broadway, in our home town of Toronto, across North America, in London and Australia.

It's a tribute to the story and the people we are celebrating that the show continues to perform to sold out houses and standing ovations. But more important, we are amazed, but not surprised, that telling this story on stage has inspired a movement of Kindness. From the bucket we passed at our first workshop for the Gander area SPCA because it was kitten season, to the hundreds of thousands of dollars in Broadway Cares/Equity Fights AIDS donations by our audiences; from our cast's "Come From Kindness" campaigns and concerts and fundraisers for the families of Humboldt, Daffodil house and other Newfoundland

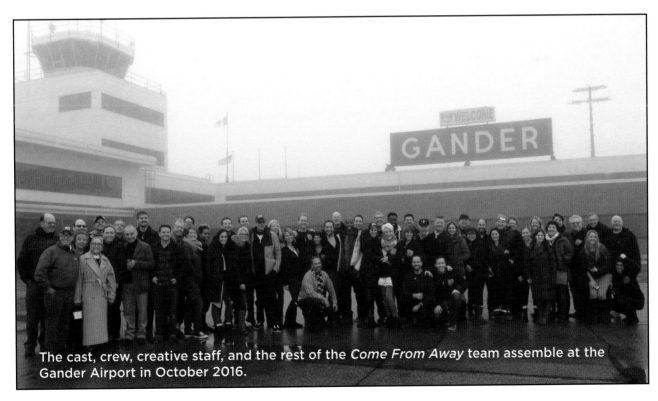

The cast, crew, creative staff, and the rest of the *Come From Away* team assemble at the Gander Airport in October 2016.

SANKOFF AND HEIN AT MATT AND BRENDA'S HOUSE IN GAMBO, SEPTEMBER 2011

charities, to Pay-It-Forward 9/11 days, inspired by the people we interviewed, spreading random acts of kindness to strangers. This story has taught us that we can respond to tragedies with kindness and that we don't need to wait for a tragedy: We can respond with kindness every day. We see it every night in our theatres: audience members sharing a tissue, smile or hug after the show, making new friends and even planning trips out to Newfoundland–sometimes with complete strangers who then become friends.

All of this started because of the kindness that was shown to strangers and the friendships that were made in towns across Newfoundland and across Canada, where many other flights were diverted. We are incredibly grateful for the kindness that has been shown to us, and for the friends we've made from the Rock and From Away who join us at each opening, reuniting as they did at the Tenth Anniversary when they first shared their experiences with us. Thank you from the bottom of our hearts for trusting us to be the channel of your stories.

We are also honoured and humbled by the 9/11 community of family members and survivors who have joined us for previews, tours, and discussions, sharing with us that "this story has helped them to heal" or has provided some hope in humanity. We promise to always honour what was lost while we commemorate what we found.

At each step of the way we've collected our own stories, along with material cut from the musical which we're thrilled to share here for the first time, accompanied by Laurence Maslon's excellent history and interviews. From the beginning, Larry told us that he believed this book was not just a piece of theatre history, but also an important piece of world history. His commitment to tell that story led him to Newfoundland himself, unearthing even more untold stories, information and photos which have never been published (and yes, we made sure he got screeched in while he was there). These pages document a story that we never expected to go as far as it has gone–and we are profoundly grateful to every friend who supported us along the way, and every member of our CFA family and audience who made this journey possible.

Back in 2011, in that candlelit cabin–and after a few drinks–we jokingly asked Matt, ". . . are you saying the show is going to go to Broadway?"

"Oh," Matt answered, looking off into the distance. "It's going to be much bigger than that."

You were so right, Matt. You were so right.

–Irene Sankoff and David Hein

BEFORE

It is an island that has welcomed come-from-aways as far back as the time before clocks.

In a gallery in The Rooms, the Provincial Museum of Newfoundland and Labrador, there's a display that sums up what contact with come-from-aways means to the province's cultural character:

"Contact" is one of the most powerful agents of cultural change. Contact-driven cultural change had occurred many times in Newfoundland and Labrador, as resident cultures and new arrivals met and adapted to each other's presence. The ensuing relations between the newcomers and those who were already "home" have had long-lasting effects on both.

Perhaps it is whimsical to suggest that one of the reasons that Newfoundlanders and Labradorians—these robust residents of the North Atlantic—are so good at contact with folks from across the ocean is that they were once part of the same continent. When the tectonic plates shifted after three hundred million years, North America tore itself away from Europe and Africa and started floating east, it took some of the Old World with it like a memento for its long voyage.

There is a massive continental shelf offshore of the province that provided a fertile—and unmatched—breeding ground for codfish. It turned Newfoundland and Labrador into a piscine breadbasket that had sustained its own populace for millennia and provided an important staple for cultures as far-reaching as Portugal, Spain, the West Indies, and West Africa. It also transformed Newfoundland and Labrador into a very attractive place for all varieties of visitors.

When the ice retreated after the last ice age, indigenous groups started to move in, drawn, no doubt, to the swarms of sustenance. A small but vibrant and peripatetic aboriginal people called the Beothuk inhabited the island for millennia. More than a thousand years ago, the first

A somewhat fanciful 19th-century engraving of John Cabot making landfall in Newfoundland, an event that probably never happened.

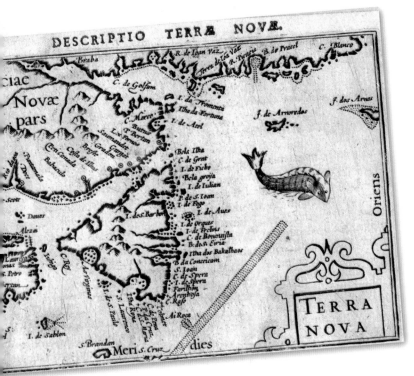

This map from a 1602 atlas is the first to show the island with some accuracy.

European come-from-aways were intrepid Norse travelers who sailed to "the Rock"; driven by exploration and survival rather than by conquest, these hearty visitors vanished seemingly as unpredictably as they arrived. Half a century later, a fleet with more pecuniary interests sailed around the rocky island. A Venetian merchant and sailor with the Anglicized name of John Cabot traveled from the English sea town of Bristol in 1497 to the coast of Newfoundland, the farthest point east on the North American continent; in fact, it was he who dubbed it "New-Founde-Lande." His ship made landfall at Cape Bonavista on the island's northeast coast–probably 115 kilometers (about seventy miles), as the crow flies, from Gander. Most historians concur that Cabot and his crew never made direct contact with the Beothuk people, but what Cabot did encounter was codfish–and lots of it: "[swarms of] fish," as he reported, "which can be taken not only with the net, but in baskets let down with a stone."

By the time the sixteenth century vanished into the history books, French and Portuguese sailors and fishermen joined British settlers on the island–which had been named a British colony–diversifying its European influence. Also, by that point in time, the European sailors and traders would have encountered the tribal successors to the Beothuk, the Mi'kmaq (on the west coast of the island) and, much later, the Innu people, communities that continued the harvesting of the natural resources of the island. Contact between indigenous groups and the European traders over these resources often ended tragically; it was a universe increasingly swirling with different nationalities and agendas

The craggy coast of Bell Island in Conception Bay, a sight for early explorers.

in that heady, avaricious, and often mercenary time. Newfoundland became a frequent pawn in the European wars of conquest in the eighteenth century, but by 1763, this scrappy, rugged island with its copious and enticing waters, became a colony of British Canada; 144 years later, Newfoundland and Labrador achieved dominion status as a self-governing part of the British Commonwealth.

Along with mining and forestry, the fishing industry, begot of the island's geology idiosyncrasies, was not only the heartbeat of its economy, but also of its culture. Dotted along the zigzagging coastline were hundreds of outports–small, tightly knit communities,

whose economy was based on fishing, fisheries, or other commerce, such as seal-hunting and, beginning in the early-twentieth century, whaling. The courageous seamen who risked death to harvest the water's bounty have been the bedrock of the island's traditions, music, language, crafts, and its moral compass; there seemed to be no recipe that a fresh hunk of cod couldn't make better.

The geographic isolation of the island of Newfoundland is often a metaphor for its strong, independent streak. Skepticism of the larger Canadian government and society– the world of "mainlanders"–is braided into Newfoundland's DNA. With the Second World

War, though, Newfoundland and Labrador were brought into greater contact with the United States and the rest of the globe; this was a determinate tipping point. Vigorously prodded by Joseph Smallwood, a local politician born in Gambo, a majority of Newfoundlanders and Labradorians agreed to join the Canadian Confederation, and on March 31, 1949, with the slim margin of a referendum, became Canadian citizens. Among those in the hard-won majority, the Confederation was felt to be a necessary step to improve infrastructure, utilities, and resources, but there are still those on the Rock who bewail the loss of an independent spirit, and the homogenization of tradition that was brought along by Confederation with Canada.

In the twenty-first century, Newfoundland and Labrador is a vibrant province with over half a million inhabitants stretched across the seventy thousand square miles (111,000 km) of the island. Its capital, St. John's, on the east coast, is a bustling and charming town, with idiosyncratic Victorian architecture, vertiginous streets, and colorful facades perched over a craggy and breathtaking harbor. Following a cod moratorium in July 1992, when the Canadian government imposed a halt to cod fishery along the country's east coast, putting a dead stop to a way of life half-a-millennium old, fishing now takes up only about 12 percent of its economy, but oil and gas resources and a robust tourist industry have grown to contribute mightily to the local economy.

Yet, its contradictions are baked into its existence; along with the burgeoning cosmopolitanism of St. John's, one can drive through the small towns of Goobies, Cupids,

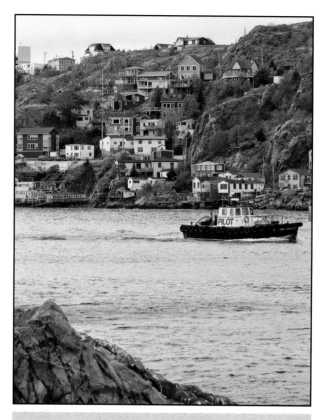

Colorful homes dot the harbor at St. John's.

Cow Head, Heart's Delight-Islington, and, yes, Dildo. The waters are still bounteous, but as Newfoundland and Labrador comedian, Mark Critch put it, "Our soil is as deep and fertile as a tray of kitty litter." Even its time zone is personal and idiosyncratic: Newfoundland and Labrador have their own time zone, which deviates from the regular standard time zone scheme by a half-hour—"That's 10:00 tonight on Canadian television, 10:30 in Newfoundland"—and ninety minutes later than Eastern Standard Time. It's a point of local pride; a 1963 resolution to bring the time zone in line with the rest of the world was roundly defeated.

Contradiction is character: a story goes that when a local zoning proposal for a video

arcade went out, the petitions came back equally for and against, and both sides had the same signatures. Apparently, no one wanted to hurt his neighbor's feelings. As journalist Jim DeFede put it, "Their willingness to help others is arguably the single most important trait that defines them as Newfoundlanders. Today, it is an identity they cling to, in part, because it is something that cannot be taken away from them."

Perhaps kindness is the best attribute to manage the omnipresent struggle between life and death that has informed every aspect of life in Newfoundland and Labrador for millennia. Newfoundlanders and Labradorians are at the tail end of an often-destructive hurricane system and also in the middle of what's called Iceberg Alley (the first distress call from the *Titanic* was received south of St. John's at Cape Race and the ocean liner sank 425 miles southeast of

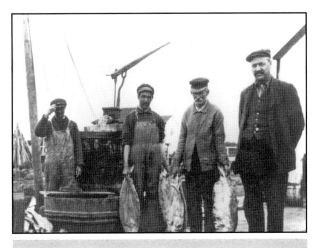

Newfoundland fishermen in the 1900s doing what they did best: catching cod.

Newfoundland in 1912). They are a people who have witnessed and been ravaged by numerous catastrophes of the sea and air–and yet welcome the new day, and all that it brings, with open arms. Chris Oravec, a guide at the awe-inspiring

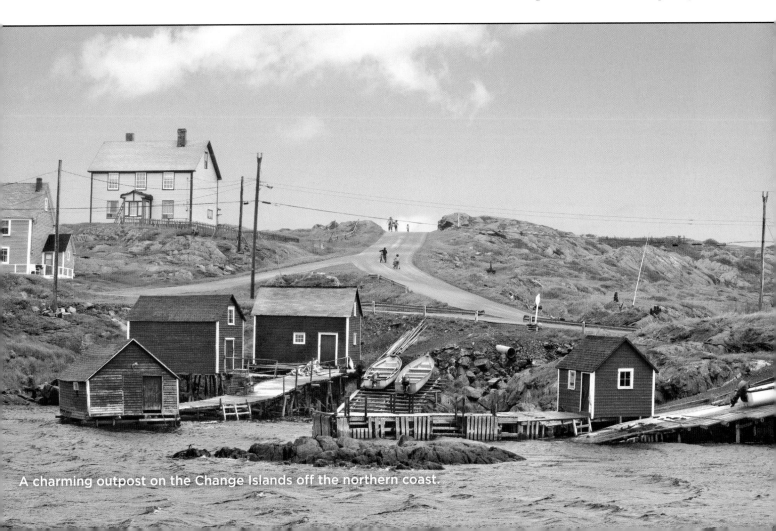

A charming outpost on the Change Islands off the northern coast.

The sun sets on tranquil Gander Lake.

Gros Morne National Park said, "The real lesson of Newfoundland is how tenacious life is. Life really, really wants to hang on."

On the island of Newfoundland, tribulation and triumph have been locked in mortal combat for thousands of years. Nature has thrown everything in its merciless bag of tricks at the settlers of this place—and yet, it has survived; more than that, it has endured and prospered. Being an islander is a choice and a calling at the same time. As Gander's former mayor, Claude Elliott put it: "It's our culture, it's our way of life. We live on an island where most of the time the weather is harsh and we survive by helping each other. If someone in the community was in need, everyone came forward to help and that's passed down from generation to generation."

Welcome to the Rock.

A hearty welcome emanates from every town on the Rock; here are some visited by the come-from-aways and, eventually, the creative team of *Come From Away*.

WE LIVE ON
AN ISLAND
WHERE MOST OF THE TIME
THE WEATHER
IS HARSH

and we survive by

helping each other.

Welcome to THE ROCK

① IRENE: This was the first song written. David sent it to me, saying he was worried it wasn't quite right. But I listened to it and as soon as I heard the beat at the beginning I knew it was—and by the end of the song I was in love with it. It was almost scrapped altogether at one point, but it is essentially the same song from our first writing session.

A bodhran beats a fast rhythm.

CLAUDE
On the northeast tip of North America, on an island called Newfoundland, there's an airport—it used to be one of the biggest airports in the world. And next to it, is a town called Gander.

OZ
There's a two-person police department.

BEULAH
An elementary school.

BONNIE
An SPCA.

JANICE
A local TV station.

DOUG
And a hockey rink.

CLAUDE
It's a small place—on a giant rock in the ocean. Everybody knows everybody else. And everybody in this room has a story about how they started that day.

WELCOME TO THE ROCK! IF YOU COME FROM AWAY ①
YOU'LL PROBABLY UNDERSTAND ABOUT A HALF OF
 WHAT WE SAY
THEY SAY NO MAN'S AN ISLAND, BUT AN ISLAND MAKES
 A MAN

CLAUDE, OZ, BEULAH & BONNIE
SPECIALLY WHEN ONE COMES FROM ONE LIKE
 NEWFOUNDLAND

ALL
WELCOME TO THE ROCK

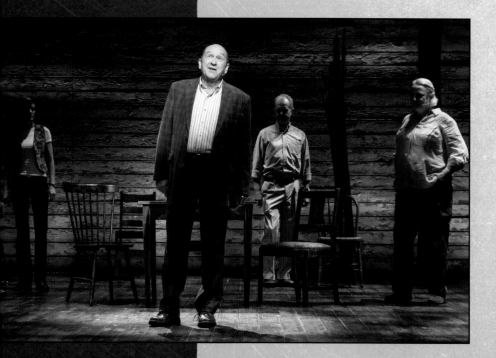

BEULAH
That morning, I'm in the classroom. It's our first day back and the school buses are on strike, so I'm covering for Annette, who's running late!

ANNETTE
Sorry, Beulah! How's the kids?

BEULAH
Not exactly thrilled to be inside on such a gorgeous day, so I told them we'd only have a half day this morning—and they were quite pleased—until I told them we'd have the other half in the afternoon.

GARTH
WELCOME TO THE WILDEST WEATHER THAT YOU'VE EVER
 HEARD OF

DOUG
WHERE EVERYONE IS NICER, BUT IT'S NEVER NICE ABOVE

ANNETTE
WELCOME TO THE FARTHEST PLACE YOU'LL GET FROM
 DISNEYLAND

CLAUDE
FISH AND CHIPS AND SHIPWRECKS

CLAUDE & WOMEN
THIS IS NEWFOUNDLAND

MEN
WELCOME TO THE ROCK

WOMEN
I'M AN ISLANDER

ALL
I AM AN ISLANDER ②
I'M AN ISLANDER, I AM AN ISLANDER
I'M AN ISLANDER, I AM AN ISLANDER
I'M AN ISLANDER, I AM AN ISLANDER

OZ
That morning I'm in my car. The kids cross Airport Boulevard to get to school—and that time a day

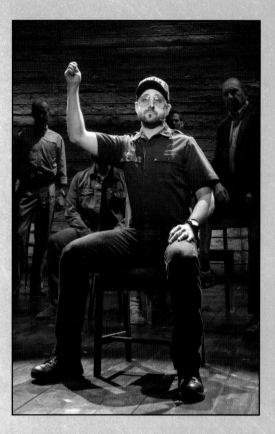

people are in a little bit of a rush to get to work and stuff, so normally I sit there and run my radar.

*Oz cues the cast to make a "WHOOP WHOOP"
noise together.* ③

And if they're speeding, I'll stop 'em and write out a warning ticket. I'll write "STFD"—Slow The Fuck Down. ④

MARGIE
WELCOME TO THE LAND WHERE THE WINTERS TRIED TO
 KILL US
AND WE SAID

ALL (EXCEPT DWIGHT)
WE WILL NOT BE KILLED

DWIGHT
WELCOME TO THE LAND WHERE THE WATERS TRIED TO
 DROWN US
AND WE SAID

② DAVID: "Welcome to the Rock" and its "I'm An Islander" chorus in particular was inspired by Newfoundland pride songs, most especially Bruce Moss's "The Islander." I wanted to write a song that welcomed people to the world, telling the audience immediately that this show wasn't set in New York, and also sharing the unique mix of pride and humility that Newfoundlanders have about their home.

③ IRENE: All the sound effects are made by the cast, including sirens, cats, dogs, and Bonobo chimpanzees. We joke that having our cast make all the noises is not only theatrical, but inspired by a certain budget-conscious Canadian aesthetic.

④ DAVID: STFD tickets from Oz have become prized possessions, so much so that some people speed through town in the hopes of getting one.

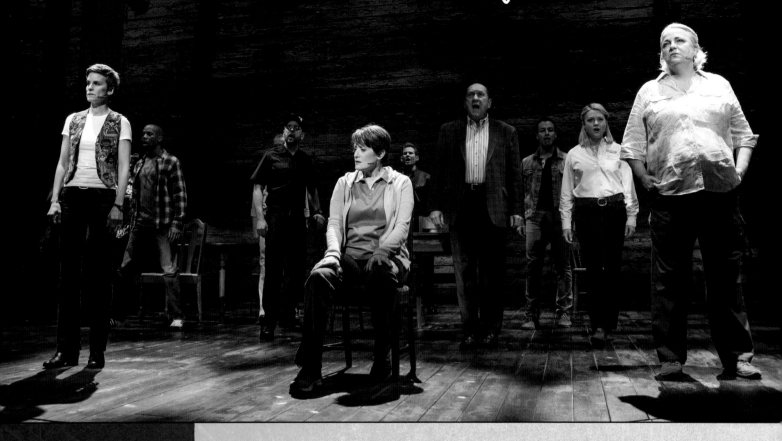

"You are here at the start of a moment."

⑤ IRENE: Each actor has been assigned a number, which refers to any characters who are unnamed. For example, actor 10 refers to the actor who plays Bob and others, but the cast doesn't let them just be numbers—each character has been imbued with their own backstory and details.

ALL (EXCEPT JANICE)
WE WILL NOT BE DROWNED

JANICE
WELCOME TO THE LAND WHERE WE LOST OUR LOVED ONES
AND WE SAID

ALL (EXCEPT 10) ⑤
WE WILL STILL GO ON

10 (LOCAL)
WELCOME TO THE LAND WHERE THE WINDS TRIED TO
 BLOW

ALL
AND WE SAID NO

BONNIE
That morning, I drop my kids off at school and head to the SPCA ⑥ , where I'm greeted by my other kids—

all barking and meowing for breakfast and a belly rub. Not that I'm complaining. I loves 'em. But by the time feeding is done, I've got to get back to pick up my human kids. So, I take just one second for myself. And I'm sitting in my car.

BEULAH
I'm in the staffroom.
ANNETTE
I'm in the library.

BONNIE, BEULAH & ANNETTE
And I turn on the radio.

ALL (EXCEPT BONNIE, BEULAH & ANNETTE)
YOU ARE HERE
AT THE START OF A MOMENT

ALL
ON THE EDGE OF THE WORLD
WHERE THE RIVER MEETS THE SEA

HERE—ON THE EDGE OF THE ATLANTIC
ON AN ISLAND IN BETWEEN
THERE AND HERE

ALL (EXCEPT BONNIE & OZ)
(repeated hushed underneath)
I'M AN ISLANDER, I AM AN ISLANDER
I'M AN ISLANDER, I AM AN ISLANDER . . .

OZ
I'm running my radar when Bonnie comes by. She pulls up and she's wavin' at me like mad, so I roll down my window and she says . . .

BONNIE
Oz, turn on the radio!

OZ
Slow it down, Bonnie.

BONNIE
Jesus H., Oz! Turn on your radio!

ALL (EXCEPT JANICE)
WHERE OUR STORIES START

JANICE
It's my first day at the station.

ALL (EXCEPT GARTH)
WHERE WE'LL END THE NIGHT

GARTH
I'm getting coffee for the picket line.

ALL (EXCEPT CRYSTAL)
WHERE WE KNOW BY HEART

CRYSTAL
Five minutes 'til my smoke break.

ALL (EXCEPT DWIGHT)
EVERY SINGLE FLIGHT

DWIGHT
I'm off to work at the airport.

MEN
WELCOME TO THE FOG
WELCOME TO THE TREES
TO THE OCEAN—AND THE SKY
AND WHATEVER'S IN BETWEEN

TO THE ONES WHO'VE LEFT
YOU'RE NEVER TRULY GONE
A CANDLE'S IN THE WINDOW
AND THE KETTLE'S ALWAYS ON

ALL
WHEN THE SUN IS COMING UP
AND THE WORLD HAS COME ASHORE
IF YOU'RE HOPING FOR A HARBOR
THEN YOU'LL FIND AN OPEN DOOR
IN THE WINTER FROM THE WATER
THROUGH WHATEVER'S IN THE WAY
TO THE ONES WHO HAVE COME FROM AWAY
WELCOME TO THE ROCK!

6 IRENE: I used to volunteer at an animal rescue—and I would scoop litter as I listened to the interviews over and over, immersing myself in who these people were. Their voices were in our heads every step of the way, so when we returned three years later and acted like they were long lost friends, we had to remind ourselves, *OH! They are a little taken aback. The interviews were a long time ago, and they haven't thought of us every single day the way we've thought of them.*

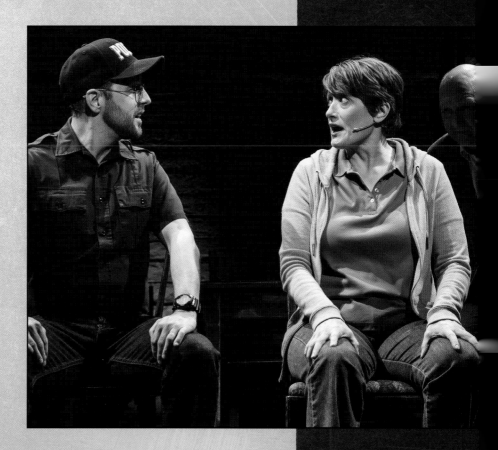

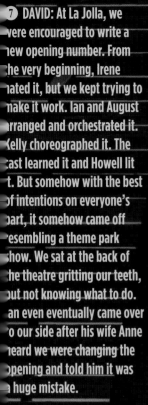

7 DAVID: At La Jolla, we were encouraged to write a new opening number. From the very beginning, Irene hated it, but we kept trying to make it work. Ian and August arranged and orchestrated it. Kelly choreographed it. The cast learned it and Howell lit it. But somehow with the best of intentions on everyone's part, it somehow came off resembling a theme park show. We sat at the back of the theatre gritting our teeth, but not knowing what to do. Ian even eventually came over to our side after his wife Anne heard we were changing the opening and told him it was a huge mistake.

—continued on next page

CUT
From Away

⑦

Throughout the script there will be sections written in blue italics representing selections of the script that did not make to Broadway. For example, here are some of the original lyrics from the end of Welcome to Newfoundland and the Finale:

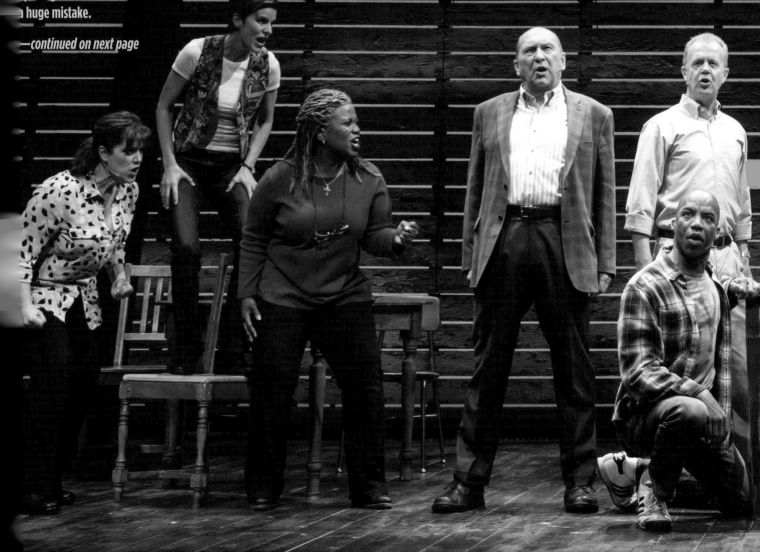

The original Broadway ensemble (left to right): Sharon Wheatley, Jenn Colella, Q. Smith, Joel Hatch, Rodney Hicks (kneeling), Lee MacDougall, Chad Kimball, Caesar Samayoa, Geno Carr (kneeling), Astrid Van Wieren, Kendra Kassebaum, and Petrina Bromley.

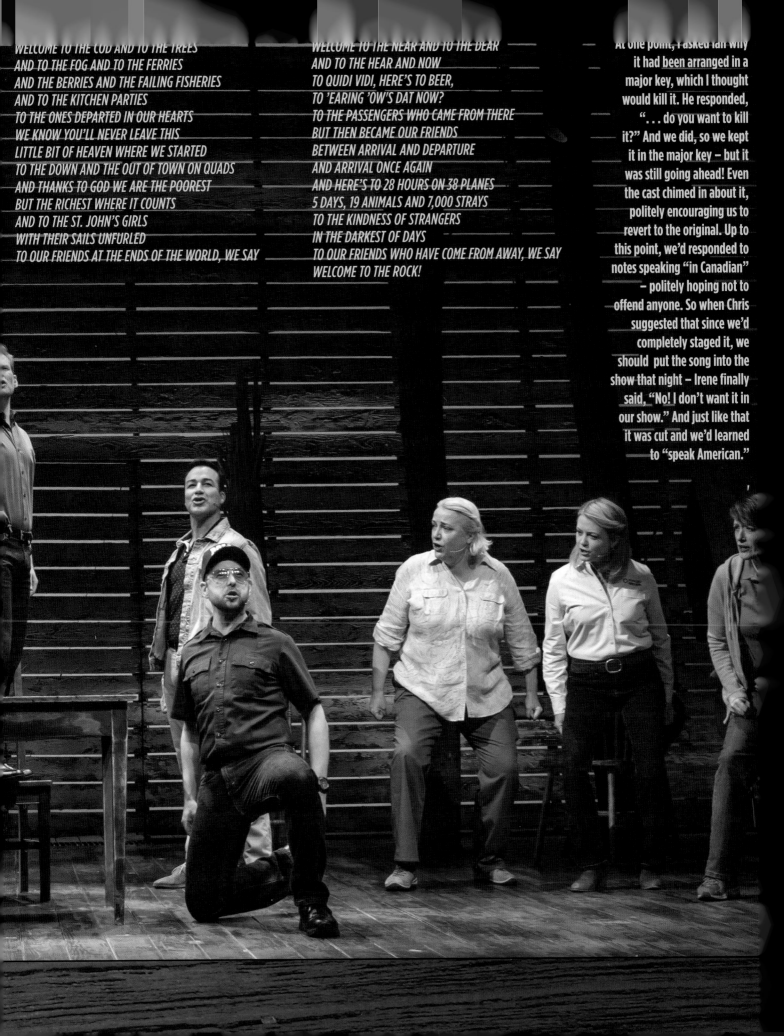

WELCOME TO THE COD AND TO THE TREES
AND TO THE FOG AND TO THE FERRIES
AND THE BERRIES AND THE FAILING FISHERIES
AND TO THE KITCHEN PARTIES
TO THE ONES DEPARTED IN OUR HEARTS
WE KNOW YOU'LL NEVER LEAVE THIS
LITTLE BIT OF HEAVEN WHERE WE STARTED
TO THE DOWN AND THE OUT OF TOWN ON QUADS
AND THANKS TO GOD WE ARE THE POOREST
BUT THE RICHEST WHERE IT COUNTS
AND TO THE ST. JOHN'S GIRLS
WITH THEIR SAILS UNFURLED
TO OUR FRIENDS AT THE ENDS OF THE WORLD, WE SAY

WELCOME TO THE NEAR AND TO THE DEAR
AND TO THE HEAR AND NOW
TO QUIDI VIDI, HERE'S TO BEER,
TO 'EARING 'OW'S DAT NOW?
TO THE PASSENGERS WHO CAME FROM THERE
BUT THEN BECAME OUR FRIENDS
BETWEEN ARRIVAL AND DEPARTURE
AND ARRIVAL ONCE AGAIN
AND HERE'S TO 28 HOURS ON 38 PLANES
5 DAYS, 19 ANIMALS AND 7,000 STRAYS
TO THE KINDNESS OF STRANGERS
IN THE DARKEST OF DAYS
TO OUR FRIENDS WHO HAVE COME FROM AWAY, WE SAY
WELCOME TO THE ROCK!

At one point, I asked Ian why it had been arranged in a major key, which I thought would kill it. He responded, ". . . do you want to kill it?" And we did, so we kept it in the major key – but it was still going ahead! Even the cast chimed in about it, politely encouraging us to revert to the original. Up to this point, we'd responded to notes speaking "in Canadian" – politely hoping not to offend anyone. So when Chris suggested that since we'd completely staged it, we should put the song into the show that night – Irene finally said, "No! I don't want it in our show." And just like that it was cut and we'd learned to "speak American."

THE WRITERS

If the score to *Come From Away* sounds like the perfect marriage between an upbeat Broadway musical and an acoustic folk band, there might be a good reason for that.

Before they met at Toronto's York University, Irene Sankoff and David Hein grew up in two different, vaguely complementary, musical universes. Raised in the Toronto suburb of North York, Sankoff sat in the back row with her mother, watching productions of *Damn Yankees* and *Guys and Dolls* and *Les Misérables*, when she wasn't watching *Top Hat* and *The Sound of Music* on her tiny black-and-white television set. Meanwhile, Hein–raised in the province of Saskatchewan–was taken by *his* mom to the Winnipeg Folk Festival, a massive worldwide venue, that regularly featured such Canadian folk rock acts as Blue Rodeo, Spirit of the West, and one particularly compelling group from Newfoundland, Great Big Sea.

Sankoff and Hein working on the script at La Jolla Playhouse, California, 2015.

By the late 1990s, they were both theater majors at York–Sankoff did more acting, Hein did more tech work and music–and wound up dating. They inevitably shared their musical tastes–"overproduced eighties pop" was Sankoff's, "folksy guy with a guitar" was more in Hein's wheelhouse–but on long car trips from Toronto to New York and back, they would swap songs, often devouring one musical theater score several times over per excursion on the car's CD player while alternating between compilations of rock bands. "I started to learn show tunes," recounted Hein, "but when we got to the score for *Rent*, that was a happy compromise. We sometimes think of music as having these hard and fast lines, dividing genres, but, in the end, it's all about storytelling."

Music sustained the couple–literally–when they made the move to New York City just before the millennium. Hein took a day gig, handling an assortment of tasks at a recording

studio, while Sankoff was studying acting and making ends meet with the obligatory waiting-for-the-big-break jobs, such as leading group tours around the city. They were living together at International House, up on Riverside Drive, a residential center for scholars and graduate students from around the world.

On the morning of Tuesday, September 11, they had every reason to sleep in–Hein had a lunchtime session and Sankoff didn't have to be at her acting studio until late morning. But, then, at around 9:00 a.m., Sankoff's father called from Toronto. Her brother had seen the news about the World Trade Center and told her father, who wasn't worried: Why would Irene be downtown at this hour? Her brother reminded him that Irene often led tour groups around the city–who knows? "Don't go down to school, don't get on the subway," he told Sankoff. As they turned on the television, the second plane hit the South Tower.

Their co-residents at International House responded in many different ways–but, by the evening, the residents stood together on the roof and watched the smoke rise from one hundred blocks downtown. Even amid such chaos, music sustained them–a friend sat down at a piano, and everyone gathered around for an informal impromptu concert. "There was

YORK U

SUMMER 2010

A Silly Little Song

How this grad couple created the hit musical
My Mother's Lesbian Jewish Wiccan Wedding

PLUS

Behind author Catherine Gildiner's latest Falls
You're never too old to build muscle
York reaches out to the neighbourhood

Sankoff and Hein, celebrated by their alma mater, fresh off their success with *Wiccan Wedding*.

something very healing about the music that helped us come together as a community," recalls Hein.

That communal spirit could be found on every street corner in Manhattan in the days following 9/11. "There was a real feeling in New York of just living for the present, so we said, 'Why are we waiting?,'" said Sankoff, so a month after the attacks, they eloped at New

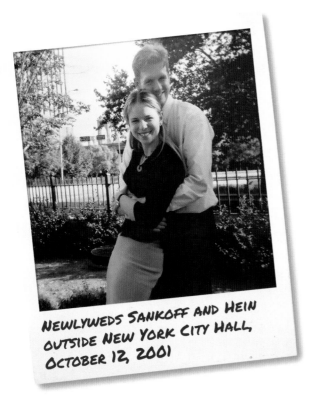

NEWLYWEDS SANKOFF AND HEIN
OUTSIDE NEW YORK CITY HALL,
OCTOBER 12, 2001

The show–also performed by Sankoff and Hein–debuted at the 2009 Toronto Fringe Festival, where it was embraced by famed Canadian entrepreneur David Mirvish, and eventually spawned productions across North America, allowing them to fulfill the dream of every struggling young artist: to quit your day job. In early 2010, Sankoff and Hein met with Michael Rubinoff, who the *New York Times* later referred to as "the one-man champion of Canadian musical theater." Rubinoff was just starting the Canadian Music Theatre Project at Ontario's Sheridan College, dedicated to the development of new works of musical theater in Canada. Rubinoff took the couple to dinner and floated another, completely unconventional idea, that some other writers "felt wasn't appropriate": Had they heard about the small Newfoundland town of Gander, which took in thirty-eight jetliners in the wake of 9/11? Sankoff and Hein had experienced 9/11 in New York, so the Gander story hadn't pinged loudly on their radar a decade later, but, upon further reflection, it resonated with dramatic possibilities.

York City Hall, which was still in the smoldering shadows of the twin towers. Hein's cousin Tanya, who had worked in the South Tower, but escaped on the morning of 9/11, joined them as their witness; after the ceremony, they traced her steps around Ground Zero–their marriage was framed by a deep respect for what had happened in Lower Manhattan four weeks earlier. After a few more tough months, the couple moved back to Toronto. Realizing that between their grinding routine of day jobs and performing gigs, they were but ships that passed in the night, Sankoff and Hein committed themselves to working together on their own project. Their first collaboration would be as quirky as it was unlikely: a musical based on the real-life journey of self-discovery experienced by Hein's mother called *My Mother's Lesbian Jewish Wiccan Wedding.*

Luckily, there was a chance to investigate those possibilities firsthand. The town of Gander was planning a week-long series of events to commemorate the tenth anniversary of 9/11. There was enough lead time for Sankoff and Hein to submit a thorough grant proposal to the Canada Council for the Arts in the spring of 2011. The request was for eighteen thousand dollars, which would cover a three-week residency in Gander and its environs, where Sankoff and Hein could meet and interview a variety of residents. The intention was to have a finished project that could have

Logo for the 10th anniversary ceremony in Gander.

a workshop at Sheridan College, followed by a presentation in Toronto, and then, if possible, return to Gander. "Gander," in fact, was the tentative title for the project.

The proposal was extremely detailed and some of the text was remarkably prescient:

"Gander" will be anchored in simple group storytelling through humor, movement, and folk music. We want to give a casual but energetic "kitchen party" feeling, as if the cast has gathered with the audience in homes and pubs throughout Newfoundland to share these stories and sing these songs. With simple staging, we can explore the full scope of the story . . . bar stools become a raucous pub . . . and later, they'll become the seats of a jumbo jet–in "Gander," we're all in it together.

One of the models for the proposed show was *The Laramie Project*, a 2000 play by Moisés Kaufman and members of the Tectonic Theater Project. It was a unique blend of theatricality and documentary storytelling, centering on the hate-crime murder of a young gay university student in Wyoming, Matthew Shepard. It was also a straight play, not a musical, and the exact form that the incipient "Gander" would take was still an argument . . . er . . . question in the

minds of Sankoff–who thought of it as a play– and Hein, who saw the musical possibilities.

The grant came through and they headed to Gander. Sankoff and Hein attended a commemorative event, called the Beyond Words Benefit Concert, at the Gander Community Centre–the local hockey rink–on the night of September 10. In spite of the solemnity of the occasion, it was a vibrant and raucous affair, with live music, including a set by Shanneyganock, a St. John's-based folk band

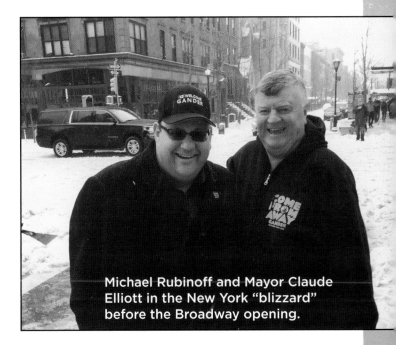

Michael Rubinoff and Mayor Claude Elliott in the New York "blizzard" before the Broadway opening.

that had always been one of Hein's favorites. Toward the end of the concert, Shanneyganock struck up "The Islander" in their set and soon everyone–locals, business executives, government officials, workers, fishermen, constables, whoever–was on the "ice," dancing and singing along to the words, with a commonality and joy that united everyone; the song was braided into their collective DNA.

Sankoff sighed: "Of course, it's a musical."

GANDER AIRPORT:
CROSSROADS OF THE WORLD

In most places, they build an airport to service the town; in Gander, they built a town to service the airport.

"They say most of the people who built Gander had never seen an airplane," recalled Gander's former mayor Claude Elliott, "and yet they walked into the wilderness and built the world's largest airport." By the 1930s, it was becoming apparent that Newfoundland needed its own discretionary airport. The British Air Ministry sent out a request for locations, using specific criteria: flat, not too hilly, and as far away from the island's perpetual fog as possible. By the end of 1938, a handpicked crew of eight hundred engineers, contractors, and builders had constructed Gander Airport, seemingly out of thin air.

They were just in time: when Britain declared war on Germany on September 3, 1939, Newfoundland and Labrador were drawn immediately into the conflict, and Gander, having the easternmost airport on the North American continent, would have a major part to play in the Allied struggle to conquer German air forces. Initially, as part of the Lend-Lease Act to support Britain, a constant stream of fighter planes–mostly B-17s and B-24s–would be built in America, flown to Gander, and then sent over the North Atlantic to Ireland and England to bolster the might of the courageous British fliers

Captain Douglas Fraser, first pilot to land in Gander Airport, 1938.

guarding their home country. Once America joined the fray in 1941, Gander officially became a military airfield, centralizing the efforts of the Royal Canadian Air Force, the U.S. Army Air Corps, and the Royal Air Force. Each country had its personnel housed in different sections, supported by a booming workforce. Hundreds of bombers landed and left Gander every day during the war; the airport's timing was impeccable, built at just the necessary moment. It also had the longest runways in the world. It's no overstatement to say that Gander helped win the war.

As the 1940s transitioned into the 1950s, Gander had to redefine its purpose. Luckily, this was the boom era of luxury transatlantic travel. No plane could make it westward across the ocean to the United States without refueling, so Gander was an essential stop on the flight–a way station, for all intents and purposes, halfway between Ireland and New York City. The barracks and hangars that housed the Air Force engineers were torn down to make way for a passenger terminal and other amenities, as elegantly appointed commercial aircraft touched down for a brief spot in Gander; epitomized by Pan American (with its famous Clipper), American Overseas Airlines, and Trans World Airlines, the names of these airlines still bring a satisfied smile to commercial travelers of an almost distant era.

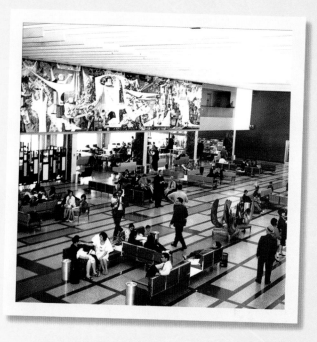

Gander's modern airport lounge, with inspirational mural above.

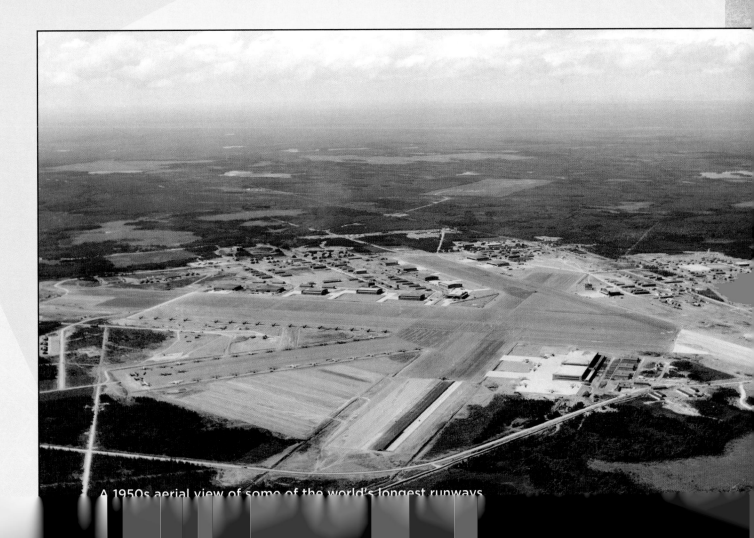

A 1950s aerial view of some of the world's longest runways.

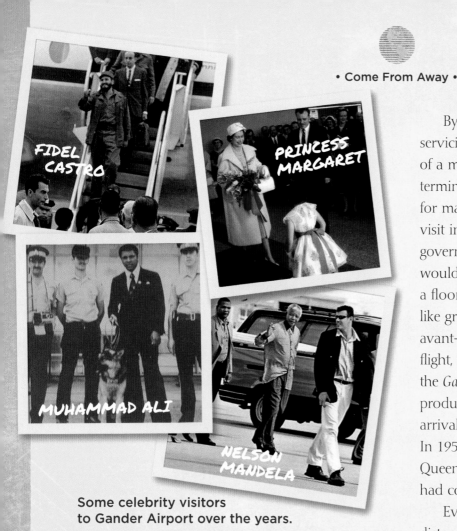

FIDEL CASTRO

PRINCESS MARGARET

MUHAMMAD ALI

NELSON MANDELA

**Some celebrity visitors
to Gander Airport over the years.**

The airport then needed to be supported by a functional town. Engineers started designing a street plan for rows of houses adjacent to the airport. In a bit of late-night whimsy (abetted by a Molson or two–who knows?), the planners came up with an undulating street grid that looked like the head of a male goose–that is, a gander–when viewed upside down. It was submitted to the local municipality as a practical joke, but no one caught the gag; the grid exists to this day. As a tribute to its roots, the town of Gander has most of its streets named after the most famous aviators of the twentieth century: Byrd, Lindbergh, Rickenbacker, Wiley Post. There's even a street named after the navigationally challenged Douglas "Wrong Way" Corrigan–although traffic goes in both directions.

By the mid-1950s, Gander Airport was servicing thirteen thousand flights and a quarter of a million passengers a year–and a new terminal was needed, especially as this was, for many, the first place that tourists would visit in the Western Hemisphere. The Canadian government commissioned an airport that would be the height of futuristic sophistication: a floor made of Italian marble in a Mondrian-like grid; chairs and benches by Eames; an avant-garde mural and sculpture celebrating flight, hospitality, and aspiration. The local paper, the *Gander Beacon*, declared that the finished product was "bound to convince every first-time arrival from overseas that this, then, is paradise." In 1959, the new terminal was inaugurated by Queen Elizabeth II and Prince Philip; Gander had come a long way in twenty years.

Even in the evolutionary era of long-distance jet flights, Gander still maintained an important prominence for the refueling of planes. The airport boasts an extensive list of famous visitors who stopped for ice cream, a cocktail, or a trip to the ladies' powder room between flights. (You can still do all three!) Gander was the first North American stop for the Beatles on their debut tour in 1964, and such A-listers as Frank Sinatra, Winston Churchill, Marlene Dietrich, Richard Burton, and Elizabeth Taylor spent time there. As a non-American airfield during the Cold War, it serviced such Communist Bloc airlines as Aeroflot and Cubana. At one point, defectors from East German flights were so routine that the West German consulate set up an office near the airport to process them. On Christmas Eve, 1976, Fidel Castro himself was stranded in Gander for

a day or two on his way back to Havana from Moscow; local inhabitants took him and his family for a toboggan ride. (To this day, the only direct flights that leave from or arrive to Gander go straight to or come from Cuba.)

Gander took some hits in the late 1960s as passenger jets were consistently improved to fly across the Atlantic without refueling–the one major exception was when Gander became the North American test site for the supersonic Concorde, which was designed to fly from New York to Europe in record speed in the early 1970s. When the Concorde was retired in 2004, it lifted off from Gander for one final flight east to Europe. At the dawn of the twenty-first century, Gander Airport was mostly handling cargo planes and aircraft from the American and Canadian military. Its incredibly long runways–two at eight thousand feet long, crossing over a third at six thousand feet long to form an "A"–still give the airport a unique advantage in the Western World; if necessary, its runways are capacious enough to be designated by NASA as an emergency landing site for the space shuttle.

If Gander Airport had embraced its share of triumph, it assumed tragedy as well: every decade or so, an aircraft crashed on landing or takeoff. In December 1985, a DC-8 was carrying 248 peacekeeping U.S. military personnel home to the United States from the Sinai Desert; it crashed on takeoff, killing everyone on board. Known as the Arrow Air crash, it had a profound effect on the citizens of Gander; a memorial to the accident still stands–and, to this day, there is no official verdict on its tragic cause.

The air traffic controllers nearby, known officially as Gander Oceanic Control Centre, are still responsible for the thousands of travelers who pass in and out of their airspace every day. The proficiency of the Gander Airport staff of workers and residents has been tested again and again, and far more often than not, it prevails. As Paul Banks, in a *Beacon* editorial put it, the week of September 11, 2001: "It's been decades since towns like Gander, with its unique position in the world, have been a key locale for world conflict and crisis. Its permanent status as a major crossroads to the world has been amended with the evolution of jet travel, but it has remained an oasis for flights that run into trouble, either mechanical or human."

Gander CYQX, still an essential airport today.

TUESDAY, SEPTEMBER 11, 2001: A.M.

"**I** have been a flight attendant for four-plus years and have been to Gander too many times to count," wrote Shauna L. Hailey, a flight attendant for ATA Airlines. "At most I have seen three aircraft on the ground at one time in Gander last year—and I called that rush hour."

Tuesday, September 11, 2001 was supposed to be such an ordinary day that even two aircraft on the ground at Gander would have been considered a traffic jam. That morning, however, Destiny scrambled the deck.

Tuesdays are typically a sigh of relief for air traffic controllers—it's the least traveled day of the week. The first Tuesday after Labor Day is even better; the vacationers and summer travelers have gone back to work—for a while, at least. That particular Tuesday, the skies over the northeast—especially over

New York City, which is serviced by three major airports—were transparently clear: not a cloud in sight.

Still, there was work to do, attention to be paid. Once an inbound flight enters North American airspace west of the fortieth parallel (roughly halfway between Ireland and Newfoundland), it falls to Gander Oceanic Control Centre to monitor its progress. That morning, Gander's controllers—located in a concrete bunker near the airport, surrounded by barbed wire fences—still had to supervise the nearly four hundred aircraft that were supposed to be heading west from Europe to various airports in the United States.

At 8:46 that morning, a domestic flight, American Airlines Flight 11, en route from Boston to Los Angeles, crashed into the North Tower of the World Trade Center. Five

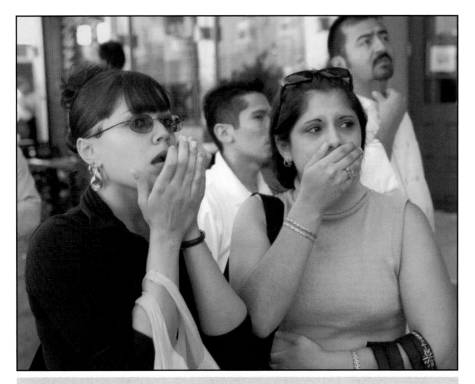

Astonished onlookers view the unfolding tragedy in downtown Manhattan on the morning of 9/11.

out to the flights under their supervision via their transponders–the receivers that allow captains in their cockpits to communicate with air traffic control via a specific frequency but a handful did not–or could not–respond. It was a dangerous sign. Around 9:00 a.m., air traffic controllers in the United States shot back the following to hundreds of domestic flights: "Every airplane listening to this frequency needs to contact your company." As *Time* magazine wrote, "With those eleven words, the world's most complex–and safe–air traffic system was brought to its knees."

hijackers, members of the Al Qaeda terrorist group, took control of the plane and flew the Boeing 767–one of the most capacious aircraft used in commercial flight–into the building's ninety-third through ninety-ninth floors. The plane, hijacked so soon after departure, contained approximately twenty-four thousand gallons of jet fuel. Instantly, the plane's seventy-six passengers and its eleven crew members were killed, along with five hijackers and hundreds of people trapped in the building's top floors.

A few minutes later, there was a disturbing "chatter" among air traffic controllers nationwide. Contact with one United Airlines transmission implied a possible hijacking on that flight. Controllers immediately reached

By the time the minute hand swung past nine o'clock, the American government had enough information to consider the first plane a terrorist attack, and started mobilizing its defense forces, including NORAD, the North American Aerospace Defense Command. At 9:03, just as the Federal Aviation Administration was requesting Air Force support, a second hijacked plane–United Airlines Flight 175–crashed into the South Tower, killing hundreds, along with its fifty-one passengers, nine crew members, and five hijackers. It was now painfully apparent to the civil authorities that any airborne plane might be in danger and might also be dangerous to people on the ground; adding to

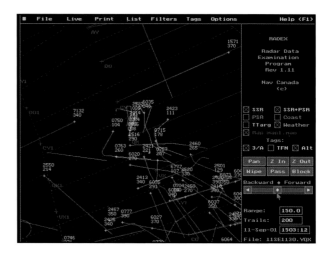

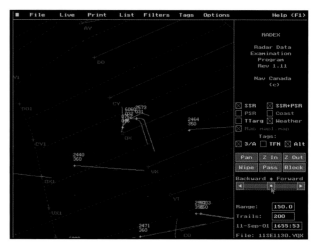

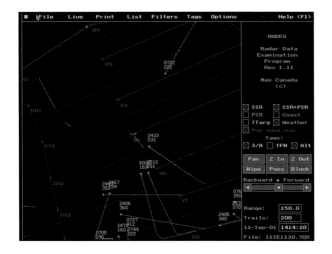

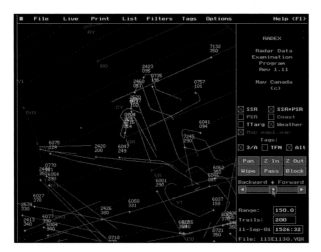

Radar screens from Nav Canada demonstrate the unprecedented convergence of planes on Gander.

the consequence is the fact that, almost thirty minutes after the first attack, a half dozen planes were not responding to their controllers.

After the second crash, the New York Police Department requested permission from the Department of Transportation to order a "ground stop" at all New York–area airports–no outbound flights could take off and all incoming flights would be diverted. But even that didn't seem effective enough. By 9:25 a.m., the FAA, whose mandate for flight safety stretched back to the Roosevelt administration, did something without precedent: it ordered a *national* ground stop, preventing any non-military plane in America from lifting off and ordering every airborne craft to land as quickly and as expediently as possible. At that moment, there were 4,546 commercial and general aircraft flying in American airspace.

Within the hour, with two more commercial jets being used as deadly weapons–American Airlines Flight 77 crashed into the Pentagon,

killing all sixty-four people on board, including six crew members as well as one hundred and twenty-five people in the building, and United 93, whose thirty-three passengers sacrificed their lives (along with the seven crew members) in Pennsylvania to avert an intended attack in Washington, DC–the FAA ordered all incoming international flights to be diverted away from the United States. It fell to the FAA's opposite number in Canada–Nav Canada, which is a privately held firm licensed by the Canadian government–to handle all flights making a beeline that morning for both coasts of the United States. At 10:43 a.m., Nav Canada's

controllers announced to every airborne flight captain: "Due to extraordinary circumstances, and for reasons of safety, all departure services are ceased, effective immediately. Due to closures of U.S. airports and airspaces, all national traffic will be recovered in Canada." Dozens of flights that had not yet reached the halfway point at the fortieth latitude began making 180-degree turns to head back to their departure cities in Europe. That left 238 flights remaining–each destined for North America.

The controllers at Gander Oceanic Control Centre knew they had an extraordinary task in front of them: "We had to drain the sky,"

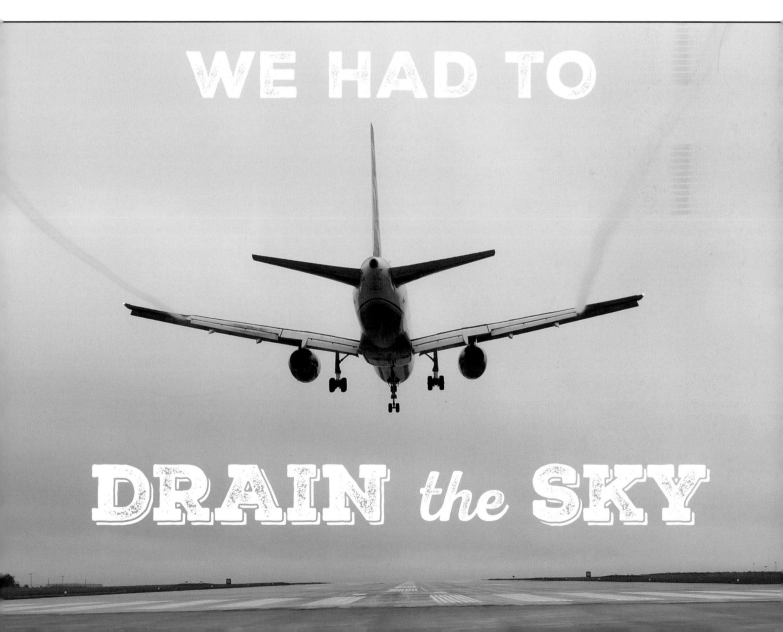

WE HAD TO

DRAIN *the* SKY

commented a flight manager in Gander, Chris Mouland. "None of us could have ever imagined we'd see something like that happen in our lifetimes." Through an unspoken sense of urgency, more than a dozen extra controllers who weren't even scheduled to work that day showed up at headquarters to assist their comrades.

The Control Centre began assessing which flights had the capacity to land where–and

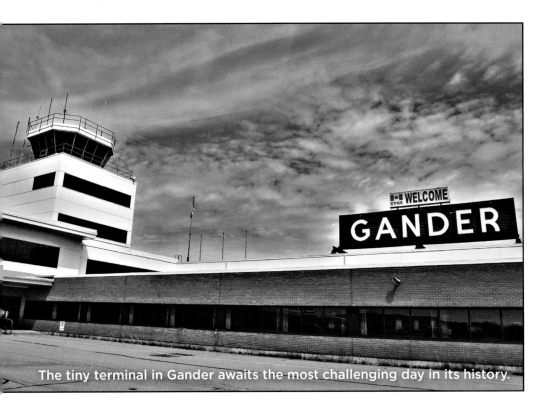

The tiny terminal in Gander awaits the most challenging day in its history.

was considered a potential bomb threat. In contacting the dozens of flights headed from Europe, the controllers radioed terse messages to the pilots and told them what their new destination was to be: Gander, St. John's, Halifax, etc. Flight captains are not used to receiving orders and a few balked. "There was no time to get into long-winded conversations with them about what was happening," recalled Gander controller Don O'Brien, "It was just, 'There's a crisis in U.S. airspace. You're landing in Gander. End of story.'"

The logistics weren't the only problem–there was also the lack of clear information. Some captains had a vague knowledge of what was happening on the ground in New York, DC, and Pennsylvania; some captains had apprehensions about potential terrorists on their own flights. Each captain had to make his or her own decisions

which facilities and airports could handle the planes and how many. Of the 238 flights headed for the east coast (dozens of other flights en route across the Pacific had to be landed on the west coast), 47 were diverted to Halifax, 56 to Newfoundland, and so on. Only a handful of jetliners landed in such large inland cities as Montreal, Toronto, or Ottawa–until it could be safely landed and checked out, each plane

about informing passengers and how much information to provide: some kept it simple–"We are landing in Gander for a technical problem"; some decided to alert their passengers about the terrorist attacks in the States. One thing all the flight captains had in common was a deep mixture of sadness and anger that the aircraft they were devoted to protecting had been weaponized for destruction.

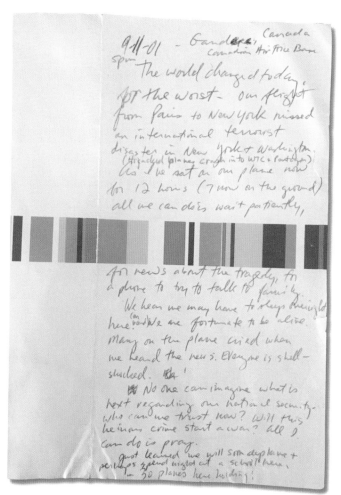

While waiting to disembark his plane on the Gander tarmac, Kevin Tuerff scribbled some notes.

"We heard a lot of airplanes which were headed for the United States were going to land in Canada and we knew we would get some of them here," said Claude Elliott, the mayor of Gander. "As we started to make plans for how we were going to handle it all, we also started to realize it wasn't going to be just a few planes, but a lot of planes."

Within a few hours, Nav Canada had safely brought 43,895 passengers and crew to the ground across Canada, coast-to-coast without incident. The tiny town of Gander–with a population of 10,500–had 6,595 of them.

Now what were they going to do with them?

Planes started landing at Gander after two o'clock (which, given their unique time zone was ninety minutes later than Eastern Standard Time in New York); in less than three hours, thirty-eight planes were lined up, nose to tail, along Gander's extensive runways. (The number of diverted flights that day would include thirty-three commercial jets, along with four additional military planes and a private plane that has not been officially identified to this day; folks think it was some sort of discreet VIP.). The planes were still being treated as bomb threats, so no passengers could be let off.

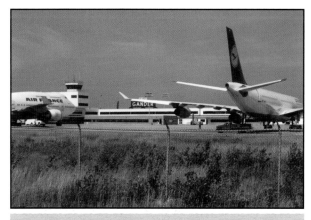

The press was kept outside the Gander Airport for security reasons; one photo captures the lineup of planes.

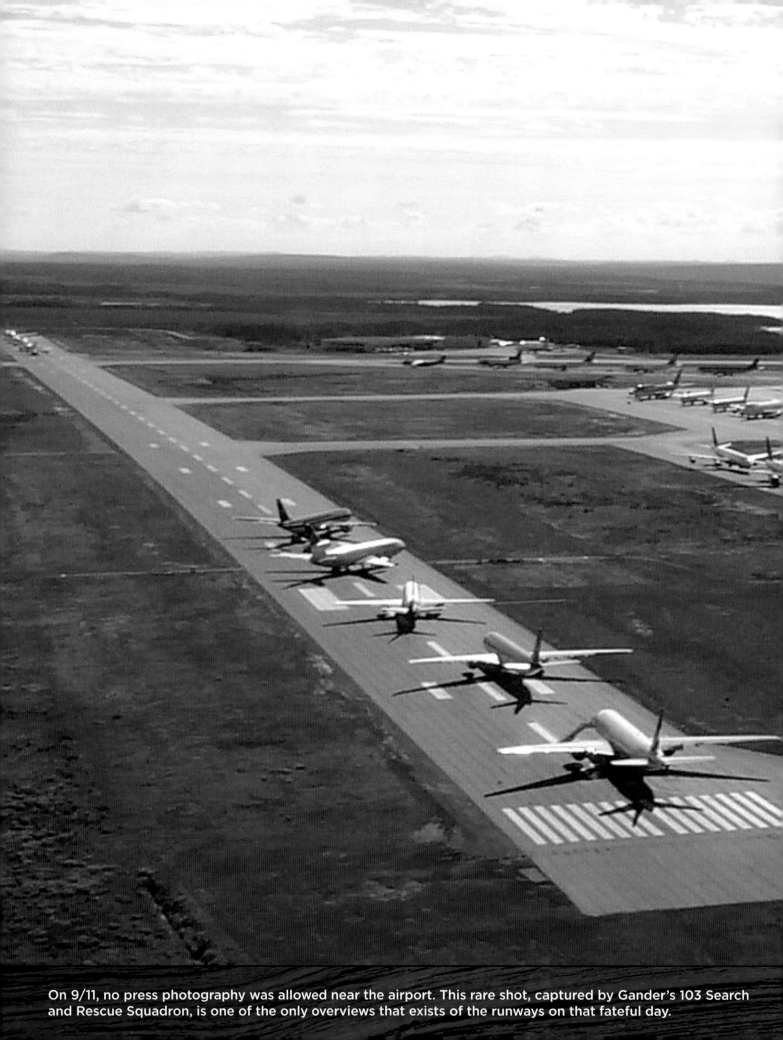

On 9/11, no press photography was allowed near the airport. This rare shot, captured by Gander's 103 Search and Rescue Squadron, is one of the only overviews that exists of the runways on that fateful day.

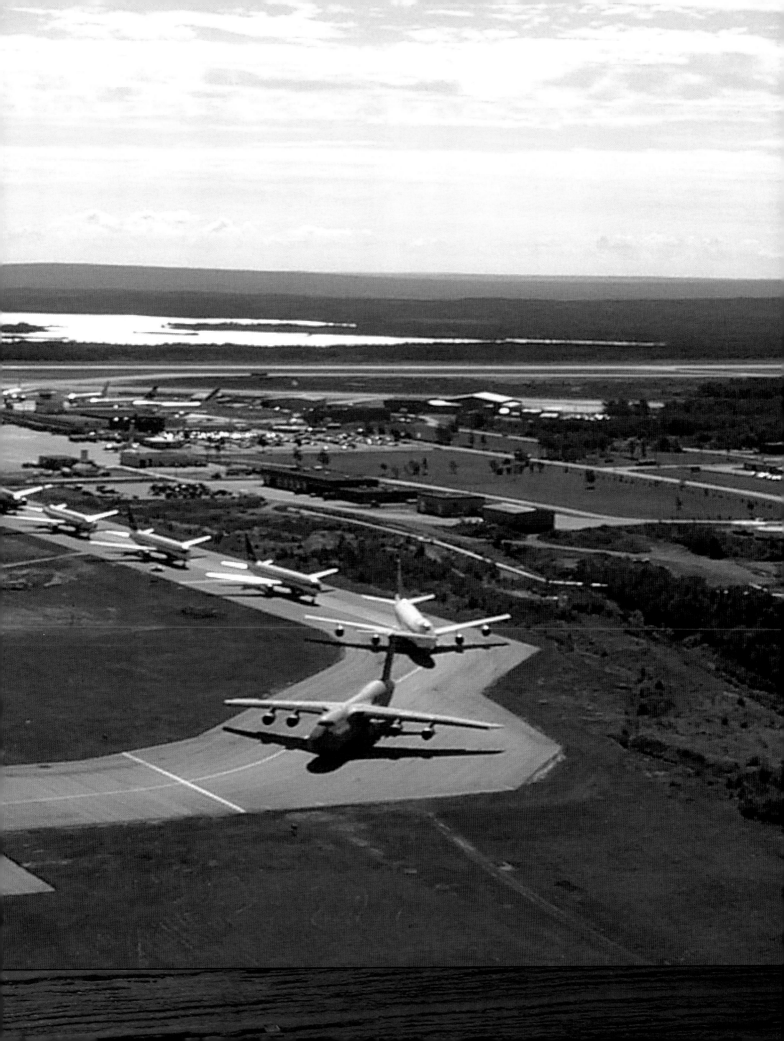

— INTERLUDE —

FLIGHTS

On the afternoon of September 11, thirty-eight flights landed at Gander Airport. Below is the list of all the flights, along with their origins and their intended destinations. The landing times are denoted as Newfoundland Time Zone, which is ninety minutes later than Eastern Time Zone (the east coast of the United States).

These statistics are compiled from the original information entered by Gander Oceanic Air Control.

AIRLINE	FLIGHT #	ORIGIN	DESTINATION	LANDING
Continental Airlines	23	Dublin	Newark	14:27
Virgin Atlantic	75	Manchester, UK	Orlando	14:31
Alitalia	644	Rome	Newark	14:35
"Reach" USAF Transport	113T	Trier, Germany	Dover AFB	14:41
British Airways	1503	Manchester, UK	JFK	14:43
Private Charter	VBBLP	Paris	LGA	14:46
Northwest	61	Amsterdam	JFK	14:47
Air France	004	Paris	Newark	14:52
Lufthansa	438	Frankfurt	Dallas/Ft. Worth	14:56
American	101	London*	JFK	15:00
British Airways	2193	London**	Dallas /Ft. Worth	15:03
US Air Force Transport	3076	Ramstein, GM	McGuire AFB	15:04
Trans World Airlines	819	Paris	St. Louis	15:10
American Trans Air	7161	Limerick	BWI	15:16
Lufthansa	440	Frankfurt	Houston	15:19
Lufthansa	400	Frankfurt	Houston	15:23
Sabena Airways	539	Brussels	Chicago	15:25
Delta	141	Brussels	JFK	15:28
United	27	Paris	Philadelphia	15:32
Delta	117	Stuttgart	Atlanta	15:40
American	63	Paris	Miami	15:41

AIRLINE	FLIGHT #	ORIGIN	DESTINATION	LANDING
United	929	London*	Chicago	15:52
Continental	29	London**	Newark	16:02
Lufthansa	416	Frankfurt	Washington, DC	16:06
ATA	8733	Manchester, UK	Gander	16:10
Delta	15	Frankfurt	Atlanta	16:14
Virgin Atlantic	21	London*	Houston	16:18
Delta	49	Amsterdam	Cincinnati	16:23
Delta	129	Limerick	Atlanta	16:29
US Airforce Transport	4892	Limerick	Syracuse, NY	16:33
American Airlines	49	Paris	Dallas/Ft. Worth	16:38
Delta	37	London**	Cincinnati	16:43
US Airforce Transport	3082	Mildenhall, UK	Dover AFB	16:45
Continental	A5	London**	Houston	16:50
Aer Lingus	105	Dublin	JFK	16:53
Malev Hungarian	H090	Budapest	JFK	16:58
Continental	45	Milan	Newark	17:02
US Air	3	Rome	Philadelphia	17:16

* Heathrow Airport ** Gatwick Airport

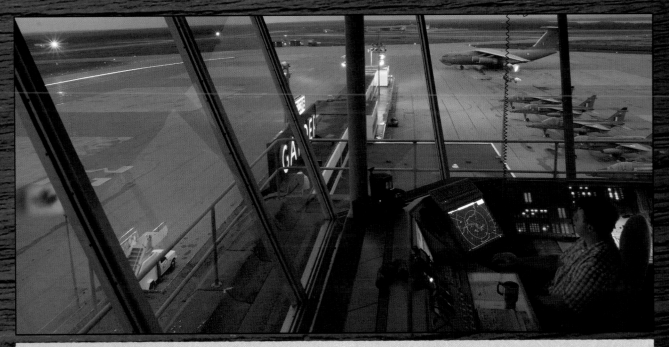

The control tower of Gander Airport; on 9/11, it had to keep track of 38 flights in less than five hours.

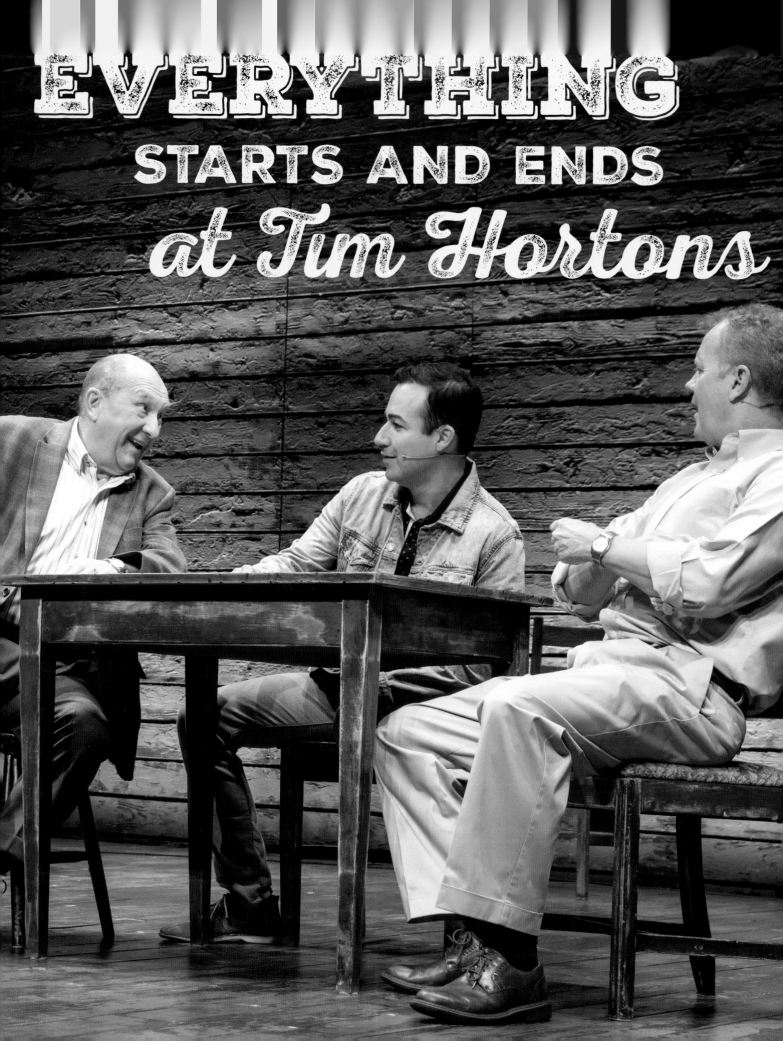

CLAUDE
I starts my day at Tim Hortons. Don't drink coffee. Don't drink tea. And I've no use for donuts. But I'll grab a Pepsi and get a lay of the land. As the mayor, it's how I keep in touch with the people and such. Everything starts and ends at Tim Hortons. ⑧

Claude enters Tim Hortons.

Morning, Garth.

GARTH
Morning, Claude.

CLAUDE
Morning, Crystal.

CRYSTAL
Morning, Mr. Mayor. ⑨

CLAUDE
Dwight.

DWIGHT
Morning, Claude. Garth. Crystal.

DOUG
Claude. Crystal. Dwight. Garth. Morning. ⑩

CRYSTAL
Morning, b'ys. Pepsi? ⑪

CLAUDE
That's right, Crystal. What's the news?

DWIGHT
School bus strike still on?

CLAUDE
Ahya. We're working it out.

GARTH
Well, we're coming to the table.

CLAUDE
Well, we're coming to the table too.

DWIGHT
Are they tearing down the airport?

CLAUDE
Not today.

DOUG
I heard Don Burton and his wife won the Super 7!

CLAUDE
You don't say.

DWIGHT
Lucky shit.

DOUG
4.6 million.

They all whistle. Janice enters.

JANICE
Excuse me, I'm looking for the mayor.

Everyone points at Claude.

Mr. Mayor—I'm Janice Mosher with Rogers TV. I'm new. To town—and new to reporting. It's my first day.

⑧ **DAVID:** They're on every corner in Canada, but Tim Hortons and Shoppers don't often end up in Broadway musicals (though there is one on the backdrop of *The Book of Mormon!*). Canadians aren't used to being represented onstage, so you can always tell when they're in the audience because they laugh here.

⑨ **DAVID:** Crystal is named after the very first person we interviewed, Crystal Flikkema-Kane. We'd found her online, and at the end of our interview she asked where we were staying in Newfoundland. We said we weren't sure yet, so she told us her parents would let us use their house. And they did (we named other characters, Matty and Brenda, after them).

⑩ **IRENE:** In Gander, David went to a public restroom. Every man who entered was greeted by name by every other man. They literally all knew each other— and David felt left out. So, he wrote this scene.

⑪ **IRENE:** Years later, we found out there's an actual woman named Crystal who works at Tim Hortons, and Sharon Wheatley got to work behind the counter with her.

⑫ DAVID: Newfoundland has a million different wonderful phrases, which we peppered in where we could, though many got cut because they were unintelligible to audiences.

⑬ DAVID: There's always slight tension between pilots and air traffic controllers around who's in control. Beverley told us that September 11 was the first time she ever heard them use the word "order."

CLAUDE
Where you longs to, Janice? ⑫

JANICE
Port Aux Basque. So if you see me running red lights or anything, just forgive me because we don't have stop lights over there.

CLAUDE
Well, welcome to Gander, Janice.

DWIGHT
Janice.

GARTH
Janice.

DOUG
Janice.

CRYSTAL
Janice.

CLAUDE
If you're looking for news, you should talk to that man running in here. That's our constable, Oz Fudge. He's full of stories.

Oz runs in.

OZ
Mister Mayor, I saw your car in the lot. Crystal, turn up the radio so's we all can hear. Doug, you probably want to get down to air traffic control right away.

DOUG
There's only supposed to be two air traffic controllers on, but instead there's fourteen. . . . Everyone's heard and they all shows up without even being asked. We're told there'll be over two hundred planes getting diverted across the country.

Everyone becomes air traffic controllers as the bodhran starts beating slowly.

DOUG
Lufthansa four one four, this is Gander Centre—squawk code seven two tree five. Due to a recent development, you are ordered to land at Gander YQX immediately. Copy that. This is an order. ⑬

12/10
(CONTROL)
Roger Lufthansa four one four. Turn right heading one niner zero degrees. You are cleared to flight level two four zero. Speedbird one one seven—squawk code two tree five. This is Gander Centre. You're radar identified—now cleared to Gander YQX via present position direct.

8/7
(CONTROL)
Alitalia six four four, reduce speed to one zero five. You are ordered to land your aircraft at Gander YQX immediately. American airspace has been closed. you are cleared to six thousand feet Gander altimeter tree zero zero one. Roger one one tree. Cleared flight level two four zero.

9/2/1
(CONTROL)
Sabena five tree niner, Gander— winds two one zero degrees five knots. You are cleared to land runway two two. Thank you five tree niner, vector for runway two two. Turn left heading two five zero to Intercept the localizer. Cleared straight in back- course runway two two.

11/4
(CONTROL)
Delta one five— Gander Centre—I show you on the localizer eight miles final. Contact tower now on frequency one one eight decimal one. Thank you one five. Air New Zealand eight five two, squawk code seven two tree five. This is Gander Centre.

5/6
(CONTROL)
Aer Lingus one oh five, the U.S. airspace has been closed. You are ordered to land at Deer Lake YDX or Gander YQX. Roger two two seven. Turn left heading one five zero degrees and proceed.

⑭ DAVID: The Gander Air Museum has a mocked-up recording of the air traffic controllers and the pilots, which we recorded and used as reference for this section. Beverley Bass also helped us with aviation lingo.

After five seconds, Actor 9, 10, and Doug continue. All others continue underneath.

CONTROL 9
No, sir. You do not have a choice.

CONTROL 10
No, sir. This is not a drill.

DOUG
Yes, sir. I understand you have VIPs onboard. I'll see your VIPs and raise you an international emergency. Land your plane now. ⑭

Everyone becomes pilots.
The bodhran builds in intensity.

⑮ DAVID: One of the challenges of this section was representing that many passengers had very different experiences depending on which plane they were on. In those early hours, pilots didn't know who might be on their plane and some chose to limit how much of the news they shared.

⑯ IRENE: The minute we landed in Gander, we started interviewing people—the first person was our hilarious flight attendant, Dale.

⑰ IRENE: This is the only place where Newfoundland is mispronounced in the show, but just to be clear, the stress is on "land," like "Understand Newfoundland."

⑱ DAVID: The flight attendants are probably the most fun part of the audition process. Chris often has actresses try them in a wide variety of styles and accents from Russian spies to Texas cheerleaders, seeing how willing to play each actress is.

BEVERLEY
Copy that, Gander Tower.

PILOT 5
This is Air France.

PILOT 1
Aer Lingus

PILOT 9
Lufthanza

PILOT 8
British Airways

PILOT 7
Emirates

BEVERLEY
This is American four niner. What am I supposed to tell my passengers?

PILOT 10
Ladies and Gentlemen, this is your captain speaking. There's been an incident in the United States.

PILOT 7
We're having trouble with the . . . cabin lighting system. We're just going to touch down while we fix the system. ⑮

PILOT 2
Meine Damen und Herren, hier ist Ihre Pilotin. Aufgrund eines terroristischen Vorfalls in den Vereinigten Staaten müssen wir in Kanada landen.

PILOTS 10/8
This is your pilot speaking. We'll be making an unexpected detour. The U.S. airspace is closed and we are being diverted. I will provide more details as they become available.

PILOTS 1/6/11
Ladies and Gentlemen: Can I have your attention? We've received word that there has been an incident in the U.S. that will require us to make an unscheduled stop in Gander, Newfoundland.

PILOTS 4/5/12
Mesdames et messieurs, nous allons faire un court arrêt à Gander, Terre-Neuve pour faire le plein d'essence. Merci beaucoup pour votre compréhension.

PILOTS 9/7
Damas y caballeros, por favor regresen a sus asientos y abróchense sus cinturones. Vamos a aterrizar en Terranova.

The cast makes a flight attendant button "BOONG-BOONG" noise, as everyone becomes passengers, facing sideways

FLIGHT ATTENDANT ⑯
Ladies and Gentlemen, please fasten your seat belts. Looks like we'll be making an unexpected landing in Gander, (mispronouncing it) Newfoundland. ⑰

The passengers start murmuring restlessly. The flight attendant turns to the audience, and the passengers freeze.

FLIGHT ATTENDANT (CONT'D)
Anybody in the business knows when you set down in Gander, it's for an emergency. Now, we don't know what's going on, but the captain tells us to keep everyone from panicking.

The flight attendant turns back, as the passengers unfreeze.

Tray tables up, please. We will be dimming the lights in the cabin. Pushing the light-bulb button will turn your reading light on; however, pushing the flight-attendant button will not turn your flight attendant on. ⑱

One of the passengers, Diane, turns toward her window.

DIANE

I look out the window to see if there's something mechanical—like if we've lost an engine or if something's on fire. But I don't see anything.

Another passenger, Nick, turns toward his window.

NICK

I told head office I need to travel less—I told them it was doctor's orders. But they say, "You're going to the conference," so you go.

Bob turns toward his window.

BOB

My dad is always saying, Bob, you've got to calm down. But the flight attendant is shaking like a leaf, so I figure I've got permission.

Hannah turns toward her window.

HANNAH

My son sends me on this vacation—he says, "Mom, you've never gone anywhere." And when I get back, I'm telling him—this is exactly why.

Kevin T turns toward his window.

KEVIN T

Suddenly, there's a drop.

The group drops, with a gasp.

A sudden change in direction. And I fly a lot, so I know that's not normal. Outside the window, all I can see below are trees and rocks and . . . nothing.

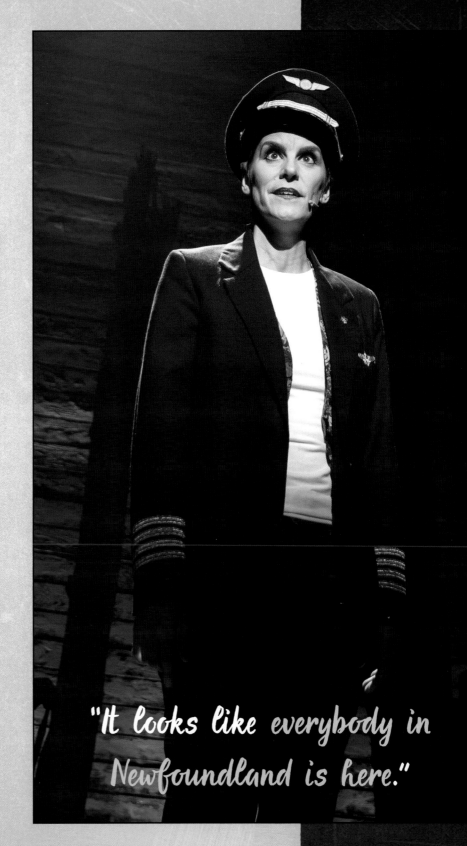

"It looks like everybody in Newfoundland is here."

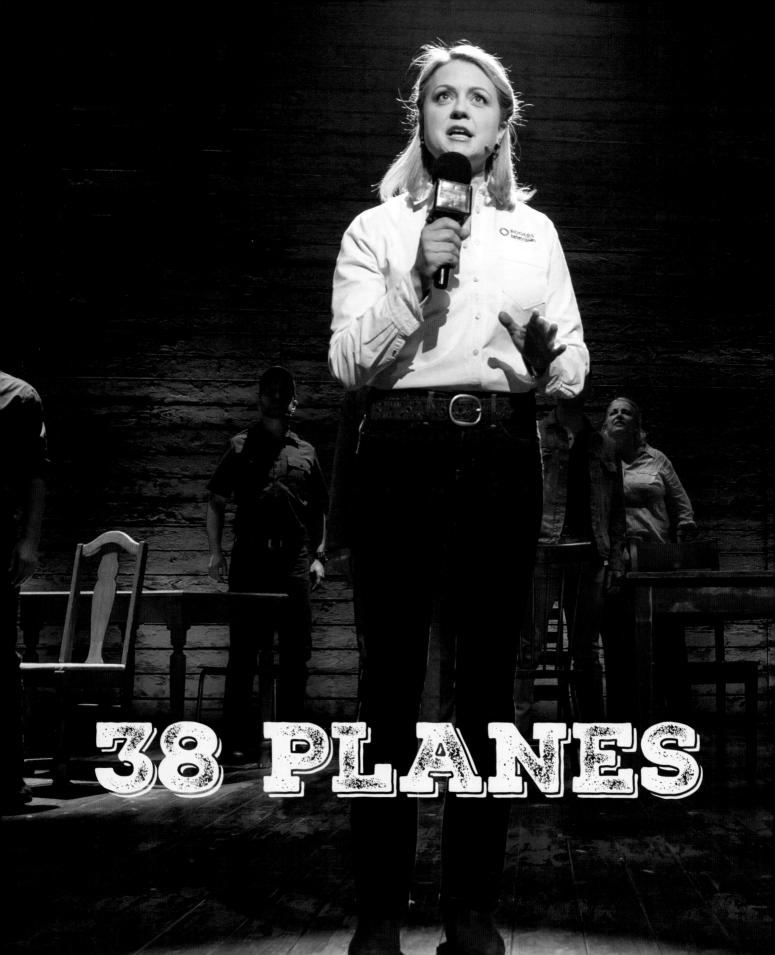

BEVERLEY
On final approach, we're coming into runway two-two, and I think, "Where am I going to park this thing?" There are planes lined up like sardines. And as far as I can see there's cars lined up too. It looks like everybody in Newfoundland is here.

The townspeople stand looking upward.

ALL UNLESS SPEAKING
(one at a time, then building together)

ONE PLANE THEN ANOTHER
AND THEN ANOTHER
AND THEN ANOTHER
AND THEN
THIRTEEN PLANES THEN ANOTHER
AND THEN ANOTHER
AND THEN ANOTHER
AND THEN
NINETEEN PLANES THEN ANOTHER
AND THEN ANOTHER
AND THEN ANOTHER
AND THEN
TWENTY-SIX PLANES
THEN ANOTHER
AND THEN ANOTHER
AND THEN ANOTHER
AND THEN
TWENTY-NINE PLANES
THEN ANOTHER
AND THEN ANOTHER
AND THEN ANOTHER
AND THEN
THIRTY-TWO PLANES
THEN ANOTHER
AND THEN ANOTHER
AND THEN ANOTHER
AND THEN
THIRTY-EIGHT THIRTY-EIGHT
THIRTY-EIGHT THIRTY-EIGHT
THIRTY-EIGHT THIRTY-EIGHT
PLANES [19]

JANICE *(to the cameraman)*
Is this on? Sorry. I'm new *(she turns to the camera)*. This is Rogers TV Channel 9. My name is Janice Mosher and I'm reporting live from Gander Airport where the nineteenth plane has just touched down. I'm here with . . .

BONNIE
Bonnie Harris. On a normal day, we get a half dozen flights, and now we've already got three times that many landing in two hours. It's a lot of noise. You can smell the fuel. You can smell the exhaust.

OZ
Jaysus, that's a jumbo! There's gotta be two-fifty or three hundred on her. That's a fairly large one, there's gotta be two hundred on her—now, I'm adding this up. We got 38 planes—we got two, three hundred people on the average . . .

OZ
Holy shit!

[19] DAVID: Verbatim text informed so much of the script, including the refrain of "One plane then another and then another." The vocals in this section build in intensity, representing the noise of so many planes landing at once, so Janice, Bonnie, and Oz have to almost yell overtop of them.

[20] **DAVID:** You may note that the flight list on pg. 38 doesn't include ATA flight 25, but this is what was recorded in the emergency minutes (the next day they corrected it to ATA 8733 – which did exist, but was headed to Manchester. The only plane to Orlando was Virgin Atlantic 75). Reading through these minutes, you can see just how much information town hall was trying to process. As they wrote at 8:20 pm on 9/13, "It should be noted that a tremendous amount of misinformation is out there and Town Emergency Operations Centre becomes inefficient and ineffective if it has to deal with this."

At town hall, everyone becomes staff members who shout for Claude as he enters, trailed by Janice.

STAFF 1/GARTH
Claude! Claude?

JANICE/DOUG
Excuse me. Mr. Mayor?

STAFF 2/6
Claude! The phones are ringing off the hook.

STAFF 4/DWIGHT
Mr. Mayor! I need to talk to you

STAFF 5/10
Claude! I just heard from Ottawa.

Claude whistles for attention and points to STAFF 10

STAFF 10
Air traffic control says five of the planes on the ground aren't responding.

DWIGHT
Reg says they're probably just on the wrong frequency.

CLAUDE
Thank you, Dwight.

DOUG
FAA won't give us a time line for reopening the airspace.

DWIGHT
And the airplane crews need to be rested or we'll never get them out of here.

OZ
American Trans Air flight number twenty-five is requesting when they deplane— (20)

DOUG
If they deplane—

OZ
That they be a priority . . .

CLAUDE
Why?

OZ
They were headed to Disney World with ninety Wish Kids.

Some of the staff react.

CLAUDE
Oh, Jaysus.

STAFF 6
Even with all the hotels in town, we've got no room—we gotta start looking at other towns.

STAFF 5
Appleton and Gambo have already offered—but we can't get them there.

STAFF 1
(pointing at Garth)
Garth's bus drivers are still on the picket line—and without them no one's going anywhere.

CLAUDE
Oh for Jaysus' sake, I'll tell them where to go. (to Janice) Don't quote me on that.

STAFF 2
(covering the phone)
I've got the SPCA lady on the line again asking about animals–

CLAUDE
Tell Bonnie we've got people to deal with.

STAFF 4
(hanging up the phone)
Claude! Apparently those five planes that aren't responding? They're treating them as bomb threats!

STAFF 2

How many ARE we getting?

STAFF 4

They don't know what's on them! Or who's on them!

STAFF 5

Bomb threats! What do they mean bomb threats?

STAFF 6

Do we evacuate the town? What do we do?

OZ

Why were they even sent here? Why not Toronto?

GARTH

Why are we getting the bomb threats?

DWIGHT

My kids are watching those planes!

STAFF 10

Half the town's gone down to watch!

DOUG

Oh no. Donny's down there. He just headed down there!

CLAUDE

Alright! The RCMP is gonna handle it. But we've got almost seven thousand people who might be spending the night. Jaysus, that's near as many as we got living here in town. We need to house them somewhere and we need to get them there–

GARTH

Don't look at me!

CLAUDE

. . . Not to mention food and supplies and anything else that snarls up.

DOUG

Well, why are they sending them here? Why not Toronto or Ottawa?

Everyone reacts. Claude looks at them.

CLAUDE

Because if anything goes wrong, we have a lot less people to lose.

A slight pause as they all take that in.

Alright, Janice Mosher. Here's your news. Gander town council declares a state of emergency.

Town of Gander Emergency Operations Centre
American Disaster Flight Diversion
Chronology of Events

September 11, 2001

☆ 11:45 a.m. EOC Set Up

12:00 p.m. Airport EOC Contacted
18 Planes Inbound to Gander plus Canadian Military
Provincial EOC Notified
Passengers to be kept on planes

12:05 p.m. Provincial EMO called Town EOC.

12:15 p.m. R.C.M.P. Contacted.

1:00 p.m. Airport advised 13 on ground, 25 to 27 more expected.

1:05 p.m. Newtel Notified and underway.
Called ▮▮▮▮▮▮▮- Health & Community Services)

1:07 p.m. Newtel representative requested.

? 1:09 p.m. ?HRE representative requested.

? 1:20 p.m. ? Provincial EMO informs 10 - 12 in Stephenville, 30 in St. John's, up to 200 in
· Goose Bay.

1:25 p.m. Newtel representative arrived - ▮▮▮▮▮▮

☆ Salvation Army & Anglican Church advise that camps are available to house 500
- 600 people.

1:35 p.m. HRE representative arrived.

Airport EOC advises that 5,000 - 6,000 people will be taken off aircraft.

1:50 p.m. ☆ ▮▮▮at College of the North Atlantic called and they are on standby.

2:10 p.m. ☆ ▮▮▮▮at Airport advised following:

- 37 on ground, up to 50+ expected.
- treating US planes as bomb threats.

We sent one of our EOC staff to the Airport EOC
as a liason.

| B | A | C | K | S | T | A | G | E |

RESEARCH & WORKSHOPS

Having been given eighteen thousand dollars by the Canadian government, David Hein and Irene Sankoff were determined to get their money's worth.

As soon as they boarded their flight to Gander for their research trip, they began by interviewing the flight attendant; then, while checking in at the local Comfort Inn, they started in on the receptionist. In short, they buttonholed everyone they could possibly buttonhole. It wasn't hard: "Everyone was ready to tell stories," recalled Hein. "Partly because all of these come-from-aways were returning, everyone was remembering what had happened ten years before."

For nearly a month in mid-September 2011, they covered every possible base. "We were writing down everything we possibly could. Gander Academy had all these 'thank-you' things they had kept on file. We went to the library and photocopied every letter that had

Sankoff and Hein interviewing Kevin Tuerff at the College of the North Atlantic, September 2011.

been sent back." A couple in Gambo, on the way to their vacation cabin, lent Sankoff and Hein the keys to their house for an additional week of research. "They basically just said feed the cats, but you should lock the door–not because it was unsafe –because someone might stop by for tea. We thought they were joking, but in the morning, we came down and there was someone sitting in the kitchen. He said, 'Oh good, you're up! I heard you were here. I wanted to give you a tour!' We went into [our research visit] knowing this was a story about people being welcomed and we had no idea how much we would be welcomed," recalled Hein.

Next came the hard part: putting the story together. The couple retreated to Sankoff's brother's cabin in Northern Ontario to sort out all the interviews, all the letters, all the memorabilia, and to put all of the anecdotal stories into some kind of thematic narrative with an arc. "We went quietly out of our minds," said Sankoff. There was so

Opposite: The Town of Gander EOC Timeline that inspired the timestamps in the musical.

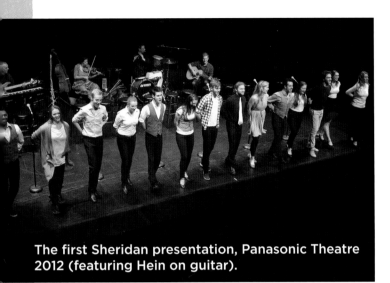

The first Sheridan presentation, Panasonic Theatre 2012 (featuring Hein on guitar).

much colorful detail, so many terrific twists of fate, so many towns and organizations that deserved a shout-out. When the initial draft of the show, now dubbed *Come From Away* by Sankoff, went into the rehearsal room at Sheridan College in the early spring of 2012, the first read-through was between three and four hours long: "It was page one hundred and we hadn't even gotten off the planes," said Hein.

Given that Sheridan College had only offered a forty-five-minute reading at music stands, this was going to be a challenge. The show would be Michael Rubinoff's inaugural project with the Canadian Music Theatre Project's residency at the school's Trafalgar campus, located in southern Ontario. With a student ensemble of fourteen singer-actors, the developmental process began with the creative team of Newfoundland director David Ferry and musical director Callum Morris. The workshop was scheduled for five weeks, seven hours a day, six days a week; ostensibly enough to figure out, at least, how to get the characters off the planes.

Initially, the theatrical event began with students welcoming the audience back to the tenth anniversary in Gander, mirroring the casual and friendly ritual of a kitchen party; the welcome was largely improvisational—but in some cases, the students, who were only tiny kids in 2001, had some difficulty navigating the sensitivity of the event. Sankoff remembers cringing when one student cheerily asked an audience member, "And what did you do on 9/11?" Structurally, the script itself started with "Welcome to the Rock" and in some cases capsule narration was required, simply to get from A to B; in any event, the piece needed a lot of editing to get to a forty-five-minute presentation. There were twelve presentations at Sheridan College—with the cast at musical stands, backed by a four-piece band (Hein on guitar)—and then two subsequent performances at the seven-hundred-seat Panasonic Theatre in Toronto. Part of the deal was a return to Sheridan College eight months later to produce a full-student production of a two-act script.

Except that almost didn't happen. During the recess, Sankoff and Hein went to New York to check out the National Alliance for Musical Theatre. The festival is a kind of national clearing house resource for new musicals, holding an annual conference where concert versions of new projects could be presented to potential producers. The attempts at networking by the self-proclaimed "unknown Canadian writers" were met with collective shrugs—except that they led to a phone call from the esteemed Goodspeed Opera House in East Haddam, Connecticut. They were producing a workshop festival, but one entry had dropped out, and

Opposite: Sankoff and Hein's interview notes, trying to capture every detail.

...in - winter childhood
- ice cream bkfast @ movies in PJ's

[we anecdotes]
...ot Academy - one of 100 shows up - principal "busy"
...cologists cleaning bathrooms - most educated people
...lic health - threw idol out, shot, that
...still moved because of contagious disease
...men on oxygen - 2 girls - "two of god's angels"
...the ones from wherever → bathroom - scaling napkins, tampons, ...
...et of Hardwick-
...ey kept asking EO
...to put "out of ...
...wen freaking out -
...in code - look ...

...ge Bin Laden -
...t Marg: gym ...
...red -
...in Commisso Storm
...t helping all sort
...miners (or forge
...took kids to ca
...took kids to
...highchair from N
...passengers theme
...watch speeders, while
...h - moose/codfish
...daughter - at crew
...mart - shower g
...back from for
...airport in
...canada creed
...in O'Brien (OC)
...fairy princess part
...plane stories ...
...took 4 girls to go
...- step my Academy

...ves valley - up ot
...have to laugh on
...NFLD see kept
...Smirky Socks jon
...Bevan - 9 fellow
...getting steel up
...non give up ha
...men drove away
...car for sale - 8
...women in fur + ...
...Richard Branson
...3 Arabian princess
...Air Lingus pil...
...- 78 yr. old - tra
...Vienim family -
...shoppers (Can. Tire
...Xuhome Marine

9/11
...ossing Alo.
 Air France-
PS - starte'

...lot - hopefully long way, then have ar Toronto

... plane at 39 planes

—— wife freaking ot
...bock' I thought... would ser wife l.le - Devon

(Darlene Rodie

Loose Stories
- Kevin
+ Nick + Dianne
+ Beverly Bass

College culinary students * guidance counsellor
 - kevin afterwards - food from air traffic control
 - Hove w/ Sign - military base trips for showers
...sign not Secret team - say killed on runway - bill at grocery store
 - scholarship - 4:30 point germany
 ..Brian Mosher - working in TV UK plan
[Small anecdotes] - Robs - 5 days to get into US - ued to set ad time
 - Adit walking in rain - panicky french women
 -- Henri from france - 11 grand stepdaughters

- C. Folk photographer climbing on ladder on top of Shoppers

- Loretta (of Loretta's flower) - take my van

- strollers

- Reg: 1st escalator in Newfoundland
 brand new
- Terri: nurses

- Derm took Tom to get BBQ's

- German couple pointing

- Loretta lent van to airline crew - "tell Loretta Marty say
· Terri: Hobo Bill - people couldn't stand it
 deaf + dog
- ice rink - world's largest ~~refridgerate~~ walk-in cooler

- Terry + Patricia taking Ginny to church

- Terry's son at border - going to Alabama - recognized from border
 + sent through
- "felt like 2 cents" talking to parents who'd lost a son
 post 9/11
- Terry playing - wakes them up - wanted to be an artist
 - handed out words - became a real reveler
- Gambo: bar - "no one's gonna want to be drinking"

- kevin closing company on 9/11, telling story + sending people out

- starbucks $20 card passed back to him ~~some~~ people are doing this ...
 9 months later
- Academy - "how do I get uptown?" "g. down + wait" - get picked up
 starts
- Couldn't walk for pleasure - cars kept stopping

- in 1 women's home: argued between american + muslim
 "this is the kind of thing that started this" "it's not all muslim"

- woman offered shower - checked w/ staff "do you know this woman?
 is it ok to shower?"
 came back a diff. person, then after "I don't know why I hesitated"

- woman - "did you get your shower?" "no, there was no one there"
 "well. I can't be everywhere" - "I'll let you in"

- woman scared - was locked in to feel safe

- where can I put my wallet while I have a shower?... I'm being

- Achromingly is this man buying me a
 - only need 8 to setup - 25 show

[right side panel notes - rotated]
...to wk.
Ralph, the pupils, ...
+ talking him out
 too many trade...
- went on to Da
from Sweden to
 to Germany

+ 2 Bonobo monk..
 5 days
(libra slowly slot
while
Edith
9/12
 Brin..
a joke - Bar
media after go
library)
? (Lipton)
? (article)

MATT KANO
...praise be to go
everyone's say ...
Gambo too gossip ...
me: it must be
Dave: ... I don't drink

[bottom right panel - rotated]
boards - ~~to~~ order - not normal - "land now"
 - no discussion - US normal - no con
passengers were using cells - fed into by pass...
-listened to BBC - didn't see TV for 2
~~~~ landed - 10:30
2:30/3 - Bes phones Tom from passenger

[top right notes]
- as planes leaving - airport wa
     say which floes were leaving
          Jake talked to the...
- 2 people out moose hunting
- Ramadan - people in Glenwood
     - pilots ok, FAA not

...move one group - 2 re
...key to other just adop...
...Russia - "look yourself
                              - Tom
...- protective guys/car
...d of leaving
...ding animals on plane
...y got out to help ut do
...ander academy

...- Loaded paper
...uments on TV/...
...2011)
...- piled up

spread around people
w/ different language
abilities

...m (Beth's sister-in-law)
gave honeymooners her
                 address

they were intrigued by the new project about Gander and 9/11. The scale and scope of *Come From Away* fit perfectly with Goodspeed's resources and seemed like a tremendous opportunity to develop the new musical further—but the workshop dates were a dead hit with Sankoff and Hein's previous commitment to return to Sheridan College.

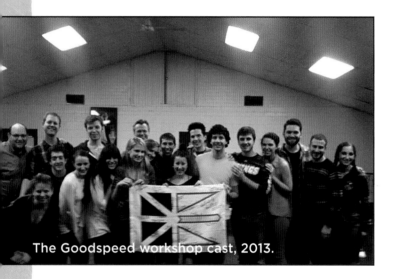
The Goodspeed workshop cast, 2013.

But Michael Rubinoff convinced Sankoff and Hein that saying "no" to Goodspeed would be a mistake, so they worked out a plan. While the Sheridan students were learning the script and the music, the Goodspeed cast—composed of students from Boston Conservatory at Berklee and The Hartt School of Music (and directed by Brian Hill with Dan Pardo as music director)—were putting the show on its feet. The two student casts collaborated with each other over the Internet: "They Skyped and Facebooked and sang to each other. It was really wonderful to see; they knew which songs were going to be cut before we did," said Sankoff. The final presentation of the Goodspeed workshop was the first time that a

full script was performed before an audience—an audience only 125 miles from the World Trade Center. "Many of the students there, or their families, had direct experiences with 9/11. We wanted it to be respectful," remembered Hein, "but we were really surprised at how much humor we got from Newfoundland and how funny the characters were. We didn't realize how well it had translated through us to an American audience that close to New York."

Typically, there's a post-show discussion after each Goodspeed presentation and Branden Huldeen, the head of the NAMT's Festival of New Musicals, walked past Sankoff and Hein and gave them a one-sentence review: "If you don't apply to my festival with this, you're dead to me." The writers were stunned—perhaps the show was that good, after all—but they had little time to scratch their proverbial heads. They traveled immediately up to Sheridan College for a five-week workshop on a full two-act version and were able to announce at the closing performance that Sankoff was pregnant: She and Hein were about to give birth to all sorts of productions.

Right before the Sheridan College engagement, Sankoff and Hein had a friendly breakfast in Toronto with a pair of New York producers, Sue Frost and Randy Adams. Frost and Adams had formed a company called Junkyard Dog and were preparing the Toronto production of their Tony Award–winning musical, *Memphis*. Frost, who also had long roots stretching back at the Goodspeed Opera House, remembered that "a friend of mine said, 'Would you meet my son-in-law's cousin? This nice Canadian girl who married this nice

The 2013 Canadian Music Theatre Project presentation.

Canadian boy and they're writing a musical.' They had just put on *My Mother's Lesbian Jewish Wiccan Wedding* and they wanted some guidance. Other than telling them to change the title, which they ignored, it was a 'getting to know you' chat. That was the day they were going into the workshop of the show at Sheridan College. We were like, 'Okay . . . a 9/11 musical? *Come From Away?* Maybe you should change *that* title as well.'"

*Come From Away* was chosen from a group of two hundred applicants as one of the nine projects presented by NAMT during the fall of 2013. "We were nervous about performing the material in New York City," related Rubinoff. "You're usually intimated enough just by the

industry crowd–but would the New York crowd find the material appropriate?" The creative team needn't have worried. After the presentation, almost immediately, a long line snaked through the lobby of New World Stages to meet Sankoff and Hein. The Disney Company, nearly every regional theater in the U.S., all expressed interest in the new project, but pushing to the head of the line was Kenny Alhadeff, who, along with his wife, Marleen, were members of the Junkyard Dog Productions team. Michael Rubinoff was in the audience during the post-conference wrap-up and, as Sankoff recounts, "That's where they discuss each show and ask who would like to work on that show. When ours was mentioned,

everybody's hand in the room went up. Michael started to cry. He said he'd never seen anything like it."

There was plenty of positive response; the real challenge was in the embarrassment of riches. Sankoff and Hein needed a lead producer; as it happened, they had a lot of discussions with Junkyard Dog Productions. "It crossed over to everybody, with such a heartfelt telling of a really beautiful story," recounts Sue Frost. "David and Irene met with a lot of people and they chose to go with us. It was great." Adds Hein, "We thought, this is like a marriage. If we're going to be spending the next ten years of our lives with [a producing team], let's go with the people who we like having breakfast with, who make us laugh." "And,"

said Sankoff, "they took a chance on a married writing team from Canada with a newborn. Our daughter has fallen asleep on Sue Frost's lap. I think that says it all."

Not quite all. The musical had to have its initial staging *somewhere*. A continent away from New York City, at the esteemed La Jolla Playhouse, near San Diego, Dana Harrell, who had served as the show's mentor at NAMT, took the script of *Come From Away* into the office of Christopher Ashley, the artistic director of the Playhouse–and, coincidentally, the director of Junkyard's successful Broadway production of *Memphis*–and plunked it, along with a few demo songs–down on his desk and said:

"I'm not leaving your office until you read this."

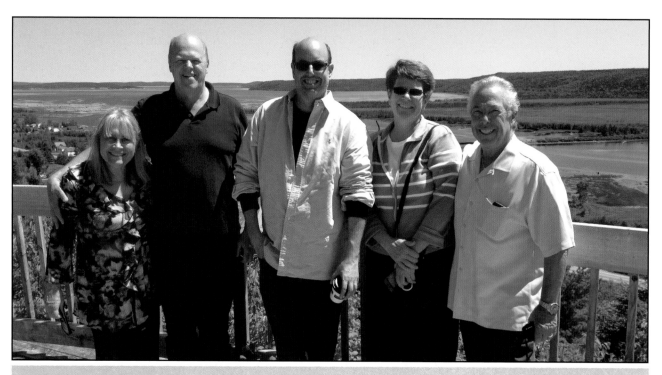

*Come From Away*'s eventual director, Christopher Ashley (center), is framed by the Junkyard Dog producing team (left to right): Marleen Alhadeff, Randy Adams, Sue Frost, and Kenny Alhadeff, during a 2014 trip to Gambo.

# TUESDAY, SEPTEMBER 11, 2001: P.M.

Just because a town is tiny doesn't mean it's inconsequential.

In our increased scramble of globalized living–with its cell phone service carriers, signature sneakers, artisanal sandwich shops–we often forget the extraordinarily supportive structures that bolster a small town. The schools, houses of worship, police and fire companies, community organizations, utility companies, newspaper publishers, and cable broadcasters that support the town of Gander are its organizational and moral foundation. The day that Destiny called on Gander's doorstep, its generous citizens took a deep breath and a coffee refill at Tim Hortons and went about their business, which was: to do unto others as you would have them do unto you. The infrastructure–if that's not too fancy a word–of Gander roused itself quickly on the

morning of September 11. Mayor Claude Elliott stopped by the local Tim Hortons donut shop on Airport Boulevard and, after the usual nods and hellos over a Timbit and a Diet Pepsi, was alerted to the events developing in downtown New York City. Heading over to the town hall a few blocks away, he found it impossible to follow the breaking news, as the town hall in Gander had no cable television. So, Elliott went home and turned on the cable news: "All I could think about was: How many people were in those towers?"

But the question quickly shifted to: "How many people will be in those planes landing in our backyard?" A few minutes before noon, Elliott convened an Emergency Operation Center at town hall, a five-minute drive from the airport, just as the planes were being contacted. The Royal Canadian

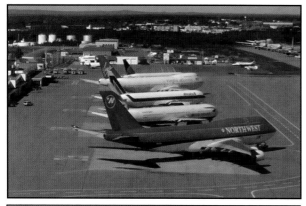

**As the planes stacked up, passengers waited hours to disembark.**

FAA regulations required that they be fully rested before being allowed to fly again.

As the afternoon wore on, and more planes were landing on the Gander tarmac–estimates as to how many might deplane swelled to ten thousand–other institutions came forward to lend a hand. The College of the North Atlantic, Gander Academy (the local elementary school), Gander Collegiate, the Unitarian Church, the Lions Club, all worked alongside the Salvation Army to clear out space and make cots, bedding, or mats available. "We were sent home from school after lunchtime and told we weren't expected back for a few days," recalls Abby Moss, then a first grader, "Not because it was a national tragedy, but because they needed the space in our school  for the passengers."

But the passengers weren't going anywhere– not yet. With so much uncertainty about the terrorist plots in the States–and potential international threats–the planes hadn't yet been cleared by security personnel. As RCMP security went systematically through each plane, its baggage, and its manifest, the passengers aboard the grounded planes–about three hundred each on average–grew increasingly antsy. What few cell phones passengers carried were operable only on a random basis and information about the attacks on American soil dribbled in in bits and pieces. It was a crisp but hot September day and some flights opened their doors just to let in some air, and passengers waved at the crowds who were lining up outside the twelve-foot high barbed wire fences on the perimeter of the airfield. Passengers and crew who were desperately craving a cigarette break were allowed to light up by the open doors. "We

Mounted Police (RCMP) have a precinct right next to the airport and, as the federal police force of Canada, it took over jurisdiction for dealing with the potential terrorist threat. The Salvation Army was contacted about finding lodging for the passengers; each of the half dozen local hotels were contacted and told, essentially, to cancel any and all reservations. Hotel rooms would now be designated specifically for flight crews and their pilots, as

**By nightfall, school buses were ready to receive the come-from-aways.**

While the waiting game was going on, Emergency Operations in town were gearing up. The town declared a state of emergency. Various institutions were assessing how many people could be taken and to where. Neighboring localities such as the towns of Appleton, Lewisporte, Glenwood, and Norris Arm to the northwest and Gambo to the southeast were renovating their facilities by mid-afternoon. The only major hitch seemed to be transporting the deplaned passengers and crew to their overnight accommodations. On September 3, a week earlier, the school workers union in Newfoundland—which comprised custodians, cafeteria workers, and, most crucially, school bus drivers—had gone on strike. Without the school buses and the fleet of drivers licensed to drive to their appointed rounds, the diverted passengers might well

bought every bit of nicotine gum that was in town," recalled an airport worker, "and brought it over."

Ground services rushed in other essentials such as food and beverages, and began draining out the lavatories that were groaning under the strain. "Although the passengers were confined, they were well looked after, "recalled Wilson Hoffe, one of the airport's board of directors. "It may not have been the best of situations, but every passenger was made as comfortable as possible." The flight attendants on Continental Flight A5 took pity on their passengers and opened up the bar carts and sundry to all; never were so many tiny bottles of Gordon's gin and Jack Daniel's sacrificed on the altar of a grateful clientele.

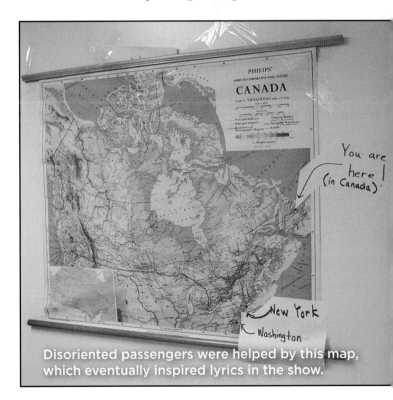

**Disoriented passengers were helped by this map, which eventually inspired lyrics in the show.**

Kevin Higgins/The Beacon

Joe McGuire and Des Dillon of the Canadian Red Cross look through some of the registration cards on record from the more than 6,000 passengers grounded in Gander last week.

be spending the night lining up outside the planes' lavatories.

By 5:00 p.m., within Gander Airport itself, the Red Cross, normally accustomed to rescue operations during weather-related disasters, was setting up a make-shift processing center in the reception area in the section of the upper deck of the airport, overlooking the runways. By then, a few reporters from the local press and cable station (Rogers TV) had been allowed into the airport, but they were kept under guard in a small room off the mezzanine; they were not permitted to interview passengers yet, due to security concerns.

It wasn't until 6:40 p.m. that the first flight got the all clear to disembark. Passengers of Virgin Atlantic Flight 75 were told to grab only their personal belongings and whatever pillow or blanket they had on hand and get ready

to leave: their baggage stowed in cargo would be off-limits. Through Gate 19, the first of the newly minted "plane people" entered Gander Airport. After a scrupulous security vetting, they were met by members of the Red Cross, who took down some basic information about each passenger and piled it into large cardboard Timbit boxes, requisitioned from Tim Hortons. (Each plane had to have its own discreet box, as that would be the only way to reassemble passenger lists, plane by plane.)

While pilots and crew were escorted to the airport's VIP lounge for separate processing, passengers were then asked to proceed to a section where they could speak to doctors and pharmacists about any ongoing medical conditions that required immediate attention; many passengers had left their medications in their luggage, now in the cargo hold. It was up to a team of local pharmacists from the Medi Plus Pharmacy to fill prescriptions, often having to decipher drugs from other countries under unfamiliar names and dosages. Passengers were then asked to pass through a team of social workers (a "Critical Stress Management Team") to see if they needed any emotional assistance. Finally, they were given food–donations from the local Subway, fried chicken, pizza, fresh fruits, bottled water, soda, a multitude of sandwiches made by a score of volunteers who came to assist the Red Cross; the owner of the airport's bite-size pub and restaurant gave away all the food and drink he had in stock.

By late in the evening, Gander Airport's beautifully tiled, geometric floor resembled a scene of carefully managed chaos; makeshift processing lines, food supplies, and bedraggled,

but upbeat lines of disembarking passengers. Every reasonable bit of attentive concern had been directed to these exhausted souls.

Except one. The airport's television consoles had initially been tuned to cable news–but the horrific images of that morning, replayed in a seemingly endless loop of tragedy proved not only upsetting to the passengers, but hopelessly inefficient for moving people quickly through the lines. "Turn them off!" shouted one official. In addition, to keep things under control, "OUT OF ORDER" signs were hastily put up along the payphone banks.

But there was nothing "out of order" in the way that Gander's emergency operations processed the hundreds–by nighttime, thousands–of visitors. The initial processing took almost three hours per flight, but through trial and error, the timeframe was reduced to about forty-five minutes per three hundred passengers. The striking bus drivers had agreed to cross the picket lines to get these folks to where they could bed down for the night. By the time that the airport's streamlined clock–

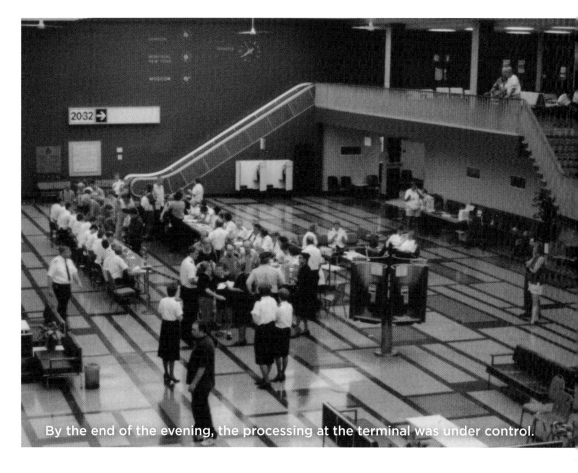

By the end of the evening, the processing at the terminal was under control.

with its settings for Moscow, Gander, and New York–had struck midnight, technically putting a much-needed conclusion to that dreadful day, an informal convoy of school buses began ferrying these wayward travelers out into the night to school auditoriums, church basements, and community centers filled with cots, pallets, sleeping bags, and bed rolls.

There would be more than enough time in the morning to process what had happened. In the meantime, the town of Gander had welcomed an unprecedented number of accidental tourists–two new folks to every three residents.

But, of course, the visitors would all be gone the next day . . .

**JANICE** *(on camera)*
11:53 a.m.

**ALL (EXCEPT JANICE)**
Tuesday.

**JANICE**
September 11, 2001. Any available community buildings will be converted into shelters. With thousands of passengers arriving at any minute, the town is asking for help with—well, anything you can do . . .

**BEULAH**
CRYSTAL, I SAW ON THE NEWS
THAT THEY'RE LOOKING FOR
BLANKETS AND BEDDING
AND MAYBE SOME FOOD

**CRYSTAL**
DO YOU KNOW WHAT THEY NEED
AND HOW MUCH

**MARTHA**
I NEED SOMETHING TO DO

**MARTHA, CRYSTAL & BEULAH**
'CAUSE I CAN'T WATCH THE NEWS ANYMORE

**ANNETTE**
CAN I HELP?
IS THERE SOMETHING?
I NEED TO DO SOMETHING
TO KEEP ME FROM THINKING OF
ALL OF THOSE SCENES ON THE TUBE

**CRYSTAL**
I NEED SOMETHING TO DO
CAUSE I CAN'T WATCH THE NEWS

**MARGIE & ANNETTE**
NO, I CAN'T WATCH THE NEWS ANYMORE

**CRYSTAL, JANICE, BEULAH & MARTHA**
IN THE WINTER, FROM THE WATER, THROUGH THE WIND

**ALL WOMEN**
IF A STRANGER ENDS UP AT YOUR DOOR

**BEULAH**
YOU GET ON THE HORN ㉑

**BEULAH** (on the phone)
Hello? This is Beulah Davis down at the Academy. ㉒ I heard we might be getting some guests and I thought I'd see if I could help whosever in charge of getting the school organized— How many passengers can we take? Uh—well, we fit about 400 students— yes, we could probably do six hundred. Or sure, seven hundred, if we really pack them in. When are they coming? Could be any time now? Well, I'm glad I phoned!

**OZ**
I get a call from Beulah looking for "anything seven hundred people from around the world might need." So, I go down to Shoppers and the manager says to just take what I want off the shelves—toothbrushes, floss, mouthwash, deodorant. And I'm back at the school, when Beulah says . . .

**BEULAH**
You know, those planes probably got some babies on 'em . . .

*A slight pause.*

**OZ**
So, I'm back to Shoppers for diapers. And we're unpacking them, when Annette says . . .

**ANNETTE**
You know, those babies are probably going to be hungry . . .

*Another pause.*

**OZ**
So, I'm back to Shoppers for formula and baby food. And when I get back, Beulah says . . .

**BEULAH**
You know, those planes are probably filled with women of child-bearing age . . .

*Another pause.*

**OZ**
Sooo?

㉑ **IRENE: this song was partially inspired by "Telephone Hour" from *Bye Bye Birdie* (where the name Margie also coincidentally came from).**

㉒ **DAVID: One of our first interviews was with Diane, Annette, Maureen, and Diane—the teachers at Gander Academy—and Wayne, the vice principal at the time. They gave us so many details that we couldn't write fast enough, and we had to frantically figure out how to record on our phones. They spoke to us for hours, each overlapping with a million stories. Transcribing it later, it was a challenge to pick out who said what, so they are all represented in the characters of Beulah and Annette.**

**㉓ IRENE:** In one of our interviews, a woman waited until her husband took David to see something, then once she and I were alone, she finally felt comfortable to talk about how they arranged pads and tampons for the passengers.

**㉔ DAVID:** This scene is a good representation of the improv tradition of yelling "cut to" in the middle of a scene, to show something that was just referenced. For example, "cut to" Dwight at home with the children. Though, eventually, it just became "cut."

**㉕ DAVID:** Kevin O'Brien and the few pharmacists in town worked five days straight phoning pharmacies around the world, trying to translate prescriptions, dosages, and drug names. This was originally multiple scenes, and even though this storyline was cut, it was important for us to keep the detail in.

**BEULAH**
So, I'm back to Shoppers to pick up as many pads and tampons as they have. ㉓

*OZ exits, wincing.*

---

**JANICE** ㉔
*Excuse me—I'm Janice Mosher...—*

**ANNETTE**
*Beulah over there's sorting clothes by sizes. Why don't you give her a hand?*

**JANICE**
*No—I'm with Rogers—for an interview. Uh ... so where's all the food and supplies coming from?*

**ANNETTE**
*Well, every town within two hours of here is dropping stuff off. And we've been to Shoppers too many times to count.*

**JANICE**
*I heard the government's bringing in some shipments as well.*

**ANNETTE**
*Well, we'll all grow old waiting for Ottawa. But don't think all this preparation isn't for us too—if I don't keep at it, I'd be home explaining what's happening to my children. This way, my husband's gotta do it.*

*At her house, Annette's husband, Dwight, is with the children.*

**DWIGHT**
*No, your mom's helping down at the school. NO, there's nothing good on television today! Who wants more ice cream!*

**CHILDREN**
*No!*

**DWIGHT**
*No? Do you want to play horsey?*

**CHILDREN**
*No!!*

**DWIGHT**
*No? ... Do you want to play Kick Dad?*

**CHILDREN**
*Yeah!*

*A pause.*

**DWIGHT (resigned)**
*... Let's play Kick Dad.*

**CHILDREN**
*YEAH!!*

---

**JANICE** *(on camera)*
The Baptist Church needs a hand moving their pews ... Dr. O'Brien down at the pharmacy is ready to fill any prescriptions. ㉕ Oh, and the Lions Club is looking for some toilet paper, if you have any extra.

*The women begin packing and stacking boxes.*

**ANNETTE**
MEDICINE

**MARGIE**
TOOTHPASTE

**MARTHA**
UNDERWEAR

**BEULAH**
ASPIRIN

**CRYSTAL & ANNETTE**
JACKETS OUR KIDS GREW OUT OF LAST SUMMER

**JANICE**
AND DOWN AT THE STATION, WE'RE TAKING DONATIONS OUT BY THE DOOR

**ALL WOMEN (EXCEPT JANICE)**
HOLY JESUS, THERE'S MORE!

**ANNETTE**
IT'S BETTER THAN BEING AT HOME ALONE
WONDERING WHAT'S REALLY HAPPENING**MARGIE**
EVERYONE'S PHONING

**ANNETTE & BEULAH**
WE'RE SETTING UP ROOMS IN THE SCHOOLS

**MARGIE**
BEEN CRYING ALL AFTERNOON WONDERING
WHAT CAN BE DONE

*The men enter carrying boxes across the stage.*

**MEN**
WHAT DO WE NEED?

**ANNETTE**
I made a tray of sandwiches.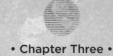

**BEULAH**
We need fifty more.

**ANNETTE**
Sandwiches?

**BEULAH**
Trays!

**MEN**
WHAT DO WE NEED?

**DWIGHT**
Two hundred gym mats! Is that enough?

**BEULAH**
You tell me and we'll both know.

**MEN**
WHAT DO WE NEED?

**JANICE** *(on camera)*
For the love of God, stop bringing toilet paper to the
Lions Club!

**DWIGHT, 10 & DOUG**
HOW DO YOU KNOW WHAT YOU NEED
WHEN YOU DON'T KNOW HOW MANY YOU'RE NEEDING
   TO FEED

**OZ, GARTH & CLAUDE**
WHEN YOU DON'T KNOW HOW MANY ARE STAYING

**DWIGHT, 10 & DOUG**
HOW LONG THEY ARE STAYING—

**ALL MEN**
WE BETTER START PRAYING THE WEATHER STAYS NICE

| MARGIE, JANICE & ANNETTE | CRYSTAL, BEULAH & BONNIE | CLAUDE, OZ & GARTH | DWIGHT, 10 & DOUG |
|---|---|---|---|
| IN THE WINTER, FROM THE WATER, THROUGH THE WIND | IN THE WINTER, FROM THE WATER, THROUGH THE WIND | | |
| IN THE WINTER, FROM THE WATER, THROUGH THE WIND | | IN THE WINTER, FROM THE WATER, THROUGH THE WIND | |
| IF A STRANGER ENDS UP SENT BY FATE | IF A STRANGER ENDS UP SENT BY FATE | IF A STRANGER ENDS UP SENT BY FATE | IN THE WINTER, FROM THE WATER, THROUGH THE WIND SENT BY FATE |

**ANNETTE**
Are we going to be ready?

**BEULAH**
Well we have to be, don't we?

*On the plane, the passengers look out the window.*

㉖ **DAVID:** When we interviewed the teachers at Gander Academy, they spoke about the vast amount of supplies that needed to be collected and how the community came together. The local dentist brought in toothbrushes and toothpaste. Every store in town was open twenty-four hours. And blankets and bedding came in from Ladle Cove, Aspen Cove, Twillingate, and Wesleyville— towns that were two hours away.

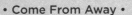

**27** DAVID: This chorus came from an interview with Tom McKeon, who had arrived on a small Continental flight. Though most of the planes were larger aircrafts, this image helped with the claustrophobia of the flights.

# 28 HOURS/
# WHEREVER WE ARE

**DIANE**
When you include the original flight, we were on the plane probably twelve, thirteen hours.

**KEVIN T**
We were on there fifteen hours.

**KEVIN J** (correcting him)
Twenty hours.

**BOB**
Twenty-eight hours. We were on the plane for over an entire day.

**ALL**
TWENTY-EIGHT HOURS
OVER AN ENTIRE DAY
THERE WAS ONE AISLE IN THE MIDDLE **27**
EVERYONE KNEW EVERY INCH OF THAT PLANE

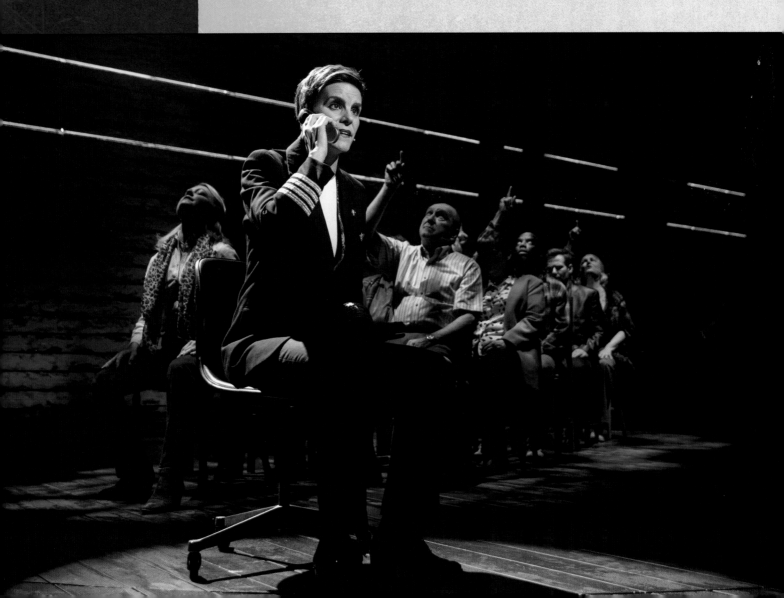

**PASSENGER 11**
We were allowed out of our seats, but not off the plane.

**KEVIN T**
You never think about it, but airplane doors are twenty feet in the air.

**KEVIN J**
And even if you survived the jump, they probably would've shot you.

**BOB**
Everyone knew every inch of that plane.

**PASSENGER 3**
You could go up to first class. You could stretch in the aisles.

**PASSENGER 4**
Our flight was full—there were children sleeping on the floor.

**PASSENGER 5**
It had three seats on each side. There was only one aisle in the middle.

**HANNAH**
We had no way to get information.

**PASSENGER 12**
This was before most people had mobile phones—and only a couple people got through.

**ALL**
28 HOURS

OVER AN ENTIRE DAY

THERE WAS ONE AISLE IN THE MIDDLE

EVERYONE KNEW EVERY INCH OF THAT PLANE

28 HOURS

OVER AN ENTIRE DAY

THERE WAS ONE AISLE IN THE MIDDLE

**ALL (CONT'D)**
EVERYONE KNEW EVERY INCH OF THAT PLANE

**KEVIN T**
Hello?

**PASSENGER 7**
Mom?

**PASSENGER 5**
Bonjour.

**HANNAH**
Operator?

*Beverley is alone in the cockpit.*
*She holds a phone to her ear.*

**BEVERLEY**
TOM? OH, THANK GOD.
I FINALLY GOT THROUGH.
I BORROWED A PASSENGER'S PHONE.
HOW ARE YOU? ARE THE KIDS OKAY?
NO, I'M FINE, TOM. I'M FINE. ㉘

SAFE AND SOUND ON THE GROUND
HERE IN NEWFOUNDLAND.
WE DON'T KNOW MUCH—
EXCEPT FOR THE BBC
LISTEN, I CAN'T TALK LONG
CAN YOU DO SOMETHING FOR ME?

**KEVIN T**
I'm okay.

**PASSENGER 7**
I'm fine.

**PASSENGER 5**
Oui. Bien.

**HANNAH**
Pick up.

**BEVERLEY**
TELL THE KIDS I'M ALRIGHT
TAKE THEM INTO THE KITCHEN
AND SHOW THEM THE MAP
THAT WE USED TO PUT PINS IN

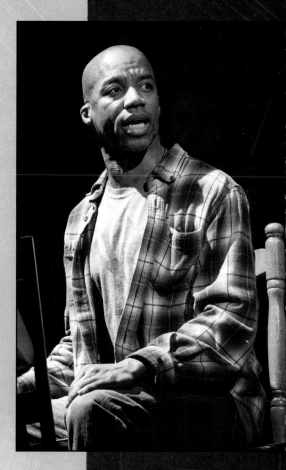

㉘ **IRENE:** Beverley and Tom have been to see the show more than 120 times now. She is a member of the International Society of Women Airline Pilots, a group devoted to encouraging women to go into aviation, and she has brought many groups of female pilots to the show with her. It always makes us very proud to see Beverley sporting a *Come From Away* purse and earrings, and Tom introducing himself to people as "No-I'm-fine-Tom-I'm-Fine" Tom.

**㉙ DAVID:** "28 Hours" and "Wherever We Are" were originally two separate songs. We merged them together to more efficiently reflect as many experiences as possible, using the rumor section as a bridge in and the radio section as a bridge out.

**㉚ IRENE:** There are several moments in the script where everyone is talking over each other. Where there is a "/," it indicates the next line interrupts the previous line at that point in the text.

FOR EACH DESTINATION
THAT WE FLEW TOGETHER
TELL THEM I'M FINE
PUT A PIN HERE IN GANDER

**PASSENGER 12**
On our plane, someone has a cell phone.

**BOB**
But then the battery dies.

**ALI**
There are phones in the backs of the seats.

**HANNAH**
But they don't work.

**PASSENGER 4**
Half the passengers on our plane don't speak English.

**PASSENGER 11**
Even if we knew what was happening, we don't speak their language.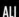

**BOB**
On our plane, we ask the flight attendants.

**FLIGHT ATTENDANT**
But the captain says not to say too much. And that's when rumors start flying. ㉙

*Passenger's lines repeat through the planes, building to everyone speaking at the end.*

**PASSENGER 5**
There was an accident.

**PASSENGER 12**
An accident?

**ALI**
The U.S. airspace is closed.

**KEVIN T**
For the first time in history.

**PASSENGER 11**
Why won't she tell us what's/ happening? ㉚

**ALI**
A helicopter crashed in/ Pennsylvania.

**PASSENGER 5**
A helicopter crashed into a/ building.

**BOB**
A build/ing?

**KEVIN T**
The White/ House!

**PASSENGER 7**
The White House was bombed.

**FLIGHT ATTENDANT**
I need you to calm down,
ma'am!
Everyone calm down!

**ALI**
We need to do something.

**PASSENGER 4**
Tell us what is going on!!

**BOB**
It's World War III!

Ohmygod, it's World War
III! ③

*On another plane, Joey jumps up.*

**JOEY**
WOOOOOO!
MEANWHILE ON OUR PLANE
WE DIDN'T HAVE A CLUE
WE WERE ALL GOING INSANE BECAUSE

**ALL**
THERE WASN'T SQUAT TO DO

**JOEY**
THEN THE CAPTAIN STARTS APOLOGIZING
SAYS ON BEHALF OF THE AIRLINE
I'M GIVING EACH AND EVERYONE SOME

**ALL**
COMPLIMENTARY BOOZE!
OPEN THE AIRPLANE DOORS
WAVE AT ALL THE CARS
HELLO TO WHOEVER YOU ARE—WHEREVER WE ARE

**DIANE**
The ground crews supplied whatever we needed.

**KEVIN J**
Nicotine patches.

**NICK**
Medication.

**PASSENGER 5**
Pampers.

**ALL**
Something to drink!

**JOEY**
SO THE FLIGHT ATTENDANTS
BROUGHT OUT ALL THE MINI BOTTLES OF LIQUOR
AND DELIVERED THEM TO EVERYONE

**ALL**
SOON EVERYONE GOT FRIENDLIER!

**JOEY**
I TOOK A COUPLE OF PICTURES OF THE VIEW THERE
    WITH MY CAMERA
WE DIDN'T KNOW WHERE WE WERE

**ALL**
BUT WE KNEW THAT WE WERE HAMMERED!
OPEN THE AIRPLANE DOORS! WAVE AT ALL THE LOCALS
SURELY THERE'S SOMETHING BETTER TO DO THAN PARK
WHEREVER WE ARE

*Joey leads the passengers in doing the Wave.*

**KEVIN T**
We'd been sitting there for 14 hours when we pull out
the Grey Goose.

**KEVIN J**
Kevin and I were kind of hiding it because, well . . .

**KEVIN T**
Because we (indicating KEVIN J) didn't want to share
it. Anyway, this woman—this hot mess behind us kept
completely freaking out.

*Delores is sitting behind them, completely
freaking out.*

**DELORES**
I don't understand why they can't let us off. I mean,
just to stretch our legs, I mean really? I need to get
some air! Oh my god! I need to get off this plane! ③

③ **DAVID:** Moments like this, where the actors jump quickly from character to character, require a lot from our stage managers and follow-spot ops, running multiple rapid-fire sound and light cues, while our sound mixer does a kind of fader ballet with his fingers, raising the volume for each line and then dropping it down on the next.

③ **DAVID:** Delores is based on a French woman on Captain Bass's plane who complained loudly until RCMP were called. She was told if she thought she felt claustrophobic on the plane she would feel much more claustrophobic in a jail cell.

**③③ IRENE:** We'd originally only interviewed Kevin T and he'd asked that we respect Kevin J's privacy, so we changed many details, including naming them both Collin. And then in Seattle, Caesar received an email saying, "I think you're playing me in a musical?! He came to see the show and loved it—and eventually both Kevins wrote to ask to change the "Collins" back to "Kevins.""

**③④ DAVID:** One of my favourite stage door moments was when Caesar was asked to sign someone's bottle of Xanax.

**③⑤ IRENE:** Some of the first lines from the show that our daughter learned—and then repeated loudly in a busy airport, "FREAKING THE FUTT OUT!"

**KEVIN T**
And my boyfriend, Kevin—we're both named Kevin. It was cute for a while. Anyway, Kevin was not dealing with it well. ③③

**KEVIN J**
I'm going to kill her.

*Delores pushes the call button above her over and over.*

**DELORES**
Excuse me?! I would like to get off the plane. I am claustrophobic!

**KEVIN J**
Excuse me! Would you like some Xanax? ③④ Because you are freaking out and it is freaking me out and we are all FREAKING THE FUCK OUT!!! ③⑤

**ALL**
OPEN THE AIRPLANE DOORS!
LET A LITTLE AIR IN HERE
CAUSE I COULD USE A SHOWER—OR A BAR (OR A BAR!)

OPEN THE AIRPLANE DOORS!
LOOK AT ALL THE PLANES OUT THERE
THERE MUST BE A CONVENTION, IT'S BIZARRE
WHEREVER WE ARE

| 3, 5, 10 & 12 | 2, 6, 9 & 11 | 1, 4, 7 & 8 |
|---|---|---|
| 28 HOURS | | |
| | 28 HOURS | |
| | | OUT OF THE WINDOWS |
| 28 HOURS | | |
| | 28 HOURS | |
| | | NOTHING BUT DARKNESS |
| 28 HOURS | | |
| | 28 HOURS | |
| | | DARKNESS AND HEADLIGHTS |
| 28 HOURS | | |
| | 28 HOURS | |
| | | NOTHING TO SEE |

*Bonnie picks up her phone in the SPCA.*

**BONNIE**
Hello? It's Bonnie Harris down at the Gander SPCA. I went down with the rest of the town to look at all those planes. Well, I got to wondering if there weren't any animals on them . . . No? There's no animals on those planes? Not A ONE?! (*They hang up on her*) Okay, then. Thank you for your time. (*She sees Doug calling her on the caller ID.*) Doug! (*She answers the phone.*) Doug, are there animals on those planes?

**DOUG**
Uh . . . Probably?

**BONNIE**
"Probably." Are they "probably" feeding them then? I'm heading over.

**DOUG**
Bonnie, there's armed guards, the army, police everywhere—

**BONNIE**
Well, then they'll have to shoot me.

**DOUG**
. . . Bonnie? Bonnie? Bonnie!

*In town hall.*

**CLAUDE**
Garth.

**GARTH**
Claude.

**CLAUDE**
Look.

**GARTH**
Look.

**CLAUDE**
Look at it from my perspective.

**GARTH**
Will you look at it from my perspective?

**CLAUDE**
We've been coming to the table.

**GARTH**
We've been coming to the table too!

**CLAUDE**
We've got the college, the churches, and we've got the hotels for the crews. But we need your school buses. (*supporters ad lib words of encouragement.*) We've got no effing way to get them there . . .

**GARTH**
Well, why don't you take them in your car? (*supporters ad lib "Yeah why don't you take them?," etc.*)

**CLAUDE**
Yeah, I can fit four in my Corolla, that's a great start. (*supporters ad lib "Yeah, that's a great start," etc.*)

**GARTH**
That's a great start.

**CLAUDE**
Great.

**GARTH**
Great.

**CLAUDE**
You think about it.

**GARTH**
*You* think about it.

**CLAUDE**
*You* think about it.

**GARTH**
*You* think about it.

**CLAUDE & GARTH**
Jaysus!

**JANICE** (*on camera*)
2:10 p.m. School bus drivers "thinking about" leaving the picket lines.

**CLAUDE**
What's the point of an emergency if no one treats it like an effing emergency? . . . And you can quote me on that.

**HANNAH**
The flight attendants keep telling us nothing's wrong—but I've got kids and I've got grandkids—I know when someone's hiding something. And when parents need their kids to stop asking questions . . . They start playing movies.

**FLIGHT ATTENDANT**
We ran through every movie we had: *Legally Blonde*, *Dr. Dolittle 2* . . . and *Titanic*.

**DELORES** (*totally drunk*)
NEAR . . . FAR . . .
WHEREVER YOU— ㊱

**ALL**
NOTHING TO DO, NOTHING TO SEE
THANK GOD WE STOPPED AT THE DUTY FREE
WHEREVER WE ARE

**NICK**
Do you mind if I sit here? I need to get some work done and there's some drunk people at the back of the plane singing at the top of their lungs.

**DIANE**
No . . . Of course. I'm Diane.

**NICK**
Nick. How are you doing?

**DIANE**
I'm worried about someone. He was flying today. I just wish there was some way to tell him where I am.

**NICK**
Newfoundland—no, you know that—you just can't tell him. Right. I'm hoping you're one of those people who laughs when English people say awkward things.

㊱ **DAVID:** Delores's song was originally "All By Myself." We then tried "Up Where We Belong," but finally landed on "My Heart Will Go On," which not only reflected "Wherever We Are" in the lyrics but got some Canadiana with a Celine Dion reference. And the idea of playing *Titanic* is kind of hilarious.

**37** **DAVID:** This quote is taken from an earlier and less well-known speech which President Bush gave that day. When First Lady Laura Bush came to see the show, we heard afterward that she wondered why we had invented text for her husband and we quickly sent her a link to the speech we were referencing.

**DIANE**
I just wish we knew what was happening.

**PASSENGER 2** *(sotto)*
What's happening?

**PASSENGER 5** *(sotto)*
What's happening?

**DIANE & NICK**
SOMEWHERE IN BETWEEN

**DIANE**
YOUR LIFE

**NICK**
AND YOUR WORK

**ALL**
WHEN THE WORLD MAY BE FALLING APART

**DIANE & NICK**
AND YOU THINK

**DIANE**
I'M ALONE

**NICK**
I'M ALONE

**DIANE & NICK**
AND I'M SO DAMN HELPLESS

*Kevin T, Kevin J, Joey, and the other drunk passengers stand together on their plane.*

**ALL (EXCEPT DIANE & NICK)**
THERE'S NOTHING LEFT TO DO BUT DRINK

*Two party girls rush to the front.*

**PARTY GIRLS**
WE OPEN THE AIRPLANE DOORS
FLASH ALL THE CARS
WOOO! I'VE NEVER DONE THAT BEFORE

**ALL (EXCEPT DIANE & NICK)**
TWENTY-EIGHT HOURS GONE
OVER AN ENTIRE DAY
RUNNING OUT OF THINGS TO SAY
AND WONDERING IF THERE'S SOMEONE

**ALL**
GOING TO CLUE US IN
TELL US ALL WHAT'S HAPPENING
BECAUSE THE SUN IS SETTING
AND WE'RE SITTING IN THE DARK
WHEREVER WE ARE

**BOB**
Later that night, I'm up in the cockpit with some of the other passengers when the pilot puts the radio on over the intercom—and the whole plane goes silent when the president gives his speech.

**PRESIDENT BUSH**
I ask the American people to join me in saying a thanks for all the folks who have been fighting hard to rescue our fellow citizens and to join me in saying a prayer for the victims and their families. The resolve of our great nation is being tested. But make no mistake: we will show the world that we will pass this test. God bless. **37**

**BEVERLEY**
YOU GOT THROUGH TO THE AIRLINE
TOM, I'M OKAY—TELL ME WHAT'S HAPPENING OUT THERE
HOW BAD IS IT—TELL ME EVERYTHING
TOM. WHO WAS IN THE AIR?
NO—NO, I WOULDN'T HAVE KNOWN THEM
NO—NO ONE ON THAT AIRLINE

Charles . . .
Are you sure?

NO, I'M FINE, TOM.
I'M FINE.

# DARKNESS AND *Trees*

**BOB**
We can see them from the plane—this long line of headlights coming through the darkness.

*In the mayor's office.*

**GARTH**
Claude, can I have a word with you?

**CLAUDE**
Garth, I don't have time to go in circles with you anymore. I've got the army delivering a thousand less cots than we were—

**GARTH**
Look. The union just voted. You've got your busses. Our complaint's with our employer, not with the people on those planes.

**CLAUDE**
Thank you.

**GARTH**
But we're back on the line the minute this is over.

**CLAUDE**
Right.

*Back on the plane.*

**ALL (EXCEPT FLIGHT ATTENDANT)**
OFF OF THE AIRPLANE

**FLIGHT ATTENDANT**
Ladies and Gentlemen, you can take only your carry-on items. Checked luggage will remain in the hold.

**ALL (EXCEPT DIANE)**
INTO THE AIRPORT

**DIANE**
The captain and flight attendants tell everyone to take their blankets and pillows off the plane.

**ALL (EXCEPT KEVIN T & KEVIN J)**
OUT OF THE WINDOWS

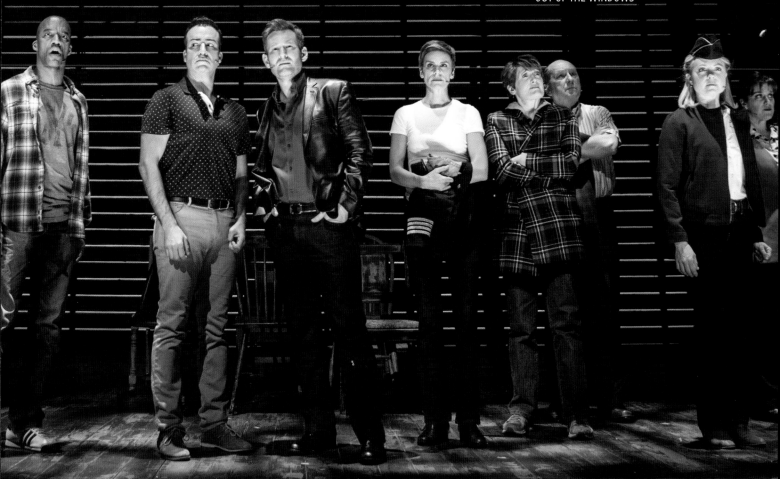

**38 IRENE:** Depending on where their flights originated, some passengers also had to endure going through a foot bath when they entered the airport, because of concerns about hand, foot and mouth disease.

**KEVIN T**
We grab bottles of water too—

**KEVIN J**
No one has any idea where they're taking us.

**ALL (EXCEPT BOB)**
DARKNESS AND TREES

**BOB**
As we enter the airport, all those car lights are still aimed at us.

**HANNAH**
We're scared. They're probably scared too.

**FLIGHT ATTENDANT**
The people here don't know what to expect off of these planes.

**KEVIN T**
The airport looks like something left over from the Cold War. Kevin is like . . .

**KEVIN J**
Ohmygod. We've gone back in time.

**BOB**
The whole procedure—the soldiers and all the formality—it just makes me really nervous. 38

*Inside the airport, two customs officers process the passengers.*

**CUSTOMS OFFICERS**
Citizenship?

**DIANE**
American.

**NICK**
British.

**CUSTOMS OFFICERS**
Purpose of your trip?

**DIANE**
Vacation.

**NICK**
Conference.

**CUSTOMS OFFICERS**
Destination?

**DIANE**
Dallas.

**NICK**
Texas.

**CUSTOMS OFFICERS**
Thank you.

*Nick and Diane are waved on, replaced by Passenger 3 and Ali.*

**CUSTOMS OFFICERS**
Citizenship?

**PASSENGER 3**
American.

**ALI**
Egyptian.

*The customs officers and a few others stop to look at Ali.*

**CUSTOMS OFFICERS**
Purpose of your trip?

**PASSENGER 3**
Family.

**ALI**
Business . . . just business.

**CUSTOMS OFFICERS**
Destination?

**PASSENGER 3**
LA.

**ALI**
Dallas then Washington, D.C.

**CUSTOMS OFFICER 4** *(to Passenger 3)*
Thank you.

**CUSTOMS OFFICER 7** *(to Ali)*
Could you come with me, sir?

*He escorts Ali to another area.*

**BEVERLEY**
There's a giant map on the wall of the airport and someone has written in red marker, "You are here."

**DIANE**
Excuse me. I need to find a phone.

**HANNAH**
I need to call my son.

**CUSTOMS OFFICER 4**
Phones are over there. But it's gonna be a while.

**OZ**
They're all lined up at the airport payphones—so eventually we put an "Out of Order" sign on them just so we can get people on the buses.

**CLAUDE**
11:48 p.m. Buses and drivers are now taking passengers to shelters, not just in Gander, but also to Gambo, Appleton, and farther communities of Lewisporte, Norris Arm, and Glenwood. ㊴

**PASSENGER 12**
Our bus sits there forever.

**PASSENGER 5**
While all the others leave.

**PASSENGER 4**
Finally, this other passenger gets on.

*Ali slowly walks to the back of the bus as all the other passengers watch.*

**PASSENGER 11**
This guy from the Middle East.

**PASSENGER 2**
Someone says he got questioned.

**PASSENGER 7**
Someone says he got searched.

**PASSENGER 1**
And now . . . he's on our bus.

**JANICE**
I try to interview the Red Cross, the Salvation Army—but they've got more important things to do than talk to me. That's when I see them—the Plane People—through the bus windows. The terror on their faces. They have no idea where they're going.

**BEVERLEY**
They take me and my crew in a separate van and I'm looking out the window, trying to see where we are, but it is pitch-dark. Now, I have flown over this area hundreds and hundreds of times. And it is just darkness—hardly any lights anywhere. And now here I am. Oh my god, this is just so remote.

**MEN** ㊵
INTO THE DARKNESS

**WOMEN**
STARS AND THE MOONLIGHT

**MEN**
BUT ALL AROUND US

**WOMEN**
NOTHING BUT DARKNESS

**MEN**
OUT OF THE WINDOWS

**WOMEN**
INTO THE DARKNESS

**ALL**
DARKNESS AND TREES

*Garth sits in front of a bus of passengers, driving.*

㊴ **DAVID:** Gander gets a lot of the press from the show and the story behind it, so it was always important to us to include the surrounding communities who also housed and fed passengers. But this doesn't even include the other communities of Corner Brook, Deer Lake, Stephenville, St. John's, Halifax, and as far away as Vancouver, where other planes were diverted. Across the country so many people helped that it would take a hundred musicals to celebrate them all.

㊵ **DAVID:** "Darkness and Trees" was originally a solo—and was originated by Alycia Novak at Sheridan, who then traveled with us, watching our daughter during the next three years of *Come From Away* productions.

**41** IRENE: One story we heard was from a granddaughter, who translated that they were being taken to a "camp"—and her grandmother, a Holocaust survivor, started crying, thinking of darker associations to the word.

**42** Translation: Where are you taking us?

**GARTH**
Every school bus we got is goin' back and forth all night. Out at the Salvation Army camp, **41** we've delivered passengers from Germany, England, and France. And around three in the morning, my bus is designated to take all these African people out there.

**MUHUMUZA**
My family and I try to see out the bus windows. No one tells us where we are going.

**GARTH**
Silence comes on the bus. We get outside of Gander and you could hear a pin drop.

**ALL (EXCEPT GARTH AND MUHUMUZA)**
INTO THE DARKNESS

ONTO A GRAVEL ROAD

AND ALL AROUND US

**MUHUMUZA**
My wife and daughter are scared. They ask me what is happening and I do not know.

DARKNESS AND TREES

**GARTH**
Behind me, this big man comes up to me and he says in this low voice . . .

**MUHUMUZA**
Wewe watuchukuwa wapi? **42**

**GARTH**
. . . What?

*At the Academy, Beulah and Annette address everyone.*

**BEULAH**
Ladies and Gentlemen, we need some help translating. If anyone speaks Mandarin, can you come to the library? And if anyone speaks Hindi, could you please come to the cafeteria? And if anyone speaks Newfoundlander, well lard tunder'n jaysus god bless ya, b'y.

**ANNETTE**
We've got passengers from all over the world coming off these busses, all speaking different languages. We can't even say "hello."

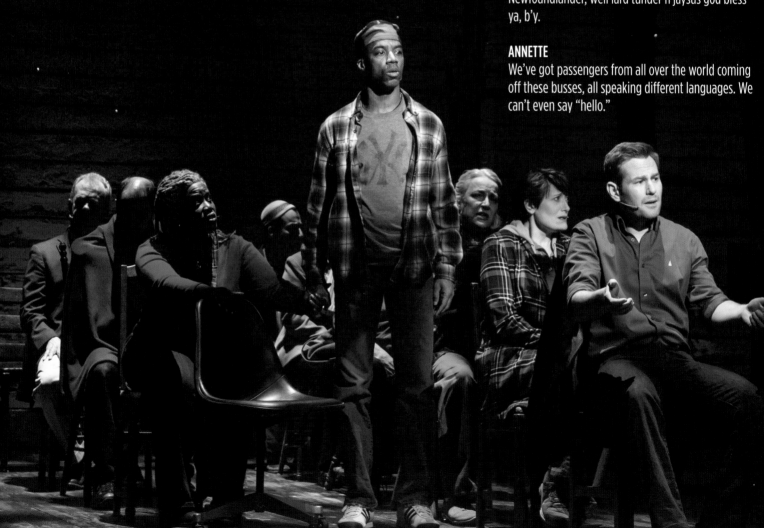

**BEULAH**
And if anyone knows—we think it's . . .

**ANNETTE**
Moldovan.

**BEULAH**
Moldovan—that would also be helpful.

**ANNETTE**
Other passengers help us translate. Mrs. Noonan, our French teacher, turns out to know a little Russian. And Mr. Michaels, our gym teacher, apparently, he speaks Spanish.

*Mr. Michaels stands, holding a shaker and dressed as a fantasy Latin lover. He moves to Annette.*

**MR. MICHAELS**
Si, hablo. Español es la lengua del amor. No sólo soy un profesor de gimnasia, soy un profesor de pasión. ㊸

*He exits with a flourish.* ㊹

**ANNETTE**
I'm sorry, what was I saying?

*Meanwhile, in an airplane hold,
Bonnie is searching with Doug.*

**DOUG**
I said, you've got five minutes, Bonnie!

*In the background, Actor 8 barks quietly.*

**BONNIE**
There's hundreds of suitcases—I can hear barking—but I can't find them! They fast them before flying, so they're starving and they need water.

*Dwight enters.*

**DWIGHT**
Sir? Sir! Oh, Doug. You got to get out of there. We're keeping all personnel out of the holds until—

**DOUG**
Sorry, Dwight. It's the wife—you know, Bonnie—from the SPCA—she's feeding some animals inside. Nothing's coming off.

*Actor 3 meows.*

**BONNIE**
I found a cat! His name is Lyle! There's a pill taped to his carrier. Well, I'm glad I got in here to GIVE IT TO HIM! It's okay, Lyle.

**DWIGHT**
Bonnie—I need you to get out of—

**DOUG**
Bonnie, you got to move your arse!

*BONNIE*
Doug, I have found ONE cat! Do you think it's LYLE who's barking?!

**DOUG** *(meekly underneath)*
No . . .

**BONNIE** *(to Lyle)*
Here's some crunchy, Lyle. I'll be back to give you your pill.

**DWIGHT**
Listen to me—FAA sent over new orders—we're treating all U.S. planes as bomb threats.
**DOUG**
Oh, god. Bonnie!

**BONNIE**
Doug . . . Doug!

**DOUG**
What? Bonnie? Bonnie, talk to me!

**BONNIE**
Doug! There are monkeys on this plane.

*Two bus drivers, Micky and Terry take a seat.
They speak over their shoulders to their passengers,
as they shift into gear and drive.*

㊸ Translation: Yes, I speak it. Spanish is the language of love. I'm not just a gym teacher, I'm a teacher of passion.

㊹ IRENE: All of Annette's fantasies are inspired by our Second City improv training. We didn't expect most of these "cut to" moments to make it to Broadway—but they did! Also: Mr. Michaels was named after Michael Rubinoff."

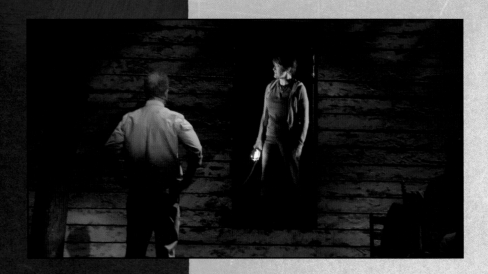

**BOTH**
The Queen.

**TERRY**
This is where the Beatles first set foot in North America!

**MICKY**
And my father once went sledding with Fidel Castro!

**TERRY**
Then they invented jet planes that can get across the ocean on one tank . . .

**MICKY**
So there's no need to refuel anymore . . .

**TERRY**
Leaving us with this giant airport.

**MICKY**
There's talk lately about tearing it down.

**TERRY**
Lucky for you, we haven't got around to it yet.

*They brake suddenly, screeching.*

**MICKY**
Now there's the reason I drives slow.

**TERRY**
That there in the middle of the road.

**MICKY & TERRY**
Yeah. That's a moose. ㊺

*Everyone faces forward, motionless.*
*An incredibly long pause.*

*Even longer than that.* ㊻

**MICKY**
She'll move when she's good and ready.

*On one of the buses, Nick approaches Diane.*

---

㊺ **IRENE: Most of our nights in Gander, we would interview people until dark. Then we would drive half an hour in the darkness back to Gambo where we were staying. On the edge of town, there is a giant cutout of a moose to warn motorists to be careful (they are a serious concern and can total a car). At one point, in the opening number we had a lyric "IF YOU KEEP ON HEADING EAST ALONG YOUR PLEASURE CRUISE/YOU'RE BOUND TO HIT THE OCEAN OR YOU'RE BOUND TO HIT A MOOSE."**

㊻ **DAVID: I think this moment is funny for many reasons, not the least of which is it's one of the only times that everyone finally stops talking onstage.**

---

**TERRY**
Climb aboard.

**MICKY**
Hop right in! You look some tired.

**TERRY**
Nothing to worry about now.

**MICKY**
We'll get you where you're going.

**TERRY**
I'm guessing you've never heard of Gander before. Well, that's it in the rearview mirror.

**MICKY**
You'll need to reset your watches—we've got our own time zone here. Everything happens a half an hour later in Newfoundland.

**TERRY**
You've all seen the airport—used to be the biggest airport in North America. Planes used to stop here to gas up from everywhere.

**MICKY**
Frank Sinatra. Albert Einstein.

**TERRY**
Muhammad Ali.

**NICK**
Mind if I sit here? The drunk people from our plane are snoring back there . . .

**DIANE**
Oh hello, Nick! Please do . . . I thought we'd lost you.

**NICK**
No—I just needed to get an emergency prescription filled—my medicine is in my suitcase. Nothing serious. Not like, "Ohmygod, he's off his medication." I'll stop talking now.

**DIANE**
It's fine.

**NICK**
. . . It's heart medicine. I've got a slight arrhythmia ㊼—nothing serious. There you go—everything you need to know about me.

**DIANE**
Okay. I'm allergic to bananas and I have never had the chicken pox.

*They both smile.*

**NICK**
Any news yet about your husband who was flying today?

**DIANE**
My—? No—do you mind if we just don't talk about that. I haven't been able to get to a phone.

**NICK**
I'm sorry. I'll help you find a phone as soon as we get . . . wherever we're going.

**GARTH**
Finally, out of the darkness, my bus arrives at the Salvation Army camp. ㊽

**ALL (EXCEPT GARTH & MUHUMUZA)**
KATI YA GIZA

**MUHUMUZA**
We pass through a large gate and the bus pulls to a stop. And through the windows—out there in the darkness—we see all these people coming out of the buildings.

GHAFLA MWANGAZA

**GARTH**
Now we rarely use them, but everyone's dusted off their Salvation Army uniforms to welcome these people.

PANDE ZOTE SISI

**MUHUMUZA**
There are soldiers everywhere.

The man at the front opens the door.

**GARTH**
I say, "Here you are. Out you go." But he's not moving. None of them are.

GIZA NA MITI

**GARTH**
But then I notice his wife. Well, she's clutching a bible. Now, obviously I can't read it, but their bible—it'll have the same number system ours does. So I ask to see it and I'm searching for something . . . and then—in Philippians 4:6—I give them their bible and I'm pointing and saying, look! Philippians 4:6—Be anxious for nothing. Be anxious for nothing.

**GARTH & MUHUMUZA**
And that's how we started speaking the same language. ㊾

㊼ IRENE: Nick's slight arrhythmia goes back to the very first workshop at Sheridan College; the students polled their parents about their various ailments and one of them suggested their father's heart condition, which was serious enough for medication, but not so serious that it would be worrisome.

㊽ DAVID: This was an amalgamation of two stories we'd heard—one about driving African passengers to the Salvation Army camp, and one about using a bible to communicate with Moldovan refugees at the Baptist Church.

㊾ IRENE: The revolve starts to move for the first time at this point. I love watching a chair come around at the exact time Chad walks by it and grabs his jacket, put there by someone else in some other scene, to become Kevin T from Garth, and the way Rodney's walk slowly changed between Muhumuza to become Bob.

**50** DAVID: When this story was first dramatized with a busload of Moldovans, instead of Africans singing in Swahili, we used a folk tune, first in Russian and then in English: HEY HI—KOGDA VY GOVORITE YA TOL'KO SLYSHU—LA-LA-LA HEY HI —KOGDA YA GOVORYU VY SLYSHITE TOJEH SAMOYEH
Translation: HEY HI—WHEN YOU SPEAK, I ONLY HEAR LA LA LA LA  HEY HI—WHEN I SPEAK,YOU HEAR THE SAME THING.

**1, 2, 6, 9, 10, 11 & 12**
KATI YA GIZA

GHAFLA MWANGAZA

MA-BADILIKO

GIZA NA MITI

KATI YA GIZA

MA-BADILIKO

**3, 4, 5, 7 & 8**

OUT OF THE DARKNESS

SUDDENLY BRIGHTNESS

EVERYTHING CHANGES

DARKNESS AND TREES

OUT OF THE DARKNESS

SUDDENLY LIGHT **50**

**BEULAH**
Welcome to Gander Academy—nicest hotel on the east coast, except for those with actual beds. My name's Beulah. Washrooms are just down the hall. There's food over there if you're hungry—and clothes, if you'd like to change. I'll show you now where you're going to sleep. Let us know if there's anything else you need.

*Everyone surrounds Beulah.*

**KEVIN J**
So what really happened?

*Everyone asks similar questions.*

**BEULAH**
Well . . . what's the last thing you heard?

**KEVIN J**
There was an accident in New York.

*Everyone chimes in, agreeing.*

**BEULAH**
Okay . . . I'm going to show you now to your rooms, and then if you want to come back, we've got two TVs set up in the cafeteria with the news on—so you can see what's actually happened for yourselves . . .

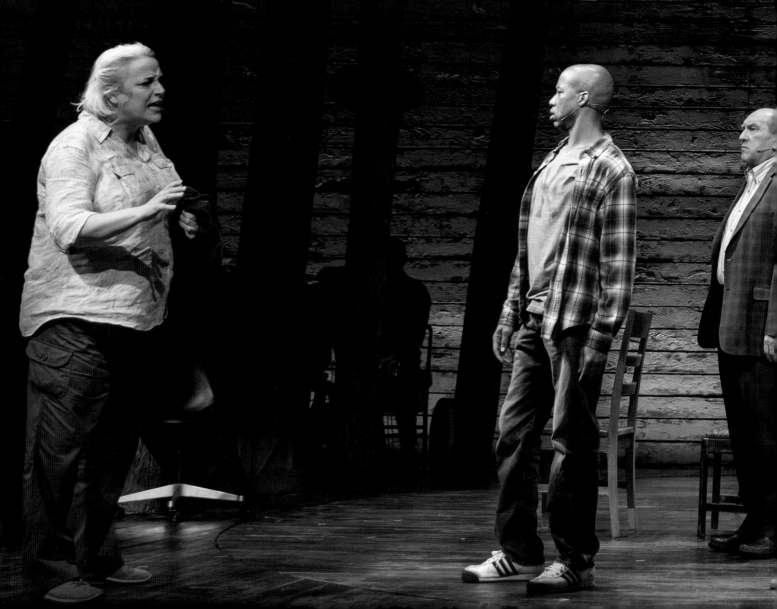

# OF THE DARKNESS

**JANICE**
I didn't even think—they haven't seen any of it yet.

**ALL (EXCEPT JANICE & HANNAH)**
LEAD US OUT OF THE DARKNESS

**HANNAH**
We're all staring at those images.

**BEULAH**
And we just stand helpless watching them.

**ALL (EXCEPT BOB)**
LEAD US SOMEWHERE TO SAFETY

**BOB**
We barely know where we are, but we know it's not there. 51

**ALL**
LEAD US FAR FROM DISASTER

**BEVERLEY**
Charles Burlingame was the captain of Flight 77 that crashed into the Pentagon. 52  I just saw him at a pub in London. You can't imagine. A pilot will fight to the ends of the earth to save his airplane. He just will.

**ALL**
LEAD US OUT OF THE NIGHT

**KEVIN T**
We watch those images for hours.

*THEY all stand and watch, unmoving. Suddenly THEY all react in shock.*

Until someone finally turns it off.

*Claude holds up a remote control and turns off the TV.*

51 **IRENE:** There used to be a "Thank God" said by Delores immediately after Bob's line which was verbatim. At NAMT David's New Yorker cousin saw the presentation and reminded us that most of the audience had been there, including her. She had escaped the tower that day. We cut the line.

52 **DAVID:** When we visited the Pentagon, our entire team found Captain Burlingame's memorial and sent a picture of us there to Beverley.

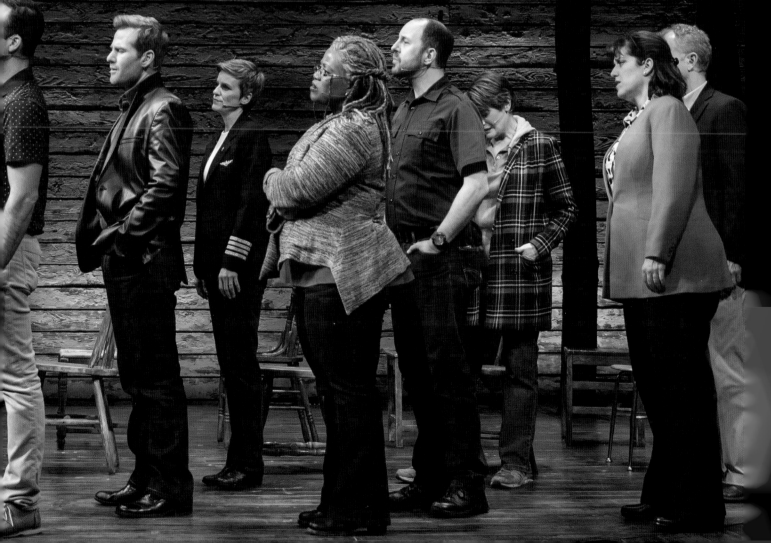

# CLAUDE • OZ • BONNIE

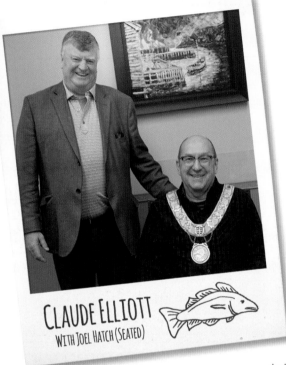

CLAUDE ELLIOTT
With Joel Hatch (Seated)

**CLAUDE ELLIOTT was born and raised in Twillingate, a coastal town in Newfoundland, not far from Gander. In 1973, he moved to Gander with his wife and children and worked there for twenty-nine years, first as a paramedic, then as a hospital administrator. He became deputy mayor of Gander in 1993 and took over as mayor three years later; he was subsequently re-elected four consecutive terms (and was in the middle of a campaign on 9/11), and retired in 2017. Elliott is an avid fisherman, collects hockey cards, and has a golf handicap of nine.**

The mind-set of helping your neighbors has evolved since the time of European settlement, around the early 1600s. The land and weather were brutal, and full cooperation meant the difference between life and death. We still have that instinct today. If we see someone in need, we tend to help first and ask questions later.

In Gander, that philosophy goes even further, given our historic role in assisting oceanic aircraft in cases of in-flight emergency. In 1985, for example, a DC-8 aircraft carrying 248 American soldiers crashed upon takeoff from Gander. Every part of our response went like clockwork—you couldn't hope for a better, faster, or more complete rescue scenario. Unfortunately, it was clear within minutes that there were no survivors.

That's something that has haunted a lot of people in Gander ever since . . . being there, ready and willing and able to help, but finding no one left who needed our help. And I think the memory of that day—and the frustration of not having anyone to help—may have played a role in how the people of Gander responded to 9/11. This time, we couldn't do anything about what was happening in the United States, but by God, we could help these people while they were here.

In Gander, we learned of the events of 9/11 as they unfolded. And I'm sure we reacted with the same horror and disbelief [that New Yorkers did] at watching those same images over and over throughout the morning. And, as the reality of what had happened settled in, we instinctively knew, as you did, that this day would change the world. We had no idea in those first hours, of course, that the impact would be so immediate and on such a scale.

You have to understand, though, that a vast majority of our residents continue to shy away from recognition of the role they played in those pivotal days. A lot of people here are still uncomfortable when I accept an invitation to tell our story to American audiences, feeling that we are, or would be seen to be, trying to capitalize on the situation. We understand and remain sensitive to these concerns, but we also recognize that, to much of the world, our instinctive response was considered extraordinary. It is our hope that if sharing our story can remind and reassure the world that we all have the inherent capacity for simple human kindness, then perhaps it is an experience worth sharing.

**JOEL HATCH (CLAUDE):**

First of all, Claude's an amazing storyteller. Before he was mayor, he was an emergency medical technician.

And he told me the story about the Arrow Air crash in Gander in 1985, and as he told me the story, the tears were running, you know? This was a man with a mission, but he watched and was powerless to help the victims in the plane and it was terrible for him. We in the United States don't have a memorial for those American soldiers who were killed, but they do. In Gander, they do. So now, the chance to help people is the mission of his life. It's a religion for him.

When Claude came to see the show in Seattle, it was his mission to make sure we told the story fairly: "It's not about me; it's not about you being

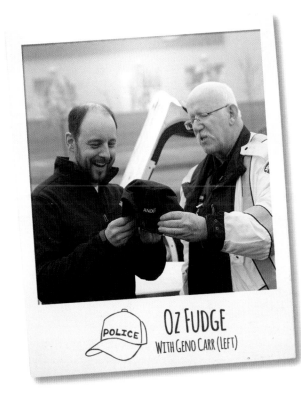

OZ FUDGE
WITH GENO CARR (LEFT)

my doppelganger; this is about telling the story. At the Seattle performance, he didn't laugh, he didn't cry. He just

sat there and listened as intently as possible. He was just totally focused. He applauded at the end. But then there was this elderly woman who came up to him at the back of the house—she had a walker—and she said, "I grew up in the Gander—I want you to know that I'm so proud of my hometown." He thanked her, walked away, turned to a corner, and started to sob.

**OZ FUDGE was one of eleven children born to a family in Lewisporte. He served as Gander's police constable for thirty years. During the week of 9/11, he spent his entire day driving from one location to the next, making sure everything was proceeding properly and that folks were looked after. He convinced his daughter, Lisa, to dress up in a Commander Gander costume for the Children's Wish birthday party on September 14. He now serves on the Gander town council.**

Airport Boulevard is kind of our main drag here. I always know when the kids have just gotten their driving permit. The first time you see them driving down Airport Boulevard, they're sitting upright, both hands high on the wheel, looking this way and that, going under the speed limit. The second time, maybe their hands are a little lower on the wheel, they're sitting more casual,

maybe going a little over the speed limit, sort of testing themselves. The third time, they gots one arm slung over the top of the steering wheel, they ain't looking out nowhere, and they're breaking the speed limit. The third time is when I pull them over. Now, usually, they're scared shitless and their friends are hiding under the back seat and all that. I write out a ticket and hand it to them. The kid is sweating like crazy, he knows he's going to catch hell when he gets home. He opens up the ticket and it says "STFD." He's completely confused, but some kid in the back seat knows what it means. The kid at the wheel is pretty relieved: "STFD" is a lot better than a fine. That usually stops them.

**GENO CARR (OZ):**

I was so happy to finally meet Oz. After creating the role without knowing much about him, I had no idea what to truly expect when in the same room with him. We hit it off immediately and our first dinner together was, as you might imagine, filled with laughter. I got to spend a lot of time with Oz over the few days we were in Gander and even got to drive his police cruiser. (Is that even legal?!) He was extremely kind and we had many great conversations. I'm honored to say that he gave me one of the three police badges he has ever had in his life. He has one, his son has the other, and I, proudly, have the third. If that doesn't tell you something about the true nature of his kind spirit, then nothing will.

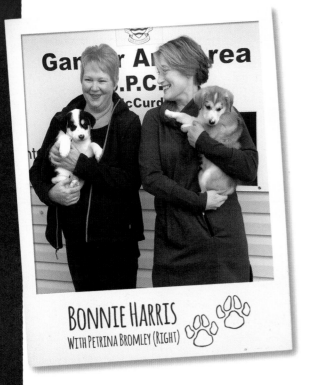

**BONNIE HARRIS**
WITH PETRINA BROMLEY (RIGHT)

**BONNIE HARRIS has run the Gander and Area SPCA for more than twenty years. The rescue organization advocates on behalf of those who can't defend themselves and is currently raising money for a new, expanded, much-needed home.**

I was at the shelter when they called me and told me what was happening, but it wasn't until I had gone back to work after lunch that I thought, jeez there's gotta be animals on the planes, and I called up airport authority and was told that there wasn't any there, so, I went got back to work and then I went home. My husband, who works there as an airplane refueller asked me, "Did you check to see if there are animals on the flight?" and I said they told me no and he said, "Oh, my god, that's bull—I can guarantee there are animals down there in cargo and you have to tell the handlers to check the

manifest." So, we called first thing Wednesday and of course they were there.

We were told [by Agri-Food Canada, the government agricultural agency] that we would not be able to take them off the planes so I gathered up what I thought we would need, and [my associate, Linda Humbly] climbed up the ladders and got into the cargo areas to feed the animals and give them food, water, and clean them up as need be. We didn't get halfway through the planes and it was already 2:00 p.m. I called our provincial vet, Dr. Tweedie, because there was a pill bottle taped on top of a cat's cage and I wasn't familiar with that drug, so he came up to the airport with us. By five o'clock, there were still two planes to do and I thought, Oh my gosh, soon we're going to have to go and do the whole thing all over again. When we came back the next day, Agri-Food had finally given permission to put the animal cages into the hangar—I don't blame them because at that time, there was mad cow disease breaking out in Europe.

I also had our own animal shelter to take care of; I would go to work early every morning, but by 8:30, the three of us would go up to the airport and take care of the animals once they were off the flight, walk them, take the dogs for little walks of for ten minutes or so, and clean them, and by that time, it was lunchtime. I'd go back home for lunch, then go to work, go to the airport, run home for supper, then back up to the airport; it was a hectic five days.

It was hard to say goodbye to an elderly Jack Russell on British Airways; whenever she heard my voice come into the hangar, the kennel would start to shake. I have a soft spot for the seniors—she looked to be, anyway. Later on, we thought we really should have stuck notes on these kennels to let us know you they got home okay.

Seeing myself in the show is amazing, it's surreal. When I saw the show first in Gander, there were some things I had completely forgotten about. I don't consider myself to be a badass, but Petrina said I was. I'm passionate about animals; when I see them not being cared for properly, I can get stern. Yeah, I'm passionate about animals.

**PETRINA BROMLEY (BONNIE):**

When we went to Gander [to do research for the show] I stopped in at the animal shelter because I had to meet Bonnie Harris. I went in and introduced myself. The folks at the shelter said, "No, she isn't here," and I said "Well, I have a car. If she's okay with it, I could call or meet her somewhere." They said, "No, no, she is on a call about a baby moose." So, I said I'm just going to leave now—obviously she has more important things to do. When I [finally] met her at the SPCA, on the bulletin board with all these different pictures that she had, there was a picture of her and the baby moose she had been rescuing that day. [The moose's mother had been killed by a car.] Which is incredible and such a testament to who she is as a person and what her commitment is to what she does.

| B A C K S T A G E |
| --- |

# DIRECTION & MUSICAL STAGING

Minimalism takes a lot of effort to achieve.

As *Come From Away* began to assemble its first professional production team in anticipation of its La Jolla debut, its challenges were becoming apparent. As co-producer Randy Adams put it, "There were three things. One: the title. Two: there were no stars and, Three: people were going to call it the '9/11 musical.' All of which continued to be true."

But in the winter of 2015, the biggest challenge was how to get this epic musical—with dozens of locations, inhabited by hundreds of characters from all over the world—up on its feet.

Christopher Ashley has been the artistic director at the La Jolla Playhouse since 2007, which allowed him to combine his talent as a director for edgy off Broadway comedies

**Kelly Devine and Christopher Ashley worked staging magic on the show.**

(Paul Rudnick's *Jeffrey*) with his ability to create a colorful canvas for Broadway musicals (*Xanadu, Memphis*), along with his knack for bringing new and contemporary plays to life. Developing a new musical at a resident theater had become an essential part of the Broadway playbook in the last three decades—*The Full Monty, Jersey Boys,* and *Waitress* are just a few of the many recent examples of shows that started that way—and given Ashley's previous collaboration with the Junkyard Dog producers, a first stop at La Jolla made perfect sense. But the producers had initially reached out to the 5th Avenue Theatre (where *Hairspray* had its stage premiere) in partnership with the Seattle Repertory Theatre, where the musical could have a three-week workshop, with musicians and an in-house presentation. "Seattle was appealing to us as producers

because it is one of the places outside of New York where you can actually find enough musical theater talent without having to fly out a bunch of people. Keeping it on the West Coast was good–until you know what you have, you don't want people sniffing around it."

Ashley called upon his frequent choreographic collaborator, Kelly Devine. As it happened, Devine was staging a show of her own at Goodspeed Opera House, back when *Come From Away* was doing its workshop there. "I said '*Come From Away*!? I love that show! Oh my god, that would be fantastic!'" Devine signed on to do "musical staging" instead of choreography: "*Come From Away* is much more musical staging in the sense that there is always something different and moving musically, but not in the traditional steps and vocabulary that you're used to seeing on Broadway." The cast was not composed of typical Broadway hoofers either–nor were they supposed to be. "That phenomenal, talented cast that I love so much?" admitted Devine, "Dance is not one of their strong suits. They are not dancers at all. It's okay, though–they're aware of it."

The first task for Ashley and Devine in the workshop was to see what kind of common vocabulary they could create. Landing on the number of ensemble members was essential. At Sheridan College, there had been fourteen actors; Sankoff and Hein subsequently squeezed it down to twelve. Ashley confirmed that "It seemed that the more bravura the acting task was, the more transformative, the more interesting it seemed; but we realized if we try to do this with fewer actors than twelve, their heads are going to explode."

With twelve actors came the logical choice of only twelve chairs (and two tables) on-stage: could the entire show be staged with those limitations? In the three-week workshop, they concentrated on staging only twenty minutes of the text–when people get off the plane and onto the buses. (The rest of the material was presented book-in-hand.) "We got very interested, very fast, in watching those twelve actors make and remake the space with these very simple elements," recalled Ashley. "We'd come in and start moving stuff around. Does this work? Does this look like we're on a bus? Can we split and do two buses? Once we got on a roll with that, conceptually, we just sort of flowed." "The choreography for that workshop is still in the Broadway show, so it was encouraging to know that we found the right vocabulary," added Devine. An added aspect was how much the cast had to cooperate to tell the story that simply. "It very quickly started to seem to us that the cooperation it took for twelve people to tell the story that way very much paralleled the kindness and cooperative spirit of the event in Gander," said Ashley.

One aspect of the production that wouldn't parallel the reality of Gander was the diversity of the ensemble. "Gander is such a white environment–but we soon decided that we had to release that literalness," recalled Ashley. "There's a couple of places where it seemed like ethnicity had to be grounded and anchored, but we were going to create a diverse cast of really flexible, transformative actors who could be three, five, ten, twenty different people and who could transform on a dime."

The members of the ensemble cast were

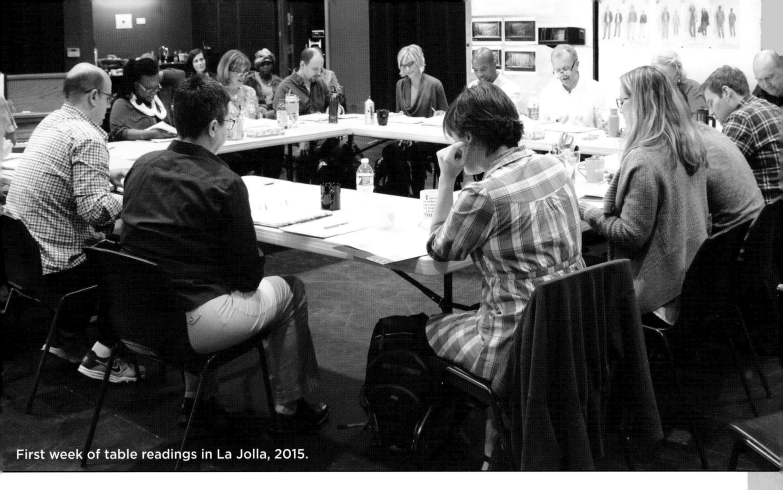

First week of table readings in La Jolla, 2015.

nearly as varied as the come-from-aways who landed in Gander. Kendra Kassebaum, a Seattle resident, and Rodney Hicks from nearby Portland, wound up being the only two Broadway cast members who also participated in the original workshop. Hicks, an African American actor played a variety of characters–some of color, others not–stretching that literalness of character that Ashley and his team wanted; Kassebaum originally played the part of Bonnie, along with other parts. The cast eventually assembled for the La Jolla premiere arrived from points beyond. Chad Kimball had played the lead in *Memphis* on Broadway, so he was already eager to join the production team. A couple of them had heard about the musical in its early days: Lee MacDougall and Astrid Van Wieren hailed from Canada, and both of them had been aware of the Sheridan College

workshop–MacDougall's partner had seen it and recommended it, while Astrid saw it in the Toronto presentation and had buttonholed Sankoff and Hein about being in it someday. Petrina Bromley did them one better: she was the only genuine Newfoundlander in the original cohort. Two of them–Geno Carr and Sharon Wheatley–were from the San Diego area and thrilled to do something worthy in their hometown. Q. Smith and Jenn Colella were keen to fly across the country just to do something at La Jolla Playhouse. Said Colella, "I didn't think I was right for the role [of Beverley Bass] itself, but then when I actually got called back and I read the script, I actually fell in love with it and was desirous to be a part of it." Caesar Samayoa and Joel Hatch were approached somewhat apprehensively by their agents with the project, but, like everyone

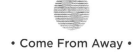

**Chris Ashley and Jenn Colella discuss approaches during rehearsals.**

else, whatever skepticism any of the actors may have had with the subject matter initially quickly vanished once they read the script.

As impressive as the script was, putting it on its feet was a difficult and complex animal, not the least because, as the script kept evolving in rehearsal (it became a one-hundred-minute show with no intermission during the workshop), it became clear that the show would never stop moving–and the actors never stopped acting. Says Devine: "Every single person has a through-line in every moment and you need to know exactly what you're playing in every moment because the movement is so specific. In two seconds, someone will pass a hat, while someone else is putting on a hat to be another person and all of those shifts are choreographed within an inch of their lives. They happen in a split second. That takes a lot of rehearsal."

Another part of that specificity was verbal. "I've never done a show that has a more challenging set of dialects to work on," said Ashley. "The actors spent a lot of hours, both figuring out the Newfoundlander accent, which all of them have to be very comfortable in, but there's people from all over the world and people have to be able to drop into that dialect in one line, drop out of it to something else, into Texas, back to England, back to Newfoundland." Although the cast was guided admirably by the skills of dialect coach Joel Goldes (and nudged by Newfoundland local Petrina Bromley) out of sounding "like a band of Irish pirates from Minnesota," the company ran out of time to thread the dialects organically into the songs themselves. "There was a slightly schizophrenic thing in the early days," said Ashley, "where the dialogue was really detailed in the dialect and the singing was singing for an American musical!"

Sankoff and Hein were in rehearsals, thrilled to be working with such a highly developed creative team. "In rehearsals we would articulate a problem that needed solving and David and Irene would come in the next morning having clearly worked on it, argued about it, wrestled with the problem all night long. They don't always agree, so they would often bring back two solutions, but they wouldn't tell me whose was which or David would pitch Irene's idea and Irene would pitch David's idea. They'd say to me 'Referee this.'"

As the workshops evolved into the subsequent La Jolla production, it became ever clearer that, in Ashley's words, "trying to follow the rules of musical theater didn't get us very far; we had to listen to the material and let it reveal itself to us." Indeed, there were few

musicals in the canon to provide any kind of precedent: Rodgers and Hammerstein's fluid, experimental *Allegro* in 1947; *A Chorus Line*, from 1975, with its emphasis on first-person testimony; *Once*, the 2012 Celtic-infused musical, with its dynamic mixture of cast and live band—but these are only signposts, not templates. "This is a show unto itself; it doesn't have a lead character," says Ashley. "It doesn't even have an antagonist, except for 9/11."

What it began to resemble, most of all, was a play–Thornton Wilder's seminal 1938 drama, *Our Town*. Its groundbreaking evocation of life and death in a small New Hampshire town over several generations had the same vast scope of *Come From Away*, but was a pioneer in rendering such a tapestry with the barest minimum of scenery or effects. It has become a perennial in theaters and drama departments all over the world, because its evocative skeletal foundations allowed audiences to project their own thoughts and feelings onto the material. "We definitely found that the acting style that best suited this production was very frank and very direct in the way that a lot of the best productions of *Our Town* have been," observed Ashley.

For the actors, the rehearsal room was, in the words of Caesar Samayoa, "an amazing time of experimentation. It was trial by fire." That fire often threatened to combust at certain moments. Observed Devine: "There's always a moment toward the end of the show, right

before they get back on the plane to go home. You will see twelve actors, they just have about four counts and they each go to grab one of the chairs and none of them can find the spike mark. They're all walking slowly, looking down, holding chairs. It's called the scattered look." Actress Petrina Bromley observes "I put my hands on and move and touch four chairs; I put on a jacket; and the one chair I twist, I have to make sure it's on the spike mark. It's literally only six seconds of time, but it's very stressful for me every night. Five hundred shows later, I still wonder how I pulled that off, all the time."

When asked how the ensemble came together so quickly, so well, and with such precision, Jenn Colella answers simply: "Fear." Chad Kimball elaborated: "Most of us didn't really know each other and a lot of us lived

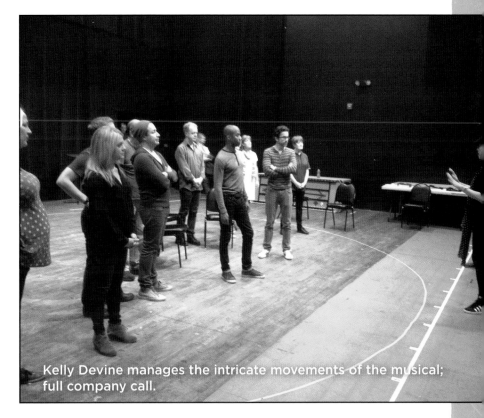

Kelly Devine manages the intricate movements of the musical; full company call.

through 9/11 in New York, so it's a story that we're all incredibly sensitive about. We were scared to death–the show is so fast-paced, there are a lot of moving parts that we actually did bond over the fear factor and became fast friends that way." And that just like what happened to the come-from-aways in Gander.

For director Ashley, the process of putting twelve actors through their paces in a voyage of discovery and generosity comparable to their real-life counterparts has a kind of poignant affirmation: "I hope I'm wrong about this, but I don't think there's a lot of signs that we're going to be magically living in an incredibly generous and amicable moment over the next ten years. That's why we need a story about the importance of taking care of each other. I think that *Come From Away* will mean different things to different people at different times, but its pertinence is not likely to go away."

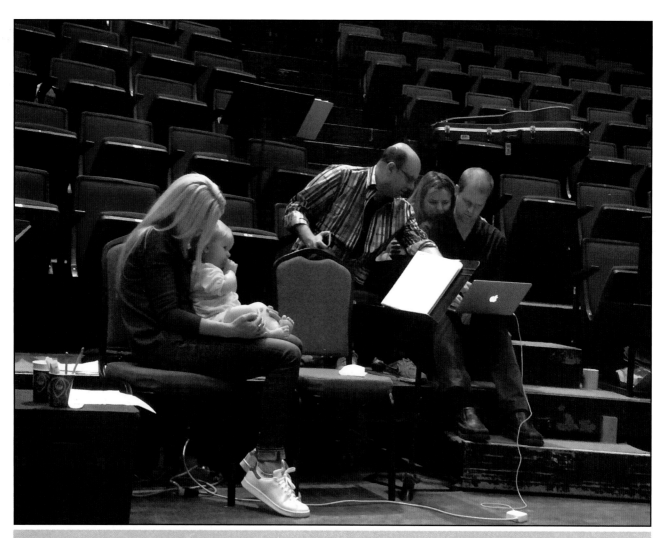

**And when the day is done, Ashley confers with writers Sankoff and Hein; on Devine's lap, their daughter Molly patiently waits for the conference to end.**

# WEDNESDAY, SEPTEMBER 12, 2001

When the next day began in Gander, as it inevitably had to, everything seemed different. One of the biggest changes was that the Americans there–normally among the most well-informed people on the planet–woke up as the last people on earth to discover what had happened the day before.

Information about the previous day had been incomplete–remember, no smartphones, and video transmission had been cut off– and as the school buses dropped off their charges to Gander's various churches and school rooms early in the morning, the exhausted visitors were finally confronted by television consoles and monitors–large and small–broadcasting CNN. "You heard this '*huh*' when the plane hit the towers," recalled Oz Fudge, the town's police constable. "That sound I heard all the

time, of the shock that's on their faces as they're standing there looking at this TV and the look of loss on their faces. I'll live with that for the rest of my life."

A passenger from Oregon commented, "It's that feeling like it's so big you can't comprehend it and you feel like you're almost in a movie. When I first heard the news, I was feeling like crying, but after that, people were just trying to sustain some normalcy." "We got on the school bus and the driver stood up and said, 'The name's Moody, but that's not what I is,'" remembered Shirley Brooks-Jones, an Ohio resident. "It just broke the tension."

Communication was a priority on the visitors' list of basic needs and requests. Newtel, which was the province's telecommunications giant at the time, set up banks of four dozen phones and a few

computers on card tables outside their headquarters on Airport Boulevard, manned by volunteers who helped visitors navigate the complex codes to place phone calls to foreign locations. Additional phone lines were installed by Newtel at most of the local schools; this was also still the era of the dial-up Internet connection. As one sign read: "You may make local calls or long distance calls at no charge to you, courtesy of the local phone company . . . Please keep your calls as brief as possible to allow others to use the phone." In the middle of the night, the Emergency Operations had set up toll-free numbers for families to call in to inquire about their loved ones; the phones were answered by members of the Red Cross, who were able to pass along messages to passengers, guided as they were by their inestimable files stacked in Timbit boxes. Some folks–with connections–were able to vault over these practical obstacles: one police detective from Marietta, Georgia, called Constable Fudge directly at town hall to ask him to pass along a supportive hug to her sister, a Delta stewardess boarding at a Gander motel. It took a while to make contact, but Constable Fudge persevered and the hug was professionally implemented.

Within the town, passengers were billeted at the local community college, the College of the North Atlantic; the local high school, Gander Collegiate; and the local middle school, St. Paul's Academy. These were all located next to each other on Magee Road, in the center of town. A short ways away was the elementary school,

**Distraught passengers learn of the previous day's events on a cafeteria TV screen.**

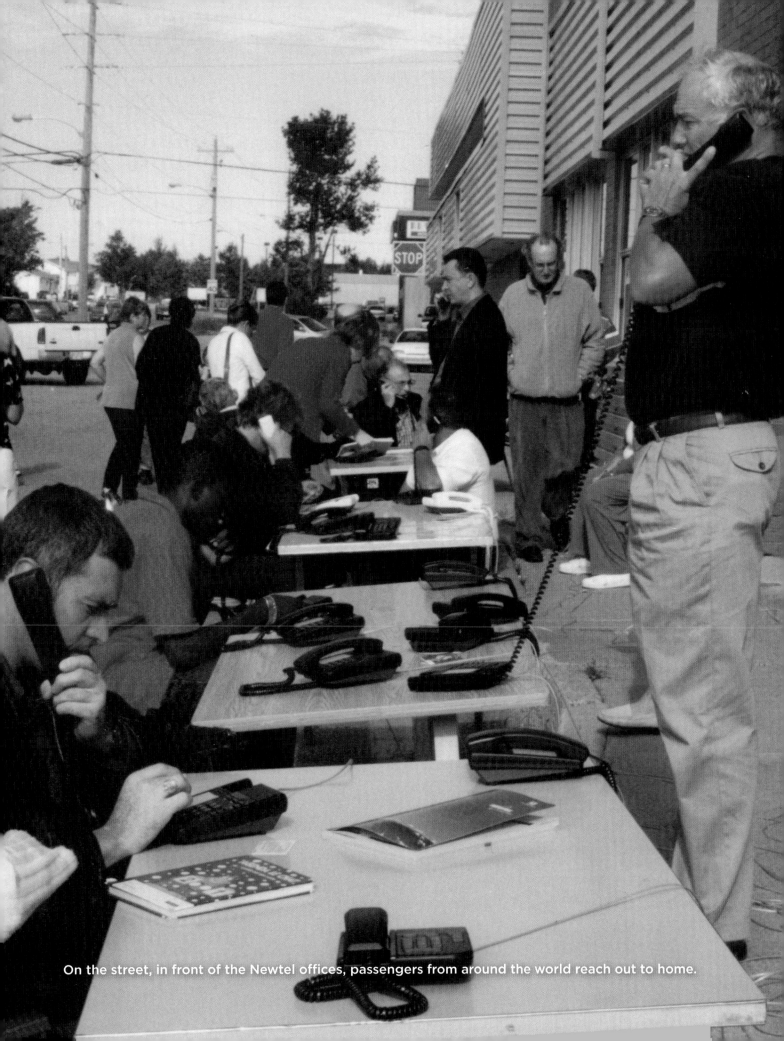

On the street, in front of the Newtel offices, passengers from around the world reach out to home.

Transport of rare chimpanzees delayed in Gander

The Beacon
A Response to Crisis
Gander sees influx of 6,500

Gander Academy. Among civic organizations, the Lions Club, the Knights of Columbus, and the Royal Canadian Legion hall hosted the most visitors. Farther outside the town, along the Trans-Canadian Highway–the main artery in Newfoundland–the hotels and motels, such the Albatross Hotel and Comfort Inn, were completely occupied by the 550 crew members and pilots.

The night before was not without its complications, but given the extensive–and improvisational–logistics, that wasn't surprising. American Trans Airways Flight 25, en route from England to Orlando had nearly one hundred Children's Wish Foundation kids and their parents on board; throughout the night, there were requests to bump them to the head of the disembarkation line, but it was logistically too complicated, and they weren't let off and processed until the morning. At four o'clock in the morning, four thousand brand-new military cots were sent to various locations;

they were so new that not even the army staff knew how to assemble them. An Arabic translator was sought for an Iraqi passenger; an Orthodox Jewish couple requested separate accommodations, but the request was declined; two passengers on an Aer Lingus flight managed to find a rental car in the middle of the night and made a clean break for Montreal. And, as the need for more accommodations began to burst Gander at the seams, the neighboring towns of Lewisporte, Gambo, North Arms, and Appleton welcomed school buses in the dead of night; one bus bound for Lewisporte made it just as dawn broke–after pausing along the way for the bus riders to admire a moose in the morning light.

This gave folks in Gander time to prepare for the onslaught of visitors. While the Emergency Operations was coordinating cots and bedrolls, residents of the town emptied out their linen closets and called their friends–and friends of friends–to do the same. A manager of a hotel located miles away in Glenwood drove through the night with a truckload of old bedspreads and curtains, destined for Gander.

Not to mention the food. The food. The endless trays and platters of food. A sheet cake that was so big that it couldn't make it through the Gander Collegiate cafeteria doors; it had to be laid out and sliced in the parking lot. Gander was informally renamed "Casserole City." "Anything you asked for, it came right away. There was no 'no,'" recalled Brian Mosher, who was virtually on the air 24/7 for a week on the local cable access channel, Rogers TV (Channel 9), reading updated requests as soon as they came across his desk. "And you got six

times what you asked for." A request for more toilet paper at St. John's Academy turned into a mountain of donations; the school, er, dined out on that full storeroom of toilet paper for the remainder of the school year.

"We did not know how we would be affected, if these people were staying, if the people who were coming were good people or not-so-good people," recalled Linda Sweetapple, a local accountant. "We just knew that we had to make room for them and take care of them. They were here, and they needed our help." The visitors were not only grateful, they were in awe. "So many people, so many supplies . . . Everything had been covered—our families notified, passengers cared for. Thank you, Gander," wrote an ATA flight attendant to the *Gander Beacon.*

The beneficence stretched beyond the human species as well. Among the cargo of the grounded planes, there were at least nine dogs, ten cats, and a pair of rare Bonobo chimpanzees destined for a zoo in Columbus, Ohio. It took the local owner of the SPCA, Bonnie Harris, a co-worker, and the regional veterinarian to intercede with regional authorities to get permission to move all the animals to a separate hangar at the airport, where their individual needs could be met. All creatures great and small, indeed.

No one would question that everyone in the town of Gander—from the authorities at air traffic control to the most eager volunteer—had been more than equal to this monumental task. No one would question each citizen's honest enthusiasm and concern. But the one question on everyone's mind was also the most simple: When do we get to go back home?

As the sun set on September 12, no one had a clear answer to that question.

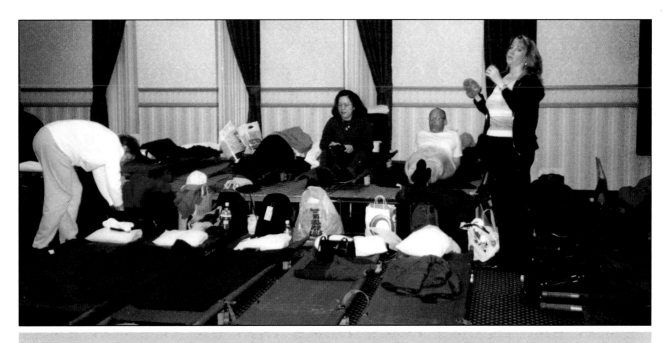

**Sleeping Room Only: one of the many makeshift dormitories in Gander.**

# Phoning HOME

**53** IRENE: Micah is our daughter's best friend in Toronto, and her parents, Anna and Meredith (together with Heather, our old friend), helped us too many times to count while writing this. Celena's is a bakery that we used to write at in Toronto. The name "Lauren" is a small tribute to 9/11 survivor Lauren Manning. And of course, Kev is what Hannah still calls her son.

**54** DAVID: Diane's son David worked in the air force, and she was afraid that he may have been flying that day.

**55** IRENE: Including the mayor of Frankfurt, to whom Claude offered his office!

**56** DAVID: Toutans are fried bread dough and are ridiculously good. Often served with molasses or syrup, I'd also recommend the toutan breakfast sandwich at Gander's Breadbox Café.

**CLAUDE**
1:15 a.m.

**ALL (EXCEPT CLAUDE)**
Wednesday.

**CLAUDE**
September 12.

**CLAUDE**
Crisis counselors are called to Gander Academy.

**BEULAH**
The plane people—they're exhausted—but they don't want to sleep. And we're standing there, ready with all that food. But that's not what they want. They want phones.

**JANICE** (on camera)
1:45 am—Six phones are put on tables for the plane people to use free of charge—lined up alongside the road by the Newtel building.

**BEULAH**
An hour later, they setup twenty more phones.

**CLAUDE**
An hour after that, there's severnty-five phones and computers with Internet—all being used round the clock.

*A number of passengers appear on telephones.*

**PASSENGER 5**
HELLO? YES—IT'S ME.

**BOB**
DAD, I'M OKAY. IT'S OKAY.

**HANNAH**
I'M CALLING FROM CANADA.

**KEVIN J**
SAFE AND SOUND ON THE GROUND HERE IN ICELAND

**KEVIN T**
NO, NEWFOUNDLAND

**BOB**
YEAH.

**PASSENGER 5, KEVIN J, KEVIN T, BOB**
WE JUST SAW THE NEWS

**HANNAH**
HAVE YOU HEARD YET FROM KEV?

**KEVIN J**
OR CELENA

**PASSENGER 5**
CALL MICAH **53**

**PASSENGER 7**
AND LAUREN

**KEVIN T**
MY PARENTS

**PASSENGER 6**
MY AUNT

**DIANE**
IT'S DIANE. NO, I'M FINE.
Where's David? 54

*She covers her mouth and starts crying.*

Oh, thank God.

**NICK**
Hello. It's Nick Marson—My plane's been diverted. Can you pass on to someone at head office that I'm fine? . . . No, no—I just thought someone should know.

**JANICE** *(on camera)*
3:45 a.m. Overnight, the community's population has gone from approximately nine thousand to sixteen thousand. I'm sure barely any of us have slept tonight. We're hopeful that our visitors will be back in the air come morning.

**KEVIN T**
I woke up from a dream which I can't quite remember, but there was this music in it that I'd heard somewhere before.

**KEVIN J**
I woke up from a dream that we were stuck in some backwater Canadian town and that my air mattress deflated.

**BOB**
I woke up to the smell of . . . freshly baked bread.

**ANNETTE**
4:00 a.m. in Newfoundland is breakfast time in Germany. And we've got a lot of passengers here from Frankfurt, 55 so breakfast starts at 4 a.m., and we start scrambling eggs.

**BOB**
Poached eggs, scrambled eggs, omelettes.

**DIANE**
Fried Bologna.

**NICK**
Something called "toutans." 56

**KEVIN T**
I saw a casserole dish I don't think I could lift.

**BOB**
They made enough food to feed seven thousand people. It's like they never slept.

**BEULAH**
There's this one man—from the Middle East—well, we don't really know. Hasn't said a word to a soul— and some of the other passengers seem a bit wary of him. So, it's a little odd to find him poking around the kitchen.

**ALI** *(surprised)*
Hello.

**BEULAH**
Hello. Can I help you with something?

**ALI**
I would like to be of assistance with the food.

**BEULAH**
No. That's not necessary.

**ALI**
But/ I am—

**BEULAH**
Really. You go out there and sit down.

**CLAUDE**
We've been going all night, but we can't stop. I splash some cold water on my face and just keep going. We've got seven thousand scared and angry people who don't want to be here. And they're about to wake up.

# Costume PARTY

**DIANE**
IN A CROWDED ROOM FILLED WITH STRANGERS
SLEEPING 57

**KEVIN T**
AN AIRPLANE BLANKET AND PILLOW ON THE FLOOR

**DIANE**
THE SUN COMES STREAMING THROUGH THE WINDOW

**KEVIN T & DIANE**
AND I CAN'T SLEEP ANYMORE

**KEVIN J**
STARING AT THESE STRANGERS—WAKING UP AROUND
ME

**HANNAH**
SITTING IN A CROWD OF PEOPLE WAITING FOR THE
PHONE

**KEVIN J**
AND IN A TOWN THAT'S SUDDENLY DOUBLED
POPULATION

**KEVIN T, HANNAH, DIANE, KEVIN J**
I FEEL SO ALONE

**KEVIN J**
IT'S LIKE ANY OF US COULD HAVE DIED ON TUESDAY

**KEVIN T**
AND LIKE WE'RE DARED TO SEE THINGS DIFFERENTLY
TODAY

**DIANE**
I'M FEELING DIFFERENT

**HANNAH**
DISTANT

**KEVIN J**
STRANGE

**KEVIN T**
WHO ARE THESE PEOPLE HERE?

**HANNAH**
WHERE AM I?

**DIANE**
NO ONE KNOWS ME HERE

**KEVIN T, HANNAH, DIANE & KEVIN J**
WHO AM I IF I DON'T FEEL LIKE THE ME FROM
YESTERDAY?

**NICK**
I wake up in a crowded room full of people sleeping
on the floor and I see Diane and ask, "Are we
leaving?"

**DIANE**
Any time now.

**NICK**
Is your hair different? I mean . . . you look nice. I like
it.

**DIANE**
Oh! Thank you. No shampoo for three days.

**KEVIN T**
They start handing out clothes to anyone who
needs them.

**KEVIN J**
I haven't changed my clothes in thirty-nine hours.

**BOB**
I wanted to burn my socks.

**KEVIN J**
Kevin puts on this plaid thing. He says he's
"incognito" and that he's going to "blend in with the
locals," but he just looks like a gay lumberjack. ⑧

**DIANE**
CHANGING INTO ANOTHER WOMAN'S DONATED SET OF
CLOTHES

**KEVIN T**
LOOKING DIFFERENT—FEELING KIND OF DIFFERENT TOO

**DIANE**
I CAN'T QUITE EXPLAIN

**KEVIN T**
BUT WHEN I WOKE

**DIANE**
WHEN DAVID WASN'T ON THAT PLANE

⑤⑦ **IRENE:** "Costume Party"
was originally a song just
Diane and Beverley. I was
inspired by Elphaba and
Glinda's duets in *Wicked* and
wanted to include the same
powerful female storytelling
in this show. As it became
more of an ensemble piece,
the song had to be rewritten.

⑧ **DAVID:** After seeing the
show the first time, Kevin T
originally told us he would
never wear buffalo plaid. But
I love that several years later,
he and I have to check to see if
we're both wearing our
gay lumberjack suits to
opening nights.

⑤⑨ **IRENE:** "Costume Party" was easily the most rewritten— and most rechoreographed song in the show and was almost scrapped at one point. The title and theme come from direct quotes from Diane, so we never wanted to just start all over again.

⑥⓪ **IRENE:** Beulah's son, Aubrey, passed away shortly after the show opened on Broadway. We were very thankful that we could bring Aubrey onstage on our opening night and a few days later introduce him to Prime Minister Trudeau.

⑥① **DAVID:** An original cut lyric from the Diane/Beverley duet, showing some of Beverley's obstacles and telling Diane's original story—that after meeting Nick the night before, she woke up early to freshen up. And another passenger walked in and gave her a look that made her question what the point of putting lipstick on was. Anyway, she returned and lay down and Nick woke up, quite confused at how good she looked after sleeping on a cot all night.

**KEVIN T & DIANE**
IT'S LIKE I CHANGED INTO SOMEBODY ELSE—BUT WHO?
AND IT'S SOMEHOW LIKE WE'RE AT A COSTUME PARTY ⑤⑨

**KEVIN T**
AND FOR A SECOND YOU ARE NOT YOURSELF

**DIANE**
YOU ARE NOT YOURSELF

**KEVIN T**
AND YOU LOOK AROUND AND BLINK YOUR EYES

**DIANE**
AND BARELY EVEN RECOGNIZE

**KEVIN T & DIANE**
THE PERSON IN THE MIRROR WHO'S TURNED INTO SOMEONE ELSE

**KEVIN J** (on the phone)
Hey, Little Sister—Yeah, still here where they eat rainbows for breakfast. Are you taking care of mom? No. I'm just freaking out. I wish I was home. No, not LA. Brooklyn. Shut up. You're such a brat. No. I just needed to hear your voice.

*Beulah approaches Hannah.*

**BEULAH**
Excuse me? Are you Hannah?

**HANNAH** (expectant)
Yes, that's me.

**BEULAH**
My name's Beulah. Someone told me your son's a firefighter . . . Mine is too. ⑥⓪ Here in town. And I know Gander's not New York, but . . . Is there anything I can do?

**HANNAH**
No. I just need to hear from my son.

**BEULAH**
I understand.

*Beulah leaves.*

**HANNAH**
PRAYING FOR A PHONE CALL

**KEVIN J**
PRAYING FOR A WAY HOME

**HANNAH & KEVIN J**
ASKING QUESTIONS

**KEVIN J**
ASKING CAN I GET BACK ON THAT GODFORSAKEN PLANE?

**HANNAH**
AND ALL AROUND ME, PEOPLE CHAT

**KEVIN J**
AND PEOPLE ACT LIKE NOTHING'S HAPPENED

**HANNAH & KEVIN J**
AND I NEED TO HEAR WE'RE GOING BACK BEFORE I GO INSANE

---

*DIANE* ⑥①
*LOOKING AT THIS WOMAN—IN THE MIRROR HERE*
*IN ANOTHER WOMAN'S DONATED SET OF CLOTHES*
*I CAN'T QUITE EXPLAIN,*
*BUT WHEN I FOUND OUT DENNIS WASN'T ON THAT PLANE*
*ME AND THE WOMAN IN THE MIRROR WERE JUXTAPOSED*

*BEVERLEY*
*PUTTING ON MY UNIFORM—AND A BRAVE FACE*
*HAVE TO SEE MY PASSENGERS AND CHECK IN WITH MY CREW*
*TELL YOURSELF TO FIGHT THE FEAR, 'CAUSE THERE ARE HUNDREDS HERE*
*COUNTING ON YOU*

*DIANE (& BEVERLEY)*
*AND IT'S SOMEHOW LIKE A MESSED-UP COSTUME PARTY*
*(SOMEHOW LIKE I'M IN A COSTUME)*
*WHERE YOU BARELY EVEN RECOGNIZE YOURSELF*
*(BARELY EVEN RECOGNIZE YOURSELF)*
*AND YOU HOLD YOURSELF TOGETHER AND YOU*

*DIANE & BEVERLEY*
*WAIT TO SEE IF WHETHER*
*YOU ARE BETTER JUST TO BE SOMEBODY ELSE*

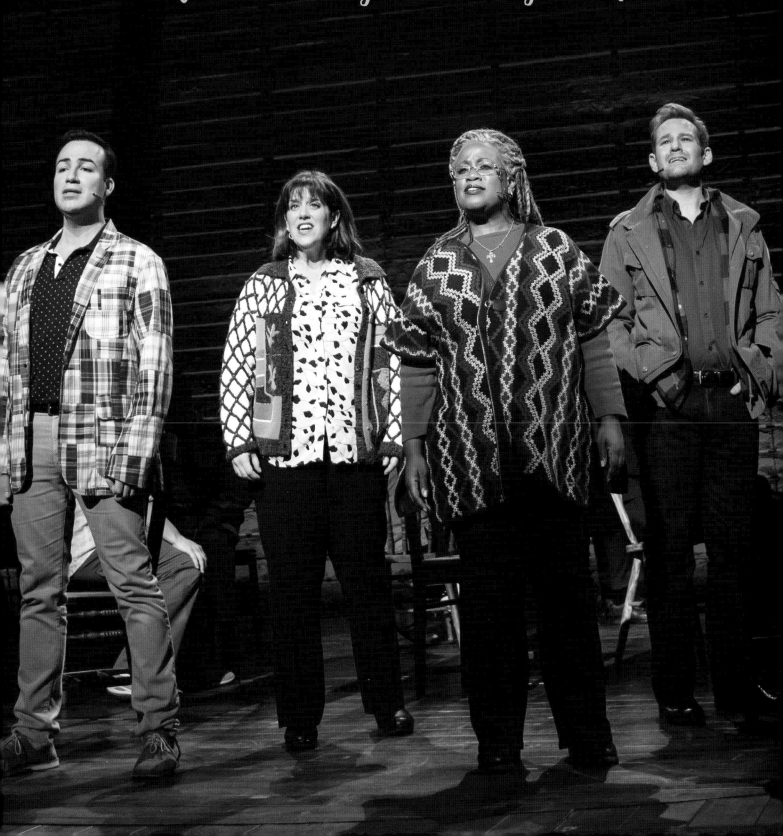

And it's somehow like we're at a costume party and for a second you are not yourself."

⑥₂ **IRENE:** Part of the challenge with this song is that it had to represent multiple points of view—Kevin T and Diane wanted to explore this new world, while Kevin J and Hannah wanted desperately to go home, and Beverley was wrestling with being strong in the face of watching her industry collapse. Plus, it is extremely hard to cut anything sung by Jenn Colella—but eventually we whittled it down into a foursome—two wanting to seize the day and two wanting to go.

⑥₃ **IRENE:** I still miss this bridge we had in the original version that referenced what the characters would be seeing once they stepped outside. But it didn't reflect the frustration and fear that some of our characters were feeling and it was too soon for Diane to feel so relaxed and at home.

*DIANE (& BEVERLEY)*
*THIS YOUNG GIRL STUMBLED IN (SO I STUMBLED THROUGH THE HOTEL)*
*AND SAW ME WITH MY LIPSTICK (AND I STOPPED BESIDE A MIRROR)*
*SHE LOOKED AT ME LIKE, REALLY? (I LOOKED AT MYSELF LIKE, REALLY?)*
*AND THEN LEFT ME STANDING STARING AT MYSELF (STANDING, STARING AT MYSELF)*
*AND SO I STOPPED (AND SO I STARED)*
*I TOOK MY HAIR DOWN (I PUT MY HAT ON)*
*I PUT MY MAKEUP BACK INTO MY HANDBAG (I PUT ON A BRAVE FACE)*
*AND PUT TRUST IN MYSELF* ⑥₂

**BEVERLEY**
Good morning. I'm Captain Beverly Bass. Now I know this is going to be hard to hear, but the American airspace remains closed. *(Passengers react in shock.)* I can't tell you how long we'll be on the ground. But we are going to be here for some time.

**DIANE**
HERE FOR SOME TIME

**KEVIN J**
HERE FOR SOME TIME

**HANNAH**
HERE FOR TOO LONG

**KEVIN T**
HERE FOR HOW LONG

**KEVIN J, 10 & 12**
WHEN WILL WE KNOW

**DIANE, 5, 6, 7 & 11**
WHEN WILL WE KNOW

**ALL (EXCEPT BEULAH & JANICE)**
HOW MUCH LONGER?

**HANNAH**
Beulah, wait. Can you help me find a Catholic Church?

**DIANE** *(to Nick)*
I can't sit here. I need to get some air.

**KEVIN T**
Let's go see where we are. It'll do you good.

**KEVIN J**
What'll do me good is to lie down and pretend this isn't happening.

**KEVIN T**
Suit yourself.

*DIANE & KEVIN T*
*AND EVERYTHING IS DIFFERENT THAN IN TEXAS (CALIFORNIA)*
*THE PINE TREES AND THE BEAUTY OF THIS PLACE*
*AND THE HOUSES THERE TOGETHER*
*ALL ALONG THE RIVER*
*WELL, YOU COULDN'T WIPE THE SMILE OFF MY FACE* ⑥₃

**HANNAH & KEVIN J**
AND IT'S SOMEHOW LIKE WE'RE STUCK HERE
AT A MESSED-UP COSTUME PARTY

**DIANE & KEVIN T**
AND THERE'S NOTHING HERE FAMILIAR

**HANNAH & KEVIN J**
FAR AWAY FROM THOSE YOU CARE FOR

**KEVIN T, KEVIN J, HANNAH & DIANE**
ON AN ISOLATED ISLAND IN BETWEEN
THERE AND HERE

**ALL (EXCEPT JANICE, KEVIN T, KEVIN J, HANNAH & DIANE)**
THERE AND HERE

**JANICE**
By the middle of the day on Wednesday, I'm coordinating menus for seven thousand people. (to the camera) Ladies and Gentlemen, the Rotary Club is looking for some fish dishes. And we have a bunch of German passengers down at the Moose Club who'd like to try elk . . . No, sorry. That's the Elks Club that's looking for moose. Sorry, I'm new.

**BEULAH**
Well, if you won't try cod tongue, we got cheeseburgers—or we got hot dogs too—and there's tuna casserole over there—or I could make you up a bologna sandwich?

**KEVIN J**
Are there vegetables in Canada?

**KEVIN T** *(to Beulah)*
We're vegetarians.

**KEVIN J**
I converted him.

**KEVIN T**
Anyway, I notice this other passenger who hasn't eaten anything at all—

**KEVIN J**
Kevin's suddenly in everyone else's business.

**KEVIN T**
So, I notify our hosts.

**RABBI**
No. No, thank you. Please. I'm fine. ⑭

**BEULAH**
Turns out he's an Orthodox Jewish rabbi and he only eats kosher food. Now, we have all kinds of people living in Newfoundland: Protestants, Baptists, Catholics, Salvation Army-ists—but not a lot of Jewish people.

**RABBI**
The next thing I know, I'm set up in the faculty lounge, making a kosher kitchen for any other Jewish passengers—but also for two Hindu women, some Muslims.

**KEVIN T**
And a couple vegetarians.

**ANNETTE**
One of the pilots for Virgin Atlantic—Captain Bristol—he's a very—strong leader. He's good to his passengers. And he's handsome too. Anyway, he takes me aside and he says . . . ⑮

**CAPTAIN BRISTOL** *(over the top romantic)*
I've been watching you—you're doing beautiful work. I'd like you to be my personal liaison and . . . work closely with me, helping to handle anything I might need.

*Captain Bristol exits. The fantasy ends.*

**BEULAH**
Annette—what'ya on about? He did not say that.

**ANNETTE**
Well, he said something like that.

*Ali approaches Beulah holding a bowl.*

**ALI**
Miss Beulah? Hello.

⑭ **DAVID:** It took some time to get in touch with the rabbi, but he eventually came to meet our London company— and was insistent about how important it is that this story be told.

⑮ **IRENE:** One of the women we interviewed talked with great admiration about a certain handsome captain of a diverted Virgin Atlantic flight— and we eventually got to meet him when he also attended the show in London.

103

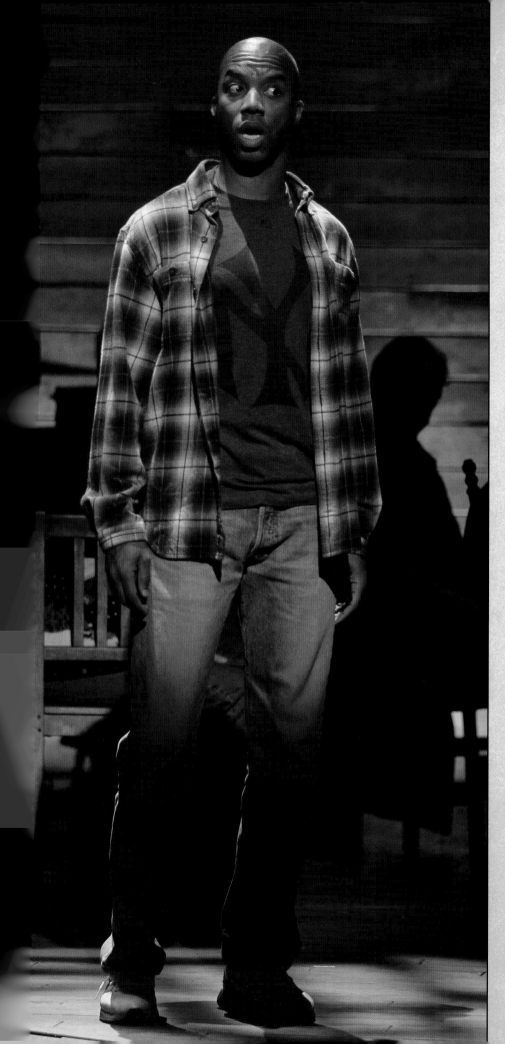

**BEULAH** *(caught off guard)*
Ah! . . . Hello, Ali.

**ALI**
May I ask? This food. What is it?

**BEULAH**
That's called Cod au Gratin. ⑯

**ALI**
Cod oh . . . ?

**BEULAH**
Fish with cheese. It's fish. With cheese.

**ALI**
 . . . Are you sure I cannot help you with the food?

**CLAUDE**
People start taking passengers back to their houses to get cleaned up and then inviting them to dinner—and then putting them up in their guest rooms.

**MARTHA**
Look, Misses. I'm just twenty weeks along and my Terry's already set up the nursery, you and your little one will be much more comfortable there.

**BRITNEY**
Thank you for shopping at Walmart. Would you like to come back to my house for a shower?

---

*ANNETTE* ⑰
*People ask me, "How do I get downtown," and I'm like—just walk down those stairs. At the bottom, there'll be somebody ready to give you a lift. Probably our constable, Oz Fudge.*

*OZ*
*I give this one fella a lift and he's just delighted.*

*OLD MAN*
*I'm ninety years old and I've never been in the back of a police cruiser! Turn on the siren!*

*The chorus all make a "WHOOP-WHOOP" noise together.*

---

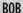

**BOB**
People are saying "we want you to come to our house." And I think, what is up with this? I mean, are they charging for these "free" showers? Or are they gonna go all Norman Bates . . . Anyway, I wasn't falling for it. But finally, I'm invited back to the mayor of Appleton's house—that sounds fancy, but it's not—there's a mayor for every town of a thousand people in Newfoundland. There's the mayor of Gander *(he points to Claude)*. There's the mayor of Lewisporte *(Claude puts on glasses)*. There's the mayor of Gambo *(Claude puts on a mustache)*. Anyway, I'm staying with the mayor of Appleton. *(Claude puts on a hat, becoming Derm)*

**DERM**
Come on in, son. The Irish whiskey's in the bar downstairs.

**BOB**
His wife shows me where my bedroom is and where the shower is and through it all, I keep thinking— where am I going to leave my wallet? Someone is gonna steal my wallet.

**KEVIN J**
Someone says there's a way out of here. They say there might be a boat—

**KEVIN T**
Kevin, we're on the other side of the continent. We're not taking a boat.

**KEVIN J**
So I stop an officer and ask him, "How do I get back home?"

**BOB**
Yeah, how do we get out of here?

**OZ**
Well, you take a taxi to the Goose—there's a bus there to Port aux Basques, leaves once a day, that's about six hours. Once you're there, you take the ferry across the Gulf, right? That's eight hours or so, then you catch another bus, not sure how often they leave, but it's another eight hours to Yarmouth ⑥⑧ where you can get another ferry to the U.S. border, that's another four hours or so—and from Bar Harbor you should be able to grab a Greyhound to wherever you need to go.

It's about two or three days travel. But it's sure a nice view.

**BEVERLEY**
I don't leave the hotel. I wait by the phone. Wait for someone to tell me we can fly again. Planes aren't made to just sit on the tarmac—planes are made to be in constant motion. They arrive, you switch crew, you switch passengers, you empty the honey buckets, and the plane keeps going. When they sit still for too long, well, it's not good for 'em. They start to break down. ⑥⑨

**DIANE**
Our pilot says we're not leaving anytime soon, and Nick says . . .

**NICK**
I might take a picture or two before we go.

**KEVIN T**
I finally convince Kevin to go for a walk. ⑦⓪

**KEVIN J**
There's four of us to begin with. This Texan woman and this English guy with a disposable camera and a huge stick up his ass.

**KEVIN T**
They're nice enough . . . *(pointing at KEVIN)* Kevin and I are a little wary of telling people we're together.

**KEVIN J**
I mean you just don't know how redneck people can be.

**DIANE** *(happily)*
This nice gay couple come along with us.

**NICK**
We kind of make small talk. They ask me what I do.

**⑥⑥ DAVID:** I initially wrote a recipe song called "Cod Au Gratin." Irene wisely stopped that quickly.

**⑥⑦ DAVID:** Another cut section true story—I miss it mostly for the WHOOP-WHOOP callback!

**⑥⑧ DAVID:** Occasionally we've had helpful fact-checkers write to us to help us get details correct, though usually, we've already been down most research rabbit holes over and over. In this case, yes, the ferry leaves from Digby, Nova Scotia, not Yarmouth; however, in 2001, it left from Yarmouth. We checked about a million times.

**⑥⑨ IRENE:** When Beverley first said this to us, we knew it had to be in the show, representing both how planes and people began to break down this week.

**⑦⓪ DAVID:** Almost the entire book of the show is scored like a movie—and Ian Eisendrath spent hours with us working out what each scene needed. I still hum the bass line to the walk music here when I go on walks—and during band rehearsals, I often wish we hadn't written so many words to cover up Ian's beautiful arrangements and August Eriksmoen's incredible orchestrations.

**71 IRENE:** One of my day jobs was as a receptionist, and in one particular place, one of the higher-up women would refer to me as the "Sexy-tary." It made me feel awful. Then David put it in the script and it was aaaall worth it.

**KEVIN J**
He works for this oil company in England and she was there visiting with her son.

**NICK**
Wait . . . You've got a son?

**DIANE**
Yes. David. The one who was flying on Tuesday.

**KEVIN J**
She goes on and on about England and how she didn't get to travel much when she was married.

**NICK**
Wait . . . You're divorced?

**DIANE**
Yes. For a long time now.

**KEVIN T** *(to Nick)*
What about you?

**NICK**
No. Not divorced, I mean . . . Not that I'm married! I'm neither. I travel a lot for work—

**KEVIN T**
Kevin and I work for an environmental energy company. It's my company—and Kevin's my secretary.

**KEVIN J**
I'm his sexy-tary. 71

**KEVIN T**
Anyway—we do a lot of green work, so we generally hate people who work in oil.

**NICK**
I just got the feeling that they hated me.

**DIANE**
Then they want to go into some old building that looks like a shed. Now, they'd heard it was a bar, but I wasn't going into a bar in the middle of the afternoon with three men I had just met.

**NICK**
And I think, I'll stay with Diane, you know, instead of the gay men who hate me.

*They exit in opposite directions*

*In an airplane hangar, Bonnie is feeding animals, as Doug gets increasingly frustrated.*

**BONNIE**
Doug's helping me feed the animals—and after security checks each plane—slow as cold molasses—we finally find eight dogs, nine cats—one of whom's epileptic—not to mention two rare Bonobo chimpanzees! And the female Bonobo is pregnant. We've got to get them off these planes! *(into the phone)* Hello? Is the mayor there? It's Bonnie Harris again. Yes, I'll hold.

**DOUG**
FAA was pretty clear about "No rare chimpanzees on Canadian soil."

*Bonnie hands a bucket to Doug.*

**BONNIE**
Doug. Take that.

**DOUG**
—what is that?

**BONNIE**
It's rare chimpanzee shit. What do you think it is? *(into the phone)* Yes? The mayor! Yes! I'll hold!

**DOUG (finally losing his patience)**
I've got to get back to air traffic control!

**BONNIE**
Doug—look up! Do you see anything flying?

**DOUG**
I can't see across the friggin' Atlantic!

**BONNIE**
Just get me more litter from the truck!

**DOUG**
Get your own litter!

*Doug exits.*

**BONNIE**
Fine then! Goodbye! *(into the phone)* No! No! Not you! Hello? Hello?!

*At town hall. Claude enters, and the staff fires a barrage of questions at him.*

**ALL (EXCEPT CLAUDE)** *(variously)*
Claude! Excuse me. Claude! Mr. Mayor! Claude!

**STAFF 8**
Health Canada says all this food needs refrigeration, but we've got nowhere to store it—none of the shelters are equipped for this!

**STAFF 1**
We're getting three more truckloads of food tonight—

**STAFF 8**
Stop them! We've got nowhere to put it!

**STAFF 7**
Well, then what do we feed people?

**STAFF 12**
We also need that girl at Rogers to announce that rotary, hockey, boys and girls club—everything's canceled until further notice. ⑦²

⑦² **IRENE:** Each actor plays, at the least, a come-from-away and a local character (in this section Lee MacDougall plays Nick, then Doug in the next scene, and then Staff 12 in the next). Not only is this theatrically fun (and economical when telling sixteen thousand stories), but it reminds the audience that we could all be in each other's shoes—at any moment you could be helping or need to be helped.

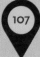

**STAFF 1**
That Rogers girl does NOT know what she's doing.

**STAFF 2**
Until further notice? What does that mean?

**STAFF 4**
Now there's five vats of chili. My uncle has a truck.

**STAFF 6**
You need to talk to Health Canada.

**STAFF 8**
Well cancel the effing food too!

**STAFF 12**
Don't look at me! It's not my decision!

"We somehow ended up in the gayest town in Newfoundland."

**CLAUDE** (over the previous—quieting them down)
Hold on.

*A pause.*

Did you just say that hockey's canceled? (73)

**JANICE** (on camera)
3:47 p.m.—The town is asking all bulk food deliveries be taken to the Gander Community Centre hockey rink. Since hockey's canceled, the mayor is now calling it . . .

**CLAUDE**
The world's largest walk-in refrigerator!

*In Gambo, Kevin T and Kevin J are at the bar.*

**KEVIN T**
It's hot outside, so we stay in the bar, and make small talk with Matty, the owner, and his wife, Brenda—

**KEVIN J**
We're not sure how much to say—you just don't know where the red states are in a foreign country, right?

**KEVIN T**
But we'd been drinking all afternoon and I accidentally say something like, Kevin and I have been together for almost five years . . .

**KEVIN J** (quickly)
In business. We've been together in business. I'm his sexy-tary—His secretary!

*The music stops as everyone looks at them.*

**KEVIN T**
And it feels like the entire bar goes silent—

**KEVIN J**
And I'm like . . . Oh god.

**KEVIN T**
And then Matty says . . .

**MATTY**
You're gay.

**KEVIN J**
And I'm about to pass out.

**KEVIN T**
But then Matty says . . .

**MATTY**
Well, praise be to God. My daughter's gay!

**KEVIN T**
And then Brenda says . . .

**BRENDA**
Sure, my sister's gay—and the woman across the road just ran off with her best friend!

**KEVIN T**
And then Brenda's brother says . . .

**BRENDA'S BROTHER**
Our uncle is sixty-eight years old and he just told us he's a bisexual.

**KEVIN T**
We somehow ended up in the gayest town in Newfoundland. And Kevin and I are looking at each other like—I think I even say, "There must be something in the water." And then Brenda's brother says . . .

**BRENDA'S BROTHER**
That's why I only drink the beer. (74)

*In Appleton, Bob is helping Derm.*

**BOB**
Watching the news all day, some of us are starting to lose it. So these people here, they decide to have a big cookout for the whole community—just trying to get our minds off of everything. And Derm, the mayor of Appleton, says to me . . .

**DERM**
Right, m'son, do me a favor and start to round up some grills.

(73) **DAVID:** This is one of my favorite moments. It looks like we've just set up a silly Canadian hockey joke, but you realize that they're smarter than you've given them credit for.

(74) **IRENE:** This scene happened almost word for word in Matty and Brenda's living room, except David was explaining about his mom and about our first writing endeavor, another true story: *My Mother's Lesbian Jewish Wiccan Wedding*. We were new to Newfoundland and afraid to "come out" as either writing a musical (which some people associate with making fun of a subject) or telling them the title to our first one (which sounds like we're making fun of it, even if it was a loving tribute). Either way, we were worried about giving any impression that we wouldn't treat their story respectfully.

**75** DAVID: I remember when Tom McKeon first saw his barbecue story on stage, he told us, "It's not funny coming out of my mouth, but when Rodney says it, it's hilarious."

**BOB**
Round up some grills?

**DERM**
Yeah, just go to people's yards and take their grills.

*A pause.*

**BOB**
. . . Take their grills? Someone's gonna shoot me.

**DERM**
No, no, no, no, no . . . Just go to people's yards and grab their grill.

*Another pause.*

**BOB** *(to audience)*
So, I'm going from yard to yard and the whole time, I keep thinking, someone is going to shoot me in the back.

**MALE TOWNSPERSON**
Hello there!

*Bob freezes.*

Are you taking my barbecue?

**BOB**
. . . This is your barbecue?

**MALE TOWNSPERSON**
Yeah, buddy.

**BOB**
Listen, I am so sorry—

**MALE TOWNSPERSON**
The wife's got the kettle on, if you want a cuppa.

**BOB** *(to the audience)*
I get offered a cup a tea in every single backyard—and most of them offer to help me steal their own barbecues. We bring them all over to the community center—no names on them. I don't know how they ever get 'em back. But that's how we have a big cookout—completely free. After that I stop worrying so much about my wallet. **75**

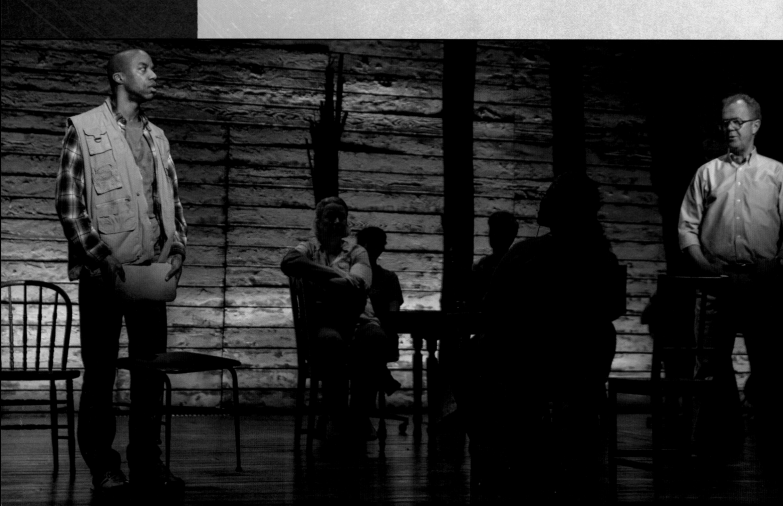

CUT FROM AWAY

# Werner BALLDESSARINI

**76** DAVID: People often ask us about stories that didn't make the cut and there are a few, but the story of how Byron met his hero, Werner Balldessarini, is the longest. Cut at Goodspeed, because the story was so separate from the others, this never saw an audience.

**BYRON**
*It starts with a phone call.*

*A drum starts playing.*

**BYRON**
*I'm in my shop in St. John's. Byron's Menswear. I'm Byron. Anyway, I get this phone call from this guy in Toronto, who I do a little business with. His name is Les Minion. Les works for Hugo Boss, and he's a pretty excitable dude.*

*The phone rings. Byron picks it up. Les, an excitable dude, enters holding a phone.*

**LES**
*Byron?*

**BYRON**
*Yeah, Les.*

**LES**
*Where's Gander?*

**BYRON**
*Whadda you mean "where's Gander"? . . . It's a four-hour drive outta town.*

**LES**
*. . . I'll call you back.*

*Les exits.*

**BYRON**
*So then he calls back.*

*The phone rings. Byron picks it up. Les enters again.*

**LES**
*Byron?*

**BYRON**
*Yeah, Les.*

**LES**
*Where's Gander Collegiate?*

**BYRON**
*Whaddayou mean "where's Gander Collegiate"? . . . It's in Gander.*

**LES**
*. . . I'll call you back.*

*Les exits. Byron sits down.*

*The phone rings. Byron looks at it. It rings again. He sighs, gets up, and picks it up.*

**BYRON**
*Yeah, Les.*

**LES**
*Byron?*

**BYRON**
*Yeah, Les.*

**LES**
*We need to get a courier. We need a courier. We have to get a courier out to Gander Collegiate right away!*

111

We need to get some stuff together and find a courier and get it out there and—

**BYRON**
Les.

**LES**
Yeah?

**BYRON**
Calm down. First of all, you're not gonna get a courier on short notice just to drive to Gander. It just doesn't happen. Look. Tell me what's going on.

**LES**
Byron, can I trust you?

**BYRON**
Yes, you can trust me! Who's in Gander?

**LES**
Werner Baldessarini.

**BYRON**
I'm sorry?

**LES**
Werner Baldessarini is on one of the planes.

**BYRON**
You're telling me Werner Baldessarini is in Gander Collegiate.

**LES**
Yeah.

**BYRON**
Well, I just became a courier.

I fill up my Mazda Tribute with a bunch of shit and head to Gander. I mean, the reason I went out there is that NO ONE in retail gets to meet Werner Baldessarini. I mean, this is not your everyday dude.

First of all, he's not Werner Baldessarini. He's
WERNER BALDESSARINI.

Werner enters, dressed impeccably, surrounded by fashion models. He throws money in the air, pulls out a cigar and lights it. He snaps his fingers flamboyantly and puts on a pair of sunglasses.

YOU'VE HEARD OF DOLCE AND GABANA?
VERSACE? RALPH LAUREN? WELL, THEY'RE
 ALL KIND OF BORIN'
NEXT TO BALDESSARINI
KEN COLE, VALENTINO
JUICE COMPARED TO VINO
THOSE WHO KNOW, KNOW
IT'S BALDESSARINI

HEAD OF HUGO BOSS,
BACK WHEN HUGO BOSS WAS ACTUALLY
 BOSS
HE CHANGED THE FASHION UNIVERSE—
 BECAUSE

HE IS A DESIGNER REFINER WHO DEFINED
 THE FINE WEAR DESIGNS THAT YOU'LL
 FIND ON THE SIGNS THERE IN PARIS

**ALL EXCEPT WERNER**
WERNER BALDESSARINI
WERNER BALDESSARINI

**BYRON**
IT'S A FULL-TIME JOB
FITTING FOLKS IN FASHION
AND IT AIN'T NO HOBBY, THIS HERE IS A
 PASSION
SOME FOLKS WATCH SOAPS
SOME PEOPLE PLAY HOCKEY
THEY'RE A BORE WHEN COMPARED TO DIOR
 AND VERSACE
P. ELLIS, MIZRAHI, HUSSEIN CHALAYAN
VALENTINO, AND KENNETH, BILL BLASS, AND

VUITTON
DKNY, MARC JACOBS, AND YVES ST.
 LAURENT
THEY'RE A YAWN ONCE YOU TRY ON
BALDESSARINI

SUAVE AND RICH TO BOOT
THINK OF JAMES BOND, BUT WITH BETTER
 SUITS
OR THINK OF DON JUAN, BUT THE POINT IS
 MOOT
BECAUSE

WHATEVER YOU THINK OF THE MAN IS A
 MAN WHO COMMANDS THE PLANS OF
 EVERY MODEL IN MILAN

**ALL EXCEPT WERNER**
WERNER BALDESSARINI
WERNER BALDESSARINI

**BYRON**
FASHION AND PASSION AND STYLISH
 SUCCESS
HE REPRESENTS CONFIDENCE FROM HIS
 BRIEFS TO HIS VEST
HIS COLLECTION'S PERFECTION AND NOW
 THERE'S A FRAGRANCE
THAT SMELLS LIKE A MAN WHO DOESN'T
 SMELL LIKE THE REST
ULTRA-LIGHT SILK SUITS, HALF-LINED
 KNICKERS
BOMBER JACKETS IN LEATHER, AND
 BLAZERS IN CASHMERE
WE ARE IN A FERRARI WITH A MARTINI
YELLING, I'M MEETING
BALLDESARINI!

**ALL EXCEPT WERNER**
WERNER BALDESSARINI
WERNER BALDESSARINI

I get there about seven-thirty that evening. I go into the school and head up to the office.

*An exhausted Beulah enters.*

**BEULAH**
Can I help you?

**BYRON**
Yeah. I'm looking for
WERNER BALDESSARINI

**BEULAH**
I'm sorry?

**BYRON**
I'm looking for
WERNER BALDESSARINI

**BEULAH**
Werner Baldessarini?

**BYRON**
No—
WERNER BALDESSARINI

**BEULAH**
. . . Right.

*She speaks into the intercom microphone
nasally.*

**BEULAH**
Werner Balchessini, please report to the
front desk.

> *She exits.*

**BYRON**
Now, I've seen lots of pictures of Werner—
in catalogs—brochures—annual reports,
you know. But this was different—this
was seeing him in the flesh. Perfectly
coifed silver hair, polished shoes, gold
rings, a suit that I can't even afford to sell,
much less even own. Figure he's wearing
his Black selection tailored line. Probably
Salvatore Ferragamo.

*Werner enters in shorts and a T-shirt.*

**BYRON**
Instead he's wearing . . . Walmart?

**WERNER**
Hey. You the guy?

**BYRON**
Mr. Baldessarini—I'm Byron Murphy—it's
an honor. I run Byron's in St. John's—you
probably never heard of it, but . . . what
are you wearing?

**WERNER**
I have no idea. The people here donated
everything—no one has a change of
clothes, so . . .

**BYRON**
Well, as I was saying—it's a real honor,
Mr. Baldess-

**WERNER**
It's Werner. Nice to meet you.

**BYRON**
Werner. Cool.

**WERNER**
You have the stuff?

**BYRON**
We go out to my car and I open the trunk
to show him the stuff.

**WERNER**
You can't bring this in there.

**BYRON**
I'm sorry?

**WERNER**
You can't bring this in there.

**BYRON**
The trunk was packed with—Les Minion
had told me to pick up some cheese
and crackers and chocolate and caviar. I
brought some clothes—different lines—
some briefs and socks. They were going
to reimburse me anyway.

**WERNER**
Listen, we're getting looked after
terrifically here—and we've got more
than enough to eat and drink. I mean,
dude, that's an insult.

**BYRON** (to the audience)
Werner Baldessarini says "dude."

**WERNER**
Look—give it to your customers when
you get home. You're getting reimbursed,
right?

**BYRON**
Yeah. This stuff—there's this guy in
Toronto—Les Minion. This stuff was his
idea.

**WERNER**
I'll take the underwear, though. So tell me
about your store.

**BYRON** (to audience)
So there I was. Hanging out behind the
school with one of the most influential
men in the history of the fashion
industry. But that's the thing. He was
just a genuine dude, right? The next
day I'm back in St. John's and had a big
"Customer Appreciation Day" with cheese
and crackers and chocolate and caviar.
That's what I learned that day—under
even the best suits in the world—when
something like this happens—we're all
just regular dudes.

---

BACKSTAGE

---

# DESIGN

"Interestingly, in a way, the show defies scenery."

That's an odd case for a scenic designer to make, but the three major visual designers on *Come From Away*–Beowulf Boritt (scenic design); Toni-Leslie James (costume design); and Howell Binkley (lighting)–each, in his/her own way, surrendered to the idea that simplicity and storytelling–rather, simplicity in storytelling was the way to go on *Come From Away*. "I have to put up the least I can on stage to jog the audience's imagination and let them fill in the blanks," said Boritt. Finding that "least"– and making the "best of the least" was the major challenge for the designers.

Upon reading the script, Boritt instinctively felt, "When you've got a small number of actors playing multiple roles and changing roles on a dime so quickly, that immediately defines that you're not doing realism; you're automatically in a theatrical world doing it that way." Binkley concurred: "I just said to Chris [Ashley], 'How are we gonna

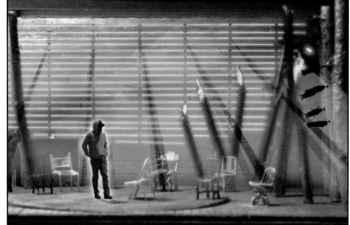

**Beowulf Boritt's set design model originally featured a background image of three broken trees, not two.**

do it? 'Cause there's so many scenes. And he said, 'That's your job.'"

Each one of them credits the power of the script and the incisive guidance of director Ashley for helping them find the way forward. For James, the story of *Come From Away* was immediately accessible: "It wasn't hard for me to connect with the characters–they're just regular people and I come from Clairton, in western Pennsylvania, a small solid working-class town in Allegheny County. It's a totally multi-ethnic city, with a mix of African American, Polish, German, and Italian families– if something happened to one family, all the families would come around." (In fact, Clairton has roughly the same population size as Gander.) "There was something [about the theatrical event] that felt like telling a story on a back porch or something–that was a good approach," said Boritt. "I looked at the script quickly, but there wasn't anything that didn't

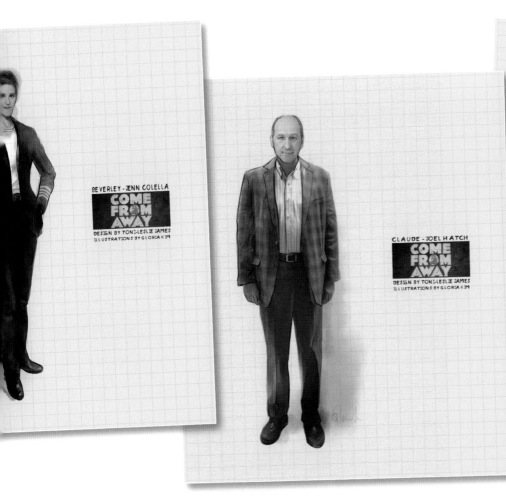

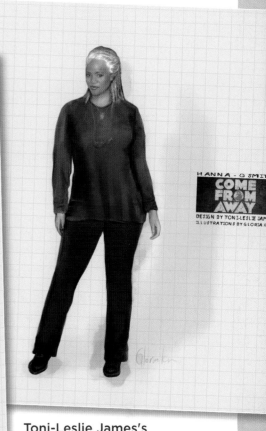

Toni-Leslie James's costume renderings—very accurate!—of Beverley, Claude, and Hannah.

seem like it couldn't be basically solved with chairs and a couple of tables."

Finding and selecting the right sorts of chairs and tables, however, required an artist's touch. "We started at La Jolla, so we went into their furniture shop and I just said I like this, I like that and they tended to be kind of wood and worn and things that were interesting. They also have to be light enough that they can pick them up and carry them around quickly. But, you're making kind of a jungle, so, also, we always wanted them to represent humanity in a sense–that they're all similar but all the details are different."

The specificity of the set pieces, costumes, and props had their own laws of unintended consequences. "Once the show was put together, it becomes kind a nightmare replacing each

chair as it breaks because you're trying to find a random chair that fits all those criteria," said Boritt. "There are only five pieces built for the show [including the matador costume, Beverley Bass's jacket, etc.]; the rest of it, we're at the mercy of the manufacturers," observed James. "As long as they stay in business, we're good."

For the costumes, the basic signifiers of character had to be as carefully chosen as the chairs. "You only get one piece; you don't get two pieces," says James. "It's what the actor understands about what to do with that piece. When you give them the right piece, they know exactly what it means and how to transform. The actor changes his voice, his posture, everything, and the piece comes alive. If somebody drops a hat, the whole show could come to a halt."

Once the basic vocabulary of twelve–highly individual–chairs and two tables was decided on (and the Seattle workshop was invaluable for making sure that template would hold through the next iterations), "The trickier question was then," posed Boritt, "What is the surround for that? How do you do something that's minimal enough to allow all those locations but that thematically ties in with what's going on?" In addition to the rustic locations in Newfoundland, Boritt wanted "something that, at the same time, would acknowledge the reality of 9/11 and what happened that day. So the back wall of the set is meant to be a kind of abstract portrait of the sky–the crisp blue sky of that day."

The back wall was particularly important for lighting designer Binkley: "It was kind of a palette that I needed to use for transitions and so I could set the time of day and place and this and that." Normally, a set designer might provide a blank fabric wraparound–called in theater design a cyclorama or "cyc"–but Boritt and Binkley collaborated on, essentially, two cycs: the bare canvas wall upstage and the slatted, wooden wall three feet in front of it. This gave them an exponential variety of possibilities. "When we started this show in La Jolla, the slats in the wall weren't quite as big as they are now. Beowulf provided me with such a great landscape for the show," says Binkley.

Over the course of the show's travels across North America en route to Broadway, there were a number of changes in the design choices. In one major scene, the Costume Party, where come-from-aways had to put

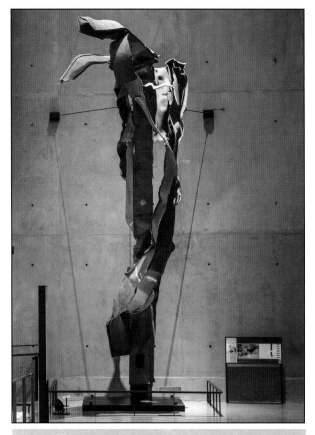

**A twisted section of the WTC North Tower inspired Boritt's background.**

on donated clothing, there was a major effort getting the right sweater for Diane to change into; it had to look local and it had to look lived in and it had to look different enough and it had to fit in with the show's color palette. "I wanted it to look like someone's mother knitted it. We could not get that sweater. We finally found a twenty-four-dollar sweater on Etsy when we were at Ford's Theatre in DC, just to get through it. We eventually found someone who could knit it from scratch. The journey to get that sweater would put a lot of people in their graves, but the payoff was worth it."

At one point, there were to be slide projections of the events of 9/11; additional scenery for the bar scenes; even a "memorial" image to evoke the Twin Towers late in the show–none of them made it to Broadway. Typically, producers might add bells and whistles for their incipient Broadway shows, but, other than an extremely useful (and subtle) turntable and "lights hanging off trees and signs and things," the physical look of *Come From Away* was a matter of judicious reduction. "We tried these 'improvements' and instantly they just felt so heavy-handed and such a huge gesture, we never did it again."

Even the set's most resonant image was pared back. "The broken trees in the back of the set, it's my favorite part," says Boritt. "It started out as a reference to these three broken I-beams in the rubble of Ground Zero. Three trees were too much back there and ultimately two broken trees were actually more poignant. When you get to the moment where the towers come down, there's a spotlight on them, but again it's all so subtle. When people notice it, they tend to find it moving."

Although the trees were crafted in the scene shop for La Jolla, Boritt insisted that they be real trees for the Broadway version. "We were looking for trees that would be native to Newfoundland, but we had to get them relatively local to New York. We drove up into the Adirondacks and we just went through and tagged everything we wanted. And the lumberjack whose land it was cut them all down and delivered them to the shop for us." But even crafting the look of the trees– especially the two broken trees–requires a lot of detailed work in the shop. "I wanted it to look like a hurricane came through and ripped the tops off those two trees."

Putting together the technical moves of the show proved to be an easy, fluid task among director Ashley, movement person Kelly Devine, and lighting designer Binkley. Says Binkley, "We've done a lot of work together; we have an unspoken vocabulary. When Chris is staging somebody downstage right, I know that he wants a tight funnel of light there to let him tell that part of the story while other things like the turntable can turn and the chairs can get

**Seeing the neon for the trees: Boritt planted some authentic local signage in the woods.**

**Load-in: real trees from the Catskills make their Broadway debut.**

preset for the airplane, or whatever downlight is needed to get ready for the next scene. My challenge was to tell the story and keep that seamless transitional quality going—the speed of the show is just boom, boom, boom; it just doesn't stop, which I love. It's like a big ballet to me. It was really just so much fun, just a lot of fun and challenging and rewarding and collaborative." "Nobody will ever notice the costumes—my ego has accepted that; I'm just grateful when they do, and when they appreciate the effort," says James, laughing. "After I got over the fact that I wasn't going to get a pretty dress [into the show], I was fine."

In the design for *Come From Away*, it became increasingly apparent that—despite how much the creative team enjoyed working together—the most important collaborator was the audience. The sparseness and simplicity of the visuals was made possible by the fact that nearly every single person who came to see the musical already knew the larger context of the story; the audience could meet the design halfway. Boritt sums it up: "In the most theatrical and beautiful way, the show uses the spectator's memory of that day to fill in those blanks and so you just don't need to do much else."

# THURSDAY, SEPTEMBER 13, 2001

We've all experienced what scientists called the "return trip effect"–that a journey back home feels shorter than the journey leaving from there.

Here again, the circumstances in Gander confounded expectation.

At 11:00 in the morning, on Thursday, September 13, the FAA was directed by the Department of Transportation to allow domestic flights to resume for the first time in forty-eight hours. "The reopening of our national airspace is good news for travelers," said Transportation Secretary Norm Mineta in a statement. "But I must caution everyone that a system as diverse and complex as ours cannot be brought back up instantly. We will reopen airports and resume flights on a case-by-case basis, only after they implement our more stringent levels of security."

What Mineta declared had a profound subtext: the world had been transformed within the previous forty-eight hours and, when it came to security procedures in airports around the globe, all the rules had to be redrawn from the ground up. Because of these new security procedures–which were being invented and implemented almost simultaneously–the FAA placed many restrictions on which planes could take to the skies, and to which airports they could go. Nav Canada endorsed the FAA's plan, as long as its staff could oversee the new security procedures.

What this meant for the six-thousand-plus visitors to Gander was that the journey home was going to take an increasingly long time. Every piece of luggage in every hold of every flight had to be taken out of cargo and screened by the Royal Canadian Mounted

**Food and beverages were readily available at every temporary shelter.**

Police; each piece would then be placed on the tarmac and identified by each passenger, and packed back into the hold. Most important, no flight was allowed to take off without its original full complement of passengers and crew. Those folks would need to be fully assembled (crews brought from hotels, passengers brought from shelters); bused back to the airport, processed again, put on the proper plane–after it had been fully vacuumed, serviced, stocked (food from the original flight had to be taken out and incinerated), and fueled–and then, get ready for takeoff. Takeoff might be delayed as well; it was Gander Airport's intention to get planes off the ground in the order in which they landed–first in, first out–but the runways were an immense parking lot and any one detail, such as a plane that might have sunken into the tarmac due to its weight and the heat, could screw up the whole order. Officials at the airport estimated

that, given these complex logistics, it might be days before the plane people were no longer, well, plane people.

The extended stay in Gander was not without its consequences–not all of which were terrible–but plainly the result of six-thousand-plus people doing what it is that people do.

One thing that became immediately apparent was a stay longer than twenty-four hours duration is not an optimal condition for fresh food. It was up to the local department of health services to make sure that all the makeshift accommodations and the mountains of donated food weren't creating any dangerous conditions. They weren't wrong to be concerned–one passenger came down with salmonella poisoning, which resulted in a group from his plane being briefly quarantined until health officials realized he had contracted the illness before boarding in Europe. And with the

restriction that no flight could depart unless *all* its passengers were present and accounted for meant that anyone bedridden or debilitated could negate the departure of hundreds of fellow passengers.

Food spoilage was at the top of the health services agenda–the amount of donated food far outweighed the number of refrigerated trucks in Gander–and so, after briefly considering the morgue (which was too small to accommodate all the food), the local hockey rink, housed at the centrally located community center, transformed into, as residents called it, the "World's Largest Walk-In Refrigerator." (The nearby Gander Curling Center volunteered its ice rink as well.) The hockey rink became one giant bazaar–with dry goods on one side, and perishables stocked on the other–where locals could go in and take food and other products as they wished, free of charge.

Food wasn't the only thing getting a little, er, overripe. Stuck in crowded shelters for two days now, often with only utilitarian locker room showers, the come-from-aways were looking for a refreshing change of pace–or at least a change of clothes. A short walk to the local Walmart took care of that; free of charge, the plane people were given much-desired new pairs of underwear (until the stock ran out in some sizes). The nearby Shoppers Drug Mart supplied all sorts of necessary toiletries and sundries–not that they were always necessary. As one passenger temporarily transplanted to nearby Gambo, along with 886 others, put it:

> They did all and everything for us. Fed us. Clothed us. Entertained us. Took us on trips. Allowed us into their homes. . . .

When we arrived, many people didn't have basic toiletries, razors, soap, toothbrushes. All these, and then some, appeared as if by magic.

Gander's residents began opening up their homes to folks who wanted a more private hot shower, or even a "cuppa tea and a biccy." Beulah Cooper, a long-standing member of the Women's Auxiliary of the Lions Club, was among the town's most accomplished shower keepers; her door was always open, and with the number of folks coming by for a hot shower, that door might as well have been a revolving one.

Because of the combination of good weather and tight accommodations, a walk to tour the somewhat limited sights and sounds of Gander became a frequent occupation to pass the time–but even this had its unique consequences: According to reporter Jim DeFede, "The most

**Keeping perishables fresh was a different kind of goal in the Community Centre's ice rink.**

common complaint [among visitors] was that it was difficult to go for a walk: someone would always stop and offer a lift." If you didn't get a lift, you might get a car. Gander residents driving to work would frequently offer their cars to visitors for the day, while they went to work. "I'm not using it–it would just sit in the parking lot for eight hours," said one resident. "Besides, where would they run off to? We're on an island."

Happily, spirits were still mostly buoyant among the remaining passengers. Friendships were forged, excursions to nearby harbors, lakes, parks, and attractions were organized, parties and pub crawls were concocted, informal concerts were arranged. As one stranded passenger put it: "We had a singer from Somerset, England, who entertained us every night and was very proud of the fact that he didn't sing any song more than once; he sang over one hundred songs in four nights."

But as the hours on Newfoundland mounted, special needs emerged–most of which were handled with dispatch and diplomacy. There were several honeymooning couples whose original plans, obviously, incorporated more privacy than a cot in a middle school gymnasium. One Italian honeymoon couple was offered a more private place to stay, but they declined, preferring to stay with their fellow passengers. As the Friday night Sabbath loomed in the distance–without definite plans to leave Gander–several Orthodox Jewish families wondered how they might keep the Sabbath. Cable newsman Brian Mosher went out of his way to set up an elaborate media hookup in the A.V. classroom in Gander Collegiate so that one

A local mascot, Commander Gander, was sent in to entertain some weary folks.

Orthodox rabbi could participate in Sabbath services, if need be; Mosher soon realized, to his chagrin, that Orthodox rules prohibit the use of any electronic equipment on the Sabbath. And the vast number of kids stranded with their families had a daily routine to keep up their spirits: a fire truck was commandeered to round up as many toys in the neighboring retail warehouses as possible and distribute them to each of the shelters.

Of course, one of the reasons that supplies were in short demand was that because nothing was flying out, nothing was flying in either. All through that Thursday, supplies to Gander and the surrounding communities were mobilized by a battery of volunteer cars, trucks, and SUVs. Even the Newfoundland and Labrador Association of Public and Private Employees– the bus drivers who helped out so much on

9/11, even while on strike–agreed to volunteer their time, while still on strike, to bring the various crews and passengers being assembled by fits and starts back to Gander Airport.

By Thursday afternoon, the airport was crowded with anticipatory passengers, even as officials and crews alike were baffled and bewildered by contradictory information coming their way from both the FAA and Nav Canada. Two flights had been able to leave earlier in the day–a Virgin Airways Flight 75 bound for Manchester and British Airways Flight 2193 going straight back to Gatwick–but a new FAA directive decreed that all internationally based airlines–Lufthansa, British Airways, Alitalia, thirteen separate flights overall–had to fly *back* to their airport of origin, then rebook passengers on new flights to return to the United States across the Atlantic one more time. Some American passengers refused to fly back to Europe first, which only delayed those flights from getting off the ground.

**What a little propane can do: a BBQ round-up in Glenwood.**

Everyone in Gander, and particularly within the Emergency Services Office, was doing their best to wrest some control away from the capriciousness of events. And sometimes events got the better of them. A group of Middle Eastern passengers was overheard speaking to each other in Arabic, which caused some concern among their fellow shelter inhabitants; the tension was quickly defused. Of more consequence was a scrawled message on a brown strip of paper in Gambo: "Yahoo, Osama bin Laden. Looks good on you." When the Royal Canadian Mounties were called upon to investigate, they discovered that a young Irishman on a Continental Airlines flight, en route to Newark from London, wrote it, as a way of ironically "thanking" bin Laden for giving the passengers the gift of Newfoundland kindness. No one was amused; in fact, once the Continental flight was up and running back in Gander, the pilot refused to bring him on-board for the final leg of the trip. The Mounties, perceiving no real threat beyond an inappropriate sense of humor, prevailed, and the passenger–who hadn't exactly made a lot of friends–sat quietly (and humbly) in the back of the plane when it eventually headed back to Newark.

By the end of Thursday, it was getting complicated, complicated and tense. A few passengers were attempting to bypass the airport and its immense security restrictions and find a way to drive back to the States. But as a wise Gander resident once said, "Where would they run off to? We're on an island."

# Bigger PROBLEMS

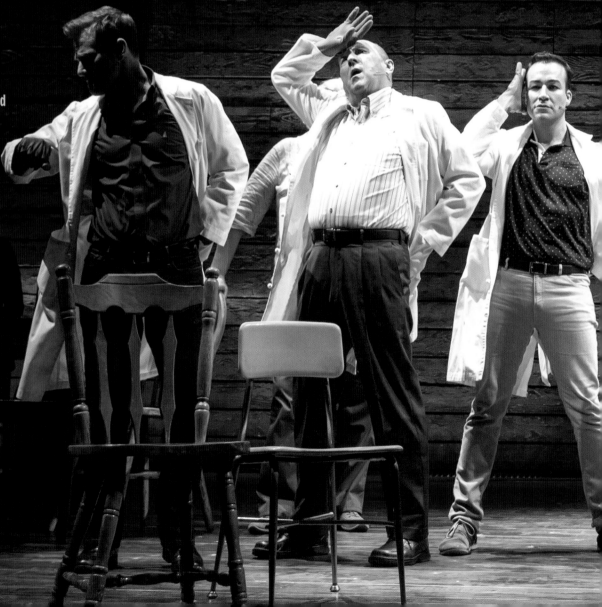

**77 DAVID:** Like most details in the script, this actually happened, and several of the cardiologists have now visited the show. The doctors knew that if the bathrooms weren't properly cleaned, it could lead to health problems. The teachers at Gander Academy were clearly all very excited about a group of men who knew the importance of cleanliness. "The most educated men were cleaning the toilets," they excitedly told us. But we took it to another level by putting it in Annette's fantasy world. Also, the red gloves were found by googling "Canadian cleaning gloves," and they have yellow flowers on the inside that no one ever sees.

**JANICE** (*on camera*)
8:45 a.m.

**ALL (EXCEPT JANICE)**
Thursday.

**JANICE** (*on camera*)
September 13. We've got a . . . situation down at Gander Academy.

*At the Academy, Beulah and Annette address everyone.*

**BEULAH**
Ladies and Gentlemen. We have an indelicate request. We need volunteers to help clean the bathrooms. As you can imagine, with seven hundred adults in a primary school . . .

**BEULAH (CONT'D)**
Health Canada needs us to clean them every hour and a half and we just don't have the people. So, we're asking for your help.

*A pause as everyone looks away.*

**ANNETTE**
But no one volunteers.

**BEULAH**
No one comes. And we're run off our feet with everything else. And then—

**ANNETTE**
Sweet Jesus in the garden.

This line of men comes walking down the hall.

*Six men in doctor coats walk toward her in a slow-motion burlesque. Annette's jaw drops.*

**ANNETTE**
The top six cardiologists from all over the world. On their way to a conference. 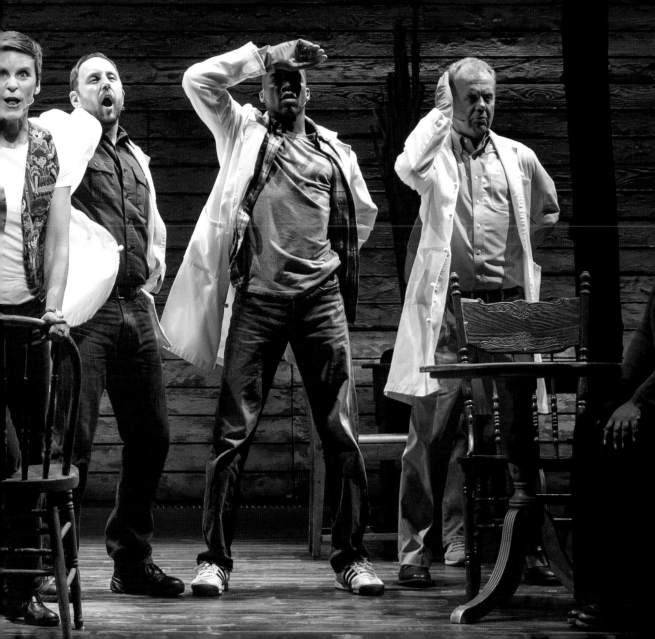⑦⑦

Highly qualified cardiologists.

And they know about the importance of cleanliness.

**HEAD CARDIOLOGIST**
If we don't get these bathrooms clean, we're going to have . . . bigger problems.

*The cardiologists exit.* ⑦⑧

⑦⑧ IRENE: When Lin-Manuel Miranda came to the show, he commented on how few buttons we put on the end of songs—and therefore how few applause points there were. Chris did that on purpose, to maintain the audience's connection with the story, limiting applause to four moments: after "Welcome to the Rock," after "Screech-In," at the end of the show, and here, where we are often literally unable to stop the clapping. People really want to applaud sexy cardiologists.

# I am HERE

79 **IRENE:** This song was the last one that was added. Chris had been asking for "more" from Hannah since La Jolla, but we were always hesitant since we hadn't met her in person yet. Finally, just before Christmas 2017, we were invited to spend a Sunday with Hannah and her now late husband, Dennis, and the rest of their family, touring the places in town that honored their son Kevin O'Rourke. In our final moments before having to leave, we joined some carolers in a park across from the train station—and suddenly a fire engine came roaring up and Santa Claus jumped out, giving our daughter a fuzzy white bear. "I am Here" was written shortly after.

**BEULAH**
Anyway, I get lunch set up, labeling anything that'll go bad with the date and time, I let the pants out for one of the pilots who's been enjoying our cooking. I make a balloon animal for a crying toddler—and then I check on Hannah, talking to anyone she can reach.

*Elsewhere, Hannah puts the phone to her ear.*

**HANNAH**
I AM HERE—I AM HERE ON AN ISLAND 79

**HANNAH (CONT'D)** *(on the phone)*
HELLO? HELLO. IT'S ME AGAIN
YEAH, MY SON. HE'S WITH RESCUE TWO
ANY NEWS?
I AM HIS MOTHER
I'M FAR AWAY—STUCK HERE
I'M TRYING TO FIND OUT IF—
FINE—I'LL HOLD AGAIN *(putting the phone down)*
I SHOULD BE DOWN THERE
AND CHECKING THE HOSPITALS
PUTTING UP SIGNS
DOING SOMETHING!
INSTEAD
I AM HERE—I AM HERE IN CANADA *(on the phone)*
I AM TELLING YOU—LISTEN
MY SON, HE TAKES RISKS
HE'S NOT MISSING—HE'S HELPING OR HURT
HE'LL GET OUT OF THIS
YES, I'LL KEEP TRYING
AND YES, HERE'S THE NUMBER
AND YES, AT THE GRADE SCHOOL
IN GANDER—I'LL BE HERE *(hanging up the phone)*
I SHOULD BE THERE WHEN IT'S OVER AND DONE
WHEN HE COMES THROUGH THE DOOR
AND SAYS, "I'M HOME, MOM"
I SHOULD BE THERE FOR MY SON
BUT INSTEAD

I AM HERE
I AM HERE

**BEULAH**
She leaves message after message for her son—until there's no more room on his answering machine.

**HANNAH** 80 81
ALL I KNOW
IS YOU ARE THERE
YOU ARE THERE
AND I AM HERE

**BEULAH**
She finally got some news.

**HANNAH**
They said it was Kev's day off—but someone else said there were more men down there than were scheduled. I should be looking for him. He's always there for me—trying to make me laugh. Tells me stupid jokes. He loves jokes—tells them to the kids at the firehouse, while he fixes their bikes.

I should be there.

**BEULAH**
I know there's nothing I can do to help. But I do know a few jokes. There was a sailor who was stationed in the South Pacific, far away from his wife who he'd just married. And when he was away, he wrote her a letter. He said, "We're going to be apart for a long time—and this island is full of young, attractive local girls. I need something to take my mind off them."

So his wife sends him an accordion and says, "Why don't you learn to play this then?" So finally, he comes home from his tour of duty and says to his wife, "I can't wait to get you into bed." And she says, "First let's see how well you play that accordion." 82

*SHE laughs at her own joke, but sees HANNAH's face and stops.*

**HANNAH**
That was a really stupid joke

*A pause.*

Tell me another one.

**KEVIN T**
Everywhere you look, there are people from around the globe. Going back and forth for phones—or showers. Grabbing something from Shoppers. I'm getting coffee at a gas station on the main drag—and suddenly the entire place goes quiet . . .

*Everyone on stage stands still. Kevin turns around, looking.*

And nobody moves. Even the people outside are standing still. And I look up at the TVs and realize—it's a national moment of silence in America. And all of these Newfoundlanders—these people from another country—they maintain that moment of silence. I don't know if that would happen back home—at a busy gas station on the main drag—but it happened here.

**HANNAH**
Beulah walks me to church—and when we get there, I light a candle for my son.

**BEULAH**
And I do too.

**KEVIN T**
I suddenly realized what that music was from my dream—it was an old hymn from when I was a kid. Now, I haven't been to church in years, but for some reason that song was in my head.

80 DAVID: Q. Smith is a hero for learning this song while she was recording it. We would literally be changing lyrics and passing her Post-it Notes between takes. And she debuted it for the first time on Broadway.

81 IRENE: When Hannah first saw the show, we sat on either side of her with her family in the second row of the theater. She held our hands so tightly. It meant so much that she chose us to sit with her. Almost more than any other person we interviewed, her support and the support of her family and community of first responders has meant the world to us.

82 IRENE: The real Beulah is also a wonderful joke teller—though some were a little too risqué to include in our show. The only other person I know who tells jokes like Beulah is Astrid Van Wieran. Cut from the same cloth, just like Beulah and Hannah.

# Prayer

**83 DAVID:** When Kevin Tuerff first saw the second Sheridan workshop, he couldn't believe we included this song. "I've never told anyone that it was running through my head," he said. Maybe it was because we'd interviewed him for hours, but he'd told us.

**KEVIN T**
MAKE ME A CHANNEL OF YOUR PEACE 83
WHERE THERE IS HATRED, LET ME BRING YOUR LOVE,
WHERE THERE IS INJURY, YOUR PARDON, LORD,
AND WHERE THERE'S DOUBT, TRUE FAITH IN YOU.

**HANNAH**
MAKE ME A CHANNEL OF
    YOUR PEACE

WHERE THERE'S DESPAIR
    IN LIFE,
LET ME BRING HOPE,

WHERE THERE IS
    DARKNESS,
ONLY LIGHT,

AND WHERE THERE'S
    SADNESS,
EVER JOY

**KEVIN T**

MAKE ME A CHANNEL OF
YOUR PEACE

WHERE THERE'S DESPAIR
    IN LIFE,
LET ME BRING HOPE

WHERE THERE IS
    DARKNESS,
ONLY LIGHT,

EVER JOY

**RABBI**
OSEH SHALOM BIM'ROMAV
HU YA'ASEH SHALOM ALEINU
V'AL KOL YISRAEL
V'IMRU, V'IMRU AMEN

**RABBI (CONT.)**
There is a man here in town. He's lived here nearly his entire life. He heard that there was a rabbi diverted here and he came to find me and tell me his story.

**EDDIE**
I was born in Poland, I think. And my parents—they were Jews—they sent me here before the war started—I still remember some prayers they taught

me. As a boy, I was told I should never tell anyone that I was Jewish—even my wife. But after what happened on Tuesday—so many stories gone—just like that. I needed to tell someone.

**ALI**
During El-Fagir, when most people are asleep, it is easier to pray. But at Dhuhr, I can feel them watching me. Sometimes I catch them when they think I'm not looking—and I can see the fear in their eyes. ⑧④

| RABBI & EDDIE | HINDU PASSENGERS |
|---|---|
| YA'ASEH SHALOM (YA'ASEH) | ASATO MAA |
| YA'ASEH SHALOM (SHALOM) | SAD-GAMAYA |
| SHALOM ALEINU V'AL KOL YISRAEL | TAMASO MAA JYOTIRE-GAMAYA |
| OSEH SHALOM BIM' ROMAV | |
| HU YA'ASEH SHALOM | TAMASO MAA JYOTIRE-GAMAYA |
| ALEINU V'AL KOL YISRAEL | MRITYOR-MAA-MRITAN GAMAYA |
| V'IMRU AMEN | OM SHAANTIH SHAANTIH SHAANTIH |

**ANNETTE**
Excuse me? Beulah wanted me to check on you. The library's open—for anyone looking for some peace—and a quiet place to pray. ⑧⑤

*Ali lays out a prayer mat and begins to pray.*

**RABBI & EDDIE** *(Eddie sings hesitantly)*
YA'ASEH SHALOM (YA'ASEH)
YA'ASEH SHALOM (SHALOM)
SHALOM ALEINU V'AL KOL YISRAEL

| BEULAH, HANNAH, KEVIN T & 10 | ALI |
|---|---|
| | Allahu Akbar |
| | Subbhaan Rabbi al Azeem |
| | Allahu Akbar |
| | Subhaan Rabbia Al-Aala'a |
| | Allahu Akbar |
| | Alhamdulilah |
| O MASTER, GRANT THAT I MAY NEVER SEEK | |
| SO MUCH TO BE CONSOLED AS TO CONSOLE; | |
| | **PASSENGERS 1 & 6** YA'ASEH SHALOM |
| TO BE UNDERSTOOD AS TO UNDERSTAND, | |
| | YA'ASEH SHALOM SHALOM ⑧⑥ |
| TO BE LOVED, AS TO LOVE WITH ALL MY SOUL | |

**KEVIN T**
MAKE ME A CHANNEL OF YOUR PEACE
WHERE THERE'S DESPAIR IN LIFE, LET ME BRING HOPE
WHERE THERE IS DARKNESS, ONLY LIGHT
AND WHERE THERE'S SADNESS, EVER JOY

⑧④ **IRENE:** The character of Ali is inspired by at least five people, some through second-hand reports, some through interviews, and our friend Amal, a Muslim woman that we went to baby class with, who taught us how to pray.

⑧⑤ **IRENE:** One of the women Annette is based on also offered a Muslim man a mat for his knees, but we couldn't include it. It was such a nice thing to do, people had trouble believing it was real. There were a number of stories that were so "nice" that we couldn't include them for that same reason. What a strange world we live in.

⑧⑥ **DAVID:** Making the prayers of the world work together in harmony was a huge amount of work; however, like a metaphor for religions finding common ground, the effort was well worth it.

# ON the EDGE

87 DAVID: Working on the script, we were always asked to find more tension—but since everyone worked so well together, tension was really hard to find or was often quickly overcome, like a bomb scare which turned out just to be a mistaken bottle of vodka. This section was originally a song called "Let's Go Out," but then Irene thought of calling back the early "On The Edge" (and "Blankets and Bedding") lyrics and then progressively building them word by word, so the lyrics are literally "on the edge," like the characters.

88 Translation: I am well, thanks be to God. The food here is very good. It is incredible. But, there are people, there are a lot of people here. They look at me as if I have committed a crime.

89 Translation: I have to go now—bye. I love you—

*Actor 8 makes animal noises.*

**BONNIE**
Health Canada finally lets the animals off and quarantines them to Hangar One. It's a big room with cats and dogs and chimpanzees, and there's barking, meowing—and then the chimps start imitating the dogs, and they're barking too. The phones are ringing off the hook with people who want to see their pets . . .

**DOUG**
. . . But they're not allowed anywhere near the planes.

**BONNIE**
And I'm worried about Unga, the pregnant Bonobo. All animals are affected badly by stress—not just humans.

**CLAUDE**
Some people spend their days crammed inside— shoulder to shoulder with nothing to do but watch the news and wait for something to happen.

**ALL**
ON THE EDGE ⑧⑦

**BEULAH**
We've got the TVs going 24/7 in the cafeteria. And the more they watch, the more scared and angry they get.

**ALL**
ON THE EDGE OF THE

**OZ**
Some of the plane people haven't slept in three days. None of us have either—and we're jumping at our own shadows.

**ALL**
ON THE EDGE OF THE WORLD

**BEULAH**
Around suppertime on Thursday, people are waiting to use the phones/ and there's a fight in the hallway—

**ALI** *(on the phone)*
Ana Kwayiss Alhamdulliallah. El aakl hena helw awi. Hagga Faw'a el wassif. Lekin, (pause) fee ness, fee naass kateera hena, Be-yeboosooly akinylrtakept gereema. ⑧⑧

**PASSENGER 11** *(to Ali, interrupting him)*
Hey. Hey! What the hell are you saying?

**ALI** *(putting his hand over the phone)*
I beg your pardon?

**PASSENGER 11**
You celebrating this? You praying for your friends?

**ALI** *(into the phone again)*
MaaMa, Laazim 'afil el sikha delwaa'ty—salaam. Bahibik— ⑧⑨

**PASSENGER 11** *(to PASSENGER 8)*
Why doesn't he speak English?

**ALI**
Excuse me?

**PASSENGER 8**
You telling your Muslim friends where to bomb next?

**ALI**
This was not all Muslims! And I was not—

**PASSENGER 11**
Go back where you came from! Ⓐ⁰

**MUSLIM PASSENGER**
I'm Muslim and I was born in Connecticut!

**PASSENGER 1**
I've got a family to protect.

**MUSLIM PASSENGER**
What does that even mean?

**BEULAH**
Sir, stop it! Everyone calm down!

**PASSENGER 6**
You can relax!

**PASSENGER 10**
They haven't done anything!

**PASSENGER 11**
What did you say? The bible says an eye for an eye! An eye for an eye!

**BEULAH**
She's an American citizen.

**PASSENGER 11** (to PASSENGER 2)
She don't look American.

**FLIGHT ATTENDANT**
They should question all you people!

**PASSENGER 8**
I'm not waiting 'til you do!

**ALI**
We haven't done anything!

**PASSENGER 12**
Leave him alone!

**ALL**
ON THE EDGE OF THE WORLD OR WHEREVER WE ARE

**2, 4, 5, 7, 9 & 10**
WE ARE—WE ARE—WE ARE ON THE EDGE

**1, 3, 6, 8, 11 & 12**
WE ARE—WE ARE—WE ARE ON THE

IS THERE SOMETHING

I NEED TO DO SOMETHING TO KEEP ME FROM THINKING OF ALL OF THOSE SCENES ON THE TUBE

I NEED SOMETHING TO DO—CAUSE I CAN'T WATCH THE NEWS

NO I CAN'T WATCH THE NEWS ANYMORE ON THE EDGE

NO I CAN'T WATCH THE NEWS ANYMORE ON THE EDGE

**CLAUDE**
The FAA keeps delaying opening the airspace—and here on the ground, we're dealing with a whole mess of other problems.

**ALL**
ON THE EDGE OF THE

**BEVERLEY**
Some of the planes are parked on a runway where the surface is all torn up. That debris gets into an engine and they'll never leave.

**ALL**
ON THE EDGE OF THE WORLD

**DOUG**
One of the big planes—a triple 7—is sinking into the asphalt. If we don't do something, she'll be stuck here forever.

**ALL**
ON THE EDGE OF THE WORLD OR WHEREVER WE ARE
WE ARE—WE ARE—WE ARE ON THE
ARE—WE ARE—WE ARE—WE ARE ON THE EDGE!

**JANICE**
I interview a woman from Queens—a mother. Her son is a firefighter and they still can't account for him. She starts crying and I start crying too. And I can't stop shaking. I don't know if I can do this anymore.

**BEVERLEY**
I check in with air traffic control again and it's more bad news. Not only is the airspace still closed, but there's a storm headed for Newfoundland. Hurricane Erin is making landfall by tomorrow or the day after. If we don't get these planes in the air soon, no one's going anywhere.

Ⓐ⁰ **IRENE:** We were told several stories of tensions and Islamophobia that arose while watching the news. One host witnessed an argument in their living room between two American passengers, one who blamed Muslims and one who was Muslim. The Muslim told her, "It's not all Muslims." Another Muslim man at Gander Academy stayed to himself, uneasy that he would be blamed, until he finally unveiled a granite plaque that he presented to the school as thanks. All of this informed Ali's character and added to what the Newfoundlanders had to overcome.

**91** DAVID: Brian Mosher talks about how Chef Vikram Garg, who Ali is partially inspired by, finally was let into the kitchen and in about a second with one hand, he had created the most beautiful fruit salad Brian had ever seen.

**92** DAVID: The Ugly Stick has passed through many hands. As our honorary Newfoundlander, it started with Petrina. It then made its way to Jenn Colella, and ultimately ended up with our bodhran player, Romano.

**93** IRENE: This moment was partially inspired by Dan Pardo, our music director at Goodspeed, who took us all out for a night of sea shanties nearby at one of the oldest pubs in America. At the start of each rehearsal, Dan would teach the cast new sea shanties, partially to remind them this was rowdier and rougher than traditional musical theater.

*In the mayor's office.*

**OZ**
Claude, people are starting to crack.

**CLAUDE**
Let's get everyone down to the Legion.

*At the academy.*

**KEVIN T**
Everyone's going down to the Legion for a drink.

**KEVIN J**
Hi, have you seen my boyfriend? His name is Kevin, he's about that tall, and he's lost his mind.

**KEVIN T**
I just want to go out!

**KEVIN J**
Well, I don't!

**KEVIN T**
Well, I'm not going without you.

**KEVIN J**
Well, I'm not . . . staying for a long time.

**KEVIN T**
One drink!

**KEVIN J**
One drink!

*In the phone room.*

**BEULAH**
Hannah? Everyone's going out tonight.

**HANNAH**
You go on without me, Beulah . . . I need to wait by the phone.

**BEULAH**
. . . I'll wait with you

*At the hotel.*

**BEVERLEY**
I keep waiting to hear from the airline. So I'll just be here by the phone, Tom, if the kids want to speak with me.

*In the hangar.*

**DOUG**
Bonnie? I know you're not leaving the animals, so I brought you some chili. But I really think that tonight, you should come home and get some sleep . . .

*Bonnie runs on.*

**BONNIE**
Doug! Oh my—Get in here! We are about to have the first rare Bonobo chimpanzee born in Newfoundland!

*At the academy.*

**OZ**
Beulah! They need some food down at the Legion if you can spare any.

**ALI**
Miss Beulah. Please let me help with the food.

**BEULAH**
No, m'love. You're a guest—

**ALI**
Please. I am a master chef for an international hotel chain. I oversee restaurants around the world. I would like to help with the food. **91**

**BEULAH**
Get in there!

*Beulah gestures emphatically toward the kitchen as Ali runs in, exasperated.*

**DIANE**
Everyone's going out to the bar—and Nick is going.

**NICK**
I'm going if Diane is going.

# Heave AWAY

**DIANE**
And I think, nobody here knows me—I can be whoever I want to be . . .

**BOB**
I'm not worried about my wallet. I'm not worried about getting shot. I am a little worried about how much Irish whiskey I'm drinking . . .

*Everyone enters the bar excitedly.*

**OZ**
By eight o'clock the bar is completely packed with people from around the world. Everybody's talking about where they're staying and what they've seen—and the bar staff keep making runs for more beer and liquor. After an hour, people are swimming in the river out back. And no, no one brought their swim trunks!

A couple of the local b'ys get up with their accordions and fiddles—and someone brings out an ugly stick. ㉒

*The band joins in as the locals start to dance.*

**MEN**
FAREWELL TO ALL YOU PRETTY LADIES ㉓
WAVING FROM THE DOCK
HEAVE AWAY, ME JOLLIES, HEAVE AWAY
AND IF WE DO RETURN TO YOU
WE'LL MAKE YOUR CRADLES ROCK
HEAVE AWAY, ME JOLLY BOYS, WE'RE ALL BOUND AWAY

**WOMEN**
FAREWELL, YOU NEWFOUNDLANDER BOYS
YOU'RE LEAVING US ALONE
HEAVE AWAY, ME JOLLIES, HEAVE AWAY
AND IF YOU FIND ANOTHER
WE'VE GOT LOVERS OF OUR OWN

**ALL**
HEAVE AWAY, ME JOLLY BOYS, WE'RE ALL BOUND AWAY
㉔

**OZ**
And then we get the karaoke going.

**DELORES**
NEAR . . . FAR . . .

**ALL**
WHEREVER WE ARE!

*Everyone cheers.*

**OZ**
Then we decide to have a bit of a ceremony.

**CLAUDE**
Let's make these people honorary Newfoundlanders!

㉔ **DAVID:** Several bands were on the diverted planes, including a Beatles tribute band and a heavy-metal throat singing band (their lead singer was probably the farthest person we interviewed in Tuva just south of Russia.) So this section used to have a huge Beatles mashup of all their hits, with a throat singer joining in on "Back in the U.S.S.R."; however, our producers wisely pointed out that licensing every Beatles song might be cost prohibitive, so we now happily have "Heave Away" in its place.

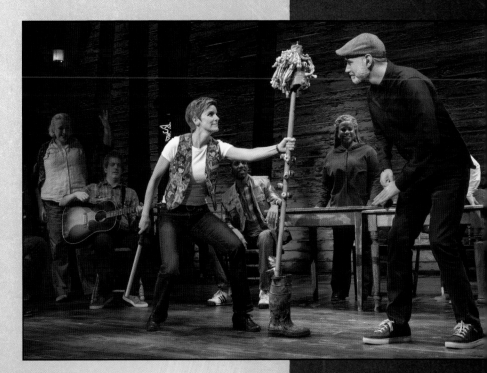

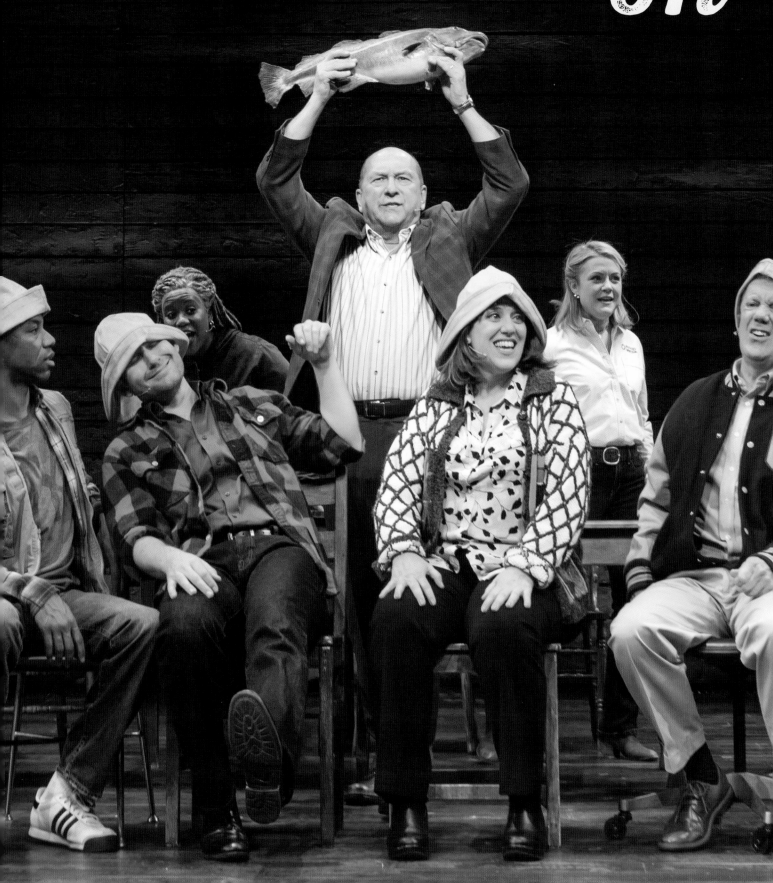

SCREECH *In*

**CLAUDE**
NOW THERE'S A SOLEMN, OLD TRADITION
FOR ADMISSION—OR AUDITION—TO TRANSITION
FROM A COME-FROM-AWAY ⑨⑤

**ALL**
TO BE A NEWFOUNDLANDER

**CLAUDE**
THE ONLY OTHER WAY AT ANY RATE
IS PASS AWAY AND PRAY TO FATE AND WAIT
TO REINCARNATE

**ALL**
AS A NEWFOUNDLANDER

HEY HEY—COME ON INSIDE
NOTHING VENTURED, NOTHING TRIED

**LOCAL 5**
ONLY A COUPLE PEOPLE CRIED

**ALL**
YOU'LL BE A NEWFOUNDLANDER
HEY HEY—SIT DOWN RIGHT HERE
YOU'LL FEEL BETTER IN A YEAR

**OZ**
TRY TO IGNORE YOUR DOUBTS AND FEARS

**ALL**
AND YOU'LL BE A NEWFOUNDLANDER

**CLAUDE**
Now we needs a couple volunteers! Who wants to become a Newfoundlander?

**BOB**
Right here!

**CLAUDE**
Good man! Who else?

**KEVIN T**
I have no idea why I put up my hand. Kevin's like . . .

**KEVIN J**
Ohmygod are you serious?

*Kevin T tries to dance a jig.*

Ohmygod—you are serious.

**KEVIN T**
Yes—I'm serious. Don't do it if you don't want to.

**KEVIN J**
I won't.

**CLAUDE**
Where you from, Buddy?

**KEVIN T**
Los Angeles.

**CLAUDE**
LA! Who else?

**DIANE**
Us!

**DIANE**
We want to be
Newfoundlanders!

**NICK**
Actually, I'm not sure—
I don't like performing . . .

**CLAUDE**
Alright, then. Where are you folks from?

**DIANE**
Texas and—

**CLAUDE**
Texas! (to Nick) What part of Texas are you from, buddy?

**NICK**
No. I'm/ from—

**DIANE**
*I'm* from Texas. He's from England.

**95** **IRENE:** When we first met Beulah Cooper, she invited us to the Legion that night, to be Screeched-in next to Nick, Diane, Beverley, and her husband, Tom, all officiated by Claude. Probably not how most writers find the subjects for their plays.

**96** DAVID: This is a tongue-in-cheek reference to Newfoundland songs, which occasionally feel like they have thirty verses. Of course, many were fishing songs used to tell stories and keep sailors rowing, so it makes sense and I love them—though it works less well in a Broadway musical.

**97** DAVID: In another bizarre bit of life imitating art, the bottles of Screech in Newfoundland now sport a sticker saying, "The official drink of *Come From Away*."

**CLAUDE**
Well, wait. Now how does that work?

**NICK**
How does what work?

**CLAUDE**
How does your marriage work with you being in England and her in Texas?

**DIANE**          **NICK**
No—we're not married.    No—

**CLAUDE**
Oh, I'm sorry—I just assumed you were married . . . Well, would you like to be?

**NICK**
Ah—

**DIANE**
Well, why not?!

**NICK**
Diane had had two beers by then, so it was probably the alcohol talking.

**DIANE**
I've never had more than one beer at a time before, so it was probably the alcohol talking.

**NICK**
I went and got us two more beers.

**CLAUDE**
NOW THE FIRST PART IS THE EASIEST

**CLAUDE (CONT'D)**
WE'LL SOON GET TO THE QUEASIEST
I'LL NEED YOU TO REPEAT THIS MESS

**ALL**
WHEN YOU BECOME A NEWFOUNDLANDER

**CLAUDE**
CAUSE WE SPEAKS A DIFFERENT LANGUAGE, SON
WE ADDS SOME ESSES AND SOME RUM
YOU'LL HAVE TO TRY A GOOD COD TONGUE

**ALL**
WHEN YOU BECOME A NEWFOUNDLANDER

HEY HEY—JUST DO YOUR BEST
NOTHING SCARY—NOTHING YET

**JANICE**
YOU'LL HAVE TO CHANGE THE WAY YOU'RE DRESSED

**ALL**
AND YOU'LL BE A NEWFOUNDLANDER
HEY HEY—JUST SING ALONG
NOTHING VENTURED, JUST PROLONGED

**CLAUDE**
THERE'S THIRTY VERSES IN THIS SONG **96**

**ALL**
THEN YOU'LL BE A NEWFOUNDLANDER

**CLAUDE**
Ladies and Gentlemen. This is Screech. **97** Back in World War II, an officer was stationed here and was offered some of this stuff. All the locals were tossing it back with nar' a quiver, so he does too, and lets out an ear-piercing . . .

*Claude and all the Locals howl.*

Everybody comes to see what's happened and says—

**ALL (EXCEPT SCREECHEES)**
"What was that ungodly screech?!"

**CLAUDE**
And now it's your turn. Are you ready?

**NICK**
Um . . . I'm not sure that—

**DIANE**
Wait—did you just say—

**BOB**
No. Nope. Not really ready.

**KEVIN T**
Do we have to drink this?

**CLAUDE**
Good! All together now. One!

**ALL (EXCEPT SCREECHEES & CLAUDE)**
ONE!

**CLAUDE**
Two!

**ALL (EXCEPT SCREECHEES & CLAUDE)**
TWO!

**CLAUDE**
Three!

**ALL (EXCEPT SCREECHEES & CLAUDE)**
THREE!

**CLAUDE**
Down the hatch!

*Everyone cheers as they drink. Bob howls. Nick grimaces. Kevin T shakes his head. Diane taps her glass, getting every drop out.*

**KEVIN T**
Screech is basically bad Jamaican rum.

**NICK**
Screech is horrific.

**DIANE**
Screech is delishush!

**BOB**
And then they brought the Cod. ⑨⑧ ⑨⑨

**KEVIN T**
The Cod.

**NICK**
The Cod.

**DIANE**
The Cod.

*A codfish is brought out and handed to Claude.*

**CLAUDE**
NOW WITH EVERY TRANSFORMATION
COMES A TINY BIT OF RISK
YOU'VE GOT TO WALK THE PLANK
AND THERE'LL BE BLOOD OR THERE'LL BE BLISS
AND IT'S THE SAME TO BE A NEWFOUNDLANDER
EVERY PERSON'S WISH
SO DON'T BE DUMB
JUST TAKE THE PLUNGE
GO ON—KISS THE FISH!

**NEWFOUNDLANDERS** *(continued underneath, building steadily)*
I'M AN ISLANDER—I AM AN ISLANDER
I'M AN ISLANDER—I AM AN ISLANDER . . .

**CLAUDE**
Ladies and Gentlemen—this is a genuine freshly caught Newfoundland Cod—and if you want to become an honorary Newfoundlander, you'll have to give her a smooch!

*Bob kisses the fish and cheers.*

**CLAUDE**
One!

**KEVIN J**
If you kiss that, I will never kiss you again!

**KEVIN T**
I'll risk it!

⑨⑧ **IRENE:** Like any proper Screech-in, this scene originally included several additional steps, including eating caplin, bologna, and peppermints, while repeating the lines, "Up the Harbour down the shore" and "Long May your Big Jib draw."

⑨⑨ **DAVID:** There's a very distinct two-note phrase repeated under the next four lines to underscore this sudden threat from the sea.

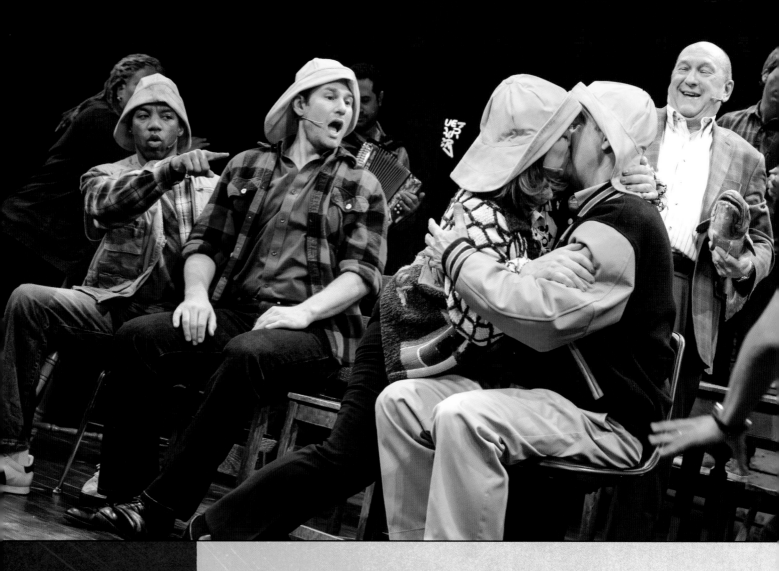

**⑩ DAVID:** Diane's fear of kissing the fish is actually based on Irene. When we were first Screeched-in, Irene could not bring herself to kiss the cod. To be fair, it's far more disgusting than you can imagine, freshly caught and dripping. After failing to persuade her, Claude eventually said, "You can either kiss the fish or you can kiss me." Irene promptly kissed the mayor. At our introductory interview, I said, "Hi, I'm David, and you've already kissed my wife."

*Kevin T kisses the fish. Kevin J exits.*

**CLAUDE**
Two!

**NICK**
I'm not kissing a fish!

**DIANE**
Come on, I will if you will!

**NICK**
Oh my god. Fine.

*Nick kisses the fish and grimaces.*

**CLAUDE**
Three!

**DIANE**
I can't do it. ⑩

**NICK**
What? I just did!

**CLAUDE**
Now you gotta kiss the cod—it's a vital part of the ceremony.

**DIANE**
No! I can't do it!

**CLAUDE**
Alright—look here. I'll make you a deal. Either you kiss this fish—or else you kiss this Englishman that you're not married to.

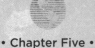

**NICK**
Wait . . . what?

**DIANE**
Okay.

*Diane kisses him.*

**ALL**
HEY HEY—COME ON TONIGHT
TAKE A RISK AND TAKE A RIDE
JUMP RIGHT IN WITH BOTH FEET TIED
AND YOU'LL BE A NEWFOUNDLANDER

HEY HEY—COME ON ONCE MORE
NOTHING VENTURED, NOTHING SORE
AFTER IT'S OVER, OUT THE DOOR
AND YOU'LL BE A NEWFOUNDLANDER

**CLAUDE**
AFTER IT'S OVER YOU'LL REMEMBER

**ALL**
THAT YOU'RE A NEWFOUNDLANDER

*The band kicks in again* (101), *as everyone trails out of the bar.* (102)

**CLAUDE**
Good job, LA!

**OZ**
Goodnight now!

**KEVIN T**
Kevin? Where'd you go? Kevin?

(101) **DAVID:** At one point, there were lyrics to this playoff, including the line, "HEY HEY, WE ALL CUT LOOSE / NOW YOU'VE GOT TO KISS A MOOSE."

(102) **IRENE:** Originally, there was an intermission here. Our producers suggested we cut it since no one in Gander was able to take a break.

# MUSIC

For the very first production of *Come From Away* in La Jolla, all of the musicians in the band were placed far stage right. As Chris Ashley says, "They were almost offstage; they were kind of peeking on." The audience reaction was so strong to their playing at the end of the show, Ashley then told the band they could stand up. "So we stood up," recalls Ian Eisendrath, the music supervisor. The reaction grew. "And then, Kelly or Chris–or both of them–were like, you know what, just come on stage. And it just became a thing and it was wonderful."

For Eisendrath, working on the show was parallel to that journey; he got pulled onto center stage, step-by-step, bit by bit–now, it's a full part of his life, making him a musical come-from-away, dropping down on tour all over North America.

Eisendrath was the only major member of the creative team to encounter *Come From Away* in its initial NAMT presentation, in his capacity as director of the New Works department at 5th Avenue Theatre, a major developmental program in Seattle. "Clearly, it had great potential and I watched people just run to David and Irene, saying, 'We wanna do it.'" As it turned out, the most enthusiastic fan of the show was Kenny Alhadeff, who was on the board of directors at 5th Avenue. Once the three-week workshop was locked in at 5th Avenue, Eisendrath was tapped as the musical supervisor and arranger– even though it wasn't typically appropriate for the director of New Works to embrace that role; and besides, he was hoping for a break: "My wife actually did not want me to [take it on] because I'd done like five new musicals in a row. But she came to me at the presentation, totally with tears in her eyes. She said, 'This is why we do this.'" Eisendrath signed up for a tour of duty on *Come From Away*: "It was very clear that the show was going to have a life beyond Seattle."

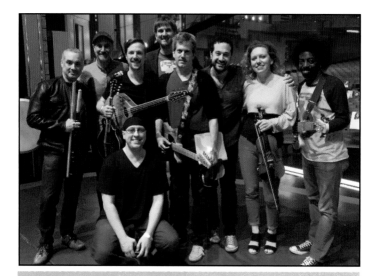

*Come From Away*'s band at Radio City Music Hall for the Tony Awards.

His first important step was to discuss the music with David Hein: "He had this love for the contemporary music of Newfoundland and I asked him to just give me a playlist. There was two days' worth of music, and I immersed myself in it, I just listened to it endlessly. I fell in love with it. When I heard [the Newfoundland classic] 'The Islander,' it all clicked. But it was actually honestly less about songs and more rhythmic feelings, colors, and harmonic progressions. There are some truths about how the Newfoundland musicians build songs, there are very consistent rhythmic patterns that you find in every single one of those songs. There is a common instrumentation. There is a sound in the voices."

When it came to voices, Hein and Eisendrath went straight to one of the sources: Bob Hallett, a singer-songwriter from St. John's who was a key member of one of Hein's favorite Newfoundland bands, Great Big Sea, and the unofficial dean of local music there. Hallett became the Newfoundland music consultant for *Come From Away*. "I think they very quickly realized that authenticity and sincerity was a huge part of what could make this production work or not work," he said. "It couldn't be faux Irish or *Star Trek* Scotty. This had to be real."

Some of those contributions were specific and enduring. "In rehearsal, there was a section of the show where [the come-from-aways] were at the bar and people were getting up and performing a bunch of different things; they had like a Russian throat singer, they had a Beatles cover band," recalls Eisendrath. These were drawn from actual events in Gander and Gambo. "But it wasn't quite landing. We spoke with Bob, who knows every song ever, and 'Heave Away' was one of them. And then built it from there. It was great." "Some pieces needed that Newfoundland touch, the way Great Big Sea or Shanneyganock can mix Newfoundland music with pop music, making it more accessible without selling out that thing that there is that makes Newfoundland music great," added Hallett.

Orchestrator August Eriksmoen on mandolin jams with Music Director Ian Eisendrath on the accordion (right).

The orchestration of the score is always the most direct manifestation of its unique characteristics, and Eisendrath teamed up with August Eriksmoen to create them: "We knew to land the Celtic world and the Newfoundland sound, you're going to have to have whistles, a fiddle, a button accordion, a guitar, bass, a Bodhran [a flat Irish drum that Chris Ashley calls 'the heartbeat' of the score]–that's six.

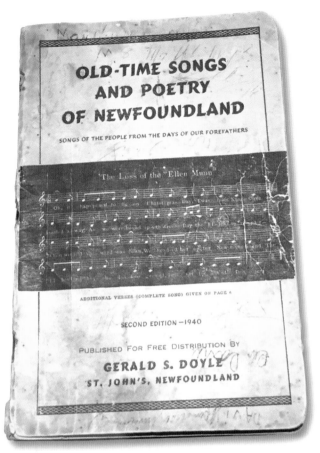

**The first edition of Doyle's seminal book of songs.**

To have the contemporary sound of the Newfoundland bands, you're going to add a drum set to that. Then you're playing onstage in a Broadway theater, so there's not time to stop recording and switch guitars constantly, so we knew we needed to introduce electric guitar. With those eight musicians, we knew we could clearly be in Newfoundland, both contemporary and traditional, in that world." There's also additional orchestration to create musical come-from-aways, instrumentation from around the world to accent a Muslim prayer, or an Hebraic Kaddish.

Another, subtler, aspect that gives the show excitement is its soundbed, the result of Ashley's tight pacing of the narrative. "There's almost no silence in this show," said Ashley. "It's pasted up in a way that it just keeps on moving. The musical beds that weave through this show are rich and it's a launchpad for the actors to do their scene work." Eisendrath concurred: "That's how David heard the show–cinematically–like the soundtrack to a film where there are constant color, melodic, harmonic shifts based on character shifts, location shifts, based on the moment and the event. The underscoring is really part of the story. We often thought of *Come From Away* as one long song." Bob Hallett, no stranger to songs, long or short, noticed that subtlety: "It's the connective tissue, it's the underscore–that is what brings out the spirit of Newfoundland."

That spirit was best defined by Gerald S. Doyle, the pioneering musicologist whose *Old-Time Songs of Newfoundland* was first published in 1927: "There is a dignity as well as beauty and melody in the folk songs that puts out of court flippancy and any cheap attempts to ridicule in rendering them. These old songs are part of the web and woof of the life of Newfoundland." Needless to say, the most frequent songs have to do with the sea and the rovers who ply their trade upon it with equal dashes of courage, humor, and longing for the "gals" left behind. The shadows of separation, death, and loneliness are never too far away in these songs, but they never fall so close as to be dreary or despairing. One of the most nautical "sea shanties," "Heave Away," which appears in its own iteration in *Come From Away*,

has its roots in the British Isles from the mid-nineteenth century. Originally, it contained references to France and Bengal Bay but has become a more recent favorite with references to Newfoundland localities.

As new generations have come along, musicians have both embraced the Newfoundland folk tradition and contributed to its evolution. In the 1960s, many local artists took the songs of their ancestors and adapted them to the taste (and instrumentation) of their generation. In the last decade or so, audiences within and outside the province have embraced the music as never before. The success stories include the Punters, the Irish Descendants, the Dardanelles, the Navigators, and Shanneyganock. In nearly every case, it's impossible to attend a contemporary concert without at least one or two traditional songs belted out as part of the evening's repertoire.

The folk influence is a vibrant and unique form of music, which makes the score to *Come From Away* and its presentation from start to (often extended) finish substantially different from a "typical" Broadway score–if such a thing even exists anymore. There are no down-center power ballads, no group tap-dancing numbers, nothing detachable for easy consumption at a piano bar. "I don't think it's a 'Greatest Hits' kind of score," summed up Eisendrath. "It's not a lot of solos; we had all twelve people together; we had the range of voices that we needed. The score is contemporaneous musical theater with a lot of music in the style of contemporary Newfoundland folk music. That was always a fine line to walk. We always wanted to believe we were capturing the essence of a world of music, but not being subservient to it.

"It's storytelling. If you like stories with music, this show's for you."

**Accordion, bodhràn, and ugly stick, clutched by percussionist and native Newfoundlander Di Nillo.**

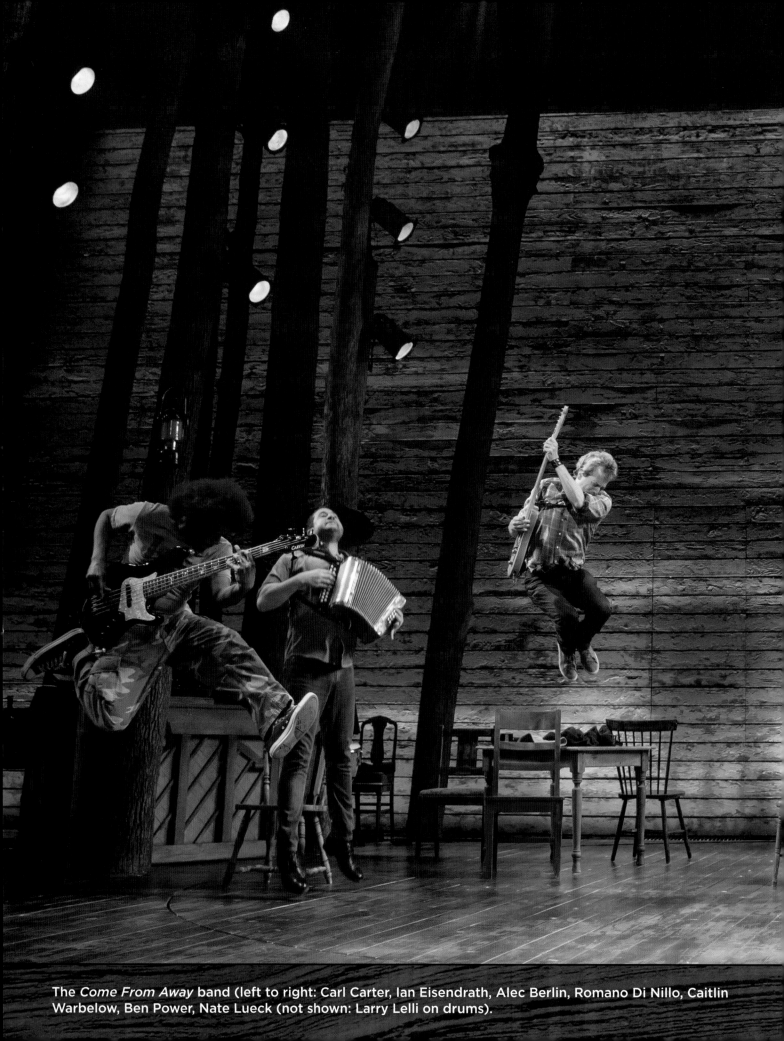

The *Come From Away* band (left to right: Carl Carter, Ian Eisendrath, Alec Berlin, Romano Di Nillo, Caitlin Warbelow, Ben Power, Nate Lueck (not shown: Larry Lelli on drums).

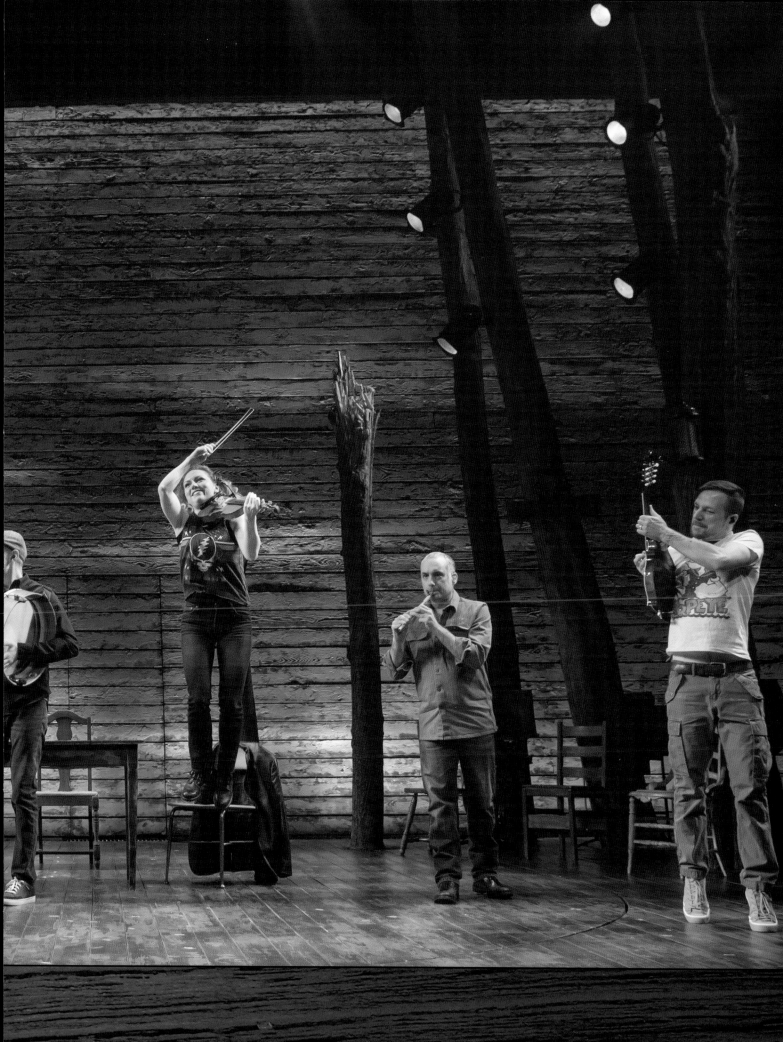

# SCREECH-IN

No local likes to be reduced to a stereotype, but when you can grab that stereotype by both horns–or both gills, as the case may be–you can use it to your advantage.

The "Screech-In" ceremony has become ubiquitous in Newfoundland in the last half century, often as a way of trapping tourists, but also as a way of expressing a Newfoundlander's priorities and identity.

The history of Screech, in all its manifestations, stretches all the way back to the roots of the Newfoundland economy in the

from England and the States. One American serviceman thought nothing of kicking back a generous shot of the local rum, as if he were drinking Old Grand-Dad back home. He was in for a surprise and, supposedly, let out a blood-curdling screech. When another American ran over to the bar to ask what all that was about, the local bartender countered, "Tis the rum, me son."

It became popular enough as an adopted neologism that, soon after the Second World War, the local spirits distillery was bottling

## "The ceremony can be performed in a neighborhood bar or a friend's living room—it's all part of the tradition."

eighteenth century. Cod was a cheap import to the American South and the West Indies, where its plentiful bounty was used to feed the slave population. In exchange, as part of the "Triangle Trade," Newfoundland got more than its fair share of Jamaican rum, distilled from Demerara sugar. It's a deep, dark, amber brew–more than 40 percent alcohol. It's not for every taste–certainly not for timid spirits.

An anecdotal legend has it that this potent potable acquired a second name in the days of World War II, when the island had more than its share of visiting soldiers, sailors, and airmen

and promoting the strong rum as "Screech." The ceremony where Screech plays such an essential part is, according the *Canadian Encyclopedia*, the result of a collision between "the rough-hewn native tradition of Newfoundlanders and the outside, modern world" which created "a fertile ground for a new initiation ritual to germinate." It was also a ritual that made it not so easy for any condescending "come-from-away" to appropriate the local culture.

"Screech-Ins"–like "Love-Ins"–became more prominent from the late 1960s on, and exploited

the most basic (and base) stereotypes about Newfoundlanders. Most always, the ceremony is run by a kind of secular cleric–usually dressed in a yellow slicker and a floppy rain hat called a "sou' wester" (occasionally with a gender switch as a jocularly padded and slatternly Newfoundland housewife). The initiate is asked to repeat a barrage of local jargon, often unintelligible and impossible to replicate. Still, the one essential call-and-response is when the local asks the come-from-away, "Is ya screechers?" to which the correct response is "Indeed I is, me ol' cock, and long may your big jib draw"–a mariner's term meaning may there always be wind in your sail.

Next comes a kind of culinary Stations of the Cross, where the initiate has to sample of variety of local dishes. There might be fried bologna or a Vienna sausage, eaten directly from the can (and the liquid inside swallowed as well); a swig of a frighteningly red and sweet concoction called Purity syrup; a bite of caplin, a skinny salty fish; a jaw-breaking bite of a biscuit called "Hard Bread," with its granite-like texture; and a sample of a St. John's candy, Peppermint Knobs. All of which has to be knocked back with a shot glass full of Screech (teetotalers can request a Pepsi).

But, wait, there's more: the *pièce de la résistance*: a good, slobbery smack on the lips of a slimy, slippery, skeevy codfish. This makes the ritual complete, a way of recognizing that, over the decades, over the centuries, no matter what has transpired with the local economy, in Newfoundland, the cod will always be king.

At this point, the crowd goes wild, and often the initiate will be given a "Royal

SLICKER, SCREECH, COD, AND CERTIFICATE: ESSENTIAL INGREDIENTS

Order of Screechers" certificate (provided by the Newfoundland and Labrador Liquor Corporation), which anoints the initiate as an honorary Newfoundlander. The ceremony can be performed in a neighborhood bar or a friend's living room–it's all part of the tradition.

Some folks, over the years, have tried to scale back the ceremony, fearful of its stereotypical implications–at one point in the 1990s, a Newfoundland premier tried to stop the issuance of Screecher certificates–but that would be like commanding the tide to stop rolling in. The Screech-In is a tide of its own, and shows no sign of avoiding its giddy crashings against the Rock.

The Screech-In asks every come-from-away to take on that most Newfoundland of traits–not the funny hat or the garbled jargon–but simply being a good sport.

# FRIDAY, SEPTEMBER 14, 2001

If anything summed up the simmering frustration of the end of that dreadful week, it was the fate of those stalwart souls on the passenger list of Continental Airlines 23.

Continental had left Dublin's Shannon Airport en route to Newark at dawn on September 11, four days earlier; it was, in fact, the first flight to land at Gander Airport. According to Tom McKeon, one of the passengers, its Newark destination singled Continental 23 out for a particularly intense security review and the passengers weren't allowed to deplane for hours after other, later flights had been discharged. All of the flight's eighty-eight passengers were brought to nearby Appleton, population six hundred, fifteen miles northwest, where they apparently had a perfectly reasonable and cordial time, enjoying the hospitality of the town—including a number of impromptu

barbecue cookouts. By the time the Gander policy of keeping come-from-aways out of local homes had filtered up to Appleton, it was too late; dozens of folks were being hosted at the homes of local residents. McKeon, in fact, had stayed with Appleton's mayor, Derm Flynn, and his wife, Dianne.

Late on Thursday night, the Continental passengers received an urgent call to get their things together—they were finally being bused to Gander Airport. The passengers were comparatively lucky; since Continental was an U.S.-based airline, its flights could now enter American airspace. Even luckier for the passengers, the three major airports in the New York area—Kennedy, LaGuardia, and Newark—had just been reopened by the FAA. So, the intention was to process Continental 23 in the wee small hours of the 14th, in anticipation of flying back to Newark

before sunrise. So confident was the Gander Airport staff that this plan would work, they scheduled a break from 2:00 a.m. to 6:00 a.m., once the flight departed.

Except that at exactly the same time that the Continental passengers were being bused on the twenty-minute ride to Gander, FBI agents were storming planes on the ground at JFK and LaGuardia, arresting a dozen suspects. As a result, because of these intense security concerns, practically as soon as they were reopened, the New York-area airports were shut down again. The Continental group was bused back from the airport into Gander, where they would have to cool their heels in a makeshift shelter in the ballroom of the Hotel Gander. It was a mess: infants on gym mats were cheek-by-jowl with elderly folks sitting on hallway floors. There was a near-mutiny when the flight's captain, Tom Carroll, arrived to inform passengers that they were destined to go wherever and whenever Continental decided. Fate, as it would be in so many corners and crevices that week, was particularly fickle.

Such security precautions might seem unnecessary—neurotic, even—but in the days after 9/11, as the world was trying to get back on an even keel, there was so much that was still uncertain back in the States, particularly in the New York area, where one-third of the come-from-aways were bound. Late in the week, Manhattan was slowly bringing normalcy back online: the northernmost restricted area around what was becoming known as Ground Zero was being scaled back to Canal Street, businesses were reopening, even all twenty-one of the currently running Broadway shows

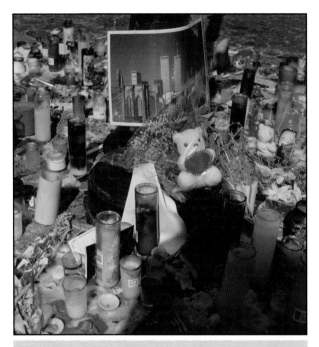

**While plane passengers were still stranded in Gander, New York City mourned the missing and the lost.**

were raising their curtains back up after a two-day hiatus. But, still, almost five thousand people were missing or unaccounted for by September 14, and the city was plastered with heartbreaking Xeroxes from families and friends asking about the whereabouts of hundreds of missing people. The acrid smoke of the World Trade Center ruins could be inhaled from dozens of blocks away. As more information came in about the hijackers and their methods, security was ratcheted up in new and unprecedented ways every moment. There was a scalpel-fine edge between vigilance and paranoia in every aspect of American life.

As that Friday went on, Gander Airport was able to move out more and more flights. Because many of the flight restrictions were lifted, more Canadian employees were flown in

**Extended coverage: Brian Mosher interviews visitors for Rogers TV.**

by their stay in Gander: "The people are so supporting and nice. Due to the circumstances, it's great, and it looks so much like Sweden."

Mosher corralled a young American air force officer who had been waylaid on his way from his base near Stuttgart to the air force base back home in New Jersey. The fellow was wearing a T-shirt with a generic decal he had acquired at the local Walmart. "It's been nice, nice, " he said, complimenting the locals, "but *I'm ready to go.*"

to help with the processing of passengers. There was an additional imperative to get the flights up and out; Hurricane Erin had been roiling in the Caribbean for nearly two weeks and was now making an unexpected turn toward Nova Scotia. Newfoundland was predicted to be within its path and the week's brilliant weather was starting to gray around the edges.

Brian Mosher, the local anchor of Rogers TV who had been manning the cable station's information "command center" nearly nonstop since that Tuesday, finally got out from behind his desk and interviewed various visitors on the corner of Airport Boulevard and Fraser Avenue as they took their afternoon jaunts. Each of the folks interviewed–who hailed from Dallas to Frankfurt to New Jersey–had nothing but effusive things to say about Gander and the way they had been treated. A Swedish couple traveling with a small child were despondent over the attack on America, but were buoyed

So were the weary passengers of Continental Flight 23. Their holding pattern was somewhat mitigated by a convoy of Appleton residents who drove to Gander to keep them company for the duration. By the late afternoon of Friday the 14th, just as President Bush was barking out "The rest of the world hears you! And the people – and the people who knocked these buildings down will hear all of us soon!" through a bullhorn in the rubble of Ground Zero, Newark Airport was reopened. It was official: the Continental passengers could be brought to the airport to begin processing. At 10:20 in the evening, they were informed that– sigh!–their plane had mechanical problems and they might have to go back once more to their cots at Hotel Gander. But, fifty minutes before the end of September 14, their 747 jumbo jet plane was repaired and, by midnight, the passengers of Continental 23 were finally on their way home.

# ME and the SKY

*BEVERLEY sits alone in her hotel room, wide awake.*

**BEVERLEY** ⑩③
MY PARENTS MUST HAVE THOUGHT
THEY HAD A CRAZY KID ⑩④
CAUSE I WAS ONE OF THOSE KIDS
WHO ALWAYS KNEW WHAT I WANTED
THEY TOOK ME DOWN TO THE AIRPORT
TO SEE ALL THE PLANES DEPARTING
WATCHING THEM FLY SOMETHING INSIDE OF ME WAS
   STARTING
I WAS EIGHT WHEN I TOLD THEM
THAT I'D BE A PILOT

BUT I WAS TOO YOUNG AND TOO SHORT
AND THERE WERE NO FEMALE CAPTAINS
AND MY DAD SAID BE PATIENT
HE SAID JUST SEE WHAT HAPPENS

BUT I TOOK MY FIRST LESSON
CAME DOWN FROM THE SKY AND
TOLD MY FATHER I'D FLY FOR THE REST OF MY LIFE ⑩⑤

AND I GOT MY FIRST JOB
FLYING FOR A MORTICIAN
IN A TINY BONANZA
JUST A CORPSE AND ME
FIVE DOLLARS AN HOUR
FOR FLYING DEAD BODIES

⑩③ **DAVID:** Like so much of the show, this song draws directly from our verbatim interviews. We spoke to Beverley Bass for hours on the morning of September 11, 2011, and afterward we were ready to make *Beverley Bass: The Musical!* Here are some quotes from our interview to show how closely they relate.

⑩④ "I was one of those kids that told their parents early on. I was about eight when I told them that I wanted to be a pilot. They thought they had a crazy kid on their hands."

⑩⑤ "I came home from my first flying lesson—I remember walking in the kitchen—and I told my mother, I said, 'I'll fly for the rest of my life.'"

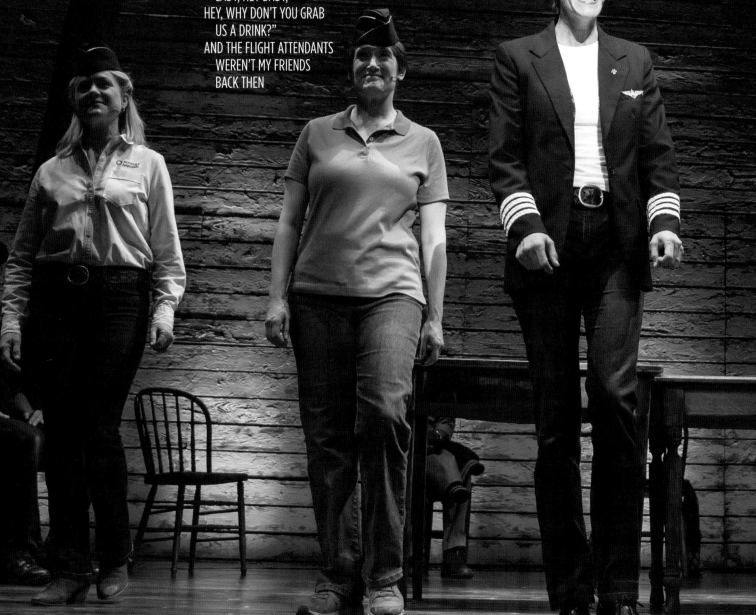

**106** "My first flying job was flying bodies for a mortician. So, I flew dead bodies—the airplane was a very small Bonanza . . . I climb over their face to get to my seat. Five dollars an hour. And they don't complain."

**107** "I only applied to American because I thought they had the prettiest airplanes."

**108** "As the World War II guys started retiring . . . the generation that was behind me was more familiar with women pilots."

I HAD TO CLIMB OVER THEIR FACES
JUST TO GET TO MY SEAT **106**

AND SUDDENLY THE WHEELS LIFT OFF
THE GROUND IS FALLING BACKWARD
I AM SUDDENLY ALIVE

SUDDENLY I'M IN THE COCKPIT
SUDDENLY EVERYTHING'S CHANGED
SUDDENLY I'M NOT TOO YOUNG OR TOO SHORT
AND THE PASSENGERS IN THE BACK DON'T COMPLAIN
SUDDENLY I'M FLYING COMPANY CHARTERS
SUDDENLY EVERYTHING'S HIGH
SUDDENLY THERE'S NOTHING IN BETWEEN
ME AND THE SKY

AMERICAN AIRLINES
HAD THE PRETTIEST PLANES **107**
SO I APPLIED AS A FLIGHT ENGINEER
BUT THE WORLD WAR II PILOTS, THEY ALL COMPLAINED
THEY SAID, "GIRLS SHOULDN'T BE IN THE COCKPIT—HEY
    LADY, HEY BABY,
HEY, WHY DON'T YOU GRAB
    US A DRINK?"
AND THE FLIGHT ATTENDANTS
    WEREN'T MY FRIENDS
    BACK THEN

AND THEY SAID, "ARE YOU BETTER THAN US, DO YOU
    THINK?"
BUT I KEPT GETTING HIRED AND
THE WORLD WAR II CREW—THEY RETIRED **108**
AND THE GIRLS ALL THOUGHT MUCH HIGHER OF ME

*The women become flight attendants, clapping and singing backup.*

1986—THE FIRST FEMALE AMERICAN CAPTAIN IN HISTORY
**109**

**BEVERLEY (WITH FLIGHT ATTENDANTS)**
SUDDENLY I'M IN THE COCKPIT (AH)
SUDDENLY I'VE GOT MY WINGS (AH)
SUDDENLY ALL OF THOSE PILOTS PROTESTING ME (AH)

WELL, THEY CAN GET THEIR OWN DRINKS!
SUDDENLY THERE'S NO ONE SAYING STAY GROUNDED
LOOKING DOWN—PASSING THEM BY (AH)
SUDDENLY THERE'S NOTHING IN BETWEEN (AH)
ME AND THE SKY

**BEVERLEY**
SUDDENLY I'VE GOT AN ALL-FEMALE CREW
THE NEWS CAUGHT AND MADE HEADLINES
    ACROSS THE WORLD
SUDDENLY IT STOPPED, NO ONE'S SAYING

**BEVERLEY (WITH FLIGHT ATTENDANTS)**
(YOU CAN'T) OR (YOU WON'T)
OR (YOU KNOW) YOU'RE NOT ANYTHING
    (CAUSE YOU'RE A GIRL)

**BEVERLEY**
SUDDENLY I'M GETTING MARRIED
AND WE'RE PUTTING PINS ON A MAP
    WHERE WE'VE FLOWN

SUDDENLY I AM A MOTHER
AND SUDDENLY SHOCKED AT HOW MUCH
    THEY'VE GROWN

SUDDENLY I'M WOND'RING HOW MY PARENTS
    WOULD FEEL
SEEING ME TEACHING MEN TO BE PILOTS
CAUSE SUDDENLY I AM A SENIOR INSTRUCTOR ⑩
AND SOMEHOW I'M FIFTY-ONE

SUDDENLY I'M FLYING PARIS TO DALLAS,
ACROSS THE ATLANTIC, AND FEELING CALM
WHEN SUDDENLY SOMEONE ON
    AIR-TO-AIR TRAFFIC SAYS,
AT 8:46 THERE'S BEEN A TERRORIST ACTION ⑪
AND THE ONE THING I LOVED MORE THAN ANYTHING
WAS USED AS THE BOMB

SUDDENLY I'M IN A HOTEL
SUDDENLY SOMETHING HAS DIED
SUDDENLY THERE'S SOMETHING IN BETWEEN
ME AND THE . . .

*Beverley answers the phone.*

Hello?

I'm on my way.

⑩⑨ "I was the first female captain on American in October 1986 . . . I had the first all female crew . . . it made headlines all over the world."

⑩ "Now I'm going to be instructing guys who are actually senior to me . . . on 9/11 I was training a new copilot."

⑪ "I was coming from Paris to Dallas . . . Our feet were propped up. And we hear on air-to-air that an airplane has hit the World Trade Center."

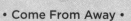

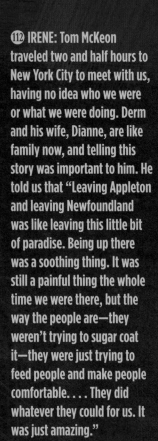

**112** **IRENE:** Tom McKeon traveled two and half hours to New York City to meet with us, having no idea who we were or what we were doing. Derm and his wife, Dianne, are like family now, and telling this story was important to him. He told us that "Leaving Appleton and leaving Newfoundland was like leaving this little bit of paradise. Being up there was a soothing thing. It was still a painful thing the whole time we were there, but the way the people are—they weren't trying to sugar coat it—they were just trying to feed people and make people comfortable. . . . They did whatever they could for us. It was just amazing."

**JANICE** *(on camera)*
1:34 a.m.

**ALL (EXCEPT JANICE)**
Friday.

**JANICE** *(on camera)*
September 14. Shelters will be alerted as each plane is cleared to go.

**BOB**
Our pilot says to pack up. It's sudden notice—the middle of the night—and we're leaving in an hour. But these people—they make these bag lunches—and they form a . . . a gauntlet—handing them out—and we all walk through it and get our lunches and say goodbye to all of them. We try to give them money, but they won't take it. **112**

**DERM**
No, m'son. You would've done the same.

**BOB**
I drank all your whiskey.

**DERM**
I would've done the same.

*The next morning, Diane wakes up, hungover.*

**NICK**
Good morning.

**DIANE**
Nnnnnn.

**NICK**
You were snoring.

**DIANE**
My head hurts.

**NICK**
You had a couple.

**DIANE**
Did I kiss the fish?

*He looks at her, surprised.*

**NICK**
Don't you—? . . . Yes, you did.

**DIANE**
Oh good . . . Wait—

**NICK**
We're running out of time. Our plane could be the next one to go.

*In another location Kevin T turns to Kevin J.*

**KEVIN T**
Our plane could be the next one to go. . . . Are you still upset that I kissed a fish?

**KEVIN J**
No. I'm upset that I left the bar and you didn't even notice!

**KEVIN T**
You left without telling me—

**KEVIN J**
After everything that's happened. You're out there acting like it's okay. And it's not okay.

**KEVIN T**
I know. But I'm not gonna shut myself inside. Let's just get back to LA.

**DIANE**
While you're in Dallas, I'd love to have you over.

**KEVIN J**
I tried to change my flight to New York. They wouldn't do it.

**NICK**
My conference was canceled. So, I head back to London immediately. ⑪③

**KEVIN T**
I don't understand. Why would you . . . ?

**KEVIN J**
I just need to be back home.

**NICK**
Back home.

**DIANE**
Back home.

**KEVIN T**
Back home.

*All four are silent.*

**NICK** *(sadly)*
Well. All good things, right?

**BEULAH**
As the plane people leave, they keep stopping us, thanking us, trying to give us money, but we say . . .

**OZ**
No, buddy. You would've done the same.

**ANNETTE**
But one guy keeps insisting 'til Beulah finally tells him . . .

**BEULAH**
Look, you can slip it in the suggestion box down at town hall, but honestly, we're happy with a thank-you on your way out.

**ANNETTE**
Captain Bristol—that pilot for Virgin Atlantic. He comes to find me to help him round up his passengers.

**CAPTAIN BRISTOL** *(over the top romantic)*
Annette. My darling. Before I leave, I need to thank you for . . . everything we've shared. Though I travel home today, I leave my heart behind.

*Annette salutes him.*

| **BEULAH** | **ANNETTE** |
| Annette,/ for the- | Don't. |
| | *(stopping her from saying anything else)* |
| | Blablablablablaba—Goodbye! |

⑪③ **DAVID:** Though they're now separated, this scene mirrors the foursome's original walk. As each of them realizes that they're heading in different directions, their lines specifically mention which town they think of as "back home."

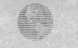

*All of the locals overlap saying goodbye.*

**LOCAL 1**
Goodbye!

**LOCAL 2**
Goodbye! I'll miss you!

**LOCAL 3**
Tell us when the baby's born!

**BEULAH**
I'll be waiting by the phone.

**BONNIE**
Let us know you made it home safe!

**ANNETTE**
Take care now!

**OZ**
Don't be a stranger.

**GARTH**
Don't forget us now!

**DWIGHT**
Thank you for the bottle of wine!

**CLAUDE**
You write us now!

**DOUG**
Goodbye!

*A beat. All the locals slump with a sigh, exhausted.*

**BOB**
We get down to the airport—and it's chaos. Passengers dropped off from multiple flights. Every bag has to be emptied.

**OZ**
No scissors. No nail clippers. If any bags are unidentified, they'll be blown up.

**BOB**
Then, someone says there's issues with security.

*Beverley steps forward.*

**BEVERLEY**
One of my flight attendants comes to find me. She says . . .

*The flight attendant steps forward.*

**FLIGHT ATTENDANT**
There's a Muslim man on our flight—

I saw him praying—and he's been acting . . . suspicious. He doesn't have a carry-on . . . and . . .

I'm not getting back on that plane with him.

*Ali steps forward.*

**ALI**
I arrive at the airport and am pulled out of line.

**BEVERLEY**
I am responsible for the safety of my passengers and my crew. And security tells me any perceived threats must be taken extremely seriously. They bring me to a private room and he is brought in for questioning.

**ALI**
At first I do not understand what the police are asking. And then I do.

In my culture, there is a word—"awrah"—the area between your stomach and your knees. It is forbidden in my religion for anyone to see this but my wife.

To have a woman in the room, watching this. Watching me.

You can't understand.

**BEVERLEY**
It is the most thorough body search I've ever witnessed. And when it's over, I find him and I tell him—I am so very sorry that happened.

**ALI** *(barely looking at her)*
Am I free to go now? ⑭

*Beverley nods.*

**PASSENGER 11**
When are we leaving?!

*The crowd jumps in with questions as Beverley addresses them.*

⑭ **IRENE:** Ali is an amalgamation of many people we interviewed or heard about. This specific moment came from Beverley Bass's journal. Her crew was concerned about two men, who were each searched, and Beverley felt it was her responsibility to observe it. She didn't know their religion, but we spoke with another Muslim man who was detained and searched in a similar manner following 9/11.

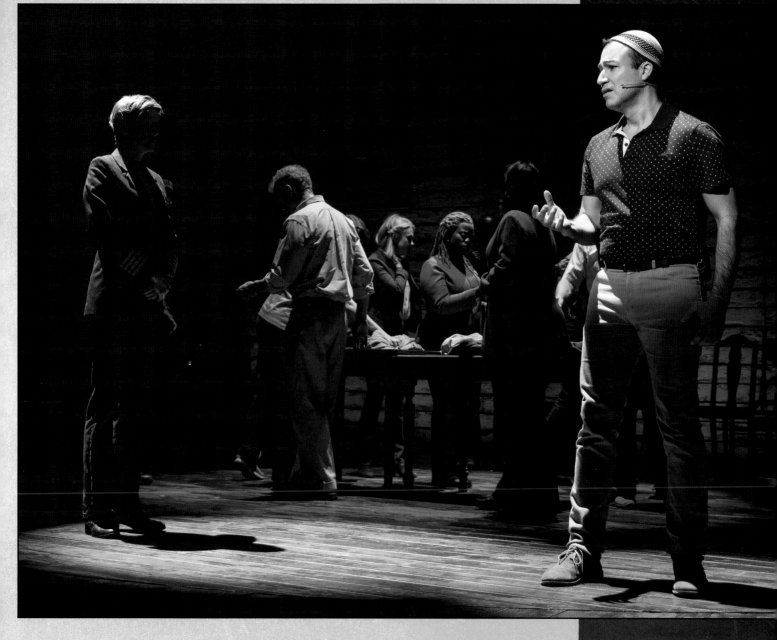

**BEVERLEY**
Good morning. We are one of the first flights to leave . . .

*The crowd responds, relieved.*

. . . which makes us one of the lucky ones as some planes may still be here for quite some time. Now, I have no control over this. You've paid for a flight from Paris to Dallas. If I get clearance, I will take you to Dallas. But if I am not cleared for Dallas, I have to take you back to France.

*The crowd starts murmuring.*

But we will make arrangements as quickly as we can to get y'all back to the United States where you need to be.

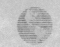

**115 IRENE:** There were several families returning with children from overseas adoptions. The process is long and complicated and there was a real fear that returning could invalidate it.

**116 DAVID:** This is one of the few Beverley moments that is amalgamated from Tom McKeon's flight, where the captain had to deal with a possible mutiny when the passengers were told they weren't going home.

**117 DAVID:** I remember the first time Chris and Kelly staged this, with Nick and Diane standing in the center of the stage on a table. And I think I must have looked a little disappointed that this majestic moment was represented so simply—but the next morning, they had replaced it with this brilliant turntable move with the cast literally building the lookout underneath them.

**PASSENGER 5**

I can't go back. I just adopted my daughter— 115

| PASSENGER 5 (CONT'D) | KEVIN T | KEVIN J | PASSENGER 10 | PASSENGER 11 | PASSENGER 12 |
|---|---|---|---|---|---|
| we could lose her if we go back to Europe . . .<br><br>I could lose my daughter. You have to take us home! | Hey. Calm down. I'm sure they're doing the best they can. If she says they're going to get us home, then they're going to get us home. Let's not make things any harder. | We've been here four days! How long are we going to be there? We were trapped on our plane forever and then we've been here for days with no information and now you— | America is at war! I'm not going back to France. You said yourself—we paid for a ticket to Dallas—that's where we should be taken. | There's over two hundred of us—they'll take us where the majority of us want to go. I'm serious— | America just got attacked—what is wrong with you? What is wrong with you? This is an international tragedy! |

**PASSENGER 11** *(after a moment he interrupts them)*
Hey! Hey! We can vote on this. We can make them go where we want to go.

**PASSENGER 5**
Well, who's for Dallas?

**PASSENGER 11**
Fuck that! Who's for Switzerland?!

*Everyone reacts.*

**BEVERLEY**
This is not a democracy! I am the captain and this is coming from American Airlines and the FAA. You are not voting on our destination. Now, if we have any situation that needs to be dealt with, we will be pulled out of line and we will be the last flight to leave. 116

*The crowd is quiet*

Thank you for your cooperation.

**HANNAH**
After hours of waiting, they tell us we're not leaving yet after all.

**JANICE** *(on camera)*
4:18 p.m. There's a 747 with a flat tire blocking the runway.

*The passengers react to the news, groaning.*

All planes are stopped. No one's taking off.

*All of the locals jump up, still exhausted and surprised.*

**ANNETTE**
Welcome back!!

| LOCAL 1 | LOCAL 2 | BONNIE | BEULAH |
|---|---|---|---|
| Hello! | Welcome back. | I'll put the kettle on. | I'll get your room ready. |

| ANNETTE | OZ | GARTH | DWIGHT |
|---|---|---|---|
| Get in here! | You must've missed us. Come on in! | Come on in! | Did you forget something? |

| LOCAL 10 | CLAUDE | DOUG |
|---|---|---|
| You've missed us. Come on in! | Hello! | Hello! That was fast. |

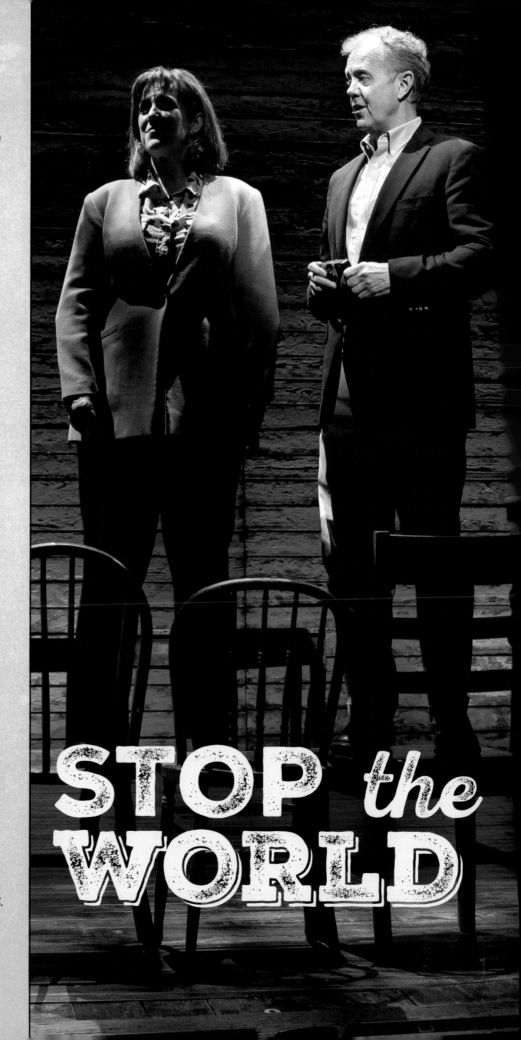

**DIANE**
We're told by our pilot to stay close to our shelters so we're ready to go again.

**NICK**
But Diane wants to take one last look around. And I can't let her go by herself.

**DIANE**
And we find a gorgeous lookout: the Dover Fault.

*Diane stands on a chair and looks out.*

**NICK** *(exhausted)*
There's about a million stairs.

**DIANE**
It's beautiful. Nick! You've gotta see this.

*He steps up next to her and looks.* ⑪⑦

**NICK**
Wow . . .

**DIANE**
I can't believe we're here.

**NICK**
I know.

**DIANE**
I can't believe we're leaving!

**NICK** *(quietly)*
I don't want to go.
**DIANE**
What did you say?

**NICK**
I don't know. I'm—I'm going to get a picture or two.

**DIANE**
Oh, okay.

*Nick turns to take a picture of her—and Diane freezes.*

# STOP the WORLD

**118** DAVID: Dover's lookout is one of the most beautiful spots, and features some very helpful displays about the geology of the area (seriously, how could we resist a good geological metaphor?). And since the show, there is now a display about Nick and Diane's love and about *Come From Away*.

**NICK**
STOP THE WORLD
TAKE A PICTURE
TRY TO CAPTURE
TO ENSURE THIS MOMENT LASTS

WE'RE STILL IN IT
BUT IN A MINUTE
THAT'S THE LIMIT
AND THIS PRESENT WILL BE PAST

SO HERE WE ARE
WHERE THE WORLD HAS COME TOGETHER
SO HERE SHE'LL BE
IN THIS PICTURE FOREVER

*Diane unfreezes.*

**DIANE**
Look at this: Five hundred and forty million years ago, the continents of the world crashed together right here. And two hundred million years ago, they separated again, moving apart from each other. **118**

**NICK**
Huh.

**DIANE**
But a little part of them was left behind.
    *Nick lifts his camera, pointing it at her.*

I should move. You're missing all the scenery—

**NICK**
No, no. Stay where you are.

**DIANE**
Really?

**NICK**
Really. It's perfect.

*He takes another picture and this time Nick freezes.*

**DIANE**
STOP THE WORLD
SEIZE THE MOMENT
BUT THE MINUTE HE GOES

YOU'RE ALONE AND IT'S THROUGH
PINCH YOURSELF
TELL YOURSELF
YOU'RE JUST DREAMING
THAT MEANS HE'LL FORGET ABOUT YOU

BUT HERE WE ARE
WHERE THE CONTINENTS ONCE CRASHED TOGETHER
BEFORE THEY WENT
THEIR SEPARATE WAYS FOREVER, SO

| DIANE | NICK |
|---|---|
| STOP THE WORD | |
| | STOP THE WORLD |
| STOP THE WORLD | |
| | STOP THE WORLD |
| STOP THE WORLD | |
| FROM SPINNING ROUND | FROM SPINNING ROUND |

*Everyone else begins to sing underneath.*

| DIANE & NICK | EVERYONE ELSE |
|---|---|
| I'M ON A LOOKOUT | OH . . . |
| OVERLOOKING SOMETHING | |
| WORTH TAKING THE TIME | |
| TO STOP FLYING BY | |
| | AND LOOK DOWN |
| AND LOOK DOWN | |
| | STOP THE WORLD |
| STOP BEING SCARED | |
| | AND LOOK ROUND |
| AND LOOK ROUND | |
| | STOP THE WORLD |
| JUST TELL HER/HIM NOW | |
| | AAH! |
| AND LOOK NOW | |
| | AAH! |

**DIANE & NICK**
TAKE A PICTURE OF THE SCENERY
OF A LOOKOUT
OF A MOMENT WHICH IS OVER
OF THE OCEAN OF THE RIVER OF THE TREES

*They look at each other for a second and then turn away.*

STOP THE WORLD PLEASE

---

PROFILES

---

# NICK & DIANE • BEVERLEY • KEVIN Y & KEVIN T

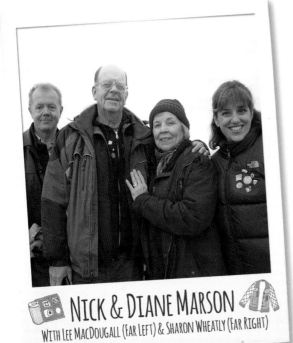

### NICK & DIANE MARSON
WITH LEE MacDOUGALL (FAR LEFT) & SHARON WHEATLY (FAR RIGHT)

**UK native NICK MARSON and Houstonian DIANE KIRSCHKE were on Continental Flight 05 and had to wait for more than twenty-four hours before deplaning. They found each other camped out on nearby cots in the Society of United Fishermen Hall in the small community of Gambo, about forty kilometers (twenty-five miles) from Gander. Nick was immediately impressed with Diane when she picked up his tab at a local convenience store. They were married in 2002 and returned to Newfoundland for their honeymoon.**

**DIANE:** A single journey for each one of us changed the course of the rest of our lives.

**NICK:** You'd like to think if this had happened in any part of the world that people would have rallied together and bonded so well. I'm not so sure that would happen.

**DIANE:** Everything was done to keep our spirits up, and theirs too at that point.

**NICK:** You had this wonderful, caring, safe harbor of people, and then you had these terrorists who did these unimaginable things to strangers. You can't put the two in one place. You could not believe they were both in the same world.

**DIANE:** We wanted to say thank you to the people of Newfoundland for all their hospitality, for opening their hearts, their pantries, their pocketbooks. Here, we just found a little bit of heaven with a bunch of angels who live there.

**NICK:** The first time we saw the show, we had no idea. We'd given this young couple our story . . . and we had no idea what they'd do to us, but they did us well; they did us proud. It really did happen the way you see it.

**DIANE:** It's like renewing your vows in the theater every night.

**LEE MacDOUGALL (NICK):**

Sharon [Wheatley] and I met Nick and Diane in La Jolla. It was very sweet to meet them; they're a very sweet couple. The lovely thing for us was that we went out for a drink with them and we were able to sit with them and say, "Okay, on the first day what did you do and on the second day what were you feeling?" It was just amazing because all this stuff that you normally would have to make up, a lot of it is already in the script from David and Irene's interviews. Then we got to fill in all the other blanks by just going through the day by day with them. They told us about flirting when they went to the Dover Fault and Nick taking a picture of her. We saw the picture that he took of her and then when we went to Gander,

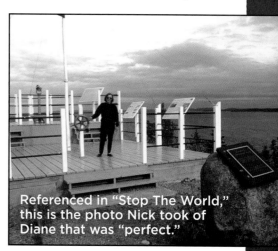

Referenced in "Stop The World," this is the photo Nick took of Diane that was "perfect."

we actually went to the Dover Fault with them. They took the microphone from the bus driver and narrated the trip to the Dover Fault saying, "And there's where we stopped and bought the candy and there's where we—" and so on. So we've been able to plot their courting and their story after that as well. It was really amazing. And no, no, they didn't "get together" in Gander. No, not in Gander. After Gander they talked on the phone for months until they finally agreed that they were gonna get together.

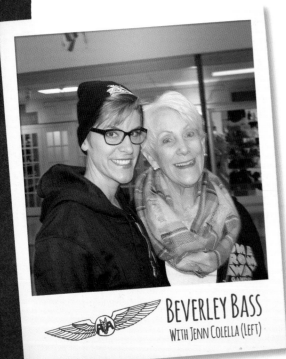

BEVERLEY BASS
WITH JENN COLELLA (LEFT)

**BEVERLEY BASS was the first female captain at American Airlines and in 1986, she was the captain of American's first all-female crew, which included a copilot, a flight engineer, and three attendants. She was the pilot of an American Airlines plane, the thirty-sixth of thirty-eight flights diverted to Gander. She retired in 2008. Using her free-flying privileges as a now-retired pilot, she has followed the musical's developmental journey from La Jolla to Seattle to Washington to Gander to Toronto to New York, often with other female pilots in tow.**

I had left Paris and I was flying to Dallas. Our absolute location was dead-smack in the middle of the North Atlantic. I was westbound. We have a frequency that is called air-to-air frequency. It was on that frequency that someone said an airplane has hit the World Trade Center. We really didn't think that much of it. We just figured it was a light airplane. Not that that isn't terrible in itself, but we thought it was some small airplane. We kept flying westbound. Then bits and pieces came across the frequency. First, it was New York's airspace was to be closed. Then it was all of the U.S. airspace was closed. At that time, we knew we were going to have to divert somewhere. We just didn't know where.

As we approached fifty degrees west, they told us to divert immediately to Gander. That's what we did. While we were still on the airplane, the passengers were actually learning more about what was going on than we. The passengers were in touch with their offices. They were filling us in on the details of what was going on.

[My plane] was overweight. I knew I was going to be overweight for landing in Gander. I had to decide if I was going to jettison four thousand pounds of fuel out over the Atlantic or was I going to land overweight. I opted to jettison the fuel. We went out and did that, and then came in on a ninety-five-mile final

approach to Gander. As we continued our approach and landing, the airplanes were parked everywhere. They were like sardines. They were on taxiways. They were on runways. They were everywhere. I just barely had room to squeeze that thing in.

We landed at ten in the morning, roughly. They told us we would not get off the airplane until the next day. We had one meal service left, which is the final meal they do coming into Dallas. The flight attendants served that at about five in the afternoon and we put movies on and they put the passengers to bed, pretty much. During our extended stay on the airplane, one French lady claimed to be claustrophobic; she became quite belligerent. I reached the limit of my patience with her and called the Royal Mounted Police to come take her off the plane. They came onboard and quickly explained to her that the claustrophobia that she was experiencing on the airplane was nothing like what she might feel in a jail cell if she continued to interfere with the crew. So, she decided to become a model passenger for the rest of our time together.

The flight crew and I were able to go to the Comfort Inn in Gander. We were one of the lucky ones. My passengers were at the Knights of Columbus lodge, so I went to brief them a couple of times every day. The one thing I begged them was "Please stay with me. Do not leave." And they did—they stayed.

I remember shortly after I got back [to Texas], a lot of people didn't want to fly. [The week after 9/11] they called some of us pilots out to the airport and asked us to come out in uniform. It was

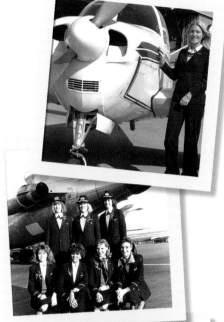

Flying for a mortician, an all-female crew, and Captain Bass with "the prettiest planes."

awful. The airport was like a morgue. The taxicab drivers had no business. All the shops were closed. The vendors had no business. The skycaps. People had no idea how it filtered down, not just for pilots and flight attendants. It just went on forever. It was like a cancer. It was an eerie time. A terrible one. You would go up to a gate and there might be two people sitting there. Our job was to thank them for having the courage to still fly and to trust us and all of that. So, I was grateful that anyone was still flying.

There are still times [watching the show] when I'll tear up. My face hurts at the end of it because I have a constant smile the whole time. Audiences look at [my song] as such an accomplishment for women. I'm not an activist in any way, but I do think the audience sees it differently. Most of the country don't know about Gander, so I always wanted the town to get the respect it deserves. The play is not about me but the gift that Gander gave us in the darkest of times.

### JENN COLELLA (BEVERLEY BASS):

I met Captain Bass the night before we opened at the La Jolla Playhouse. She had arrived; we had just finished a preview performance and we were all hanging out at a restaurant and we saw one another from across the room and she made her way over to me and said, "I think you're playing me" and I said, "I think you're right!" She and her husband, Tom, started to tell us their story of their time in Gander—she hadn't seen the show yet. And she told me, "You know, we have this map on the wall where we'd put pins on it" and I was like, "You don't say?" And then she was, like, "those people were on the planes for twenty-eight hours!" and I was, like, "Really!"

I knew that they were gonna flip out when they actually saw the show and, indeed, I could see her throughout the whole show and she had her face in her hands and was crying uncontrollably and kept reaching for Tom. I'm not a robot—I could feel something inside of me start to break. And yet, I have a job—Beverly remained stoic through those five days, and I'm in those five days.

I like seeing her publicly versus privately because, in public, there are definitely some differences there that I know, in my heart, might inform the character a little bit. She does this thing with her hands, a sweeping motion with her finger that I incorporate one or two times in the show, but other than that, we kind of look alike already so there wasn't too much work to be done. She was a badass pilot, so I was like, "Let me play a badass pilot!"

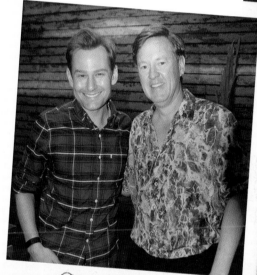

KEVIN TUERFF
WITH CHAD KIMBALL (LEFT)

KEVIN TUERFF and KEVIN JUNG were vacationing in Europe together the first weeks of September 2001. Tuerff is a marketing consultant and author; Jung, an attorney and writer, was his partner at the time. Jung had a particular fondness for Grey Goose vodka and managed to snag two large bottles at the duty-free shop before their plane departed from Paris.

### KEVIN TUERFF:

I first saw the initial staged production at Sheridan College. I cried throughout the entire performance because they had captured the true essence of both the come-from-aways and the local Newfoundlanders. But when the actor playing me started singing the Prayer of St Francis, my heart stopped, and I couldn't breathe. It's true, that prayer went through my head during this time, but I never remember telling the writers. So how did they know? Apparently, I mentioned it during the interview, but I sure don't remember.

When I saw actor Chad Kimball start singing "Prayer" opening night at La Jolla Playhouse in 2015, I lost it all over again. I hadn't met my official doppelganger, and I was truly honored by his portrayal of me, and his beautiful singing voice.

The entire experience related to the inspired me to write a memoir, *Channel of Peace*, about my 9/11 experience. Compassion wasn't just a 9/11 thing in Gander. After visiting Newfoundland and Labrador many times, I see it's an everyday thing, a beacon to the world by demonstrating the Golden Rule: treat others as you want to be treated (even gay lumberjacks).

### CHAD KIMBALL (KEVIN T.):

I first met Kevin on opening night at La Jolla Playhouse. Meeting a person who you play on stage is surreal. And it rarely happens, which made this all the more special. Being able to get to know Kevin over the four out-of-town tryouts, the Gander concert experience, and then opening on Broadway allowed me not only to hone his character to but to

witness his remarkable spirit of goodwill and kindness. Kevin really does practice what he preaches. Kindness is not the easiest choice in our world and caring for others takes effort and discipline. Being able to sing "Prayer" and summon strength and mercy from God every night on stage is a humbling experience. Kevin, his story, and his daily effort in kindness is the source material for that daily gift. sing "prayer" and summon strength and mercy from God every night on stage is a humbling experience. Kevin, his story and his daily effort in kindness is the source material for that daily gift.

### KEVIN JUNG:

I first saw *Come From Away* in December of 2015 in Seattle shortly after I found out about it. While I had a vague idea what to expect, the piece moved me to my core—I both wept and laughed uncontrollably at times, and completely annihilated two cotton handkerchiefs in those extraordinary 100 minutes. Even though I had understood every word, it was impossible for me to process what I had just seen (so I extended my reservations and attended two more performances!).

I couldn't sleep after that first show, and a million thoughts raced through my mind all night long. I am a lifelong lover of this genre, and have seen more musicals than I care to admit. But upon my first viewing I knew that *Come From Away* was unique. This incredible and poignant true story, told with startling accuracy (especially for musical theater), could only have been created by people who truly love and understand the music, culture, and indomitable people of

Newfoundland. Luckily, David and Irene were entrusted with bringing it to the stage. I no longer count the number of times I've seen it, but I still react to it just like the first time.

### CAESAR SAMAYOA (KEVIN J.):

I think all of our characters were kind of firmly established before we had met any of [the real people]; It's a testament to this amazing writing. We had already finished the La Jolla production and I hadn't been able to get in touch with Kevin. I was back home in New York, really late at night, and I got an email that said, "My name is Kevin and I think you play me in a musical." From that point on, we got in touch with him, and I had dinner with him first in Seattle, and he told me all these stories about his time—and little did he know that all the stories that he told me, he was about to see portrayed. It was amazing, I'll never forget seeing him during the curtain call, he was sitting next to Beverley Bass and he was crying so much and kind of just grasping onto her. He even had this big bottle of Grey Goose.

**KEVIN JUNG**
WITH CAESAR SAMAYOA (RIGHT)

# SATURDAY, SEPTEMBER 15, 2001

The giving back started before the last plane left the tarmac.

By Saturday afternoon, Gander airport control had sorted out most of their agenda; they were able, on average, to get a plane up in the air every two hours. Emergency operations was able to get buses to bring passengers to the airport without incident and any breaches of security were either quickly solved or would take care of themselves.

As stranded passengers were getting the calls to pack up and move out with greater frequency, local volunteers noticed a strange phenomenon: people wanted to give them money. Sally Breer, a resident of New York, who spent four days at the College of the North Atlantic, said, "We were all sitting around and thinking how we can help because they've been so wonderful

here." Her fellow shelter companions raised over five thousand dollars in donations, large and small, to go toward the college. Despite demurrals and mild protestations, collections were also raised by visitors for the local Lions Club, St. Paul's Intermediate School, and the Knights of Columbus.

When an old ballot box was turned into a collection bin, Gander Academy received more than twenty-seven thousand dollars in donations. A flight captain from Virgin Airlines donated five thousand dollars and the airline matched his contribution with a five-thousand-dollar donation, as well as some round-trip tickets to London for two students, their parents, and a teacher. In the days that followed, the town of Gander received over three thousand dollars' worth of checks at town hall, most of which came with cards of thanks, telling the town to do

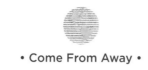

Counting generous donations in currencies from around the world at Gander Academy.

getting the outpour that's been coming into the community and surrounding areas."

While plans of what to do with the contributions may have been up in the air, the most extravagant contribution was up in the air too. Delta Air Flight 15 had originated in Frankfurt, before being detoured to Gander. Its nearly four hundred passengers were bused to nearby Lewisporte on the afternoon of the 15th and they were among the last flights out, headed to Atlanta. Shirley Brooks-Jones was one of the passengers; she had plenty of work experience in development and charitable giving. Once they were in the air, a thought struck her: "I knew that once we got to Atlanta, we would scatter to the four winds. We would never see each other again and we would all feel bad that we hadn't done something." Robert Ferguson, a doctor from North Carolina, and a fellow passenger, concurred and suggested the idea of a college scholarship fund.

Obviously, flight security was tighter than ever in the days following 9/11, but Brooks-Jones, undeterred, got the captain of Flight 15 to allow her access to the PA system. She advocated Ferguson's idea to her fellow passengers, to raise some money for a college scholarship fund for graduating seniors at Lewisporte Collegiate. "It's really difficult to

whatever they thought best with the money. Mayor Claude Elliott, whose desk was covered with thank-you letters, cards, and faxes, told the *Gander Beacon* a few weeks later: "Never in our wildest dreams did we expect to still keep

explain, you know, when you weren't there," Brooks-Jones later told a reporter. "[The folks in Lewisporte] were just awesome. They were so generous, kind, gentle, very perceptive. They could tell the passengers who needed extra tender loving care . . . very, very perceptive people. They wouldn't take any money from us. They just looked at us and said, 'You would do the same for us.'"

By the time the flight taxied down the runway at Hartsfield-Jackson Atlanta International Airport, the passengers had raised fifteen thousand dollars. The first scholarships were awarded in 2002 to graduates with an average of 85 percent or higher over their three years of high school. The fund has since grown to nearly a million dollars. As of 2018,

228 graduates from Lewisporte Collegiate have received scholarships.

In his 1841 essay on "Compensation," Ralph Waldo Emerson wrote, "In the order of nature we cannot render benefits to those from whom we receive them, or only seldom. But the benefit we receive must be rendered again, line for line, deed for deed, cent for cent, to somebody. Pay it away quickly in some sort." Wayne Witheral, the principal of Gander Academy, took on Emerson's admonition with a typically Newfoundlander shrug: "All we did was provide them with a place to sleep, with food, and showers. We didn't anticipate anything more coming out of it than that," he said, "but I guess they felt they needed to do something."

Shirley Brooks-Jones boards Delta flight number 15 with fellow passengers.

*Re-boarding Delta Flight 15 @ Gander, Newfoundland Airport*

# Good BYES

**CLAUDE**
9:35 a.m.

**ALL (EXCEPT CLAUDE)**
Saturday.

**CLAUDE**
September 15. Finally, they get the planes going again—and I go down to tell the Wish Kids that they're being sent home without getting to Disney World after all. But they're not sad about it. They're going on hayrides, canoe rides, and someone dresses up as the town mascot: Commander Gander. And it turns out that if they'd made it to Orlando, they would've got four days of rain. ⑲

---

*CLAUDE*
*September 15. Finally, they get the planes going again—but now we're missing passengers. One guy is found in the bar. Others say they can't fly today because of their religion. And another guy—he went missing completely—till we found out that one of the locals had invited him moose-hunting. Two more were up on Dover Fault taking in the view. But we eventually got everyone to where they were meant to be.*

---

*Bonnie is alone in the hangar with the animals.*

**BONNIE** *(to Doug)*
I'm just doing one more litter scoop, and then I'll get them on the planes!

*Actor 3 meows. Bonnie bends down to a carrier.*

Lyle. You're a beautiful cat. I've taped your pill bottle to your carrier and made sure someone'll see it. You did good. You're going to be fine.

*Actor 3 barks. Bonnie moves along.*

Ralph. You're a good cocker spaniel. I know the night security crew ran you a bit ragged, so I want you to get some sleep on the plane, okay?

*Actor 3 barks again.*

Okay.

*She moves along.*

. . . Unga . . . I've never met a rare Bonobo chimpanzee before. We don't get many of them here in Newfoundland. And since your partner there likes to throw his own feces, I'm going to say that you are the nicest rare Bonobo chimpanzee I've ever met . . . And I want you to know that I'm sorry . . . I'm sorry that you lost your baby . . . I've got three, and some days they're more trouble than they're worth . . . Anyway. You're going to be okay.

---

**BEULAH** *As the busses start to load up, we're checking all the classrooms to make sure no one's left behind— and on a chalkboard—one of the passengers drew this incredible sketch—of a goose in flight—every feather incredibly detailed.*

**JANICE**
*In one of the shelters, we find someone's wedding ring.*

**GARTH**
*Under the seat on one of our buses, I find a family bible.*

**OZ**
*But we have no way to contact them.*

**BEULAH**
*And the drawing—it's just chalk. Next week, it'll be wiped off. But right now—it's beautiful.*

---

**BEVERLEY**
The winds start to pick up. Fifty-mile-an-hour winds. We've been here too long. We're still on the ground and there's a hurricane coming. And I'm thinking— we're running out of time. We have to leave. We have to leave now.

---

*Bonnie runs toward Doug in the airport.*

**BONNIE**
*Doug! I've got to get back on.*

**DOUG**
*They're all loaded up, Bonnie.*

**BONNIE**
*I forgot to put return addresses on the carriers!*

**DOUG**
*They're gonna be fine.*

**BONNIE**
*I'll never know if they made it okay. I've got to—*

**DOUG**
*Bonnie. They're gonna be fine. You did good. You gotta let them go.* ⑫⓪

⑪⑨ **IRENE:** This speech was originally given by Oz, but was shifted to Claude, cutting his previous speech, which we still miss.

⑫⓪ **IRENE:** Bonnie only received updates about a couple of the animals. Ralph's adopted family sent pictures, and she was able to keep tabs on Unga. And Petrina, who plays Bonnie, eventually met Ralph's family when they came to see the show.

**⑫ DAVID:** The original lyric here was "AND OUT THE WINDOW WE SEE OVER A GAMBO A RAINBOW." Nick and Diane, who were housed in Gambo, told us that when they left, there was a rainbow, and they knew they'd "always be under the same sky" (which we knew was sadly too sweet to put in a musical). I miss this lyric mostly because it's what our daughter still sings (she sings it to our cat, named "Gambo").

**ALL (VARIOUSLY)**
ONE PLANE THEN ANOTHER AND THEN
NINE PLANES THEN ANOTHER AND THEN
THIRTEEN PLANES THEN ANOTHER
   (NINETEEN PLANES THEN ANOTHER)
TWENTY-TWO—TWENTY-FOUR—
   TWENTY-NINE—THIRTY-TWO
THIRTY-EIGHT THIRTY-EIGHT THIRTY-EIGHT
THIRTY-EIGHT THIRTY-EIGHT THIRTY-EIGHT
THIRTY-EIGHT THIRTY-EIGHT THIRTY-EIGHT
THIRTY THIRTY THIRTY-EIGHT PLANES

*On a plane, Beverley makes an announcement.*

**BEVERLEY**
LADIES AND GENTLEMEN: IF YOU LOOK OUT YOUR
   WINDOWS
UNDERNEATH ALL THAT RAIN—IS MAINE
WE'VE JUST CROSSED THE CANADIAN BORDER
WELCOME BACK TO THE U. S. OF A.

*The passengers cheer.*

**BOB**
LOOKING OUT THE WINDOW AT THE WORLD
   UNDERNEATH

**DIANE**
AND THOUGH HE'S HERE NEXT TO ME, IN A SECOND
   HE'LL GO ⑫

**KEVIN J**
LOOKING OUT THE WINDOW

**KEVIN T**
KEVIN, TALK TO ME, PLEASE.

**HANNAH**
AND OUT THE WINDOW WE SEE

**ALL**
A PLACE WE ALL KNOW BELOW

*Beverley hands Bob the microphone.*

**BOB**
IS THIS ON? OH, IT'S ON. SORRY, EVERYONE—HI!
LIKE MOST EVERYONE, I AM SORRY SAYING GOODBYE
SO I WANTED TO THANK THEM FOR ALL THAT THEY DID
SO I'M DOING JUST THAT—AND I'M PASSING A HAT
FOR THE PEOPLE WHO GAVE UP THEIR TIME
AND THEY GAVE UP THEIR TOWN
SO LET'S GIVE THEM A SCHOLARSHIP! ⑫
PASS THE HAT DOWN, 'CAUSE

*Bob holds up his Sou'wester hat and passes it along.*

# MIDDLE OF NOWHERE

**1, 2, 6, 7, 8 & 9**
SOMEWHERE—IN THE
    MIDDLE OF NOWHERE
IN THE MIDDLE OF WHO
    KNOWS WHERE

THERE YOU'LL FIND

**ALL**
SOMETHING—IN THE MIDDLE OF NOWHERE
IN THE MIDDLE OF CLEAR, BLUE AIR—YOU FOUND
    YOUR HEART
BUT LEFT A PART OF YOU BEHIND

**DIANE**
Nick and I sit together and I just want to say
something, but we're leaving . . . and it's over . . .

**3, 4, 5, 10, 11 & 12**
SOMEWHERE—IN THE
    MIDDLE OFNOWHERE
IN THE MIDDLE OF WHO
    KNOWS
    (WHO KNOWS)
THERE YOU'LL FIND

**NICK**
And then she starts crying. And I don't know what to
say, so I just put my arm around her—and I go to kiss
her on the forehead—to comfort her.

**DIANE**
Well, there was some turbulence—and honestly, I just
thought he missed! So I—

*She grabs Nick and kisses him.*

**BEVERLEY**
LADIES AND GENTLEMEN, IF YOU LOOK OUT YOUR
    WINDOW
YOU WON'T WANT TO MISS THIS—WE JUST ENTERED
    TEXAS!

122 **IRENE:** Though there's a
much-shared online article
from a flight attendant on
Delta 15, which details how a
man made this announcement,
it was actually made by Shirley
Brooks-Jones, a diverted
passenger who was housed in
Lewisporte. Shirley has since
returned to Newfoundland
29 times and has granted
scholarships to more than
270 students.

**123** **IRENE:** Chad Kimball has always been a very "method" actor but he absolutely proved himself when he threw his neck out while doing the choreography here. As the cast sings their lyric "Home America," they jolt their bodies forward, signifying the plane landing. As they all came back up to neutral, Chad immediately had his hand on his neck. Once he delivered the news of what he done and started laughing, we all joined him.

**2, 6, 1 & 5**
SOMEWHERE
IN THE MIDDLE OF NOWHERE
IN THE MIDDLE OF WHO
  KNOWS WHERE

THERE YOU'LL FIND

SOMETHING
IN THE MIDDLE OF
NOWHERE
IN THE MIDDLE OF
CLEAR, BLUE AIR
YOU FOUND YOUR HEART
BUT LEFT A PART OF YOU
  BEHIND

**3 & 4**
SOMEWHERE
IN THE MIDDLE OF NOWHERE
IN THE MIDDLE OF WHO
  KNOWS
WHO KNOWS
THERE YOU'LL FIND

SOMETHING
IN THE MIDDLE OF

SOMETHING
IN THE MIDDLE OF
NOWHERE
IN THE MIDDLE OF
CLEAR, BLUE AIR
YOU FOUND YOUR HEART
BUT LEFT A PART OF YOU
  BEHIND

**7 & 8**
(SOMEWHERE)
(NOWHERE)

WHO KNOWS WHERE
  YOU'LL FIND

SOMETHING
IN THE MIDDLE OF

(SOMETHING)

(NOWHERE)

WHERE
YOU FOUND YOUR HEART
BUT LEFT A PART OF YOU
  BEHIND

**9, 10, 11 & 12**
SOMEWHERE
IN THE MIDDLE OF NOWHERE
IN THE MIDDLE OF WHO
  KNOWS WHO KNOWS

THERE YOU'LL FIND

SOMETHING
IN THE MIDDLE OF
NOWHERE
IN THE MIDDLE OF
CLEAR, BLUE AIR
YOU FOUND YOUR HEART
BUT LEFT A PART OF YOU
  BEHIND

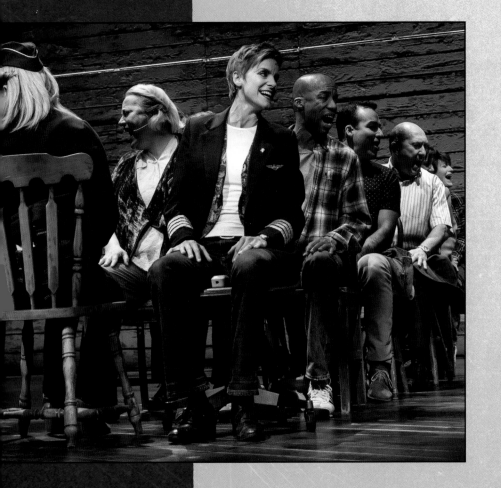

**JOEY**
Everyone's drinking and comparing stories.

**DELORES**
Where did you stay? What did you do?

**DIANE**
But mostly Nick and I spend the plane ride home canoodling in the back.

**NICK**
At one point, a flight attendant comes 'round saying . . .

**FLIGHT ATTENDANT**
Hot towel? Hot towel?

*She looks at Diane and Nick kissing.*

Cold towel?

**2, 3, 6, 9, 10, 11 & 12**
SOMEWHERE IN BETWEEN
THE PACE OF LIFE AND WORK
AND WHERE YOU'RE GOING

**1, 4, 5, 7, 8, 11 & 12**
SOMETHING MAKES YOU STOP AND NOTICE

**1, 4, 5, 7, 8, 9 & 10**
AND YOU'RE FINALLY IN THE MOMENT

| | |
|---|---|
| **2, 6, 1, 7, 8 & 9**<br>SOMEWHERE<br>IN THE MIDDLE OF NOWHERE<br>IN THE MIDDLE OF WHO KNOWS WHERE<br><br>THERE YOU'LL FIND | **3, 4, 5, 10, 11 & 12**<br>SOMEWHERE<br>IN THE MIDDLE OF NOWHERE<br>IN THE MIDDLE OF WHO KNOWS<br>WHO KNOWS<br>THERE YOU'LL FIND |

| **ALL WOMEN** | **7 & 8** | **9, 10, 11 & 12** |
|---|---|---|
| SOMETHING | (SOMETHING) | SOMETHING |
| IN THE MIDDLE OF | | IN THE MIDDLE OF |
| NOWHERE | (NOWHERE) | NOWHERE |
| IN THE MIDDLE OF | | IN THE MIDDLE OF |
| CLEAR, BLUE AIR | WHERE | CLEAR, BLUE AIR |
| YOU FOUND YOUR HEART | YOU FOUND YOUR HEART | YOU FOUND YOUR HEART |
| BUT LEFT A PART OF YOU | BUT LEFT A PART OF YOU | BUT LEFT A PART OF YOU |
|    BEHIND |    BEHIND |    BEHIND |

**BEVERLEY**
LADIES AND GENTLEMEN
PUT YOUR SEAT BACKS
AND TRAY TABLES UP
RIGHT BELOW US IS THE CITY
WHERE I GREW UP
COMING 'ROUND PAST THE
FIELD, THEN THE WHEELS    **7, 8, 9**
TOUCH THE GROUND    HOME, AMERICA ⑫③
TAXIING, WE'RE ALL CHEERING,    HOME IN AMERICA
WE'RE DOWN!    **ADD 3, 4, 5**
THANKING EVERYONE—THANK    HOME, AMERICA
YOU FOR FLYING AMERICAN!    HOME IN AMERICA
HUGGING THEM    **ALL**
HUGGING MY CREW CAUSE    HOME, AMERICA
WE'RE HOME AGAIN    HOME IN AMERICA
PAST THE GATE    HOME, AMERICA
UP THE STAIRS    HOME IN AMERICA
AND WE'RE THERE
AND HE'S WAITING IN LINE    HOME

    *(acapella)*
NO, I'M FINE TOM, I'M FINE

> "Coming 'round past
> the field, then
> the wheels
> touch the ground."

# THE ROAD TO BROADWAY

Back in the old days on Broadway, when critics only came to opening nights and dashed up the aisle to file their review before the final curtain hit the floor, you didn't know if you had a hit or not until the newspapers came off the presses a few hours later.

At the first preview of *Come From Away* at the La Jolla Playhouse, on May 29, 2015, they knew before the show was even over. In most musicals, after the curtain call, there's something called the "playoff"–a kind of anodyne "exit music" that gets the audience out of the house–but Chris Ashley remembers, "The playoff music started and nobody left the theater, they all stayed there after

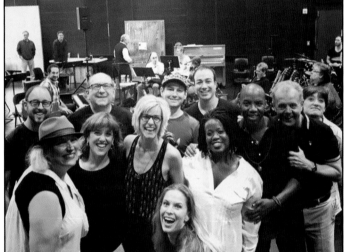

**The first rehearsal at La Jolla Playhouse in 2015.**

the standing ovation and clapped along to the music." The playoff would quickly evolve into a fully staged and fully lit three minutes of music jamming: "Not because I planned to do it, but because the audience clearly wanted it."

When the audience finally did file out into the lobby after the first preview, "they wouldn't leave," recalls Sue Frost. "They all wanted to just keep talking about it. They weren't necessarily talking about the show, they were complete strangers talking to each other and sharing stories." La Jolla Playhouse has had more than its share of developing major musicals for Broadway, stretching all the way back to *Big River* in 1984, but *Come From Away*–its eighteenth musical to make it to New York–hit audiences in an impressive way. "The next day, the box office exploded," recalls Frost. "The word of mouth on the show was not like anything we'd ever seen. It was not about telling other people to go see it–they were coming back and buying more tickets so they could bring more people with them." "Then," added Randy Adams, "after our reviews came out, which were good, the box office really exploded." Irene Sankoff was hit hard–in a good way: "We went from being this unknown show to people lining up for three hours in the

hopes of getting tickets. I was walking around in a daze."

The production had been scheduled to move to the Seattle Repertory Theatre in the late winter of 2015–a "co-pro," it's called in showbiz–and with a few minor cast tweaks (Kendra Kassebaum didn't play La Jolla, but rejoined the company after the Seattle workshop), the show opened to the same kind of rapturous response. "The theater there was much bigger and I remember the look on the cast's faces after the final blackout when the audience responded," said Sankoff. "They said it was like being hit by a wall of sound." The Rep's phone lines crashed the next day because of people asking for tickets.

In Seattle, the show broke decades-long box-office records at the Rep (including highest grossing show and largest single ticket sales day) and, while it was playing, "the word kind of bubbled up and spread," says Frost. The theater even declared an official "Gander Day" on December 8, inviting Claude Elliott to see the show and featuring a talk-back session with Canadian Consul General James K. Hill, Seattle Mayor Ed Murray, and Elliott.

"We decided that we were going to have a future for it beyond the Rep," said Frost, "and started making plans." Part of those plans involved taking the first steps to bring the show to the East Coast and to the places most affected by 9/11. "We always talked about the title–was there another title? How do you keep people from calling it *Come Fly Away* or *Come Over Here* or all of those other things that they do?" asked Frost. "After Seattle, a bunch of us went to the National September 11 Memorial and Museum

Logos from various productions: Sheridan, NAMT, La Jolla Playhouse, Seattle Repertory (initial and final), and England.

**Sankoff at the Pentagon with survivor Kathy Dillaber, who lost her sister in the attacks.**

in New York and the docent said, 'Over here is the 9/12 section of the museum where we tell some of the good stuff that happened afterward.' From that moment on, we decided to think of ourselves as the 9/12 musical."

In the fall of 2016, the production moved to the historic Ford's Theatre in Washington, DC—no stranger to the intersection of tragedy and history—where the show was meeting not only audiences who experienced the events of 9/11 in their own backyard, but the shifting tectonics of current events. Peter Marks, in his review in the *Washington Post*, remarked on this: "The 15th anniversary of the terrorist acts that resulted in 3,000 deaths in New York, Pennsylvania and Washington—and a fundamental change in the way Americans think about the world—occurs on Sunday. For anyone with even a faint memory of or connection to those events, the musical by the husband-and-wife team of Irene Sankoff and David Hein will reach into a place in your gut you may have wanted left undisturbed."

The production gave a preview performance at Ford's for survivors of the Pentagon attack and families of some of the victims, and two performances on September 11, including a talk-back with passenger Kevin Tuerff, after the matinee. "It was a somewhat quieter audience than we were used to, but very responsive,"

remembers Sue Frost. "Many stayed after to chat, and the universal feeling was one of gratitude–of telling a good story on a day that held nothing but sorrow for them. Very humbling." For Sankoff, "The run at Ford's was surreal because there were so many politicians in the audience, from both sides of the aisle. And they reacted the same way to this story of kindness–with laughter and tears. We got to tour the Pentagon with a docent named Kathy Dillaber and meet with many of the survivors and families. It was incredibly moving."

While it was clear from the run in Washington, DC, that even the most deeply affected American audiences would embrace the show and its message, there were more journeys yet to go in its future and during the run of the Ford's engagement, the producers and their creative team were emboldened by the feeling that they had turned a corner; the perception of the show was now something beyond either a gimmick or an immense faux pas. Sue Frost realized that "we referred to

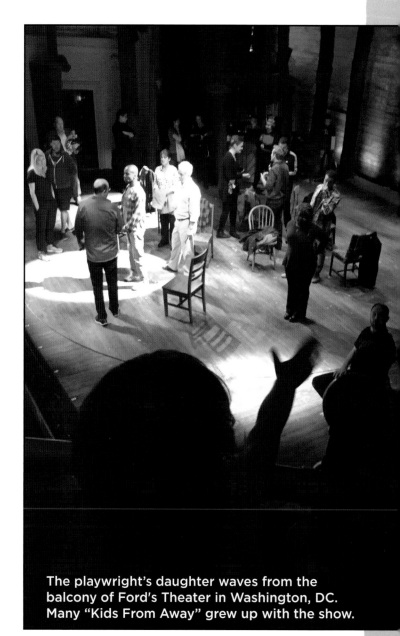

The playwright's daughter waves from the balcony of Ford's Theater in Washington, DC. Many "Kids From Away" grew up with the show.

Collection of research materials posted at La Jolla Playhouse.

[our characters] as 'plane people.' But then, we stopped calling them 'plane people' and started calling them 'come-from-aways' consistently. It kept reinforcing the title and reinforcing the 9/12 connection and reinforcing the identity of the show."

The next step was to land their ensemble of come-from-aways in the place where it all began.

# SUNDAY, SEPTEMBER 16, 2001

Now, it was almost all over but the cleaning.

On Sunday afternoon, the last flight left Gander for home, Delta Flight 37. By the end of the day, all of the other stranded planes in Canada were traversing the skies, homeward bound. American airspace was still a shadow of its former self, as the industry was operating at about 70 percent of its normal capacity. Schedules still hadn't been completely straightened out and many people were still jittery about getting back on airplanes; a few airlines began steps to file for bankruptcy.

This anxiety filtered back to Gander. Some people stayed behind—not quite yet prepared to face a long trip back to Europe and then a return flight to the United States— and another few were able to get around the earlier restrictions and switch their flights.

These were minor headaches, easy to sort out with patience and common sense.

But, as each flight left, as each group of 200, 300 stranded passengers packed up and made their way home, everything left in their wake had to be put right. The cleaning effort began the moment each group left; there was no reason not to start school on the Monday—except that each school had to be put back together as if nothing happened. Gander Academy had used thirty-three classrooms and two gymnasiums—shower stalls included—which had to be disinfected, cleaned, straightened out. On the afternoon of Monday, September 17, the town council of Gander met and agreed to stand down from the state of emergency; unfortunately, this meant that the unionized school employees—which included janitorial staff— went back on strike, so volunteers,

including the Salvation Army, came in to do the job. There was some tension when the school board felt the board of health was being too particular about its standards of cleanliness, but the health officials had final say; in fact, they directed that every wall of every school and shelter had to be scrubbed and disinfected from the height of a grown man's outstretched handprint down to the ground. By Monday evening, nearly all the schools and public spaces had been approved by the community board of health—except one, St. Paul's Academy. That wouldn't be cleared for occupancy until Tuesday the 18th at noon.

It was nearly one week to the minute since the planes started landing in Gander.

A thorough clean-up—top to bottom—was mandated by the local board of health.

Although the department of health thought it important to bring some social workers on board for the Gander residents to process what they nearly all went through, they weren't much used. Life went quickly back to normal. "It was like a light switch," said Constable Oz Fudge. "We flicked it back on, and we were just the way we were."

Mayor Claude Elliott commented some time later, "September 11 changed the world forever, but it didn't change the people of Gander and surrounding areas and the way they operate, willing to help your people in a time of need . . . if any time there's a tragedy, you feel free to drop by Gander. We will be here."

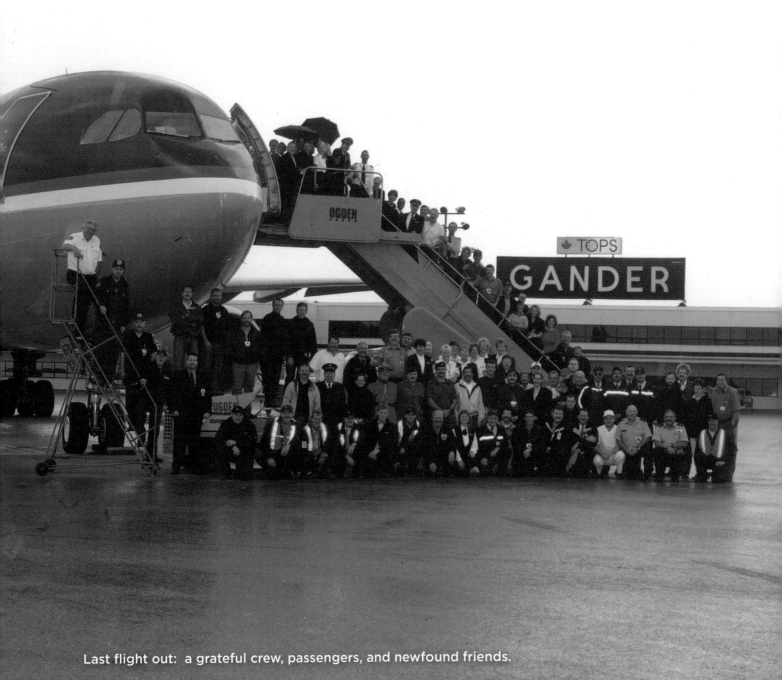

Last flight out: a grateful crew, passengers, and newfound friends.

# SOMETHING'S
## *Missing*

*Diane and Nick face each other.*

**DIANE**
So . . .

**NICK**
So . . .

**DIANE**
So you'll call?

**NICK**
As soon as I get back.

**DIANE & NICK**
And then he/she left

And then I was alone.

**JANICE**
BACK TO THE WAY THAT THINGS WERE

**OZ**
BACK TO THE SIMPLE AND PLAIN

**DWIGHT**
FOR FIVE DAYS THE WEATHER HAD BEEN SO NICE

**BONNIE**
BUT AS THEY BOARDED IT STARTED TO RAIN ⑫④

*A moment, as they all look up.* ⑫⑤

⑫④ **DAVID:** One of the few moments where no one speaks on stage—and also a callback to the threat of Hurricane Erin earlier. Though it hit other areas harder, this rain was Erin finally arriving.

⑫⑤ **IRENE:** At the first Seattle workshop, they were all seated at tables and still reading from their scripts. On a whim, Chris asked them to look up at the sky at that moment. That simple movement brought tears to our eyes. And that was the way the rest of the movement of the piece turned out. Simple and strong.

**BEULAH**
AT THE END OF THE DAY, AFTER EVERYONE LEFT

**OZ**
WE ALL TRIED TO GO BACK TO NORMAL EXCEPT

**CLAUDE**
THE TOWN WAS MORE QUIET AND SOMEHOW FAR
    EMPTIER

**BONNIE**
WE ALL LOOKED THE SAME, BUT WE'RE DIFFERENT
    THAN WE WERE

**BEULAH**
THE GYM WAS A SIGHT—AS I STACKED THE LAST
    COT

**DWIGHT**
THANK-YOUS WRITTEN EVERYWHERE AND THINGS
    THEY FORGOT

**CLAUDE**
THE BOARD OF HEALTH SAYS CLEAN IT UP—EVERY
    PART

**ALL**
SO WE START

**CLAUDE**
7:42 a.m.

**ALL (EXCEPT CLAUDE)**
Sunday.

**CLAUDE**
September 16. After five days, they just ran the
Zamboni over the ice. And played hockey.

With the plane people gone, I tell my staff,
"Go home, get some sleep." We were all
exhausted—just spent—most of us had been up
for five days straight working. But somehow,
I can't sleep, so I sit down and turn on the
television. And I just start crying. I hadn't let
myself cry the whole time.

**ALL (EXCEPT CLAUDE)**
SOMETHING'S GONE

**BOB**
Out the airplane window, I can see Manhattan
and there's still smoke. And suddenly I'm afraid
all over again—and there are others afraid too.

**ALL (EXCEPT BOB)**
SOMETHING'S OVER

**BOB**

I know Newark airport. You could pull a truck over on the side of the turnpike and shoot a grenade launcher at a plane coming in.

**ALL (EXCEPT BOB)**

SOMETHING'S DONE

**BOB**

But nothing happens.

**KEVIN T**

I drive Kevin back to his place. We don't say much.

**ALL (EXCEPT KEVIN T)**

SOMETHING'S MISSING

**HANNAH**

I go straight to his firehouse. Part of me wondered if they just weren't telling me, but . . . they still don't know.

**ALL (EXCEPT HANNAH)**

SOMETHING'S CHANGED

**NICK**

My flat is the same as I left it. But emptier. Quieter. I start to unpack—and I find the camera.

**ALL (EXCEPT NICK)**

SOMETHING'S REARRANGED

**ALI**

On the way to my restaurant, I drop my daughter at school, but she won't go in. She says she's scared. What do I tell her?

**ALL (EXCEPT ALI)**

SOMETHING'S STRAINED

**BOB**

Back at my dad's house—I look out the window—at this view I've looked at my whole life. And now a part of it—something's missing.

**ALL (EXCEPT BOB)**

SOMETHING'S MISSING

**KEVIN T**

Kevin breaks up with me. And then he quits and moves back home to New York. And I miss him. I miss his jokes.

**ALL (EXCEPT KEVIN T)**

SOMETHING'S LOST

**126** IRENE: Tom McKeon described to us how being in Newfoundland changed him. He said, "it was like taking a laser to whatever jadedness I had. It kind of excised that bit of judgment that goes with first meetings or with suspicion. And I've never been that way since. It just made me like feel more of an open person."

**DIANE**
Nick and I call each other when we can. But . . . it's awful. The only reason we met was because this terrible thing happened.

**ALL (EXCEPT DIANE)**
SOME THINGS COST

**BOB**
I go down to Ground Zero, which is like the end of the world. It's literally still burning.

**ALL (EXCEPT BOB)**
SOMETHING'S NOT

**BOB**
My dad asks, "Were you ok out where you were stranded?" How do I tell him that I wasn't just okay—I was so much better. **126**

**ALL (EXCEPT BOB)**
SOMETHING'S MISSING

**BEVERLEY**
I phone American and say, "I'm ready to go wherever you want to send me." But they say take a few days off. I phone every day and I am back at the airport by Thursday. And it's empty. Silent. It's just—a different place. And I stop what few passengers there are and I say, "Thank you for still flying."

*Beulah answers the phone.*

**BEULAH**
Hello. You've reached the Gander Academy, this is Beulah Davis. How can I help you?

**HANNAH**
. . . He's gone. It's over.

**BEULAH**
. . .Oh, no. I'm so sorry, Hannah. I'm so sorry.

**HANNAH**
YOU ARE HERE
AT THE END OF A MOMENT
AT THE END OF THE
   WORLD

YOU ARE HERE
ON THE EDGE OF THE
   OCEAN
WHERE THE STORY ENDS

HERE

**NICK**
ACROSS THE ATLANTIC

**KEVIN T**
AT THE OFFICE

**BEVERLEY**
IN AN AIRPORT

**DIANE**
IN MY HOUSE

**BOB**
ON AN ISLAND

**BEULAH**
IN A CLASSROOM

**JANICE**
AT THE STATION

**OZ**
IN MY CAR

**ALL**
AND WHEREVER YOU ARE

**DIANE, JANICE, BONNIE & BEULAH**
(SOMETHING'S GONE)

**ALL**
YOU ARE HERE

**BEULAH**
WHERE THE RIVER MEETS
   THE SEA

**EVERYONE ELSE**
SOMETHING'S GONE

SOMETHING'S OVER

**EVERYONE ELSE**
SOMETHING'S
   REARRANGED

C  U  T    F  R  O  M    A  W  A  Y

# Bob's SONG [127]

[127] DAVID: "Bob's Song" was never fully workshopped. It came from our interview with Tom McKeon about his experience returning from "heaven on earth" to find his father, a former fireman, traumatized over what had happened (though it was actually his friend Vinnie who met him at the airport. He and Vinnie returned to Newfoundland that February to "make sure it was real"). Even now, Bob's narrative still drives "Something's Missing."

*BOB*

*MY FATHER'S WAITING AT THE AIRPORT*
*LIKE HE'S BEEN STANDING THERE FOR DAYS*
*BEER IN HIS HAND AND THE OLD MAN SMILES*
*THROUGH THE TEARS—WELCOME BACK, HE SAYS*

*WE GO STRAIGHT DOWN TO GROUND ZERO*
*IT'S LIKE THE END OF THE WORLD*
*STILL BURNING, I TURN AND LOOK INTO THE PIT*
*AND THINK OF WHERE I WAS, THE DIAMETRIC OPPOSITE*

*MY FATHER IS NOT AN EMOTIONAL MAN*
*HE NEVER CRIES—I USED TO THINK HE HAD NO TEARS*
*BUT MY FATHER WAS A FIREMAN*
*AND THOUGH HE'S NOW RETIRED*
*THERE'S A PART OF HIM HE'S KEPT INSIDE*
*HIS HEART A PART THAT CAN'T STOP CRYING HERE*

*MY FATHER SAYS, "WAS IT OKAY WHERE YOU WERE*
*    STRANDED?"*
*AND I'M THINKING ABOUT APPLETON AND HEAVEN ON*
*    EARTH*
*I DON'T KNOW WHAT TO SAY, WE LANDED WHERE WE*
*    LANDED*

*BUT I WASN'T JUST OKAY -*
*I WAS ALMOST SOMEONE ELSE BACK THERE*

*WE DRIVE BACK HOME ACROSS THE BRIDGE*
*I LOOK BEHIND ME IN THE REARVIEW MIRROR*
*THIS SCENE THAT I HAVE SEEN SINCE I WAS JUST A KID*
*AND IN THE MIDDLE IN THE DISTANCE*
*LIKE A PIECE OF REMINISCING*
*LIKE A PART OF ME CUT OUT*
*I LOOK BEHIND ME AT THE TOWN*
*AND SOMETHING'S MISSING*

*NOW I AM NOT AN EMOTIONAL MAN*
*LIKE MY FATHER I DON'T CRY MUCH*
*I JUST DON'T KNOW HOW TO CRY MUCH*
*BUT IN THE REARVIEW MIRROR*
*A PART OF ME HAS DISAPPEARED*
*AND I CAN'T TELL MY FATHER*
*THAT I'M HAPPY I WAS THERE*
*THOUGH I AM HORRIFIED THIS HAPPENED*
*I CAN'T TELL HIM I WAS HAPPY*
*AND HE'S WAITING ON ME, LISTENING, CRYING,*
*TRYING TO CONNECT BUT*
*SOMETHING'S MISSING*

# RETURN TO GANDER

It's hard to imagine anything quite like it: When the national touring company of *Oklahoma!* played the Municipal Auditorium in Oklahoma City for the first time, back in 1946? Or maybe when the Broadway production of *The Lion King* opened its own tour with an all-South African cast in Johannesburg in 2007?

Perhaps. But there was nothing to compare with the meta-theatrical reality of bringing *Come From Away* to Gander. To the Community Centre hockey rink, no less.

"From the get-go, David and Irene said one of their dreams was to bring the show back there and let people see it and make sure they got it right," recalled Sue Frost. "It was something that was always out in the ether." This wildly Barnum-esque, utterly impractical performance began to gel after Claude Elliott had seen the show in Seattle. He was flying back to Canada and ran into Michael Rubinoff, who had also seen the production, at the airport and shared

his enthusiasm about bringing the show to Gander. Rubinoff called the producers to convey Elliott's interest.

"That was all we needed, because if we got buy-in from the town, we could make it happen. Claude went home and identified a few weekends when the ice rink was free," said Frost. Canceling a local hockey game was, apparently, out of the question, but luckily, the weekend of October 29 fit in perfectly between the Ford's Theatre and the incipient Toronto engagement. With Elliott's blessing, the logistics were made easier; there was also some government and in-kind support. Also, every cent of the box-office revenue was set to go to charities chosen by the local communities, from the Salvation Army Food Bank in Gander to Gambo's Smallwood Academy Breakfast Program/Positive Behaviour Supports.

So, for two special performances on October 29, 2016, at the Steele Community

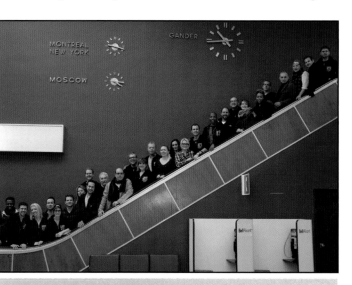

**Cast and crew, ascending under the great intercontinental clocks at Gander Airport.**

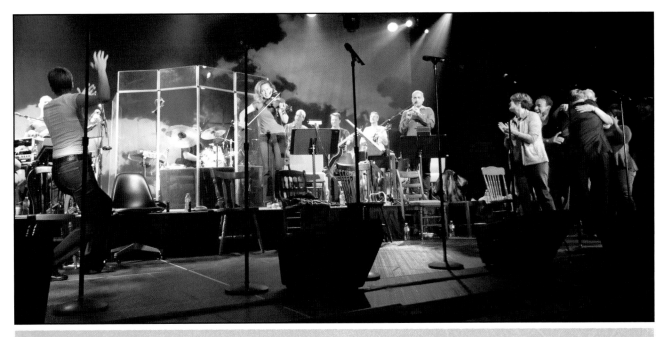

**The concert to end all concerts in "the world's largest walk-in refridgerator."**

Center, on the ice of the hockey rink, one of the most off-off-off Broadway productions of all time was scheduled as a "command performance" just for the people of Gander.

The cast joined nearly 140 members of the production–support technicians, along with press, general management, co-producers, and about two dozen investors–on the trek to Gander, via a four-hour bus ride from the St. John's airport. This was a bus-and-truck tour of an unprecedented kind. For cast member Sharon Wheatley, the experience had almost a missionary purpose: "I would ask folks from Newfoundland what was the last Broadway tour you remember coming to Newfoundland and there's no answer for that because it's too cost-prohibitive to bring a huge Broadway show to a tiny island in the North Atlantic." Indeed, the town of Gander doesn't even have its own movie theater.

The performances whipped up an unprecedented amount of enthusiasm. The evening before, there was a special benefit dinner held at the Gander Airport in honor of the cast, attended by the premier of Newfoundland and Labrador and the United States ambassador to Canada. For many of the actors, this provided the first chance to meet their real-life counterparts. "The first time I met Beulah Cooper and Diane Davis was at the big dinner that we had at the Gander Airport," said Astrid Van Wieren. "It was a combination of prom, wedding reception, awards ceremony, all in one at this dinner we had together. It was like meeting long-lost family." Of course, the cast and crew were Screeched-in as well, perhaps the largest mass Screech-in throughout the history of Newfoundland.

On the day of performance, there were lines around the Community Centre, with residents

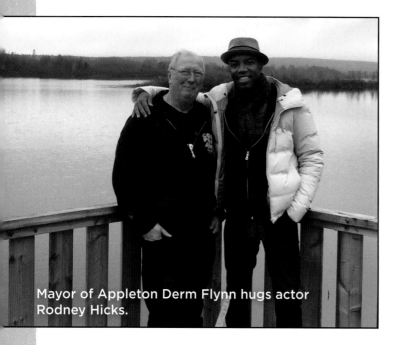

Mayor of Appleton Derm Flynn hugs actor Rodney Hicks.

clutching twenty-dollar tickets. Michael Paulson, a *New York Times* arts correspondent who was "embedded" in the presentation said,

> It was so unusual; just start with the fact that it's not in a theater, but it's in a hockey arena—and that the town is small enough that basically anyone who wanted to see it could.

It wasn't, of course, a typical performance of anything. Irene Sankoff noted, "I looked over at a friend, and I couldn't believe my eyes. There was Kathy Dillaber, the docent from the Pentagon Memorial; she was a survivor and had lost her sister in the attacks. And she made the not-at-all easy trip to Newfoundland to experience a concert version of a Broadway show in a hockey arena." Randy Adams recalled that "the first performance was so overwhelming. People went crazy. When the Ganderites started walking down the aisle [to join the cast at the curtain call], we

started to bawl." Petrina Bromley, the sole Newfoundlander in the cast, was greeted as a rock star by spectators sitting in the hockey stands and on folding chairs set up at ice level when she stepped up to the microphone to speak her first words as Bonnie Harris. Kendra Kassebaum remembered "the thing that hit us was a feeling that when we all came out, seeing hundreds of people, the energy, the pride they felt when we said 'I'm an Islander.' It was too much in the best way, a different kind of awareness that bringing the show to Gander was the right thing to do. It made me believe in Santa Claus again." "The audience started cheering in the opening number, sang along to parts like 'Heave Away' and started a standing ovation ten minutes before the show ended," remembered David Hein.

There was still an evening performance: "We were a little calmer the second time," said Sue Frost. The second show required, according to Kassebaum, "a delicate balance of adrenaline and discipline—it was our job not to cry."

In his *New York Times* feature piece, Paulson noted,

> Regular waves of laughter of recognition followed at local references—The crowds were wildly enthusiastic. . . .They stomped their feet at the Celtic-influenced folk rock sound and cheered the ugly stick, a local instrument fashioned from bottle caps and a boot attached to an upside-down mop . . .

Upon reflection, Paulson perceived a reaction that went beyond simple recognition:

> I think people in Newfoundland are kind of accustomed to and yet fearful about being mocked. The fact that the show manages

to be firmly rooted in that place and gently poke fun at some of their linguistic and cultural characteristics without seeming to sneer at them was a relief to people and made the show a pleasure for them.

"It was an extraordinary experience," said Frost. "The entire thing cost less than a full-page advertisement in the *New York Times* and yet you can't put a dollar sign on that experience."

Even the correspondent for that same *New York Times* realized the resonance of the Gander event.

There was this family in the front row that looked to be Muslim, which caught my attention, and I went up to talk to them, and, sure enough, they were Syrian refugees, because the show arrived in Canada at the same time that Canada was differentiating itself from the United States by welcoming what for them was a substantial number of refugees. That was a pretty interesting reinforcement of the message of the show.

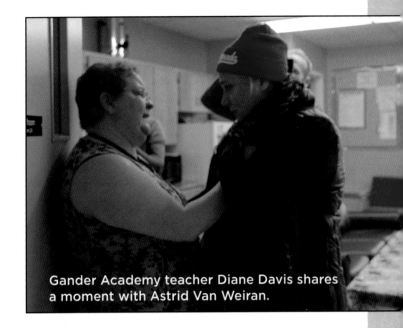

**Gander Academy teacher Diane Davis shares a moment with Astrid Van Weiran.**

Paulson concluded his piece for the *Times* with a quote:

I'm so proud that I'm here," said Talal Ibrahim, who arrived forty days ago with his wife and two children, from Homs, Syria, by way of Turkey. "I had heard a lot about this story, but now I understand it."

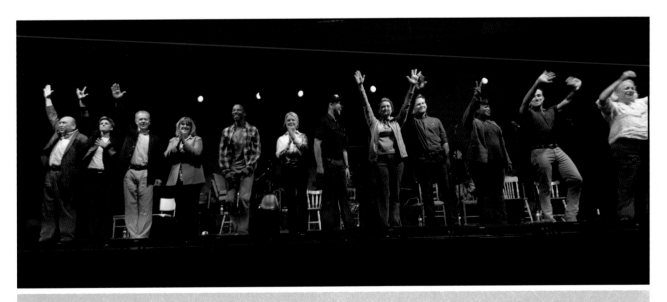

**A final bow from the Gander concert.**

---

PROFILES

---

# BRIAN & JANICE • BEULAH & HANNAH • TOM

**BRIAN MOSHER & JANICE GOUDIE**
WITH KENDRA KASSBAUM (CENTER)

**BRIAN MOSHER and JANICE GOUDIE:**
In 2001, Brian Mosher did double duty as a media teacher at Gander Collegiate high school and as an on-air correspondent for the local cable station, Rogers TV. He was on the air practically non-stop during the week of 9/11. He still has the message from Oprah Winfrey's office, asking for an interview with him, on his phone machine. Janice (Henstridge) Goudie was a reporter for the *Gander Beacon*; she now works as a radio host for CBC's *Labrador Morning*.

**JANICE GOUDIE:**
I moved to Gander the Thursday before and I wrote a little column for the paper about being a "new-in-town reporter." I had just come from Channel-Port aux Basques, which has a really small paper, and we always joked that the biggest news we had over there was that the ferry wasn't going back and forth between Newfoundland and Nova Scotia. So when I landed in Gander and got to this paper, the expectations were a lot higher; there was a lot more of a learning curve. I started on Monday and then 9/11 happened on Tuesday; it was more of a learning curve than I ever imagined.

I was sitting in my office and somebody had called; they mentioned to me that the World Trade Towers had been hit. I didn't really know how this was impacting me all the way up to Gander, Newfoundland, so then I went home for lunch. I was just turning on the news and when I saw all the news clips, so I went back to the newspaper and went into my editor's office, who had been working all the way through lunch and I said to him, "You know, all the flights—What does that mean for us?" He said, "It means that you need to get yourself up to the airport."

I went up and there was myself, and Brian Mosher, of course, with Rogers TV, and a few other CBC reporters. People were landing, planes were landing, and we're not used to seeing planes like that. You might see one every now and then, but there was were thirty-eight of them on the runway. We weren't allowed to have access to people the first day. But then as people kind of got a little more comfortable with what was taking place, we started moving around the community more.

There were so many people who landed in Gander with little stories. They all had little stories. And there was a lady whose brother or husband—I can't recall at this time what it was—but she had somebody who was missing. And I remember standing up and talking to her, and fighting back the tears, and then going out into my car and sitting down and just crying. Because it was so emotional, right? You're here asking these people in their most devastated time to open up and talk to you. I wouldn't have such an ordeal doing it now, I think. I would like to think I would be able to do a better job now.

**BRIAN MOSHER:**
To see yourself portrayed on a Broadway stage is pretty unimaginable.

To see yourself portrayed with that level of accuracy in terms of content, word-for-word replication, and even pauses in television delivery where I actually used them is absolutely surreal. I still fill up every time I see *Come From Away*. I'm actually going back in time and looking at me.

### KENDRA KASSEBAUM: (JANICE MOSHER):

I always felt in the rehearsal room with Chris [Ashley] that there was no pressure to imitate any one person. It's not just "Janice Mosher"—a lot of characters in the show were compilations of several people. Our job as actors was to honor their story and bring ourselves to it. The first time I met Janice and Brian was in Gander. Brian and I hit it off right away—that's the guy he is—everybody is his best friend. Janice is salt of the earth. They were just wonderful. You may be rolling your eyes, but if you'd been to Gander and met these people, that's it; that's the way it is.

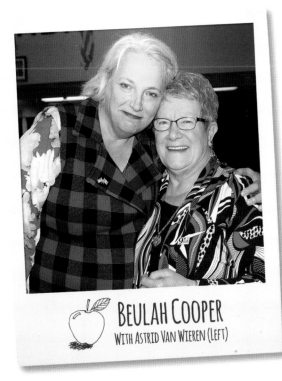

BEULAH COOPER
WITH ASTRID VAN WIEREN (LEFT)

### BEULAH COOPER and HANNAH O'ROURKE

Beulah Davis is drawn particularly from David and Irene's interviews with Beulah Cooper and the women at Gander Academy: Maureen Burton, Diane Davis, Annette O'Rielly, and Diane Vey-Morawski.

Beulah Cooper was provincial president of the Ladies' Auxiliary and local president of the Royal Canadian Legion and was in the Auxiliary for twenty-eight years. Hannah O'Rourke made a friend for life in Beulah Cooper, whom she met at the Royal Canadian Legion, where O'Rourke stayed and where Cooper still volunteers as head of the Ladies' Auxiliary. O'Rourke lost her eldest child, Kevin, a Brooklyn firefighter trained in rescue operations, on 9/11. His body was recovered almost two weeks later in the rubble of the Twin Towers. The two women call each other every two weeks or so.

### BEULAH COOPER:

My first thought [upon hearing the planes were diverted to Gander] was, "Good, at least they'll be looked after." I received a call at 7:00 p.m. to bring a tray of sandwiches down to the Legion for people. I had no idea what it was for. We were told planes would be landing in Gander, and some passengers were coming to the Legion. When I saw them coming, all you could do was feel sorry for them. They were somewhere where they didn't know where they

were, or what was going on. They didn't know what was going on.

I've met some beautiful people. [Hannah O'Rourke and her husband, Dennis] wanted to stay at the Legion because their son was missing. That was understandable. They didn't want to miss a phone call. I did talk Dennis into coming up [to my home] for a shower, and after bringing him back, Hannah came up. I took people around town shopping. I wish I could've taken them all home with me.

A couple of my granddaughter's friends asked her how come the media were always after her nan. She said it's for doing what she does every day. To me it was nothing I don't do normally. It does your heart good knowing that what you did touched people.

### ASTRID VAN WIEREN (BEULAH COOPER):

The DNA of my character is a combination of two women, Diane Davis and Beulah Cooper, and all the other school teachers and women who stepped up and gathered everything together that people needed. People would come up and say to me "You've really got Diane down pat." or "You really remind me of Beulah." But mainly I'm representing Beulah Cooper; she's still very good friends with Hannah O'Rourke. They've seen the show together and are beautiful together. They're both mischievous and fun-loving, and I think that, even though it was over tragedy that they connected, they still recognized a kindred spirit.

Diane was a schoolteacher at the time and really helped convert the school. They had seven hundred people in this small elementary school. I can just imagine what the halls must have been

like and the confusion. At the same time, a sense of camaraderie and actually getting to have a place to really land, and people really taking care of them. That really speaks to the spirit of these women and how we can all be and should be.

**HANNAH O'ROURKE**
WITH Q. SMITH (RIGHT)

### HANNAH O'ROURKE:

I met Beulah and she took me under her wing. She's unbelievable, there's nobody like Beulah; there's only one Beulah, and she's full of love. She has so many jokes and yarns, Beulah.

I said to her, "Until we do part, we're stuck with one another like glue." We talk together all the time, which is great. I [used to be] more outgoing and full of the devil and all that [before Kevin's death]. Ah, there's not a minute of the day that you don't think, Now he would be enjoying his children and his grandchildren. But I will never forget Gander.

### Q. SMITH (HANNAH O'ROURKE):

Hannah was one of the last people that we met. She came a few days before opening night. She was sitting in the orchestra and I think she was a bit overwhelmed. I can't imagine, you know, seeing your story on a Broadway stage. She was very touched and really moved by the show. She just kept hugging me and kissing me and just holding my face and kept saying, "Oh, honey, good job." and kissing, kissing.

She's full of so much love and light. You know, it gets a little nervous meeting the person that you're portraying. You wanna honor them and tell their story to your best ability.

She came again opening night with her entire family and they gave me a replica of Kevin's badge. Her family came with grandkids, kids, friends, and family. They come pretty often, family members of Kevin O'Rourke. It was nice meeting them, and I'm looking forward to spending more time with them.

**TOM McKEON was traveling from Ireland to Newark, after doing research for a book about the politics of Northern Ireland. His flight, Continental 23, was the first to land and one of the more difficult flights to get back in the air. In the meantime, he stayed at the home of Mayor Derm Flynn and his wife, Dianne, in Appleton. His flight eventually left for Newark in the early hours of September 15.**

There were some inconvenient times, but basically, we were comfortable. Sometimes we felt ashamed: I shouldn't be enjoying this, I shouldn't be relaxed and enjoying this hospitality. Everyone

there had to kick themselves in the ass, saying how lucky can we be?

Still, everyone was in doubt we would get home until the wheels were up—and suddenly we're scared. We're going back to Newark. We didn't know much about security. First commercial plane into Newark after 9/11. I know Newark Airport. You could pull over a truck, pull out a shoulder grenade launcher and shoot at a plane coming in from out in the parking lot. So people were scared something could happen. But nothing happened.

The airport was empty. There wasn't anyone other than our flight waiting. And there was my pal Vinnie waiting for me—like he'd been there for four days—it was like he didn't even go home. Waiting for me with a beer. He told me there wasn't a single car in short-term parking. We drove straight to Ground Zero.

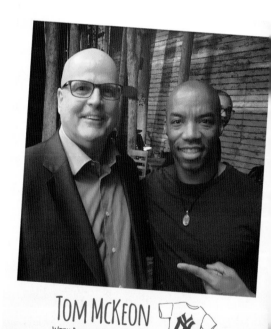

**TOM McKEON**
WITH RODNEY HICKS (RIGHT)

I didn't take [the notion of these stories becoming a musical] that seriously; I felt these kids were going to get smacked down. At one point they said, We're coming to Broadway, and I was shocked. My wife and I went to the first preview, we bought our own orchestra seats. I heard from Derm and Dianne: We're not telling you much. Just go see it. Keep an eye on a guy named Bob.

I didn't know what to expect. I figured whatever I said is going to be turned into a poignant, but doofy, character that might not represent me. When I walked in and saw Rodney playing Bob, I immediately got it that they were going for the jaded New Yorker—I just didn't think I'd be the only jaded New Yorker. Whatever I expected, I was blown away by the singing and dancing and talent, and my shock at seeing Rodney [playing me] was more about his talent than about him being black. I actually thought Rodney would have a more shocked view of me because of who I am, because they thought I'd be a tough guy from the Bronx or Brooklyn, but I'm from Hoboken and Hudson County.

**RODNEY HICKS (BOB):**
When we went to Gander, it gave us all another perspective. There are practically no black people in Gander, so I really allowed myself to be a foreigner in a strange environment. I finally felt like Bob, the character I created. I said to myself, I'm going to be part of the mind-set in Bob's head in terms of giving myself over to being a foreigner. So that was my aim for Bob—he's scared, he's just scared. I wanted to pretend that I didn't really know any white people and I wanted to take that journey. But then I was personally so welcomed that the energy blew me away. I walked into the stores and I never felt like anyone was watching me—because they weren't. There was that honest welcoming. From now on, I'm going to take everyone for what they present to me; that's my life lesson, and I learned it there.

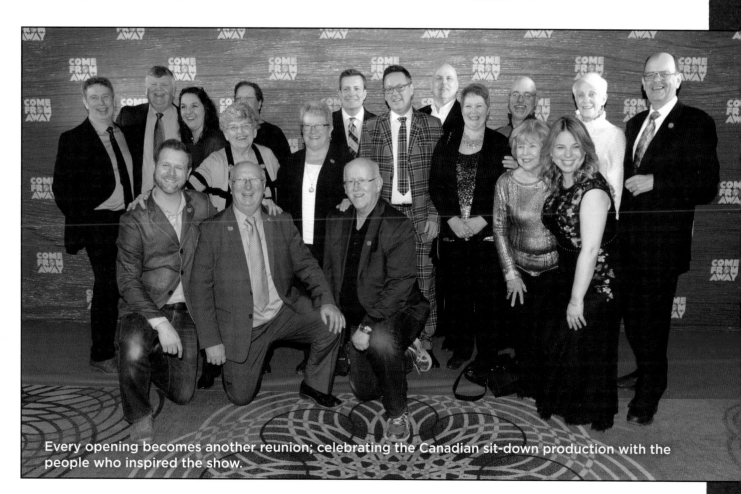

**Every opening becomes another reunion; celebrating the Canadian sit-down production with the people who inspired the show.**

# SUNDAY, SEPTEMBER 11, 2011

A year after the 9/11 attacks, on the tarmac of Gander Airport, where so much had happened that day, American and Canadian servicemen were lowering their respective flags to half-mast. There was a moment of silence, along with moments of silence across America, coordinated to the times the towers fell at the World Trade Center; in Gander, of course, it was ninety minutes later.

The first anniversary of 9/11 was a sober reminder of how the world had changed–the Royal Canadian Mounted Police provided heavy security for the event–as well as some basic values that still endured. Both the prime minister of Canada, Jean Chrètien, and the U.S. Ambassador to Canada, Paul Cellucci, attended the ceremony to pay tribute to the people of Newfoundland and Labrador, along with other local dignitaries, and a tremendous representation from folks in Gander and the "surrounding areas": Gambo, Appleton, Lewisporte, Glenwood, and Norris Arm. A plaque was unveiled that day by the prime minister; it read in part:

This marker is a tribute to the generous acts of individuals, organizations, and communities across Canada on September 11, 2001. Their countless acts of caring remind us that compassion and generosity are truly cherished as Canadian values.

In his speech at the ceremony, Mayor Claude Elliott said,

To be chosen to represent all of Canada in this event today and to be [a symbol] of the compassionate deeds of all Canadians . . . this is the greatest honor that could be bestowed upon us. . . . Today I want to say thank you to all the volunteers. There is at least twelve

thousand people in this region that is as deserving to stand here as I am.

Although, clearly, several other municipal leaders did their parts in organizing support for their communities back in 2001, Claude Elliott eventually became the public face of small-town generosity. In 2004, he was summoned to Halifax to meet President Bush for an American-Canadian unity event. (Apparently Elliott and the president briefly chatted about fishing on the Gander River, which Bush had done with his father several times.) At a 2011 gala hosted by the Center for National Policy in Washington, DC, Elliott received an International Resiliency Award on behalf of

plane people returning. The theme of "Beyond Words" was a phrase coined by the Gander town manager, Derm Chafe: "It was beyond words what was done by the people of Gander and surrounding communities and it was beyond words the kind of friendships that were made during those five days." The organizers devoted all charitable contributions through the events to offer a scholarship to children who lost a parent in the attacks.

The first offerings were two immense community breakfasts—one in Gambo, the other at Gander's community center (which made sense as the former "Walk-In Freezer"), occurring simultaneously on September 10. They were co-

## "You affirmed our faith in the goodness of people. You were the best of us."

Gander, and visited Capitol Hill for a series of tributes from Congress.

In fact, while Elliott was "on the road," reporters and interviewers from all over the world were inundating the deputy mayor, Zane Tucker, with press requests: "We knew there would be interest, especially where it's a milestone anniversary of ten years," he said, "but I think just the volume is a bit surprising to me."

As the years went on, there would be annual memorial services at Gander and the other towns every September 11, but it was clear that a special commemoration would need to happen in Gander. A three-day event was organized, called "9/11 Beyond Words," meant to bring together all the communities in the surrounding areas, as well as a large number of

sponsored by Boeing and Lufthansa as a way of giving back, and the dozens upon dozens of breakfasts served to local residents were prepared by former passengers, eager to return the favor to their hosts.

The next day, on the exact tenth anniversary, there were several Ecumenical Memorial Services in the area. The memorial service in Gander, attended by U.S. Ambassador David Jacobson and Newfoundland Premier Kathy Dunderdale, took place as hundreds of people crowded into the Community Center. Mayor Elliott accepted two steel beams—one from a fire department in Bethpage, Long Island—rescued from the rubble of the World Trade Center. The rusting and slightly twisted beams were unveiled and blessed during the

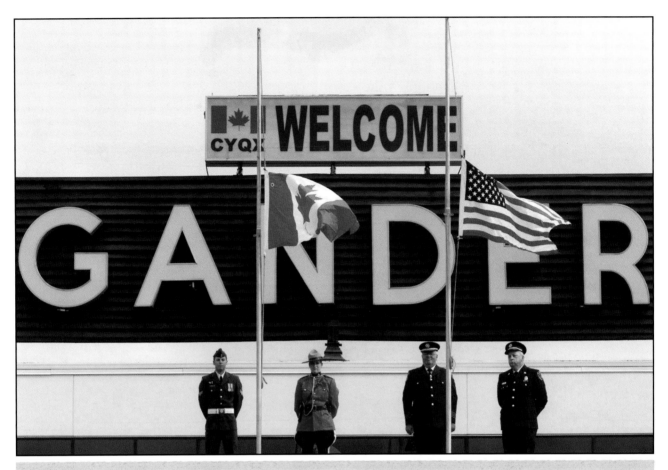

**A joint commemoration of 9/11, one year later, Gander Airport.**

ceremony; one was placed at Gander Airport, the other in the North Atlantic Aviation Museum in Gander. He told the gathered crowd of residents and visitors that, "You affirmed our faith in the goodness of people. You were the best of us."

That same Sunday morning, Ambassador Jacobson attended a more low-key service in Appleton. Out of a town of seven hundred, hundreds arrived at Appleton's riverside Peace Park under skies so clear and blue, many in the crowd recalled the bright weather on that September 11, a decade earlier. For Mayor Derm Flynn, the local memorial was a source

of particular pride; as every dignitary kept referring to "Gander and the surrounding areas," Flynn pointed out, "I'm the mayor of the surrounding areas."

In his speech, Jacobson quoted a former passenger who called the province a "solid rock of humanity," and he praised it with a reference to Shakespeare's *Twelfth Night*. "On September 11, 2001, the people of Appleton and Gander and the towns across Newfoundland had greatness thrust upon them," he said.

What made the events of the Beyond Words commemorations particularly moving was the arrival, in droves, of former

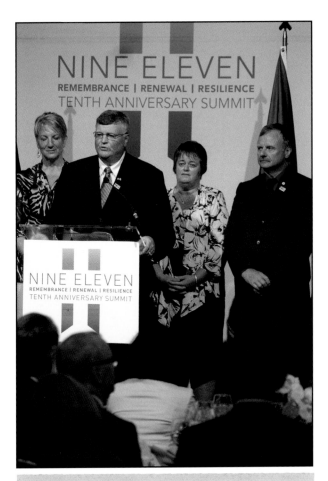

**Claude Elliott receiving a community resilience award in Washington, D.C.**

and other of the island's important folk bands performing. Brian Mosher, the tireless anchorman of Rogers TV, covered the event, interviewing a host of come-from-aways who returned for the weekend, querying them about their experiences and their fond memories. Toward the end of the program, Mosher came across a fresh-faced couple on the rink floor and asked them about their experiences in Gander, a decade earlier. "Actually," said the tall gentleman with sandy hair, "we weren't here then. My wife and I are here for the anniversary, collecting stories about what happened that week for a play we're working on. There's so much material, the challenge is cutting it down." Mosher, somewhat abashed, laughed at his mistaken identification of David Hein and Irene Sankoff.

Sankoff saved the day by adding, on-air: "You can see how that week changed everyone. I'm proud to be a Canadian."

passengers who simply wanted to return to Newfoundland, show their respect, and renew ongoing friendships. Shirley Brooks-Jones, who had helped kickstart the Lewisporte scholarship, came back: "All of the plane people remember each and every day what you did for us, and we will never forget you," she told a local reporter.

The most festive event of this somber and respectful weekend was, no doubt, the Beyond Words concert on the rink of the Community Center, on the Saturday evening; it was a buoyant dance party, with Shanneyganock

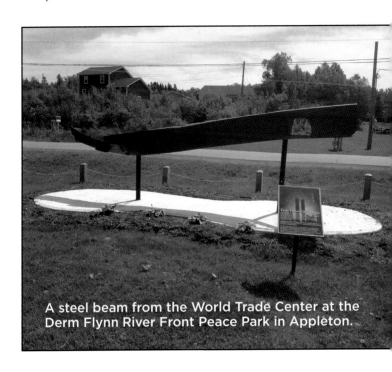

**A steel beam from the World Trade Center at the Derm Flynn River Front Peace Park in Appleton.**

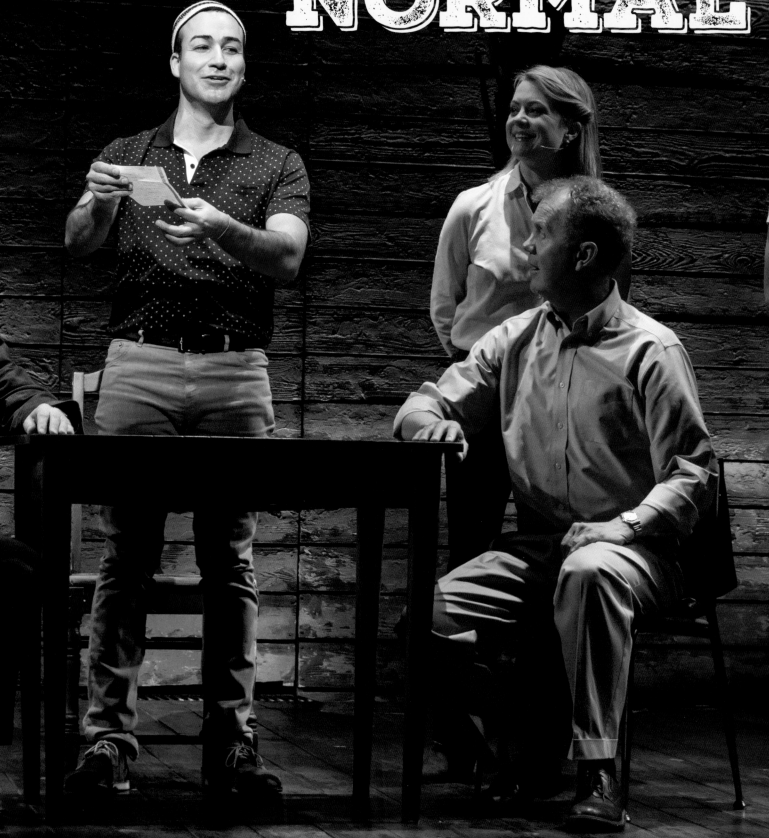

**JANICE**
When Gander town council declares the state of emergency over, it means that everything goes back to normal. (128)

*She moves to reveal Claude and Garth.*

**CLAUDE**
Garth.

**GARTH**
Claude.

**CLAUDE**
Look.

**GARTH**
Look.

**CLAUDE**
Look at it from my perspective.

**GARTH**
Will you look at it from my perspective?

**CLAUDE**
We've been coming to the table.

**GARTH**
We've been coming to the table too!

**BOTH**
Jaysus!

*Claude enters Tim Hortons.*

**CLAUDE**
Morning, Crystal.

**1 (CRYSTAL)**
Morning Mr. Mayor. Pepsi?

**CLAUDE**
That's right. Morning, Dwight.

**DWIGHT**
Morning, Claude. Garth. Crystal.

**DOUG**
Claude. Crystal. Dwight. Garth. Morning.

**JANICE**
Morning, B'ys.

**CLAUDE**
Morning, Janice.

**DWIGHT**
Janice.

**GARTH**
Janice.

**DOUG**
Janice.

**CRYSTAL**
Janice.

**CLAUDE**
What's the news?

**JANICE**
Strike still on?

**GARTH**
Well, we're coming to the table.

**CLAUDE**
Well, we're coming to the table too.

**DWIGHT**
Are they tearing down the airport?

**CLAUDE**
Not today.

*Oz runs in.*

**OZ**
Mr. Mayor, I saw your car in the lot. You might want to get down to town hall. We just opened the suggestion box.

(128) **IRENE:** We were so worried that there was going to be a rewrite coming, because at the end of the previous scene, they are all on stage as one character and in the next moment they need to become another and be in the exact same spots. Just as I could feel the rest of the creative team looking over at us to tell us to go back to the drawing board, Petrina, our only Newfoundlander involved at that point, piped up. "Why don't I just take Chad's jacket off him?" Thus turning him from Kevin T to Garth. We tried it. And she reached up to his collar and ripped that thing off him as he said his first line. And it worked. And it became clear in that moment that was the way the show was going to work. Everyone would help everyone else and things would change on the fly, both hidden from sight and in plain view. Petrina's track remains the hardest of everyone's, because she always offered to do something for someone else.

**129** DAVID: A cut section that used to include more ways that people gave back to the community that gave them so much. We eventually cut it down because it felt like we were focusing too much on the rewards, though the truth is that the passengers gave back in a myriad of uncounted ways.

**CLAUDE**
When the bank finally converted all the currency from around the world—people had donated over sixty thousand dollars.

*Everyone whistles.*

**ANNETTE**
Every day, for months, passengers sent back chocolates, flowers . . .

**BEULAH**
Donations of all kinds.

**OZ** 129
*Some of the plane people were from the Rockefeller Foundation.*

**BEULAH**
*They donated a new computer lab.*

**ANNETTE**
*And we updated the school library.*

**CLAUDE**
Postcards and letters came in from everywhere. Beulah opens a letter as Ali reads.

**ALI**
Dear Miss Beulah. When my daughter asks about what happened to me over those five days, I tell her about your kindness. Thank you again. Sincerely, Ali. P.S., please send me the recipe for the fish and the cheese.

*Bonnie and Doug step forward.*

**BONNIE**
Ralph, the cocker spaniel, went on to become a champion show dog! 130

**DOUG**
And Unga, the rare Bonobo chimpanzee arrived safely at the Columbus Zoo.

**BONNIE**
And soon after, she had a baby—which they named Gander.

*Janice steps forward.*

**JANICE**
Tom Brokaw 131 phones me. Tom Brokaw. He's doing a documentary—and since I was the only reporter in town—I'm the only one with any footage.

Tom. Brokaw.

It was a big break—but I didn't really like shoving microphones into people's faces when they were going through so much. So, I stayed here in Gander—and I'm still here today—on the tenth anniversary.

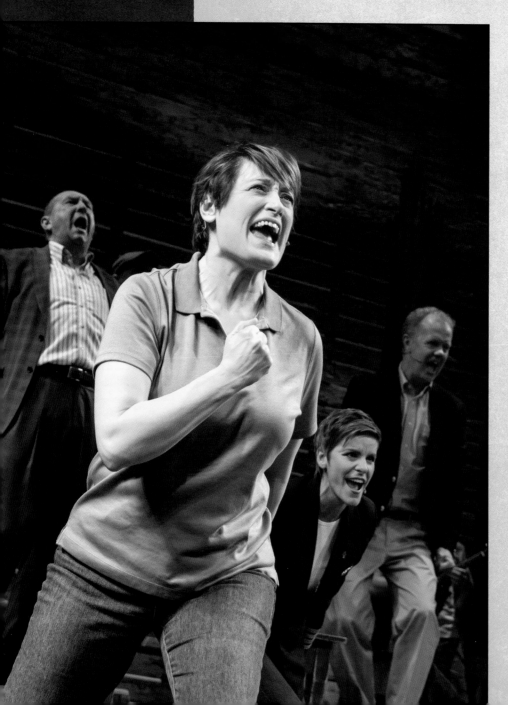

## CUT FROM AWAY

# Washington[132]

**JANICE**
*It's been almost ten years since September 11, 2001—
Today in Washington, Mayor Claude Elliott will receive
a community resilience award from the White House.*

*CLAUDE stands, surprised, awkwardly waiting to
accept his award.*

**CLAUDE**
THEY ASKED ME HERE TODAY TO BE AWARDED
RESILIENCE FOR MY COMMUNITY
BUT I'M NOT SURE THAT IT'S RIGHT
THAT I AM HERE TONIGHT
WITH ALL THESE OTHER PEOPLE HERE BESIDE ME
THERE'S A WOMAN TO MY LEFT WHO LOST A SON
THERE'S A CEO WHO LOST ALL OF HIS CREW
AND I DON'T THINK THAT IT'S RIGHT
THAT I AM HERE TONIGHT
AWARDED FOR WHAT ONE JUST OUGHT TO DO
BUT I AM

**CLAUDE & MALE CHORUS**
PROUD OF MY TOWN
PROUD OF MY COMMUNITY
AND PROUD TO SAY I COME FROM NEWFOUNDLAND

**CLAUDE**
BUT I DON'T THINK THAT IT'S RIGHT
THAT I AM HERE TONIGHT
BEING THANKED FOR SIMPLY GIVING FOLKS A HAND

BACK HOME THEY'LL BE SAYING WE SHOULD
COMMEMORATE THE DAY
BUT PLAY IT DOWN, GOOD DEEDS DON'T COUNT
IF THEY ARE DONE WITH PRIDE
AND AWARDS AND CEREMONIES AREN'T A FITTING WAY

TO PAY
RESPECT FOR ALL THE PEOPLE WHO HAVE DIED

AFTER ALL IS SAID AND THE AWARDS ALL GIVEN OUT
THAT MOTHER HUGS ME AND SAYS THANKS FOR WHAT
  YOU'VE DONE
SHE SAYS KINDNESS—HUMAN KINDNESS
IS WHAT THIS WORLD NEEDS MORE OF NOW
AND YOU'VE GIVEN ME THE STRENGTH TO CARRY ON

I DON'T KNOW WHAT TO SAY, SO I SIMPLY MUMBLE
  THANKS
AND I SHYLY SHAKE THE CEO'S HAND
MAYBE IT IS RIGHT
THAT I AM HERE TONIGHT
BUT I WISH EVERYONE WAS HERE FROM
  NEWFOUNDLAND
SINGING SONGS ABOUT OUR HOME AND NATIVE LAND

GIVE ME A HEY, HO—PUT YOUR BACKS INTO IT, BOYS,
  AND THEN
WE'LL BE ROWING TILL WE SEE THE HARBOR LIGHTS

**CLAUDE & MALE CHORUS**
GIVE ME A HEY, HO—PUT YOUR BACKS INTO IT, BOYS,
  AND THEN
WE'LL BE BACK AGAIN IN NEWFOUNDLAND TONIGHT
GIVE ME A HEY, HO—PUT YOUR BACKS INTO IT, BOYS,
  AND THEN
WE'LL BE ROWING TILL WE SEE THE HARBOR LIGHTS
GIVE ME A HEY, HO—PUT YOUR BACKS INTO IT, BOYS,
  AND THEN
WE'LL BE BACK AGAIN IN NEWFOUNDLAND
BE BACK AGAIN IN NEWFOUNDLAND
BE BACK AGAIN IN NEWFOUNDLAND TONIGHT

**130** **IRENE:** I asked Bonnie in 2011 if she had been the recipient of any of the goodwill that was directed back to Gander, and other than Ralph's "parents," she had not been. I vowed then to help the small Gander and Area SPCA, and it started by passing a bucket at the first Sheridan workshop.

**131** **DAVID:** Tom Brokaw's documentary, *Operation Yellow Ribbon*, has been a wonderful reference for us—and came full circle when Tom attended the show and then interviewed us on stage; however, Brian Mosher, who Janice is partly based on, was initially contacted not by Tom, but by Oprah Winfrey! He still has her message on his answering machine. We only changed it because Tom actually made a documentary; however, in England and Australia, where Tom Brokaw is less well-known, Janice talks about receiving a call from Oprah.

**132** **DAVID:** More than any other cut material, I miss this song.

# Finale

**133 DAVID:** We originally included reporters from ABC and NBC, but Beverley Bass corrected us in that there were no American TV stations covering the tenth anniversary in Newfoundland.

*Reporters from around the world overlap, all on camera.* (133)

**REPORTER 9**
I'm reporting live from Newfoundland for BBC.

**REPORTER 8**
CBC.

**REPORTER 7**
CTV.

**REPORTER 5**
Al Jazeera.

**JANICE**
For Rogers TV, I'm Janice Mosher—on September 11.

**ALL (EXCEPT JANICE)**
Two thousand eleven.

**JANICE**
The town is again filled with come-from-aways. On the tenth anniversary, from all around the world, we welcome back the plane people.

**CLAUDE**
One! Two!

**ALL**
One two three four!

**CLAUDE**
WELCOME TO THE FRIENDS WHO HAVE COME FROM AWAY (HEP!)

WELCOME TO THE LOCALS WHO HAVE ALWAYS SAID THEY'D STAY (HEP!)
IF YOU'RE COMING FROM TOLEDO OR YOU'RE COMING FROM TAIPEI
BECAUSE WE COME FROM EVERYWHERE

**ALL**
WE ALL COME FROM AWAY

**MEN**
WELCOME TO THE ROCK

**WOMEN**
I'M AN ISLANDER,

**ALL**
I AM AN ISLANDER
I'M AN ISLANDER, I AM AN ISLANDER
I'M AN ISLANDER, I AM AN ISLANDER
I'M AN ISLANDER, I AM AN ISLANDER

**ANNETTE**
WELCOME TO OUR ISLAND WITH ITS INLETS AND ITS BAYS
YOU COULD KEEP ON HEADING EAST, BUT THERE'S AN OCEAN IN THE WAY

**GARTH**
WHERE EVERYTHING IS MEANT TO BE, BUT NOTHING GOES AS PLANNED

**OZ**
AND THE DRUNKEST FELLAS IN THE ROOM ARE PLAYING IN THE BAND

*The band rocks out on stage.*

**ALL**
WELCOME TO THE ROCK

*A reporter is interviewing Beverley.*

**BEVERLEY**
With all the new security, kids aren't even allowed up in the cockpit anymore. Of course on my retirement flight, I brought my whole family up to the cockpit, on our way back to Gander.

*A reporter is interviewing Bob and Derm.*

**BOB**
I came back with the scholarship money we raised—now worth over a million dollars.

**DERM**
I bring out the Irish whiskey and we have ourselves a toast.

*A reporter is interviewing Diane.*

**DIANE**
Nick and I just couldn't make the long distance relationship work.

*Nick joins the interview.*

**NICK**
So, I moved to Texas—and then I proposed!

**DIANE**
And we honeymooned in Newfoundland.

*A reporter is interviewing Kevin T.*

**KEVIN T**
My new secretary's name is Robin.

**ROBIN**
What's up?

**KEVIN T**
Every year on September 11, I close my office and

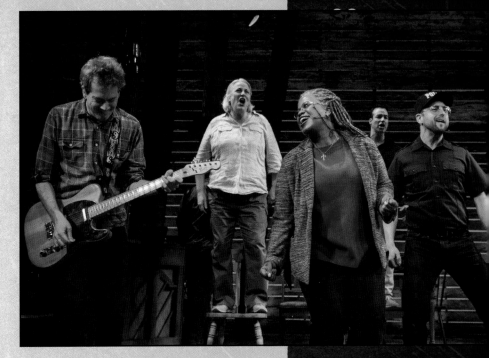

give each employee one hundred dollars to go and do random good deeds for strangers. It's my way of remembering what happened. ⑬④

*A reporter is interviewing Hannah and Beulah.*

**HANNAH**
Beulah and I still keep in touch. She even came to visit me in New York—and I still phone her if I hear a really stupid joke. Hey, Beulah. Why are Newfoundlanders terrible at knock-knock jokes?

**BEULAH**
I don't know, Hannah.

**HANNAH**
Well, try it. I'll be a Newfoundlander.

**BEULAH**
Knock knock.

**HANNAH**
Come on in—the door's open! ⑬⑤

*Beulah laughs.*

⑬④ **IRENE:** There was an early idea for a song that started with Kevin's pay-it-forward movement that saw a wave a good deeds spread across all the cities the characters were in. Eventually, it got cut, but it's been amazing to see it actually happen in practice as each of our companies embraces random acts of kindness toward strangers, raising money for charities, making packages for food banks, and spreading kindness.

⑬⑤ **DAVID:** I love this Newfoundland joke, but my favorite is, "How do you tell the Newfoundlanders in Heaven? They're the ones that want to go home."

here were inspired by his speeches he gave at the tenth anniversary. Since then, we have seen him speak time and again and he is an incredible orator, who consistently makes his wife nervous by improvising his speeches on the spot. Thankfully, Joel Hatch captures him perfectly (though Claude does often mention that Joel has slightly less hair than him).

**137** IRENE: From the very first workshop in Seattle to his last performance with us, Rodney Hicks pointed at the sky on this line and then tapped his chest. I still miss it.

The donation we are most honored by just arrived today.

**OZ**
It's about four meters long and 1,200 kilograms.

**JANICE**
Newfoundland is one of the only places outside of the United States, where we share the steel from the World Trade Center.

*Claude steps forward.*

**CLAUDE**
On the northeast tip of North America, on an island called Newfoundland, there's an airport—and next to it, is a town called Gander.

Tonight, we honor what was lost. But we also commemorate what we found! **136**

YOU ARE HERE
AT THE START OF A MOMENT
ON THE EDGE OF THE WORLD
WHERE THE RIVER MEETS THE SEA
HERE ON THE EDGE OF THE ATLANTIC
ON AN ISLAND IN BETWEEN

| 2, 3, 5, 6, 7, 8 & 10 | 1, 4, 9, 11 & 12 |
|---|---|
| THERE AND HERE | I'M AN ISLANDER—I AM AN ISLANDER |
| | I'M AN ISLANDER—I AM AN ISLANDER |
| THERE AND HERE | I'M AN ISLANDER—I AM AN ISLANDER |
| | I'M AN ISLANDER—I AM AN ISLANDER |
| THERE AND HERE | I'M AN ISLANDER—I AM AN ISLANDER |
| | I'M AN ISLANDER— |

**ALL**
I AM AN ISLANDER

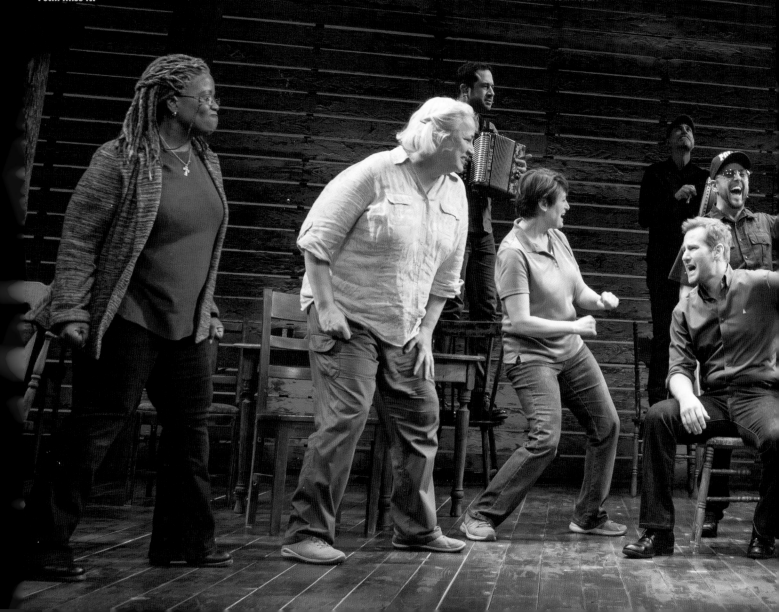

WELCOME TO THE FOG
WELCOME TO THE TREES
A KISS—AND A COD
AND WHATEVER'S IN BETWEEN
TO THE ONES WHO'VE LEFT (137)
YOU'RE NEVER TRULY GONE
A CANDLE'S IN THE WINDOW
AND THE KETTLE'S ALWAYS ON

**ALL**
TO THE COVES AND THE CAVES
AND THE PEOPLE FROM THE PLANES

**CLAUDE**
FIVE DAYS!

**BONNIE**
NINETEEN ANIMALS!

**BEULAH**
AND SEVEN THOUSAND STRAYS!

WHEN THE SUN IS SETTING
AND IT'S DARKER THAN
   BEFORE
IF YOU'RE HOPING FOR A
   HARBOR
THEN YOU'LL FIND AN
   OPEN DOOR
IN THE WINTER FROM THE
   WATER
THROUGH WHATEVER'S IN
   THE WAY

I'M AN ISLANDER
I AM AN ISLANDER

I'M AN ISLANDER

I AM AN ISLANDER

I'M AN ISLANDER

I AM

**ALL**
TO THE ONES WHO HAVE COME FROM AWAY, WE SAY
WELCOME TO THE—WELCOME TO THE
WELCOME TO THE—WELCOME TO THE
WELCOME TO THE—WELCOME TO THE—WELCOME TO THE
   ROCK!

*Blackout. Bows, followed by the band
rocking out.* (138)

asked for some exit musi
that the band could play a
the audience left, and Iar
Eisendrath stitched togethe
this incredible medley of tune
from the show—a kind of post-
overture—but it backfire
when the audience refuse
to leave. It was the worst exi
music ever! Eventually, we ha
the band come out to perform
and everyone stays to clap
For the album, we wante
a better title than just "Exi
Music"—and Petrina Bromle
came up with "Screech Out."
(Petrina also came up with
the definitive title to Bonnie's
unwritten song (for now)
"Fish and Chimps.") I love tha
after watching the entire show
the audience is welcomed int
a Newfoundland kitchen party
It feels like the best way we
could have ended this story

# THE ENSEMBLE

Being a member of the *Come From Away* ensemble of twelve actors required navigating a series of imponderables–a sensitive subject matter, an ongoing tour of international performance venues, earning the trust of your fellow actors (and they of you), and, last but not least, the unpredictable tremors in current events. And if that doesn't make you feel like the ground is shifting under you all the time, there's a turntable.

Accepting any acting job in the first place was a matter of personal taste; almost all of the original cast responded to the script, the music, and the fact that they could bring something to the table. Joel Hatch was born and raised in rural Minnesota: "We were used to people from the big city treating us more rural folk as if we were country bumpkins. I saw in *Come From Away* a chance to tell the story of these Newfoundlanders as honestly as we could; the script treated them with such dignity."

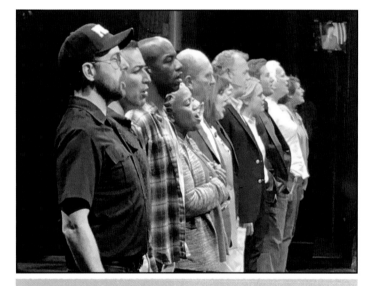

**A view from stage right; the Broadway cast.**

The developmental aspect of the show allowed the original members of the ensemble to put their own personal stamps on the roles. For Rodney Hicks, developing Bob, the eternal "outsider" from Brooklyn, required him to draw on his own identity. "On the second day of rehearsals, I went up to Chris Ashley and asked him, 'Hey, Chris, can I make Bob black?' He said, 'Try it.' And then his character dropped into place for me. I could see Bob as someone who is never around white people, typically, someone who is removed. And his first instinct is to isolate himself, because if he crosses a line, if he moves anything he shouldn't, he thinks he's going to get shot."

It was essential to get a specific grip on each character–each actor plays a dozen of them–because the performance itself is a whirlwind. Caesar Samayoa says, "In rehearsal, many times we'd be sitting onstage wondering what's next? But once we figured it out, it's

like showing off." Jenn Colella picks up that thought: "As an actor, that's the absolute fun part—where we can show off—where we can express what we do best; switching from character to character, I find quite thrilling. The harder thing is getting the chairs in the exact right spot for your colleagues at the right moment." "It's the nature of the show that you depend on everybody else all the time," says Sharon Wheatley, "because the chair that you're putting down is not the one that you're going to sit in—it's one that someone *else* is going to sit in."

The cast had several chances to perfect their chair movements; the same ensemble, essentially, had four shots at getting it right— La Jolla, Seattle, Washington, and Toronto—en route to Broadway. Says Lee MacDougall, "We're lucky that it wasn't just one tryout. We would meet in another strange city and rehearse the show again, break, and come back. So that really formed bonds as well." Astrid Van Wieren concurs: "We were living together [in various locations] almost like college students in different dorms and campuses—getting on the bus together, going to rehearsal, all of our social time was spent together as well. You're like this molecule of Mercury, you might leave each other for a moment and immediately come back together. You either fall in love or not and we all did."

Different venues brought different values. Hicks modulated his performance depending on where the production took him; "I looked at Bob's role as a class thing; I started him as solid blue-collar working class, but as we went along, in DC, I made him unapologetically

lower middle class—that, I thought, would make him universal. And for many people in the audience, he's the character they immediately relate to. Joel Hatch saw a strong shift once they moved from the West Coast and the East Coast: "In DC and New York, it's different from other parts of the country, in terms of their relative experiences with 9/11. Canada welcomed the show with a lot of national pride. When we pulled out the ugly stick, the houses would get hysterical—'Oh my God, there's an ugly stick!'"

In Gander, with the tight proximity of the material to its source, the reactions to the two performances were even more pointed. Joel Hatch recalled that "Derm Flynn, [the Appleton mayor], came up to me before the matinee and said, 'Everyone tells me I should be wearing a hat—what kind of hat?' I explained to him it was just a quick gag in the show, but between the matinee and the evening performance, he went out and bought that kind of a hat— so everyone knew it was him."

The cast was always aware of their obligation to truth and to the near-documentary aspect of their characters. Samayoa put it best, "So many shows you play fictitious characters or people who are long gone. Our characters are real people who are still alive and it's really important for the entire artistic team not to do any kind of impression or imitation." Geno Carr confirmed, "We watched a couple of videos of some of the interviews with [the actual] people, but it was amazing—once we started meeting them, we were already similar to them in ways." "The writing is so specific and Chris's direction was

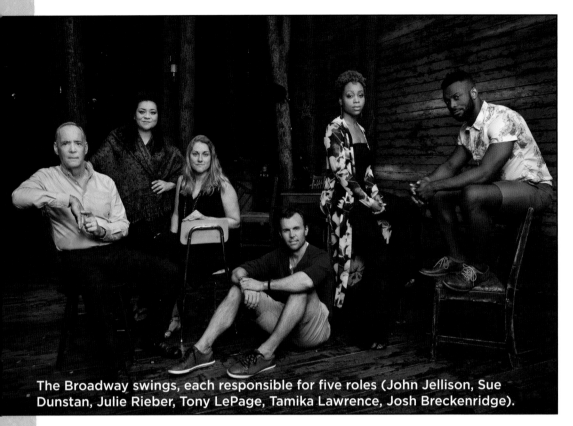

The Broadway swings, each responsible for five roles (John Jellison, Sue Dunstan, Julie Rieber, Tony LePage, Tamika Lawrence, Josh Breckenridge).

That affection has extended to the ensemble and allowed them to stay together as a group far longer than most Broadway casts–almost four years. "I always get asked: Are you all friends? You seem like such great friends," says Sharon. "And I say yes, we are–we all love each other, we take care of each other and they say we can see that, we see you looking at each other, winking at each other, helping each other with the chairs and jackets and things." Colella again: "The fact that the audience is picking up on that [vibe] and knows that we've also fallen in love with one another feels awesome." Some of that affection is baked into the nature of *Come From Away*: "Typically, you're in a show where you're offered two or three scenes and you go back to your dressing room and you're bored," said Wheatley. "But, with this show, you never leave the stage, the show flies by and it's over before you realize you're into it. It's no mistake that ten out of the twelve of us are still in the cast. You look around at other shows, you don't see that and this is why: it's about community and we have become a community."

so detailed that suddenly we were like 'Oh, this is something they would say and how they say it!'" Samayoa added, "Without fail, all of their friends come up to us and always say 'Oh my god, you got your person so right!'"

Of course, by the time the production made its way to Gander, then Toronto, and finally New York, the ensemble and their real-life counterparts had been irrevocably intertwined. "We are all friends on Facebook so we see them visiting their families, pictures of them visiting their kids, playing with their dogs," said Carr. Jenn Colella concurred: "It's also beautiful that there are no other circumstances in which we would've met these people. We're all so different and so to have met these people and now have them so deeply part of our lives is another gift."

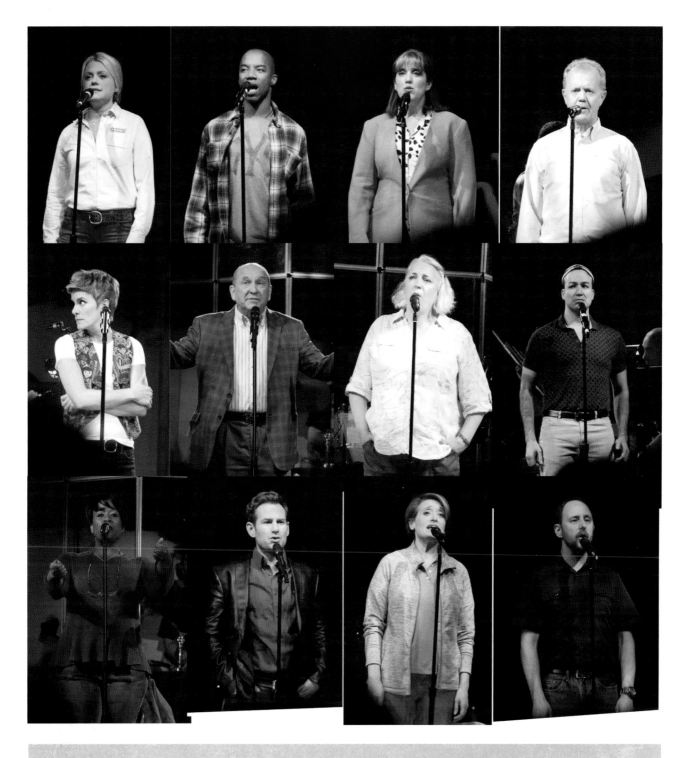

A collage of the ensemble from the Gander concert (top left to right): Kendra Kassebaum, Rodney Hicks, Sharon Wheatley, Lee MacDougall, Jenn Colella, Joel Hatch, Astrid Van Wieran, Caesar Samayoa, Q. Smith, Chad Kimball, Petrina Bromley, and Geno Carr.

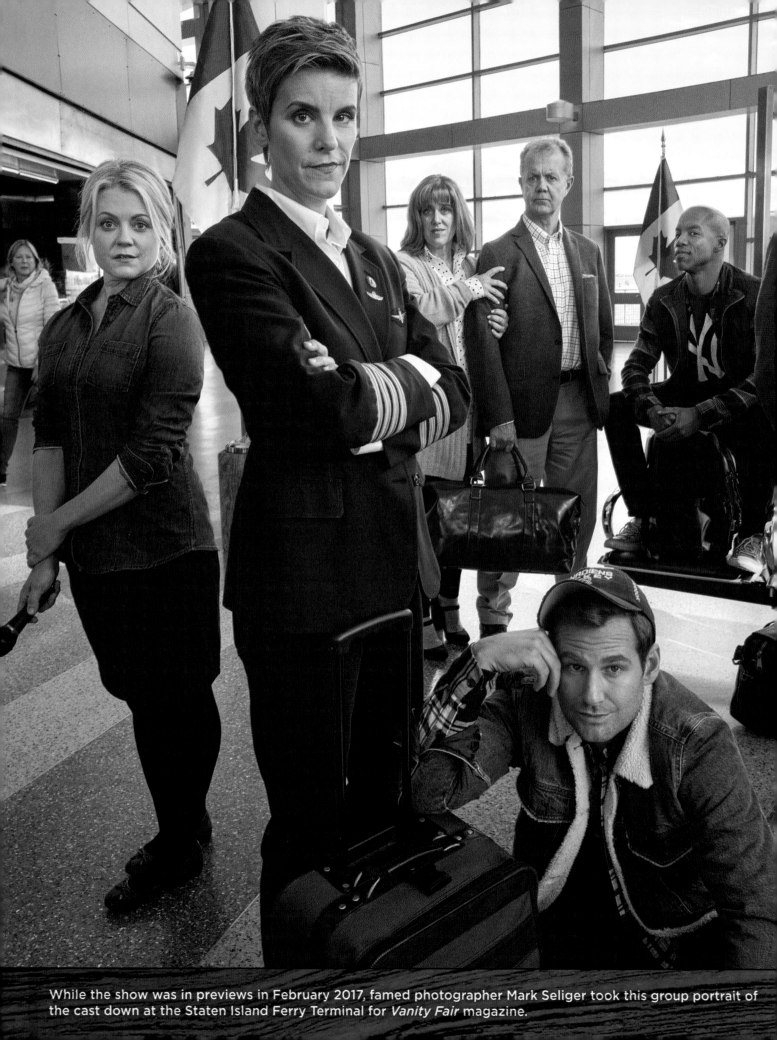

While the show was in previews in February 2017, famed photographer Mark Seliger took this group portrait of the cast down at the Staten Island Ferry Terminal for *Vanity Fair* magazine.

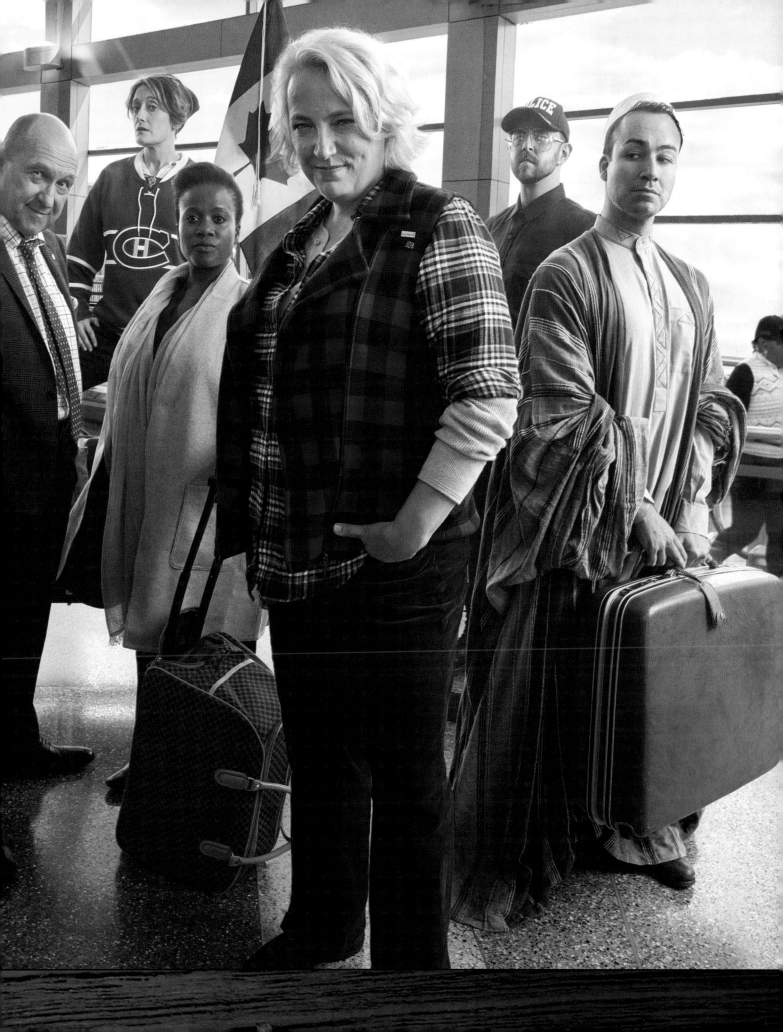

# SUNDAY, MARCH 12, 2017

Estimated date of arrival on Broadway was the evening of March 12 and *Come From Away* approached its landing with a strong tailwind; it had to navigate a little bit of turbulence from the shifting winds of history before setting down.

After the Gander presentation, the show opened only two weeks later at the Royal Alexandra Theatre in Toronto on November 15. "We really just had this instinct that Canada should happen before New York did. It worked out great for us," said Randy Adams. For David Hein, it was yet another homecoming: "Finally, we returned to where we first started writing *Come From Away*, our home in Toronto—and it was wonderful to finally share the show with our friends and family—in one of the theaters where we first fell in love with musical theater." By the second week of performances, the entire

eight-week run had sold out; ticket sales set a record, selling $1.7 million in a single week. An extension was impossible, because of commitments to previews on Broadway in mid-February.

It was a celebratory homecoming in Canada. Canadian musicals have rarely had any kind of success on Broadway—*The Drowsy Chaperone* ran over a year and a half, beginning in 2006, but that's the only exception that comes readily to mind, and *Come From Away* has already surpassed that run—and the feeling was that, independent of its subject matter, it was a case of "local boy and girl make good." Michael Rubinoff observed the musical as a watershed: "The reaction said to me that a Canadian presence in this business was now possible. Canada is really a small town that's a country and *Come From Away* has filtered

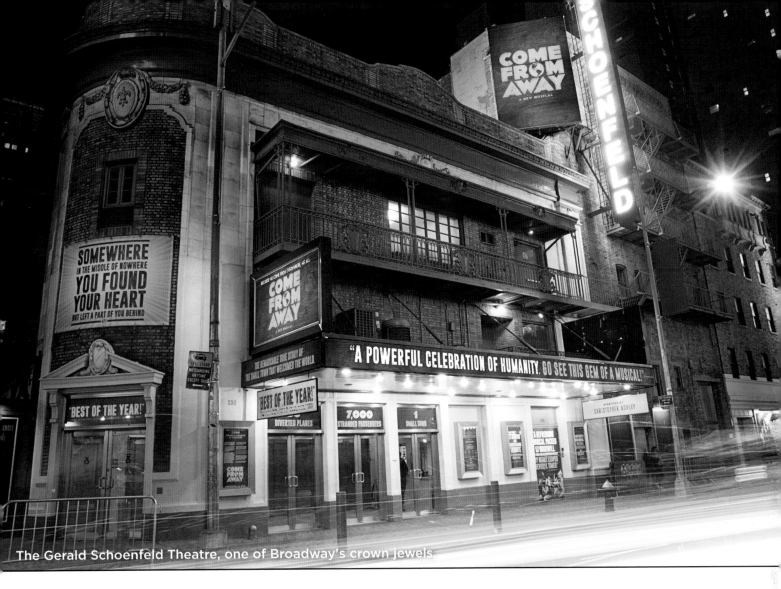

The Gerald Schoenfeld Theatre, one of Broadway's crown jewels.

into the zeitgeist, from the prime minister all the way down."

But, then, of course, there was that small town . . . According to Chris Ashley, "There's a justifiable Canadian pride that beams out of that audience; it is all the way Canadian in its DNA. I think the Canadian audience watches it both like a show and like a hockey game." Kendra Kassebaum was impressed by the "extreme laughter" in the production and the sense that the cast was handing out a kind of expansive present to the Toronto audience. In one case, literally so: as Hein remembered, "The show sold out—they added standing room to get folks in—and on the last day, which was freezing cold, we went down with our team to give Tim Hortons' donuts and coffee to the people waiting in the standing-room line and performed some material for them."

The final leg of the long *Come From Away* journey—six years in the making—would be, of course, the touchdown on Broadway. Despite all the accolades and box-office enthusiasm along the road, New York could present some stumbling blocks for the show's commercial success—and it wasn't only the infamous cadre of discerning critics in New York that had derailed many a promising production in the past. "Even if you didn't live in New York, you have a really intense relationship to

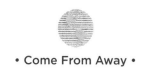
those events," said Ashley, "but it's particularly weighty to New Yorkers."

The producers sought to soften the approach. Through an odd coincidence, Sue Frost had run into someone she knew from New York during the DC engagement at Ford's; he was a New York fireman and was so impressed with the show that he offered to help in any way he could. Through his connections, *Come From Away* played to a special preview in mid-February for an invited list of first responders. "This paved the way for us to have a very successful invited preview on

Broadway for first responders, thanks to the FDNY Foundation and the Tunnel to Towers Foundation," she said. "That audience, they were the missing link," said Kassebaum. "If *they* say 'no go,' it's 'no go.' But you felt them soften, they opened up–and you felt it's a 'go.'" The special preview was a risky idea, but it succeeded; "There was great excitement about it because word had spread among NYC's first-responder community that the show was 'safe,'" observed Frost. Ashley confirmed that "it became clear through word of mouth that even if you're still healing from that event, it's not a show that

**Proud Newfoundlanders (notice the flag) and come-from-aways join their stage counterparts at curtain call.**

is going to do you damage. It's a show that is going to affirm something about humanity."

By the time *Come From Away* was playing a solid eight preview performances a week at the Gerald Schoenfeld Theatre on West 45th Street, there was a major sea change in the culture; there was a new presidential administration. It would have a profound effect on the show's message and its perception. "When I saw it [at Ford's Theatre in DC]," recalled journalist Michael Paulson, "it was totally clear that by the time it arrived on Broadway, Hillary Clinton was going to be the president of the United States. [Beverley Bass's solo, "Me and the Sky"] was going to be especially meaningful, given that the opening of the show was going to coincide with the first female president of the United States. Obviously, we turned out to be mistaken about how the election would unfold." "I thought it was going to be a triumph-of-women song, when Hillary was president–this song was going to be so fun because it was going to be like, 'Look how far we've come,'" Jenn Colella recalled in a *New York Times* piece. "And now when I sing the song, it's completely different. It's like, look how far we have to go."

The entire country was also being asked to rethink its entire ethos of welcoming strangers from abroad. By the end of Trump's first month in office, his administration introduced sweeping changes to immigration status and enforcement; the week that *Come From Away* opened, President Trump issued an executive order, temporarily suspending immigration from six countries. History had, once again, become a subtext to the musical, a subtext that was impossible to ignore. "The

The show opened at the height of the Trump administration's change in immigration policy.

show arrived on Broadway early in this new presidential administration that asked a lot of people to think about what it means to be an American and what our posture is going to be going forward to people that are unlike us," observed Paulson. "For Canadians, the show is a point of pride, but for Americans, it's a point of hope."

However, any anxiety that, somehow, New York wouldn't "get it" was quickly blown into the wind by the morning of March 13–or sooner, really, because of the Internet.

The review posted by the *New York Times*, written by chief drama critic, Ben Brantley, went, in part:

> [T]his Canadian-born production, written by Irene Sankoff and David Hein and directed by Christopher Ashley, is as honorable in its intentions as it is forthright in its sentimentality. And it may provide just the catharsis you need in an American moment notorious for dishonorable and divisive behavior.

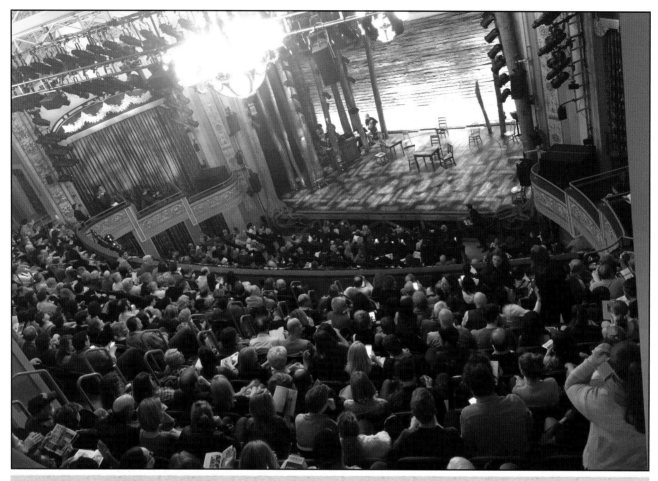

**Opening night on Broadway.**

[W]e are now in a moment in which millions of immigrants are homeless and denied entry to increasingly xenophobic nations, including the United States. A tale of an insular populace that doesn't think twice before opening its arms to an international throng of strangers automatically acquires a near-utopian nimbus.

Instead, it sustains an air of improvisational urgency, which feels appropriate to a show about making do in crisis, and it doesn't linger on obvious moments of heartbreak and humanity.

Peter Marks, of the *Washington Post*, had seen the show at the Ford's Theatre months earlier and came away, if anything, more impressed:

Most people want to believe they're capable of taking in stricken strangers, so just as anyone who's flown can easily project themselves into the roles of the stranded travelers, we also like to imagine we'd be as welcoming in a crisis as the people of Gander. That's why this musical is so suited to this particular moment. Not as a mournful reminder of who we all might have been for one another, but who we are all meant to be.

The reviews were overwhelmingly positive; but the real affirmation, the real approbation was with every audience that came to see the musical and their deep, ongoing connection to the artistry of the material. Said Chris Ashley,

> I've never watched an audience watch a show the way I think most audiences watch this one. Most Americans, I think, who were of age during the attacks have a very specific set of memories. They know where they were in their own story. I've never seen a show that operates that way before.

There's one final anecdote that threads the idea of memory and experience in its own way, full circle. At the opening night party for *Come From Away*, the producers made sure that the loyal and generous Ganderites were in attendance (in fact, they joined the cast onstage for the curtain call to a rapturous reception), along with production staff, creative staff, and family and friends. It was destined to be a whale of a party. But the producers had one more trick up their sleeve. At the Gotham Hall ballroom, six blocks south of the theater, where the raucous crowd was enjoying the smooth deplaning at this particular part of the journey, David Hein and Irene Sankoff were celebrating mightily, as well they should. Sue Frost told David to turn around from the end stage on the ballroom floor, and cover his eyes. He was mystified, but, hey, he and Irene had trusted his producers this much, this far.

"Okay, turn around," said Frost. And there on the stage, with guitar and button accordion and bodhràn, were Shannyganock, one of Hein's favorite Newfoundland bands, wailing away with "I'm an Islander"–just the way they had on the hockey rink in Gander, five and a half years earlier, where it all began.

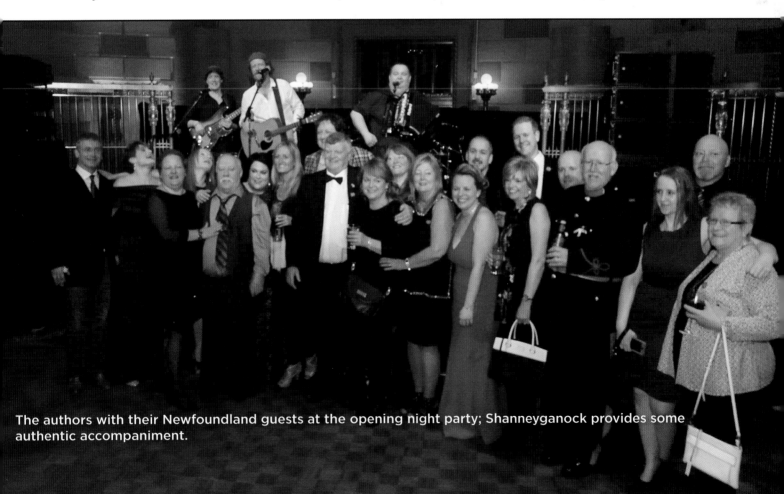

The authors with their Newfoundland guests at the opening night party; Shanneyganock provides some authentic accompaniment.

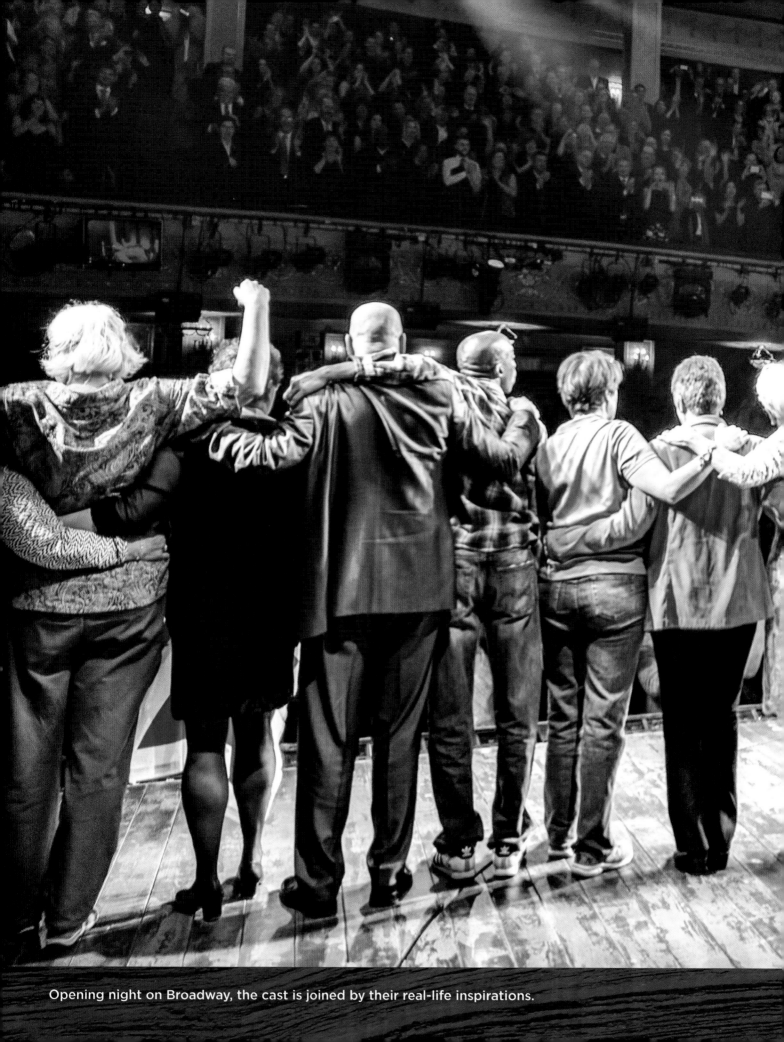

Opening night on Broadway, the cast is joined by their real-life inspirations.

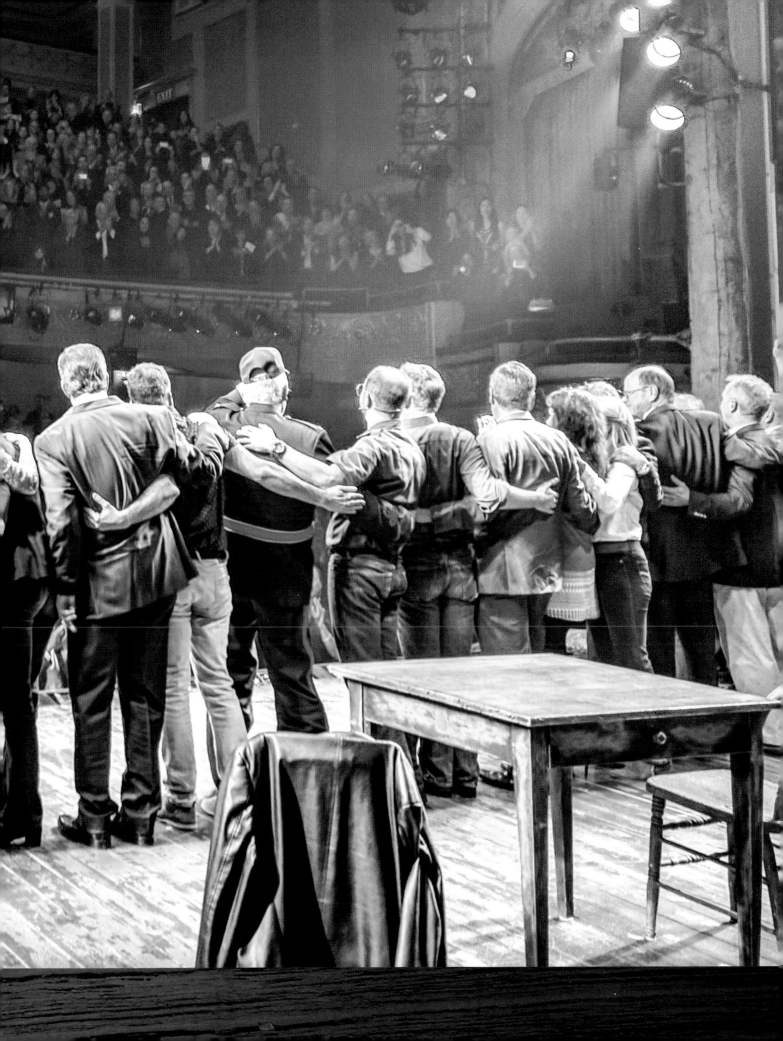

---

### E P I L O G U E

# FARTHER "AWAY"

When the figurative curtain comes down on any Broadway opening night, it feels like crossing the finishing line. *Come From Away*'s Broadway opening was just the beginning as the show took its artistry and its message even farther "away" to audiences across the globe.

First, though, an important stop five blocks uptown: after winning an array of local theater awards and scoring Best Musical prizes across North America in the San Diego area, Seattle, Washington D.C., and Toronto, in addition to numerous other critics' awards in New York, *Come From Away* was nominated for seven Tony Awards including Best Musical. On June 11, 2017, the Tony Awards were held in Radio City Music Hall and the cast performed in front of a national viewing audience of millions (including singing "Welcome to the Rock" while dancing with the Rockettes!). That evening, Christopher Ashley took home the Tony Award for Best Direction of a Musical. In his

The UK *Come From Away* team with presenter Gloria Estefan, after winning four Olivier awards, including Best Musical.

acceptance speech, Ashley specifically honored the "people who extended their hearts and their homes at the very worst moment."

*Come From Away* launched its first post-Broadway production with a second company in Canada in January 2018, starting with a sold-out four-week engagement in Winnipeg. A limited run of the show played in Toronto at the Royal Alexandra Theatre before transferring to the Elgin Theatre, where it continues to play to sold-out houses. A subsequent North American Tour across the United States and Canada began at Seattle's 5th Avenue Theatre (where the first professional workshop was held) in October 2018. The North American tour won four Los Angeles Drama Critics Circle Awards, including Best Production.

One of the more extraordinary consequences of the multiple productions across North America is, how some of the people actually stranded in Gander back in

2001 have gotten to see themselves–or at least a version of their experiences–portrayed on-stage in their very own hometowns.

A fourth production of *Come From Away* made its long-awaited UK premiere at the Phoenix Theatre on February 18, 2019, following a limited engagement at the Abbey Theatre in Dublin during December of 2018 and January of 2019. In April of 2019, it won four prestigious Olivier Awards, including Best New Musical. A fifth production of *Come From Away* makes its exclusive Australian premiere at the Comedy Theatre in Melbourne in July 2019.

Back in New York City, the musical recouped its $12 million capitalization in less than eight months on Broadway (the national tour and the Toronto productions each recouped their investments even faster), and *Come From Away* broke its own box office record at the Gerald Schoenfeld Theatre for the Christmas holiday week of 2017. The Schoenfeld's backstage has played host to any number of notables, including Canada's prime minister Justin Trudeau, who, on March 15, 2017, led a delegation of 600 people to the show–including more than 125 ambassadors to the United Nations–as guests of the Canadian consulate general in New York. The guests also included Ivanka Trump, the president's daughter. Another White House daughter, Chelsea Clinton, brought her parents to see the show three months later. Proud Newfoundlanders and Canadians of all stripes have attended the Broadway production, often bringing local memorabilia, much of which has been memorialized backstage at the Schoenfeld. Eager audiences at the stage door not only treat

The *Come From Away* tour, bringing Newfoundland to North America.

the performers as celebrities, but the real-life participants as well–witness the girls who wait after the show, dressed up in Beverley Bass outfits. And Beverley Bass herself, has now attended over 120 performances, returning with countless female pilots and crew, encouraging young women to follow in her footsteps. At each opening night in venues across the globe, the Newfoundlanders and the come-from-aways reunite to honor that extraordinary week in 2001.

But, perhaps it's the ever-expanding ripple effect of kindness and generosity that resonates most movingly back to away. On the first anniversary of 9/11, Kevin Tuerff decided to honor the day by sending his staff out to do good deeds for strangers. This evolved into Pay It Forward 9/11, a year-round effort of remembrance and service: "There are many acts of kindness." said Tuerff, "which don't cost a dime." The event, referenced in the musical, has spread to other businesses, schools, and houses of worship across the United States and Canada.

In between packing meals for food banks, the cast performs for volunteers.

The various companies of *Come From Away* have taken this message to heart. The Toronto company has set up its own informal #ComeFromKindness organization, raising nearly half-a-million dollars with concert performances and various other events. The tour company raised money for flood victims in the middle of America as well as the Gander and Area SPCA, among other charities. The London company began raising money within weeks of opening in support of an organization called Young Roots, which supports young refugees and asylum seekers in the UK and overseas. The Broadway company has a more than a two-year history of giving back to local New York concerns including Broadway Cares/ Equity Fights and a variety of other local and Newfoundland charities.

The annual landmark of 9/11 has a particular resonance in New York City. That day was named National Day of Service and Remembrance by the United States and Canada in 2007 and the various casts have honored that day with numerous benefits, donations,

and acts of volunteerism. Producer Sue Frost estimates that *Come From Away*, in all of its various incarnations, past and present, has raised more than a million dollars in donations to deserving parties. "The show reminds me every day that kindness takes initiative and effort," said Chad Kimball. "I think that's why the show has been a boon to people's spirits: Because we all know how unkindness works, but we want to hold up an example of kindness working so well."

On the stage of the Schoenfeld, there's a most potent metaphor for this kindness. When Beowulf Boritt originally insisted on actual trees as part of the set, it had an unintended consequence. Within a few months, aided no doubt by the warmth of the stage lights and the human affection in the theater, a few of the trees began to sprout tiny optimistic leaves.

On-stage–and off–it seems that, with *Come From Away*, hope springs eternal.

A tree grows on 45th Street; a new leaf on the *Come From Away* set.

## ACKNOWLEDGMENTS

**THE AUTHORS WOULD LIKE TO THANK:**

Prime Minister Justin Trudeau, Consul General Phyllis Yaffe, Max Grossman, Steve Ross, Randy Adams, Kenny Alhadeff, Marleen Alhadeff, Sue Frost and the Junkyard Dog Productions team, Daniel Goldstein, Jessica Bird, Sarah Harris, Clint Bond Jr., James Canal, Tina Wargo, Sara Rosenzweig and the team at ArtHouse, Colgan McNeil, Wayne Wolfe and the team at Polk & Co., Janette Roush, Allison Spratt Pearce, Michael Rubinoff and Jennifer Deighton from Sheridan College, Betsy King Militello from the National Alliance for Musical Theatre, Rick Van Noy from La Jolla Playhouse, Steve Brown from Seattle Rep., Sue Toth at Mirvish Productions, Drew Cohen at MTI, Captain Paul Hamlyn, CD, 103 Search and Rescue Squadrom, 9 Wing Gander, Royal Canadian Air Force, Andrea Peddle, director of tourism for Newfoundland and Labrador, Andrew Weir from Newfoundland Tourism, Glenda Dawe and Colleen Field at the Centre For Newfoundland Studies at Memorial University, Brian Williams and Kelly Sceviour from the Town of Gander, Reg Wright and Janice Bath, from the Gander International Airport Authority, Ron Singer at NAV Canada, Dion Faulkner from Allied Services of Canada, Adam Randell and Barbara Dean-Simmons of SaltWire Network, Brian Mosher, Abby Moss from the Beyond Words Tour, Kim Wiseman, Jerry Knee, Kathy Dillaber, Amanda Murray and Lauren Hummel at Hachette, Ellen Scordato at Stonesong, Stan Madaloni at studio2pt0, Dan Watkins and Jasmine Kaufman at Levine, Plotkin & Menin, Zoë Erwin-Longstaff, Caroline Jackson, Andrea Coles, Joanne DeFrietas, Lee Aaron Rosen, and the incredible community of cast, band, crew, come-from-aways and Newfoundlanders who contributed photos and trusted us to tell their stories.

## PHOTO CREDITS

To learn more about the people and places that inspired *Come From Away*, visit www.NewfoundlandLabrador.com. And to learn more about the show and to purchase tickets, visit www.ComeFromAway.com

• Come From Away •

Junkyard Dog Productions

Jerry Frankel   Latitude Link   Smith & Brant Theatricals

Steve & Paula Reynolds   David Mirvish   Michael Rubinoff   Alhadeff Productions

Michael Alden & Nancy Nagel Gibbs   Sam Levy   Rodney Rigby   Spencer Ross   Richard Winkler   Yonge Street Theatricals

Sheridan College   Michael & Ellise Coit   Ronald Frankel

Sheri & Les Biller   Richard & Sherry Belkin   Gary & Marlene Cohen   Allan Detsky & Rena Mendelson   Lauren Doll   Barbara H. Freitag   Wendy Gillespie

Laura Little Theatricals   Carl & Jennifer Pasbjerg   Radio Mouse Entertainment   The Shubert Organization   Cynthia Stroum   Tulchin Bartner Productions

Gwen Arment/Molly Morris & Terry McNicholas   Maureen & Joel Benoliel/Marjorie & Ron Danz   Pamela Cooper/Corey Brunish   Demos Bizar/Square 1 Theatrics

Joshua Goodman/Lauren Stevens   Just for Laughs Theatricals/Judith Ann Abrams Productions   Bill & Linda Potter/Rosemary & Kenneth Willman

and

La Jolla Playhouse and Seattle Repertory Theatre

Present

## COME FROM AWAY
### A NEW MUSICAL

Book, Music and Lyrics by

**IRENE SANKOFF** and **DAVID HEIN**

Featuring

PETRINA BROMLEY   GENO CARR   JENN COLELLA   JOEL HATCH   RODNEY HICKS

KENDRA KASSEBAUM   CHAD KIMBALL   LEE MacDOUGALL

CAESAR SAMAYOA   Q. SMITH   ASTRID VAN WIEREN   SHARON WHEATLEY

JOSH BRECKENRIDGE   SUSAN DUNSTAN   TAMIKA LAWRENCE   TONY LePAGE

| Scenic Design | Costume Design | Lighting Design | Sound Design |
|---|---|---|---|
| BEOWULF BORITT | TONI-LESLIE JAMES | HOWELL BINKLEY | GARETH OWEN |

| Orchestrations | Arrangements | Music Coordinator | Casting |
|---|---|---|---|
| AUGUST ERIKSMOEN | IAN EISENDRATH | DAVID LAI | TELSEY + COMPANY<br>Rachel Hoffman, C.S.A. |

| Dialect Coach | Digital Advertising and Marketing | Advertising | Press Representative |
|---|---|---|---|
| JOEL GOLDES | ARTHOUSE | AKA | POLK & CO. |

| General Management | Production Management | Production Stage Manager | Marketing Strategy and Direction |
|---|---|---|---|
| ALCHEMY PRODUCTION GROUP | JUNIPER STREET PRODUCTIONS, INC. | ARTURO E. PORAZZI | ON THE RIALTO |

Music Supervision

**IAN EISENDRATH**

Musical Staging

**KELLY DEVINE**

Directed by

**CHRISTOPHER ASHLEY**

*Come From Away* was originally co-produced in 2015 by La Jolla Playhouse and Seattle Repertory Theatre and presented in 2016 by Ford's Theatre

*Come From Away* (NAMT Festival 2013) was originally developed at the Canadian Music Theatre Project, Michael Rubinoff Producer, Sheridan College in Oakville, Ontario, Canada, and was further developed at Goodspeed Musicals' Festival of New Artists, in East Haddam, Connecticut. The Canada Council for the Arts, the Ontario Arts Council and the 5th Avenue Theatre, Seattle, Washington, also provided development support.

American Airlines is the Official Airline Partner for *Come From Away*